Discovering Design

Explorations in Design Studies

Edited by
RICHARD BUCHANAN
and
VICTOR MARGOLIN

THE UNIVERSITY OF
CHICAGO PRESS
Chicago and London

The University of Chicago Press, Chicago 60637
The University of Chicago Press, Ltd., London
© 1995 by The University of Chicago
All rights reserved. Published 1995
Printed in the United States of America

10 09 08 07 4 5 6 7

ISBN: 0-226-07815-9 (paper)

Library of Congress Cataloging-in-Publication Data

Discovering design : Explorations in design studies / edited by
 Richard Buchanan and Victor Margolin.
 p. cm.
 1. Design, Industrial—Social aspects. 2. Engineering de-
 sign—Special aspects. I. Buchanan, Richard. II. Margolin,
 Victor, 1941– .
 TS171.4.D57 1995
 745.2—dc20 94-27279
 CIP

⊛ The paper used in this publication meets the minimum
requirements of the American National Standard for
Information Sciences—Permanence of Paper for Printed
Library Materials, ANSI Z39.48-1992.

Contents

Editors' Note

Most of the essays selected for this volume were originally delivered as papers at an invited conference of the same name held at the University of Illinois, Chicago, on November 5–6, 1990. Funding for the conference, which was attended by twenty-five designers, design educators, and distinguished scholars and professionals representing a wide variety of fields, was provided by the university's Office of the Vice-Chancellor for Academic Affairs. The papers have since undergone extensive revision and expansion, based on discussions that began at the meeting. We have provided a conference summary as an appendix with information on the historical context of the meeting.

Richard Buchanan and Victor Margolin

Introduction

Richard Buchanan and Victor Margolin

Discovering Design reflects a growing recognition that the design of the everyday world deserves attention not only as a professional practice but as a subject of social, cultural, and philosophic investigation. This idea is not provocative, at least among those who study and practice design. Noted designers, historians, and theorists have contributed to establishing the foundations of design studies, a field of inquiry directed toward better understanding of the ideas and methods lying behind design practice. In the course of reflection, many writers have not hesitated to extend their work beyond the narrow bounds of design practice to speculate on cultural and philosophic matters, finding that design practice cannot be adequately understood apart from the issues and concerns of contemporary cultural discourse. But the prospect of reversing this pattern—employing concepts and methods drawn from other disciplines to explore design, or encouraging individuals from other disciplines and professional perspectives to address what they regard as important issues or themes in the phenomenon of design—is provocative.

Broadening the discussion of design poses a double challenge.

First, it challenges the authority of practicing designers as the only group qualified to speak for design in contemporary culture. This is threatening to some, who perhaps fear that expanded discussion will diminish their professional standing or further cloud an already difficult subject. However, it is not threatening to others, who recognize that wider discussion will ultimately help to clarify the nature of design and improve common understanding of its cultural significance. Second, broadening the discussion challenges the authority of many established disciplines which claim special insight into culture without explicitly addressing the role of design as more than a mere decoration or embellishment of cultural life. One of the anomalies of twentieth-century culture, particularly academic culture, is an excessive separation between theory and practice, between the words and symbols used to understand important subjects and the concrete actions of individuals and groups who employ personal or formal knowledge to accomplish practical purposes. This separation is nowhere more evident than in the tendency to elevate special instances of production to the status of fine art while dismissing the vast range of useful and often beautiful production as merely the result of vocational or commercial enterprise, unsuitable for serious study. The development of disciplines such as the history and philosophy of technology, material culture, and cultural studies signifies an effort to reassess the importance of things in cultural life. But the emphasis, even in these disciplines, is on the material products that result from design, not the wider range of other types of products that also result from design, and not the complex activity of designing. Design, defined as the conception and planning of all of the products made by human beings, is largely ignored. Design is a form of deliberation whose result is measured in production and in the careers of individual products in culture. Yet, the agency which serves and shapes our daily lives is seldom more than a footnote to other causes in social and cultural discourse.

If broadening the range of discussion in design studies represents a sea change in reflection on design in contemporary culture, it parallels a similar change underway in contemporary design practice. Increasingly, designers are expected to participate as members of interdisciplinary or cross-functional teams comprising engineers, computer scientists, psychologists, sociologists, anthropologists, experts in marketing and manufacturing, and a

variety of other individuals whose perspective on design owes
little to an understanding of the historical development of profes-
sional practice in areas such as graphic and industrial design. The
new circumstance of integrated product development—the de-
velopment of products with concurrent participation by diverse
individuals representing different perspectives on what products
can and should be—presents a problem for professional design
practice, with serious implications for design education. Design-
ers have been comfortable in crossing disciplinary boundaries on
their own terms and moving into the territory of other fields.
However, they are not always prepared to face the challenge
when others move into their territory and employ new concepts
and unfamiliar methods of argument to characterize the activity
of designing or the qualities of products. As an illustration of one
facet of the problem, a designer recently asked, "How should I
argue for what I know to be the most reasonable design solution
in a given situation without merely aping the style and manner of
one of the other professionals sitting at the conference table?"
What she identified is a common dilemma. Can a designer rely
on spectacle, charismatic performance, or a claim to special intui-
tion when discussing a potential design solution with individuals
from other fields, or must the designer support an idea by resort-
ing to the appearance and devices of "objective" or "scientific"
proof? Neither approach is adequate for contemporary circum-
stances, but an alternative is not clear.

Professional design practice is vulnerable in a way that it has
never been before. Based on the past success of the design profes-
sions, designers are now invited to participate in the early stages
of the product development process because of a belief that they
can contribute something special that others cannot provide in
forming the concept of a new product. In the past, however, de-
signers often prevailed through personal charisma and the vivid-
ness of their proposed solutions, without directly joining issues
with the technical challenge of competing professionals who rely
on various forms of "objective" proof of the validity of their ideas.
Now, designers must work closely and persuasively with other
participants, often including representatives of the general popu-
lation expected to use a new product. Indeed, designers must of-
ten play the subtle and informal role of facilitator in such groups,
quietly guiding the process of deliberation and encouraging the

integration of sound contributions by other professionals. This requires a new maturity and sophistication in design practice that must come from better understanding of the discipline of design thinking, not only as a body of professional practices and specialized techniques but as an art of communication. What is needed is a middle ground between intuition and science, a distinctive method of deliberation and presentation that is suited to the special knowledge and perspective of the designer and to the special ability of the designer to make concrete practical connections among diverse bodies of formal and tacit knowledge.

Discovering Design

The discovery of design in the twentieth century is not a single discovery, but a series of discoveries, following a logical pattern which informs the careers of individual designers and shapes the development of professional and cultural discourse about design. The pattern is classic in its simplicity. It comprises the fundamental issues of knowledge and understanding which determine any field of learning or professional practice. We understand a subject when we can demonstrate that it exists as a real phenomenon; when we can explain what it is; when we can explain how it is different from other subjects and, therefore, deserves treatment in its own right; and, finally, when we can explain why it is as it is. Each of these issues is resolved to some degree by the individual designer throughout the course of a career. The resolution may be intuitive, receiving expression only in specific products. However, many of the best designers express their ideas in other ways as well, contributing to the body of professional discourse and advancing public discussion.

The first discovery is a recognition, now obvious to many people, that design exists as the central feature of culture and everyday life in many parts of the world. In highly industrialized societies, design appears to have replaced nature as the dominant presence in human experience. The nature we do experience is often engineered and manipulated at an astonishing level of subtlety to serve human purposes. Indeed, it is now necessary for human beings to artificially preserve natural territories for recreation, renewal of the planet, and the enjoyment of future generations. Closer to home, we are surrounded by images and objects

produced by designers with deliberate intent to shape our experience and influence our actions. However, even our actions are often channeled into activities or supported by services that are designed for the purposes of work, play, learning, and daily living. For individuals, the discovery of how pervasive design has become in the contemporary world is often a revelation, a door opening on a new world of curiosity, questions, and possibilities. For some of these individuals, the discovery of design suggests an outlet for talents that would otherwise be directed toward traditional occupations in the fine arts, science, or business. This stage of discovery provides the impetus for the most common type of design literature: popular books or newspaper and magazine articles that accomplish little more than to raise consciousness, demonstrating the extensive presence of design in individual, social, and cultural life. This is represented, for example, in the continuing flow of coffee table books about design, filled with pictures and accompanied by enthusiastic text.

The second discovery is the possibility of the meaningful interpretation of design. If design exists as a feature of cultural life, what is it? Is it, as civil engineer Henry Petroski suggests, the disassembling and reassembling of the parts of nature? Or is it, as Nobel Prize–winning economist and scientist Herbert Simon suggests, a new domain best described as the science of the artificial? Or, is it, as others suggest, a new form of practical art and communication? The possibility of meaning has led to diverse ideas and claims about design. Young designers are rightfully confused about the pluralism of competing ideas, and they struggle to form their own concepts and find a place in the design professions. For design literature, the discovery that design can have meaning has led to protracted debate over the best definition of design. The debate has been valuable, but it has not led to consensus. Indeed, it has often led to acrimony and a fragmentation of the design community into schools and sects, each driven by a different vision of the meaning of design. At its best, however, debate about the meaning and definition of design has gradually broadened the subject matter under discussion, revealing new aspects of products and suggesting alternative paths for exploration in practice and reflection.

The third discovery concerns the nature of the activity of designing: how design is different from other activities and how it

xiv *Richard Buchanan and Victor Margolin*

may be characterized in its own terms. This is based on the recognition that design involves distinctive discipline and method, although there is little agreement on what the discipline may be. Discussion of method is an ongoing feature of design literature, marked by several recurring issues. Is design an art or is it a science? Is it an activity for individuals or for groups? What kind of knowledge does it require? How is it related to other activities? Treatment of these issues has broadened our understanding of design and opened the way for the exploration of other themes in the study of design. This has served to connect design with cultural and professional discourse in many fields.

Finally, the fourth discovery is that design is a domain of contested principles and values, where competing ideas about individual and social life are played out in vivid debate through material and immaterial products. The key issue, however, is not what it was expected to be in the early part of the twentieth century, when many of the diverse forms of modernism seemed to share a belief in the perfectibility of human life. It is a not a question of which principles and values should guide design. Principles and values are extremely diverse among designers, and the internal debate among designers about which principles are most valid will likely go on forever. Rather, the key issue is, who shall judge? Should it be the designer, or the manufacturer, or critics of taste, or scientific and technical experts, or segments of the population, or the individual customer, or society and culture at large? Increasingly, this translates in design literature into a struggle to determine who is the designer and how the activity of designing can best represent the interests and values of the human user. Understandably, professional designers are nervous. They have long argued that the professional designer represents the human being and the human dimension of product development. But how can this claim be maintained when every member of a product development team claims to possess special knowledge about what people want and need? This remains one of the deepest and most challenging issues in contemporary design thinking.

The ongoing discovery of design in each of these four areas has affected general understanding of the potential of design. It has affected public consciousness and the perception of design, the development of design education and the design professions, and the investigation of design in the emerging field of design studies.

However, the process of discovery is far from complete. The purpose of this book is to continue the discovery of design and bring new perspectives to light. The essays we have chosen are best regarded as explorations in design studies. They do not define the core of the field, nor do they attempt to set its boundaries. Either effort would be premature for a subject as rich and complex as design. Nonetheless, there is a logical pattern in their organization. The book is divided into three broad thematic sections, representing a sequence of fundamental issues in design studies: how to shape design as a subject matter, distinguish the activity of designing in the complex world of action, and address the basic questions of value and responsibility that persistently arise in the discussion and practice of design.

Shaping the Subject

The essays in this section present three perspectives on design as a subject of practice, appreciation, and investigation. Distinguished designer Gianfranco Zaccai argues that the division of labor introduced in the industrial revolution led to specialization in the diverse elements that comprise products. As a result, there was a loss of the unifying quality that once made objects satisfying to the soul and senses of those who used them. The nature of this quality is difficult to define, but it is more than the individual qualities identified in terms such as reliability, performance, or visual appeal. For Zaccai, the loss and rediscovery of this quality charts the history of industrial design, setting the stage for post-industrial culture. He argues that earlier designers abdicated their role as generalists in the product development process, deferring to the marketing specialist. Yet, the marketing specialist failed to take on the larger task of integrating the contributions of others and directing attention toward the seemingly ephemeral issues that transcend specialization and short-term profit. Furthermore, designers failed to develop depth in their understanding of the nature and meaning of aesthetics and, particularly, the dynamic, kinesthetic features of products that are essential for satisfying and fulfilling interaction. He suggests that designers must reclaim their role as "visionary generalists and coordinators in the product development process" and they must expand their understanding of aesthetics to the original meaning of the term, concerned with

"the appropriate and harmonious balancing of all user needs and wants within technical and social constraints."

Albert Borgmann, a philosopher who has written extensively on the problems of technology and contemporary life, suggests that the province of design is the world of engagement: "the symmetry that links humanity and reality." However, he observes that engagement is a declining quality of contemporary life, due in large part to the division of design into branches of engineering and aesthetics. "Engineering," he argues, "devises the ingenious underlying structures that disburden us from the demands of exertion and the exercise of skills and leaves us with the opaque and glamorous commodities that we enjoy in consumption." In turn, aesthetic design has become a superficial smoothing and stylizing of the surfaces of technological devices. What is needed, he believes, is new attention to the depth of design, a recovery of the unity of engineering and aesthetics to provide a material setting that provokes and rewards engagement. This is the task of the designer, whether shaping the large environment of the city or the small environment of the home. Designers hold humanity's common memory of the daily practices of engagement: they are trustees and conservators of values as well as innovators in the exploration of new expressions of engagement.

For Richard Buchanan, the development of design in the twentieth century is a pluralistic exploration of a new, expanded form of rhetoric, directed toward the conception and planning of the artificial or human-made world. Unlike scientists, who investigate a common subject matter that is given by nature, designers continually create their subjects through the activities of invention and planning. The diversity of products in contemporary culture—ranging from words and images to material objects, activities, and systems—is evidence of the diversity of approaches to design in theory as well as in practice. To probe this empirical diversity, Buchanan discusses different accounts of the origins of design and, through this device, traces different conceptions that continue to shape the discipline. He argues that design is a new liberal art of industrial and technological culture. Unlike traditional rhetoric, which is typically conceived in contemporary culture as no more than a verbal art—a misunderstanding of the nature of rhetoric that contributes to the separation between words and things in contemporary life—design offers a variety

of ways to reunite theory and practice for productive purposes. Buchanan concludes that design is an essential element of a new philosophy of culture directed toward the empowerment of individuals in exploring the diverse and common qualities of community experience.

Although the essays in this section represent distinctly different perspectives on design, they share key themes in shaping the subject. First, they direct attention to the wide range of designed objects that must be addressed in understanding design. Zaccai focuses on industrial objects, Borgmann on material objects ranging from the urban to the domestic environment, and Buchanan on images, material goods, activities and services, and systems. Second, each author identifies a characteristic property or feature of design as subject matter. Zaccai focuses on a unifying quality that satisfies the soul and senses of the human user, Borgmann on human engagement with reality, and Buchanan on individual empowerment to explore a plurality of qualities in the common experience of the community. Third, each of the authors rejects the idea that design is a superficial styling concerned only with the surface appearance of products. Although designers have often been forced to limit their contribution to surface treatment, the core of their discipline lies in integrating issues of engineering and technology, aesthetics, and social values. How this is to be accomplished—and to what end—is the long-term challenge that motivates each essay, pointing toward a new humanism in design. Indeed, these are the issues addressed in the following sections of the book by other contributors.

The World of Action

Past attempts to conceptualize design as an activity have focused either on the methodology of product planning or the characteristics of products themselves. In the former case product planning is seen as a specialized professional activity whose outcome can be affected by an analytic approach to method. In the latter, the product is considered as evidence of values that have been instilled in it and can be read out of it through a variety of interpretive strategies.

As a result of these two emphases, design has been considered too narrowly and the central role it plays in social life, both as an

Richard Buchanan and Victor Margolin

activity in which everyone engages and as one that results in products that are inextricably intertwined with human action, has been neglected. The essays in this section seek to redress this neglect.

Augusto Morello, a marketing consultant, calls for a theory that can help clarify the values that infuse the process of design and production. Such a theory, he believes, can lead to more meaningful products in the marketplace. Although Morello focuses his attention directly on the market, he is nonetheless concerned with the integral relation of products to the quality of life. Thus, he distinguishes between useful and wasteful products. Those he deems valuable are produced for users, rather than consumers. The user, he argues, is the person who best knows how to integrate products into an action project.

For Morello, design must be brought back into culture. The function of the market as he sees it is to provide objects that are more than the expression of a manufacturer's economic strategy; instead they should be cultural contributions. For a new "project of design," there can be no separation of the marketplace from cultural values. Morello believes that design theory can contribute to the common good. He presumes that many products are detrimental to this aim and states a need to better clarify the purposes of production. His interest in an ennobling product culture is hardly typical of marketing discourse, which, when it includes design, tends to focus on the pragmatics of its role in economic competition. Hence, design theory enables us to locate the discourse about products in a larger cultural frame, rather than isolate it within a strategic discussion of market success.

Morello's distinction between users and consumers is explored by Tufan Orel, who examines a particular category of user projects—the public use of medical research and clinical devices for diagnostic purposes, the cure of ailments, and self-transformation. Orel draws on literature from design, marketing, psychology, and sociology to pursue his investigation, which combines empirical data with speculative reflection. He is particularly interested in the unpredictability of user behavior as evidenced by the way users adapt existing products to their own purposes.

Orel defines a new product category which he calls "vital self-technologies." What unites these products is their incorporation into a particular kind of user project of self-care and transforma-

tion. The independent use of medical devices for self-diagnostics and cure is a move to rely less on medical professionals and take more responsibility for one's own health and well-being. Orel's account of vital self-technologies bears some relation to the theoretical arguments made by each of the other authors in this section. The inventive use of existing devices as a form of design behavior exemplifies Margolin's contention that the project of living is also a project of design. As well, it broadens Nigel Cross's concept of design ability to include the design of action as well as the design of products.

Orel makes clear that users behave in ways not anticipated by manufacturers. The incorporation of products into personal projects that are unforeseen and possibly not even approved by manufacturers makes more complex Morello's call for manufacturers to offer products that have great cultural significance. The question becomes one of who controls the production of cultural meaning. Is it a result of the manufacturer's intentions or does it arise from a negotiation between everyone involved in the design, production, and use of products?

While users, as Orel shows us, incorporate products into their plans of action, these plans are often stimulated by the availability of things to be used. This fact, as Morello suggests, should be better recognized by manufacturers so they can introduce more meaningful products to the market and avoid the waste and excess that he deplores. Morello speaks from within the marketing profession and his voice adds practical relevance to discussions of product use.

Though Nigel Cross is concerned in his essay with the act of designing rather than with product use, his conception of design ability as something possessed by everyone links his research to the broader theory of products in society that interests other authors in this book. Cross distinguishes his exploration of natural design ability from earlier theories that conceptualized design as a systematic method which could be defined independently of individual capability or invention. But he does not wish to return to the idea of design as an ineffable art which the design methods theorists rejected.

The intent of his essay is to establish a set of principles that mark a direction for further investigation. He approaches this task logically, supporting each principle with examples of re-

search from the social and cognitive sciences. In his approach to theory, Cross is less concerned with charting a new task for it than with demonstrating the use of existing data to support the principles he enunciates. One of his aims is to separate design intelligence from broader theories of intelligence. He believes there are distinct designerly ways of knowing, thinking, and acting. This thesis supports the interest of other authors such as Victor Margolin, Langdon Winner, and Carl Mitcham in how products get designed.

As Cross points out with his principle that design ability can be damaged or lost, the quality of design activity can be improved through a better understanding of how it occurs. He recognizes that design quality is still determined by individual ability, regardless of the constraints placed on design activity by social policies or marketing decisions.

Both Cross and Morello use C. S. Peirce's concept of abductive reasoning to characterize the design process as one of planning or conjecture. For Cross, this serves the purpose, as it did previously for Herbert Simon, of distinguishing design thought from scientific reasoning, while for Morello, who applies the concept of abduction to both design and marketing methods, it confirms a close relation between industry, which plans and manufactures products, and culture, which absorbs them. Morello believes that design and marketing should be based on a more responsible strategy of product innovation which closely approaches the idea of value-in-use rather than the consumer's inclination to make a purchase.

Cross reminds us that design ability is not a black box phenomenon to be ignored when constructing social theories of product culture or ethical arguments for design practice. These theories are ultimately affected by the human ability to act in what Cross believes are designerly ways. However, just as he seeks to define design ability as a separate phenomenon, he also argues for design studies as a discipline in its own right. Cross's definition of design studies raises questions of whether it has a unique subject matter and research methodology or whether instead it is a space or topos where problems not addressed by existing disciplines reside.

It is clear from the essays by Morello, Orel, and Cross that the relation between the conception and planning of products and

their use is not a simple one. Victor Margolin argues that products do not just mediate between motives and acts but are instead part of a more complex loop in which they are dynamically engaged with the formulation of both. He employs the term *product milieu* to designate the vast array of material and immaterial products that human beings devise and sustain in order to conduct their lives. Drawing on the philosophy of Alfred Schutz and Thomas Luckmann, whose grounding in phenomenology animates their theory of social action, Margolin links the product milieu to the directed courses of action or *projects* that human beings engage in.

He divides the product milieu into three spheres, the sites respectively of civic, market, and independent activity. Human projects, he argues, depend on the objects, activities, services, and environments that are found in each sphere. By recognizing the broad presence of design in society, Margolin asserts its relation to all aspects of life. But, he states, action theorists lack a conception of the product as an essential component of social theory, which has, in fact, given products little recognition.

This is also noted by Langdon Winner. His essay critiques political theorists who ignore the materiality of design and the specific products that embody their theories of political organization. Winner sees an enormous lacuna in the political imagination which, he believes, is yet to recognize the role that objects play in the political process. As an antidote, he proposes a new field of *political ergonomics* that can help to explain the influence of technology on how we shape our lives.

Although Winner has framed his concerns within the field of technology studies, in this essay he locates the political identity of technological objects within the project of design. He recognizes the inherently political circumstances which shape choices about what to produce, and he is aware of the way that products, once designed, take on lives of their own and can even overpower the individuals who must live with their effects. Implicit in Winner's call for a design theory that can help to clarify policy decisions is the argument that design ability does not operate freely but is embedded in a nexus of social, political, and economic motives. Winner recognizes that design activity can take many forms, which depend on how clearly the policy issues and social consequences of new products are articulated.

Elsewhere Winner has called technologies "forms of life"

which link humans and inanimate objects together in various kinds of relationships. But technologies are designed and produced by humans, and Winner sees an urgent need to better understand this process in order to explore alternatives to choices that are deemed unsatisfactory. An understanding of design for him must enable us to anticipate the consequences of what might be designed as well as analyze the effects of what already exists.

Winner's desire to locate design within a larger framework enables us to relate his political concerns to Morello's marketing objectives. This relation is reinforced by Margolin's conception of a product culture that embraces the spheres of civic politics, the market, and private life. What unites Margolin's product milieu with Winner's, Morello's, and Orel's interest in use is the relation of products to human action. All four authors shift the focus of design theory from the design process or the product as object to the product in use.

Without denying other concerns, this move is based on the recognition that the ultimate purpose of products is their incorporation into the projects of users. Hence, the methodology of design practice is not isolated from the anticipation or reality of product use; nor are issues of aesthetics and function viewed as separate from the responses of users to those aspects of products. Approaching design in this way runs counter to the traditional literature on product aesthetics which defines taste as a moral judgment separate from the phenomenological experience of product use. There are similar problems with the way some anthropologists theorize the relation of products to the human experience of use. They put more emphasis on the symbolic function of products than on their relation to human action. The same problems are replicated when design theorists borrow from semiotics to explore the meaning of products in society.

All the authors in this section recognize that our concern with the effect of products in society must lead us to a closer understanding of the factors that contribute to their conceptualization. Orel, for example, whose case study focuses on product users, makes clear that what users do with products, whether or not it is foreseen in the planning process, has serious implications for designers. And Margolin's postulation of a reciprocity of intentions between designers and users as it is played out in the product milieu also highlights design activity as the place where conjectures

are made concrete in products. This recognition has important implications for the study of culture. It raises serious questions about starting with objects themselves rather than with their conception and planning. As Winner cogently points out, the physical existence of products often suggests an inevitability that precludes the exploration of what might be.

The authors in this section agree that the planning, production, and use of products is a dynamic process that does not operate according to a closed system of rules and techniques as design theorists previously postulated. Instead, they recognize that its initiatives and results are malleable and dependent on multiple influences that frequently arise from outside existing theoretical constructs of how designing occurs.

Values and Responsibilities

One of the most engaging topics of contemporary design discourse is the question of ethics. Since the late nineteenth century when William Morris criticized the "cheap and nasty" goods that were designed and produced in Britain's new factories, the designer's role in industry has been subject to moral concern. It is important to note that historically the ethical critique of design has been strongest within the design professions themselves. That is because the practice of design, as opposed to its results, has remained almost invisible to the public and scholars alike.

Engineering design is something of an exception, owing largely to the developed field of technology studies. Within this field, more attention has been given to the activity of engineering design than to other design practices such as architecture, industrial design, or graphic design. Carl Mitcham's essay in this section is thus one of the first attempts to consider the problem of ethics and design from outside design practice and with the scholarly methods of philosophic discourse.

For Mitcham, design is not full-blown action. It is instead "more like a play or game" that operates between thought and act. He employs the terms "miniature action" and "proto-pragmatism" to separate design from the type of acts for which ethics has traditionally provided guidelines. Mitcham characterizes design as an anticipatory activity that treats cause-effect relations in models rather than full-scale finished products. For the

purpose of philosophic reflection, he distinguishes design from both thought and action. If, as he argues, logic is the way we reflect on guidelines for human thought, and ethics is the means of examining guidelines for human activity, then a different method is required for reflecting on design. By resisting the conflation of design and action within the purview of ethical judgment, Mitcham generates a new problematic: how do we assess the value of an act that is a nonmoral game? He argues that values are frequently imposed on design from the realms of social action which it prefigures. But Mitcham also sees design as closely related to action. While the designer must pull away from the constraints of the world in order to clear a space for free speculative thought, the results of design are then drawn back into the world, often in ways that the designer has not anticipated.

Though Mitcham's location of design as an intermediary between thought and action enables him to read it closely as a type of human behavior, his interpretive strategy is not shared by Tony Fry or Ezio Manzini, who want to empower design as a response to the ecological crisis that confronts us. This impulse embeds design in a philosophy of moral action instead of separating it from the traditional modes of ethical judgment as Mitcham attempts to do.

Fry argues that design can make the difference between creation and destruction. It is most valuable for him as an instrument of social re-creation. Within his urgent call for a new ethics is the understanding that design is not inherently resistant to this project. It becomes more malleable as we understand it as something separate from the forms of social life that have previously included it, notably corporate industrial production.

Manzini shares much of Fry's criticism of a design practice that has participated in an excess of worthless products. Like Morello, he laments the lack of objects that have a positive cultural significance. Manzini's strategy of changing design practice is to provide a new ecological metaphor of social activity, which can enable us to develop a code of ethics to insure our survival.

But as Mitcham recognizes, this metaphor imposes ethical demands *on* design rather than extract new ethical principles *from* it. Manzini, who trained as an engineer, seeks the basis for a calculus of action that can direct design to a more constructive role.

He finds it in Gregory Bateson's theory of purposive consciousness, which leads to a new ecological model of the social world—the "ecology of the artificial."

According to this model, we act within a system that is affected by what we do; hence our action must contribute to a balance of life. Manzini finds a potential for imbalance in the realm of objects as well as that of nonmaterial signs, which he calls the semiosphere. Modeling the world as a system, Manzini believes, can help us to rethink design practice so it can recognize necessary limits of growth and contribute to a social equilibrium.

Fry, for his part, invokes the idea of the sacred as the animating force for a renewal of design. But he presents the sacred as a vision of human community rather than a transcendental experience. By employing this image, Fry seeks to stimulate the human impulse to share a positive and caring life with others. Whereas Manzini relies on the power of social modeling to change behavior from without, the primary locus of Fry's ethical concern is the realm of interior consciousness from which new action will arise. The quality that most animates positive human action for Fry is caring, which manifests itself in terms of products as craft. But Fry does not define craft as preindustrial production the way many scholars do. He considers it to be a quality of feeling that can direct a machine as well as guide a potter's hand.

All three authors in this section recognize, though in distinct ways, that the problem of design ethics must be rethought. Mitcham is most tentative about how this will be done, whereas Fry and Manzini frame their quest for a new design ethic within a vision of ecological crisis. Yet, despite their differences, these authors move the debate on ethics in design well beyond the tradition of professional soul-searching that has mainly characterized it until now.

Conclusion

This book will not provide answers to tactical questions about the practice of design in a changing environment of intellectual challenge and cooperation. The problem is too deep and too important for the illusion of a quick fix. Instead, a long-term strategy is needed, based on encouraging more discussion across the many

cultural divides of intellectual, professional, and contemporary life. If discovering design appears to encourage academic or theoretical discussion of design, it also encourages individuals from different disciplines to reflect on design as the place where theory and practice meet for productive purposes. Furthermore, it invites designers and design educators to join in the discussion in new ways, helping to shape the strategic issues which must be addressed. Design is a middle ground in contemporary life. It should not become yet another in the long sequence of abstract, specialized subjects taught in our colleges and universities. Yet, it should not be cut off from theoretical speculation, even if that speculation moves, for a time, into areas that seem far removed from the daily preoccupations of professional designers. Design is too important to be confined to tactical questions and tactical solutions.

SECTION 1

SHAPING THE SUBJECT

Art and Technology
AESTHETICS REDEFINED

Gianfranco Zaccai

Prologue

The industrial revolution resulted when the concept of labor expanded from the earlier notion that individual craftsmen were responsible for the creation of entire objects. The division of labor introduced the idea of a more efficient specialization. The products of the craft age reflected the single-minded but limited capabilities and energies of the individual. In contrast, the products of the industrial evolution were conceived, developed, and assembled as a result of the collective efforts of many experts, each focusing on a specific aspect of the product. The products of the industrial age often reflect the homogeneity and compromise of an otherwise unlimited group of capabilities and energies.

If the efficiencies of an industrialized society have resulted in a wealth of material goods, it can be argued that in the midst of so much quantity, there is too little quality. By quality I do not mean the individual components of quality such as reliability, performance, value, or visual appeal. Rather, I am referring to the simultaneous presence of all of these values and something more. The exact nature of the missing ingredients is difficult to define. This absence is perceptible, however, in the fact that most

of these objects are not sufficiently satisfying to either our souls or our senses.

Too many of the things we produce, use, and discard force us to make social and ecological compromises for the sake of too narrowly defined and short-term convenience. Such compromises, besides inflicting obvious damage to society and our environment, are corrupting to our psyche. At the same time, the superficiality of the sensory experiences associated with actual use of these objects eliminates the possibility for emotional connection between them and the human beings they are meant to serve. The likelihood further increases that they will be quickly and thoughtlessly discarded. This may be a very catholic perspective, but I feel that as consumers we are all too often forced to become sinners with very little physical gratification in return.

Why is it that a system which has as its great strength the ability to assemble highly trained and specialized experts for the purpose of creating specific products rarely is able to produce objects which elicit the same spiritual and emotional connection with their users as the objects produced by our craftsmen ancestors? To put it another way, why can we produce so many mountains of manufactured waste while being unable to reproduce the equivalent of a single Stradivarius?

The answer to this question is critical if we hope to move from being an industrial society with its ever expanding production of mass-market, disposable commodities, to the much talked-about postindustrial society, where long-lived, tailored products meet individual needs while being sensitive to humanistic and environmental concerns.

The Expanding Role of Design in a Postindustrial Society

The subdivision of tasks and their assignment to individual experts is both the great strength and the Achilles' heel of our industrial society. Because of the notion of a division of labor, we have structured a society which tends to classify its individual members from an early age.

Based on the talents and interests exhibited by an adolescent, he or she is encouraged to select one of three major areas of specialization: science and technology, business and finance, or

the arts and humanities. For the sake of expediency we treat these disciplines as if they existed in isolation from each other. We encourage people to select one of these areas after providing them with only a broad-brush exposure to the others. Once a selection has been made, we further restrict their breadth of vision by requiring further specialization in ever more focused subsets of their selected field. For example, a person with an interest in science may focus his or her education on medicine, but may ultimately become an expert only in the workings of the cardiovascular system. While the cardiovascular system is an essential component of human anatomy, it cannot survive on its own.

The depth of knowledge resident in a group of narrowly focused medical specialists can provide for better health care, but only if three conditions are present. First, there must exist a broadly trained general practitioner, in addition to the narrowly focused specialist, to make sure that the whole human being is diagnosed and attended. Second, areas of expertise and specialization must mesh seamlessly, to ensure that no gaps exist. Third, generalists and specialists must be equally sensitive to both the physiological and the psychological needs of the patient.

These are matters about which we can all agree, but what does this have to do with product development and product design in a postindustrial age? If we consider the product development process in analogous terms, we see that ideal conditions seldom exist. Why?

First, marketing has claimed the role of generalist in the product development process, while acting as essentially only a slightly more broadly focused specialist whose primary focus is on short-term financial performance. In my opinion, it is for this reason that marketing as a discipline has not done a very good job of anticipating, in a comprehensive manner, the developing needs of individual consumers and society as a whole. Rather, it has most often become a force for the status quo. The analysis of past trends is often projected into the future, and decisions are guided by the need for short-term profits and the need to minimize risk.

Second, experts often do not mesh seamlessly in the product development team. Technical specialists are trained to value the quantifiable in areas such as price and performance and dismiss

the ephemeral in areas such as psychological and social concern. Marketing specialists, if they are able to identify ephemeral issues at all, have difficulty communicating them in meaningful ways to other technical specialists.

Third, design, in addition to abdicating its role as generalist to marketing, has not developed enough depth in its role as specialist in the meaning of aesthetics.

What is required if design is to play a fundamental role in the development of products and environments which fully meet the needs of human users? First, designers will have to reclaim and deepen their role as visionary generalists and coordinators in the product development process. Second, the original meaning of aesthetics must be rediscovered. We need to understand that aesthetics is not simply a visual exercise, but rather the appropriate and harmonious balancing of all user needs and wants within technical and social constraints. The designer must successfully integrate all of the requirements that balance the rational, sensory, and emotional expectations of the individual user and of society as a whole. To accomplish this in a complex social and technical environment, the designer must be able to complement and leverage the depth of knowledge resident in other specialties. Finally, designers must develop a much deeper knowledge of kinesthetics, demonstrating a concern for all of the ways human beings perceive and interact with physical objects. We must go beyond a concern for visual form and the static, mechanical treatment of ergonomics to consider the interaction among all of the senses in a dynamic state.

Historical Perspective

The industrial age was successful in exploiting efficiencies of specialization to an unprecedented degree. However, the resulting specialization largely favored efficiencies of mass production and mass distribution at the expense of humanistic values.

During the first century of the industrial revolution, the most basic needs of large numbers of people were met through development of new materials and technologies and the implementation of highly productive manufacturing systems. The prime forces which shaped the products of this period were the narrow

focus of the technically trained specialist and the constraints imposed by superficially understood technologies. Technical specialists played the dominant role in this process.

The more enlightened manufacturers of this era sensed that the products and environments produced through this process, although technically functional, often did not meet the requirements of their consumers and, as a result, could be undermined by more desirable alternatives. Consequently, other specialists from the arts, sales, and finance were recruited to participate in the product development process.

The first nontechnical specialist to be brought into this process was the artist/architect. In 1907 the Allgemaine Elektrizitats-Gesellschaft (AEG) Company hired Peter Bahrens to improve and coordinate the visual appearance of the company's products and facilities. Bahrens, who was trained as an architect, could not rely on the accumulated knowledge of architectural technologies and architectural design theory to master the full spectrum of requirements associated with mass-produced electrical products. He and many of the industrial designers who followed him focused their talents on the development of a "machine aesthetic." This new industrial aesthetic, it was assumed, would reconcile the presumed technical functionality of a machine-produced object with the human desire for visual beauty. The availability of affordable mass-produced objects to a populace desperate for them insured that the appreciative consumer would overlook the many other shortcomings of these objects.

As more manufacturers developed competitive technologies, they decided to utilize designers not for the purpose of fundamental product improvement, but rather to gain competitive advantages through superficial manipulations of the product's outer enclosures. This practice was encouraged by the appearance of a new specialist in the product development process: marketing.

During the first half of this century, the product development process was entrusted to technical specialists working in conjunction with humanist designers. The appearance of the marketing specialist during the second half of this century meant that designers could further abdicate their role of generalist in the product development process. It was assumed that the historical

division of labor could be reconciled with the disparate needs of the consumer so long as each specialist, or better yet each team of specialists, concentrated on one of the three distinct aspects of the collective consumer psyche.

The marketing specialist would focus on divining the emotional expectations of the consumer. The technical specialists would focus on the rational requirements of the product's physical performance. And the designer would focus on "aesthetics," commonly understood as the sensory need for visual appeal and differentiation.

There are several reasons why this is a highly efficient way of producing mediocre products. First, only the technical specialist, among the three specialists, has been able to develop the great depth required to solve complex technological problems. Second, marketing has not been able to develop the expertise needed to understand even more complex emotional expectations of human beings. Third, design, which has developed a superficial knowledge of ergonomics to complement its knowledge of the machine aesthetic, has not developed a deeper understanding of what might be called a humanistic aesthetic, which encompasses the intellect, the soul, and all of the senses.

Aesthetics Redefined

If we consider the consumer psyche as an extension of the individual psyche, as defined in psychoanalytic theory, we could insert certain terms as follows: the "superego" defines emotional requirements, the "ego" defines rational requirements, and the "id" defines sensory requirements.

We quickly realize that these are not distinct and independent components of an individual, but highly interactive and interdependent forces which constitute the whole person. They must be simultaneously balanced and satisfied. The failure to find a proper balance among the three means that all are compromised to some degree.

In other words, if the real focus of design is not the object, but the human user of that object, then the entire psyche of the individual must be satisfied. If we, as designers, focus most of our energy on only one aspect of the psyche, the id, for example, then we are doomed to fail. Furthermore, if we focus on only one aspect

of the id, the aspect perceived by the sense of sight, we will also fail miserably.

This is not a new concept. In 1852 Gottfried Semper wrote,

> Style is the elevation to artistic significance of the content of the basic idea and all the external and internal coefficients, which, by their incorporation into a work of art, are able to modify it actively. Lack of style, by this definition, [is] the term for what is lacking in a work, which accrues from a disregard for the basic idea and from clumsiness in the esthetics utilization of the available means for its accomplishment. The basic form, as the simplest expression of the idea, is modified particularly by the materials that are used for the improvement of the form, as well as by the instruments employed. Finally, there exist many influences outside the work itself which are important factors contributing to its design—for example, location, climate, time, custom, particular characteristics, rank, the position of the person for whom the work is intended and so on.[1]

Aesthetics in regard to any object, therefore, is not an absolute and separate value. Rather, it is totally related to our ability to see a congruence among our intellectual expectations of an object's functional characteristics, our emotional need to feel that ethical and social values are met, and finally, our physical need for sensory stimulation.

If the traditional roles of the technical, marketing, and design specialists define a triangle, then the superimposition of the complexities of the id, ego, and superego suggests that the triangle stretches much further than we had assumed. In fact, we would find that the triangle is not flat at all. As the three points are expanded by our more complete understanding of their fundamental nature, we find that the triangle becomes a curving plane. At a certain point the seemingly divergent requirements of technical rationalism, emotional content, and sensory perception converge and complete a sphere. It is that sphere which defines the true nature of aesthetics and the role of the designer in the product development process. With this definition, the designer must feel equally responsible for all aspects of the total product.

This does not mean that the designer becomes totally proficient in all, or even any, of the many technical specialties required to solve physical problems. It also does not mean that the designer

becomes a specialist in psychology or market research to identify and integrate emotional values within a product design.

It does mean, however, that the designer must be able to develop a clearer understanding of where the natural balance point is among the forces of the id, the ego, and the superego for any specific human need. For example, where is the proper balance among these forces in the design of a pacemaker versus a chair, versus a trash bag? Each one has its own appropriate aesthetic, which is inseparable from the proper balance of its functional, ethical, and physical values.

Once the natural balance point for a specific need is understood, then the actual process of design can take place as a collaborative effort among the appropriate specialists. Actual physical form, in many cases, may cease to be the outcome of the design process, which could result, for example, in the elimination of a mostly unnecessary object, or the substitution of a series of electronic signals for a complex mechanical assembly.

In most cases, the designer may find that this process will lead to design concepts which are both simpler and more complete, at the same time. Understanding the proper balance of needs for any specific object will result in design concepts which eliminate the superfluous and elaborate the essential.

Design for the Senses and Kinesthetics

One of the essential areas which will be fertile ground for elaboration through the design process will be sensory stimulation. This will require the designer to become more knowledgeable about the nature of the id. It is the area where the designer must become a more deeply focused expert.

To a great extent, many designers have focused their attention on the sense of sight and, to a much lesser extent, the sense of touch. However, human sensory perception includes other organs besides the eyes and the nerve endings at the ends of our fingers and on our posteriors. Olfactory and auditory considerations and manipulations should also be part of the design process. Frank Lloyd Wright's Falling Water and the Alhambra are two examples where the sounds of water and the scents of the natural components within the human-made environment are intrinsic to the experience of the architecture.

It seems reasonable that the design of many mass-produced products could benefit from a similar sensitivity. A slide projector, for example, would be immeasurably improved by the elimination of the noise produced by the fan which is used to cool the projection lamp. In contrast, the addition of appropriately restful sounds to an electronic alarm clock would potentially assist the user in falling asleep and be less offensive when the time came to awaken.

The thermal qualities of materials and the contrasts between thermal qualities present another untapped opportunity for expanding the sensory experience. Lisa Hershong points out that "the thermal sense cannot be easily isolated from overall experience, unlike seeing and hearing. We cannot close it off like closing our eyes . . . The thermal sense is intricately bound up with the experience of our bodies. . . . Perhaps the human fascination with fire stems from the totality of its sensory stimulation."[2] The thermal properties of spaces clearly offer a great opportunity for a richer sensory experience. However, Hershong points out that "in America, our tendency has been to get away from thermal conditions as a determinant of behavior. Instead, we have used our technology to keep entire living and working complexes at a uniformly comfortable temperature. As a result, our spatial habits have become diffused." In contrast, "In the villages [of Saudi Arabia] people commonly go out in the evening to sit and talk on a nearby sand dune. On a hot night, the north slope of a dune offers a very comfortable and cooling place to sit. When the nights get cooler, the people choose instead to sit against the slope that is still warm from the late afternoon sun."[3]

In product design, the opportunities for orchestrating the thermal qualities of an object within the whole of the aesthetic experience are equally great. Material selection, for example, could be based on the ability of the material to insulate or conduct heat, not just to meet technical or safety requirements but also to provide sensory stimulation. The pleasure derived from consuming a hot liquid from a ceramic cup is due, to a great extent, to the contrast between the cool ceramic and the warm liquid.

Finally, the interrelations among all of the sensory perceptions need to be considered in a dynamic way. Concerns for the kinesthetics associated with the actual use of an object add a new dimension to the design process. As technology becomes more adept

at miniaturization, products will become less static. As objects become wearable, or at least transportable, our interaction with them becomes more complex and the opportunities for kinesthetic experience greater.

In order to understand and manipulate these new, dynamic, and often nonvisual design elements, designers need to move beyond the use of traditional tools. Drawings and renderings, computer-aided design, and computer modeling are all insufficient to manipulate and test designs which integrate such multisensory and dynamic elements. In addition to these two-dimensional tools, the use of more sophisticated ergonomic models is required. These models test more than static biomechanical concerns such as viewing angles, reach, and accessibility. They serve to explore and, ideally, quantify all of the other sensory and kinesthetic dimensions involved.

I believe that the great designers have an intuitive understanding of the true nature of the design process and the totality of aesthetics. Unfortunately, it has been my experience that very few design students are exposed to many of these issues in the various design schools. And, worse still, they are not expected to concern themselves with them once they move on to most professional design studios.

I conclude with some words from the prophetic architect Gottfried Semper: "The abundance of means is the first serious danger with which art has to struggle. This term is in fact a paradox (there is no abundance of means, but rather a lack of ability to master them)."[4]

Notes

1. Gottfried Semper, "Science, Industry, and Art," in *The Bauhaus,* ed. Hans W. Wingler (Cambridge: MIT Press, 1986), p. 18.

2. Lisa Hershong, *Thermal Delight in Architecture* (Cambridge: MIT Press, 1987), p. 29.

3. Ibid., p. 41.

4. Semper, "Science, Industry, and Art," in Wingler, *The Bauhaus,* p. 18.

The Depth of Design

Albert Borgmann

The material culture of modern life is unique in its scale and sophistication. The most awesome and far-flung monuments of premodern life are modest, and its most sophisticated machines are crude, in comparison. In assembling our material culture, we have been much concerned with safety, efficiency, and commodiousness, and we have undertaken gigantic if often insufficient efforts to improve our material surroundings in these respects. At the same time, we almost entirely disavow responsibility for the moral and cultural excellence of our material surroundings.[1]

There is one heading, however, under which we discuss and judge the quality of our material culture, viz., design. Accordingly I propose we think of design as the excellence of material objects. Design in this objective sense is everyone's concern. So are health, justice, and education. And yet society especially entrusts the latter three concerns to particularly qualified people, to doctors, lawyers, and teachers. A group that has been so entrusted with a precious social good we call a profession, and typically such a group discharges its responsibility in a collegial and principled

way.[2] Similarly design can be thought of as a professional practice, and designers as professionals.

To stress the coordination between design in its objective sense as the excellence of the material culture and design in its practical sense as a profession is eminently urgent and desirable. Design, taken as an objective quality, needs design as a professional practice because the quality of the material culture urgently needs the care and advocacy of professionals. Design as a practice needs design as an object because designers as professionals appear to suffer from an uncertain sense of identity that would be firmed up through the focus on the excellence of the material environment.

To be sure, daunting obstacles stand in the way of this mutual alignment. Perhaps the fundamental problem is the seemingly inexorable tendency of the excellence of the material culture toward attenuation, superficiality, and even disappearance. Consider the development of sound reproduction. The original Victrolas had an intelligible and dramatic shape and required constant and careful attention from their users. More sophisticated information retrieval by way of diamond pickups and the development of electronic amplification reduced the need for interaction and the intelligibility of the apparatus. There was less occasion for tangible and expressive design. The day is not far off when the daily presence of a sound system will have shrunk to a hand-held device consisting of a small keyboard and screen that allows you to call up whatever and however much music you desire. The musical information, the retrieval and amplification mechanisms, and the loudspeakers will be concealed behind opaque surfaces. The designer's scope will be reduced to making these surfaces as pleasing and the programming device as portable and functional as possible.

In other instances, the drift of technological development tends past reduction to invisibility. At the Discovering Design conference I learned of a design project to make gas stations more pleasant and easier to use. People are annoyed by gas stations and dislike filling their cars, I was told. Even if one is ready to indulge such sullen customers, one must recognize that the ideal limit of a well-designed gas station is not a dramatically sculpted, attractively textured, and invitingly arranged setting, but the automatic filling station. The latter needs to be nothing more than a well-marked spot off the road where one stops the car, whereupon a

nozzle inserts itself in the tank and fills it while a sensor reads the owner's credit card number and charges the account.

The underlying phenomenon in these developments is a shift from aesthetic design to engineering design and a concomitant shift from user engagement to user disburdenment. To begin with the latter shift, should we worry about the disappearance of engagement? What is engagement?

"Engagement" is a term to specify the symmetry that links humanity and reality. Human beings have certain capacities that prefigure the things of the world; and conversely what is out there in the world has called forth human sense and sensibility. More specifically the most commanding and subtle things engage our talents most fully; and, conversely again, to employ our capacities most deeply we turn to the most powerful and intricate things. Engagement is to designate the profound realization of the humanity-reality commensuration. For example, a musical instrument normally engages a person deeply; a television program typically fails to do so.

Concern for engagement can spring from the human or the real side. We may be concerned to develop and use our gifts to the fullest and so find our way to the rich and grand things that require and reward such self-realization. Or we may be concerned to guard and oblige the great things of the world and find that doing so makes us most fully human. The latter approach is preferable at a time when technology imperils eminent and eloquent reality and when subjectivism infects the notion of self-realization with ambiguity.

As engagement has declined, so has aesthetic design. More precisely, design as a practice has divided into an engineering branch and an aesthetic branch. Engineering devises the ingenious underlying structures that disburden us from the demands of exertion and the exercise of skills and leave us with the opaque and glamorous commodities that we enjoy in consumption. Aesthetic design inevitably is confined to smoothing the interfaces and stylizing the surfaces of technological devices. Aesthetic design becomes shallow, not because it is aesthetic, but because it has become superficial. It has been divorced from the powerful shaping of the material culture. Engineering has taken over the latter task. But it in turn conceals the power of its shapes under discreet and pleasant surfaces.

If we are concerned to revive engagement, we must try to recover the depth of design, that is, the kind of design that once more fuses engineering and aesthetics and provides a material setting that provokes and rewards engagement. Where is such depth to be found or opened up? The first possibility one might consider are those areas where design has depth of penetration, that is, the license to reshape things vigorously and from the ground up. Nowhere has this been more spectacularly so than in the reshaping of the urban environment. The two programs that have been particularly consequential in these last hundred years are the Garden City, whose design is due to Ebenezer Howard, and *la ville radieuse,* drawn up by Le Corbusier.[3] Both of these pioneers began by proposing a spacious, luminous, and orderly alternative to the crowded, dense, and untidy conditions of the traditional and industrial cities. Through the catalytic force of the automobile, this kind of hygienic and rigorous modernism eventually invaded and reshaped the cities' texture under the heading of urban renewal.

As we have since learned, many of us under the tutelage of Jane Jacobs, the vigor of design as a process does not always lead to equal vigor in the life that is shaped by the design.[4] In the case of urban renewal there is usually an inverse proportion. The more forceful the reshaping of the urban fabric, the more lifeless and even pathological the daily activities and practices in the new surroundings.

What has been filled in or leveled down by urban renewal is the depth of history. Most traditional cities in their irregular layout and diversity of buildings constitute something like a hallway that allows you to look down generations of different aspirations, styles, and levels of prosperity. Modernism was at pains to destroy or occlude this depth. But beginning in the late sixties, a shift and then a reversal took place. There was a rising concern to preserve the architectural heritage and a determination to revive in new buildings the architectural vocabulary of the classical and vernacular styles.[5]

This movement, whose architectural aspect has come to be called postmodernism, has led to the preservation and restoration of historic urban areas, such as Faneuil Hall in Boston and Pike Place in Seattle, and to the construction of more colorful and

lively buildings, such as Philip Johnson's AT&T Headquarters and Michael Graves's Humana Building. In preservation and restoration, design takes on a both more subservient and more significant role, more subservient because it submits to the conditions that history has left it, but also more significant because careful design alone can recover historical depth for present use.

The significance of design in the postmodern architecture of high-rise buildings is far less profound. The location, size, and function of buildings is still determined by economics, and their basic and internal structure by engineering. Since economics and engineering have not radically changed in the last twenty years, neither have skyscrapers. It is impossible to say of a building under construction what style it will exhibit until it is given its skin.

Historical preservation in downtown areas has made an important difference to urban life. Faneuil Hall, Pike Place, and similar projects have drawn people back to the inner city and led to bustling prosperity. But this urban activity is in large part simply a transplant of what used to go on in a suburban mall into a historic and urban setting. What people do here or there is eat and shop. "The background is history," it has been said, "but the foreground is late twentieth-century retailing."[6] History has become an essentially indifferent container. It has no genuine depth, like a lock that will respond to any key. The sensitivity and care of design are reduced to surface aesthetics after all.[7]

I am overemphasizing the problem. Walking, seeing, and comprehending are important ways of inhabiting a place, and those ways are much richer in a diverse and historic setting than in one where opaque glamor repels all comprehension. More important, comprehension shades over into engagement, and it is depth of engagement that truly allows and calls for depth of design.

The world of engagement that is the province of design has two principal settings, a large one in the city and a small one in the home; and both of these settings have a daily and a festive side. Daily engagement in the home is still vigorous. But it is endangered by lack of appreciation and by male chauvinism. Daily engagement is housework. Its value becomes clear when we consider its elimination. It might be eliminated technologically or socially. Technological elimination would be by way of a combination of automation and service industry. It is an arrangement that

some professional people are approaching already. What is wrong with it? People who do housework extend themselves tangibly and subtly into the texture of their ownmost environment. They do so in furnishing, cleaning, repairing, adorning, and ordering their home. They lead a more extended and competent life than persons who are merely inserted into a prefabricated container. A home that shows the owners' housework is likely to be a more accurate and personable testimony to its inhabitants. Housework is eliminated socially when it is done by servants or a housewife. It is eliminated, of course, only for the lordly family or husband. For the privileged parties, social elimination is so tempting because it disburdens without the cost of anonymity. The only cost is injustice, a prohibitive cost as it happens.

Daily engagement in the home yields to festive engagement in the culture of the table. To clean and prepare food, to cook it, to set the table, and to clean up afterward, all this is a chore; it has the homely character of housework. But at the center of it is the celebration of a meal that engages and delights body and soul. The culture of the table in its central aspect is surely the most venerable and democratic kind of festive engagement in the home. Another is the culture of the word, conversing, telling stories, reciting poetry, and reading silently. Yet another is the culture of musicianship. And if someone wants to argue that the joint and thoughtful watching of a film can be festive, I will not demur.

Now what is the task of the designer in all this? It is twofold; there is a task of trusteeship and a task of artisanship. Designers are professionals in that they have been entrusted by society with a valued good and are hence accountable not only to the immediate desires of society but also for the well-being of the good that is in their care. The good of design is the moral and cultural excellence of the humanly shaped and built environment. More particularly, I want to urge, designers are charged with making the material culture conducive to engagement.

More particularly still, designers must constitute the common memory of practices of engagement. They must remind their clients of what has served the human family well and what has not. But in addition to this conservative task, there is a difficult innovative one. It follows from the fact that a life of full domestic engagement is impossible and undesirable today. We have neither

the time nor the tolerance for all the hauling, scrubbing, sweeping, washing, darning, mending, canning, and preserving that used to engage householders. Daily domestic engagement must be selective, and festive engagement must be focal. What to select and focus on and how to secure and position the selected chores and focal things in their technological setting is not an easy task and should not be left entirely to the trials and errors of lay people.

Artisanship is required for the shaping of the engaging environment. Settings of engagement have a certain depth and unfoldedness. Consider the kitchen of a gourmet cook. There is a stove with four burners, a grill, and a hood, a row of hooks with eight pots overhead, a chopping block over to the side with six knives and two cleavers, a faucet and two sinks by the window, a ceramic pot with a bouquet of wooden spoons on the counter. These are the things that people want to move among and get their hands on. Each has a well-rounded shape, a tangible texture, a certain weight and motility, and all of them compose the setting we call the kitchen. Artisanship is the skill of creating, varying, and refining the shape, color, and texture of these things. Such designing has depth because of the wealth and disclosing power of the qualities a designer imparts to a thing. The experiential qualities of paradigmatic technological devices such as a microwave oven, a stereo set, or a refrigerator are, apart from the commodities they are intended to provide, primarily visual. The tactile and motile properties are so subordinated to ease of operation that they are nearly effaced.

In the case of a cooking pot, however, not only the colors matter, but even more so the shape, weight, heat conductivity, surface texture, even the sound it makes when you stir in it or set it down. The handling and use of a pot disclose the wealth of its properties even when its ultimate constitution is veiled by technological sophistication, as it is in a pressure-cast, ceramic-plasma-coated aluminum pan with the heat-resistant, springlock mounted, Bakelite handles.[8]

Things that invite engagement are distinguished not only by the wealth of their experiential properties but also by the disclosing power of those properties. A car does not really allow for engagement although it has a fair number of different kinds of experiential qualities. But normally the tendency is to make a car

as insensitive as possible to the wider world, to outside noise and temperature and to the surface, grade, and curves of the road.

The kitchen utensils of the gourmet cook, to the contrary, disclose the texture, color, and taste of the food. The depth of the utensils opens on the depth of the world at large. They do not represent the world, as technological devices do; they allow the world to be present in its own right. Things, however, can have and hold this deeply disclosive power only if they are so designed.

Let me in conclusion expand on these points by talking about engagement in the large, daily, and festive city life. There are frequent complaints that the contemporary city lacks an engaging public life.[9] These laments, though partly on the mark, usually overlook the daily engagement that still exists; and they lack a clear vision of the festive engagement that is attainable. Not that the engaging qualities of daily city life have been without their admirers. Jane Jacobs and William Whyte have sung the praises of the vitality and charms that are to be seen in the daily errands and practices of city folk, in the ways they appropriate and animate public spaces as they do in walking, sitting, reading, eating, conversing, shopping, and playing.[10]

As in the home, such engaging activities require an unfolded and open texture. Its principal strands are the streets, interwoven in small city blocks. This fabric must contain distinct and articulate places, shops, stores, bars, cafés, restaurants, apartments, plazas, generous sidewalks, and street furniture. Parts of this setting and of daily urban engagement can, to their credit, be found in urban shopping areas such as Faneuil Hall and Pike Place. But what is often lacking is the substantial dailiness of city life. Many people come to an urban mall as mere tourists or shoppers. They come for pleasure, and then they leave. They do not live there and so cannot give the place the fullness of daily life, the habits, practices, chores, and errands that enact the substantial and serious side of life.

Here again designers are the guardians of common practical wisdom and the experts who help urban traditions to adapt to the advances of technology and to prosper in their midst. And here too design is deep and consequential. It is not confined to the cosmetics of a skyscraper's skin. The dimensions of spaces, the form and arrangement of street furniture, the distribution of economic and cultural functions, all these are intricate and consequential

matters. If ignorantly or thoughtlessly designed, they can impede
or destroy daily city life.

There is festive city life when we gather in communities of
celebration to participate in a great event, in a game, play, concert,
or divine service. Communal festivity is suffering and neglected
because we have surrendered much of the public sphere to the
utility of transportation and storage and because technological
commodification has transformed common celebration into pri-
vate consumption.[11] At the same time, the design of places for
communal celebration is the most glorious. The typical highrise
building, though imposing in bulk and flashy in appearance, is a
primitive structure sculpturally considered. It is a column or stack
on the outside and a mass of tiny cells on the inside. There is, in
the paradigmatic framework of technology, no grand, festive,
and memorable shaping of space because there is nothing grand,
festive, or memorable to fill it with.

To be sure, at the margins of the technological framework
there still exist grand celebrations; they do, for instance, in major-
league baseball. But they are often pushed to the periphery of the
urban geography and confined to artificial conditions. Hence the
designer's task is to urge a central location for structures of com-
munal celebration and to design the structures so that they inspire
a sense of orientation and festivity in the participants rather than
reduce the celebration to a commodity and the attendants to mere
consumers.

A fine example of such design is the Camden Yards Ballpark
in Baltimore. It has been built on an abandoned railroad yard
close to downtown Baltimore. Its brick facade pays respect to the
old gigantic warehouse that is its neighbor. It is a structure both
stately and inviting with its towers and arches and its moderate
elevation. It is open to the city and the seasons. The grass, the
dimensions, and the idiosyncrasies of the playing field and its
boundaries serve the game. The size of the seats and the tread
and grade of the decks make for comfortable sitting and watch-
ing. And countless details of structure, color, ornamentation, and
plantings have been thoughtfully gathered and fused into a rich
and engaging design.[12]

Trusteeship and artisanship have in this instance led to a design
that inspires deeply engaging communal celebrations. Designers
are not often enough in a position to work in this way. Yet it is

their professional responsibility, I believe, to advance the depth of design selectively and focally.

Notes

1. See my "The Invisibility of Contemporary Culture," *Revue internationale de philosophie* 41 (1987): 234–47.

2. Paul Starr, *The Social Transformation of Medicine* (New York: Basic Books, 1982), pp. 15–16.

3. Vincent Scully, *American Architecture and Urbanism,* 2nd ed. (New York: Holt, 1988), pp. 161–73.

4. Jane Jacobs, *The Death and Life of Great American Cities* (New York: Random House, 1961).

5. Scully, *American Architecture,* pp. 257–93.

6. Bernard J. Frieden and Lynne B. Sagalyn, *Downtown, Inc.* (Cambridge, MA: MIT Press, 1989), p. 175.

7. Frieden and Sagalyn, *Downtown,* pp. 199–213.

8. I am talking about Scanpans.

9. See "Public Space," *Dissent* (Fall 1986): 470–85, with contributions by Michael Walzer, Michael Rustin, Gus Tyler, and Marshall Berman; and "Whatever Became of the Public Square?" *Harper's* 281 (July 1990): 49–60, with contributions by Jack Hitt, Ronald Lee Fleming, Elizabeth Plater-Zyberk, Richard Sennett, James Wines, and Elyn Zimmerman.

10. Jacobs, *Death and Life,* pp. 27–140. William H. Whyte, *City: Rediscovering the Center* (New York: Doubleday, 1988), pp. 8–102.

11. See my "Communities of Celebration," *Research in Philosophy and Technology* 10 (1990): 315–45.

12. Peter Richmond, *Ballpark: Camden Yards and the Building of an American Dream* (New York: Simon and Schuster, 1993).

Rhetoric, Humanism, and Design

Richard Buchanan

Introduction

Confronted with the vast array of products in the contemporary world, an observer is justified in wondering whether there really is a discipline of design shared by all of those who conceive and plan such things as graphic communications, the physical objects produced by craft and machine, structured services and activities, and the integrated systems which range in scale from computers and other forms of technology to urban and humanly managed natural environments. The scope of design appears to be so great, and the range of styles and other qualities of individual products within even one category so diverse, that the prospects for identifying a common discipline seem dim. To compound the problem, histories and theories of design are also exceptionally diverse, representing a wide range of beliefs about what design is, how it should be practiced, and for what purpose. For example, design histories typically identify their subject matter as the history of objects, or the careers of individual designers who have influenced society, or the development of the technical means and processes of a specialized branch of design practice such as graphic design, industrial design, or engineering, or the influence of

broad cultural ideas on the practice of all of the fine and useful arts. Similarly, designers and design theorists present a seemingly endless array of special procedures and maxims required for what they believe to be effective designing. And, finally, design critics, as well as historians, designers, and theorists, offer a great variety of incompatible, if not contradictory, principles and slogans to explain what designers should and should not seek to accomplish through their work.

What is needed to reduce the welter of products, methods, and purposes of design to an intelligible pattern is a new conception of the discipline as a humanistic enterprise, recognizing the inherently rhetorical dimension of all design thinking. The key to such a conception lies in the subject matter of design. There is a tendency among theorists to reduce design to a form of science, as if there is a fundamental predictive quality in designing that has eluded practicing designers. The assumption is that design has a fixed or determinate subject matter that is given to the designer in the same way that the subject matter of nature is given to the scientist. However, the subject matter of design is not given. It is created through the activities of invention and planning, or through whatever other methodology or procedures a designer finds helpful in characterizing his or her work. Of course, one may argue that the subject matter of the sciences is not entirely given; it must be discovered in the activities of scientific inquiry. But discovery and invention are essentially different. Discovery implies that there is something constantly available, waiting passively to be uncovered, and that the discovery will yield only one result, which may be confirmed by other experimental techniques for questioning nature. In other words, there is a determinacy in natural science, and the goal of inquiry is knowledge of properties and predictability of processes.

There is no similar determinacy in the activity of designing. The subject matter of design is radically indeterminate, open to alternative resolutions *even with the same methodology*.[1] One may speak of "discovering design" because one is concerned with determining what design and the products of design are, or have been, in the twentieth century. The issue is a question of fact, and observations may be verified if someone else examines the evidence from the perspective of the claim. But of the designer, one speaks most often of creation and invention, and only casually or

mistakenly of discovery. The scientist *discovers* a natural process or a natural law, but the engineer or designer *invents* a possible application or a new use suited to a particular product. There are many determinate constraints on the work of the designer, but the consideration of constraints is only a background for the invention or conception of a new product.

Why is the indeterminacy of subject matter in design significant? There are several reasons. First, it immediately serves to distinguish design from all of the natural and social sciences, which are directed toward the understanding of determinate subject matters. (With this in mind, appeals to science among design theorists must be viewed with caution, because the appeal may be only a rhetorical tactic that conceals a personal preference or interest that has nothing to do with the necessities of science.) Second, it directs attention to the exceptional diversity of the products created by designers and to the continual change going on among those products. The subject matter of design is not fixed; it is constantly undergoing exploration. Individual designers extend their vision to new areas of application or focus on one area of application and refine a vision. In general, design is continually evolving, and the range of products or areas where design thinking may be applied continues to expand. Third, indeterminacy of subject matter serves to characterize design as a discipline fundamentally concerned with matters that admit of alternative resolutions. Designers deal with matters of choice, with things that may be other than they are. The implications of this are immense, because it reveals the domain of design to be not accidently but essentially contested. The essential nature of design calls for both the process and the results of designing to be open to debate and disagreement. Designers deal with possible worlds and with opinions about what the parts and the whole of the human environment should be. Any authority of the designer comes from recognized experience and practical wisdom in dealing with such matters, but the designer's judgment and the results of his or her decisions are open to questioning by the general public, as are all matters of public policy and personal action, where things may be other than they are.

What is the consequence for the discipline of design of the indeterminacy of its subject matter? Does it mean that there can be no discipline or art of design thinking, as the diversity of descrip-

tions of design seems to suggest? Quite the opposite. There can be a discipline of design, but it must be different in kind from disciplines which possess determinate subject matters. Design is a discipline where the conception of subject matter, method, and purpose is an integral part of the activity and of the results.

On the level of professional practice, the discipline of design must incorporate competing interests and values, alternative ideas, and different bodies of knowledge. This is nothing new to designers, who have understood that they must be persuasive in dealing with others and find concrete techniques for assessing the many perspectives from which products are viewed by clients, manufacturers, business and other technical experts, and potential users. What is new is the possibility of systematizing the discipline of design to explain how designers invent and develop the arguments contained in their products and how designers may present their ideas persuasively to clients and other members of product development teams. However, the elements of a new discipline of design do not have to be created entirely anew. Nearly a century of exploration and reflection have provided the materials for a synthesis which is, arguably, underway today in contemporary design thinking.

If the subject matter of design is indeterminate—potentially universal in scope, because design may be applied to new and changing situations, limited only by the inventiveness of the designer—then the subject matter of design studies is not products, as such, but the art of conceiving and planning products. In other words, the *poetics* of products—the study of products as they are—is different from the *rhetoric* of products—the study of how products come to be as vehicles of argument and persuasion about the desirable qualities of private and public life. The interplay between the rhetoric and poetics of products is a significant issue in design studies, but the orientation in logical sequence is from rhetoric to poetics. Recognition of this is important because designers, and those who study design, often confuse the qualities of existing products with the problems of designing new products. There is a tendency to see determinacy in existing products and project that determinacy back into the activity and discipline of designing. This is what Kenneth Burke means when he discusses "prediction after the fact" in literary studies. Prediction after the fact is what designers and design theorists do when they

conclude that design is a determinate activity—an activity of discovery—rather than an activity of invention concerned with the indeterminate. A designer's beliefs are sometimes elevated to the status of determinate principles governing all of design, rather than personal visions infused into a rhetorical art of communication and persuasion. From this perspective, design history, theory, and criticism should balance any discussion of products with discussion of the particular conception of design that stands behind the product in its historical context. Indeed, different conceptions of design also carry with them different conceptions of history, further complicating the task of design studies. For this reason, one way to investigate the different forms of the discipline of design in the twentieth century is to consider different accounts of the origins of design.

The Origins of Design

Serious discussions of design seldom omit some reference to the origins of the discipline. Such passages are perhaps regarded by the casual reader as ceremonial rather than substantive, but the treatment of this commonplace reveals a great deal about a writer's perspective on the nature of design and the significance of contemporary practice. There is a surprising pattern in accounts of the origins of design, revealing the systematic pluralism of the discipline in the twentieth century.

The origins of design are usually traced to one of only four beginnings. Some argue that design began in the twentieth century with the formation of new disciplines of design thinking. Others argue that design began in the early days of the Industrial Revolution with the transformation of the instruments of production and the social conditions of work. Still others argue that design began in the prehistoric period with the creation of images and objects by primitive human beings. And, finally, some argue that design began with the creation of the universe, the first act of God, who represents the ideal model of a creator which all human designers, knowingly or unknowingly, strive to imitate. The alternative origins may be represented in a schematism which suggests interesting relations and potential oppositions (fig. 1).

Such wide disparity in a matter which on first consideration seems to admit only a single answer suggests, at once, that the

Richard Buchanan

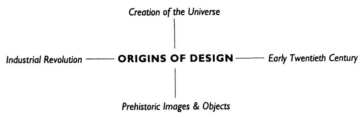

Figure 1. Schematism of the origins of design

issue at stake cannot be resolved by a simple appeal to facts or historical data. What is at stake is not fact, as such, but the principle which gives meaning to data and allows the assertion of factual claims: the principle by which facts are established and made pertinent to the practice, study, and experience of design. This is confirmed to the degree that whatever principle is selected by a writer, the data which are primary in other accounts of the origins of design are not excluded or ignored but merely given lower priority and different meaning; the data of alternative accounts do not bear directly on the question of the origins of design but on other factors related to human nature, social conditions, cultural myths, and so forth. In short, the way a writer identifies the origins of design indicates a broad rhetorical perspective on the nature of design. Such perspectives are perhaps endless in their subtle differences, but they may be grouped into four kinds, each indicating a *rhetorical commonplace* which may be made fundamental in the practice and study of design. These commonplaces are represented in the schematism of figure 2.

The history, current practice, and theory of design are presented differently from each perspective, accounting for the pluralism of conflicting approaches to design that are evident in the contemporary period. However, this pluralism does not undermine the possibility of understanding the common discipline of design shared by all designers. The scope and nature of design in the contemporary world are determined by two considerations: the pluralism of principles which have guided designers in exploring the human-made world, and the pluralism of conceptions of the discipline which have provided new instrumentalities for such explorations. The principles of design are grounded in spiritual and cultural ideals, or in material conditions, or in the power of individuals to control nature and influence social life, or in the

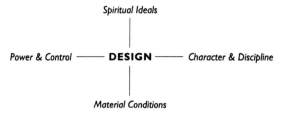

Figure 2. Schematism of the commonplaces of design practice and theory

qualities of moral and intellectual character which stand behind the integrative discipline of design thinking and the productive arts. Such principles are presupposed and pre-existent in the concerns of each designer. They are expressed as *theses, maxims, or slogans* to guide practice, and their elaboration and adaptation to new circumstances is a process of discovery.

However, the discipline of design is in a process of formation in a way that principles are not. The discipline is being invented through the exploration of instrumentalities, technologies, and specific methods which are suited to the changing circumstances of contemporary culture. The discipline of design, in all its forms, empowers individuals to explore the diverse qualities of personal experience and to shape the common qualities of community experience. This makes design an essential element in a new philosophy of culture, replacing the old metaphysics of fixed essences and natures which Dewey critiqued throughout a lifetime of work directed toward the experimental nature of inquiry after the philosophic and cultural revolution at the beginning of the twentieth century.[2]

To investigate the various forms of the discipline of design in the twentieth century, we may take as our beginning point the perspective which specifically focuses on design as a discipline. Later, we may consider how the other perspectives on design have also contributed to the standing of design as a liberal art of technological culture.

Character and the Formation of the Discipline of Design

When the origins of design are traced to the first decades of the twentieth century, the principle lies in human character. Design rests on the ability of human beings to reason and act with

prudence in solving problems that are obstacles to the functioning, development, and well-being of individuals and society. Furthermore, design is inquiry and experimentation in the activity of making, since making is the way that human beings provide for themselves what nature provides only by accident. There is a deep reflexive relation between human character and the character of the human-made: character influences the formation of products and products influence the formation of character in individuals, institutions, and society.

Integrative Arts in the Ancient World

Although design emerged as a distinct discipline only in the twentieth century, its precursors may be traced from the ancient world through the disciplines of art and changing attitudes toward production and making. In the ancient world, Aristotle discovered a science of production directed toward an understanding of the differences among all of the arts and their products due to the specific *materials, techniques of production, forms,* and *purposes* that are relevant to each kind of making.[3] He called this "poetic science," or poetics, derived from the Greek word for making. The only remaining example of this science, as it was explored by Aristotle, is the *Poetics,* a treatise on the literary arts and, specifically, the art of tragedy. (Reportedly, there was a parallel treatise on the art of comedy, but it is lost.) There are many references to mechanical objects, domestic implements, and other products of the useful arts throughout Aristotle's other treatises. These references and brief analyses provide tantalizing hints about how he would have investigated design, but there is no evidence that he ever wrote a treatise specifically devoted to a poetic analysis of what we, in the modern world, would regard as the result of design. Nonetheless, Aristotle's method of studying the artificial— even limited to the literary arts, as the most important examples are—exerted a strong influence on all subsequent discussions of making in Western culture. If not his specific philosophy, then the terms and distinctions of his analysis directly or indirectly provide the basis for how we discuss design in the contemporary world.

For Aristotle, the differences among the various literary and constructive arts depend on a fundamental understanding of the

human capacity to make, considered to be independent from the specialization of a particular art. All making is an integrative, synthetic activity. It is what he describes as an intellectual virtue: a reasoned state of the capacity to make, different from, but closely related to, the intellectual virtue that stands behind the theoretical sciences and the moral virtues that stand behind action.[4] However, Aristotle also found it important to distinguish the element of *forethought* from the specific considerations and activities that are relevant to each kind of making.[5] Forethought in making is a kind of universal art, in the sense that it is independent of any particular art of making and, therefore, able to range over all potential considerations and subjects that may enter into the making of this or that kind of product. Forethought is an "architectonic" or "master" art, concerned with *discovery* and *invention, argument* and *planning,* and the purposes or ends that guide the activities of the subordinate arts and crafts.

The element of forethought in making is what subsequently came to be known as design, although no distinct discipline of design emerged in the ancient world, perhaps because forethought and making were most often combined in the same person, the master builder or craftsman. However, one exception was in the diverse arts of language and literature. A core art of rhetoric provided the basis for systematic forethought in all of the distinct forms of making in words: history, drama, poetry, political and legal speeches, prayers, and religious sermons.[6] Rhetoric served as the design art of literature; it provided the organization of thought in narrative and argument as well as the composition and arrangement of words in style. Yet rhetoric was not conceived by Aristotle as an art of words. It was an art of thought and argument whose product found *embodiment* in words as a vehicle of presentation.

However, since words refer to things, and the use of words has consequences for action and understanding, even the literary form of rhetoric has often provided a way of connecting ethics, politics, and the theoretical sciences with the activities of making. Indeed, the themes of rhetorical thinking have exerted a powerful influence on those arts of making which employ materials other than words. For example, rhetoric and the intellectual virtues associated with rhetoric—the humanism established by Cicero in

the Roman republic—stand behind Vitruvius's account of architecture.[7] His portrait of the architect parallels Cicero's portrait of the well-educated rhetorician, except with regard to the type of product that follows from the art. The architect is an individual trained in the liberal arts and sciences of his day, prepared to practice the integrative liberal art of architecture for the fabrication of buildings, instruments for measuring time, and the devices of war.

Integrative Arts in the Renaissance

The relation between rhetoric and the arts of making, whether in words or things, is one of the most complex themes in Western culture. However, the development of this theme in the Renaissance has special significance for the subsequent understanding of design in the twentieth century. In the Renaissance, the fine arts were distinguished from the practical arts in a fashion more complete—or, at any rate, with greater cultural impact—than at any time in the past.[8] The reason for this was an unusual confluence of Platonic and Aristotelian ideas, along with a rebirth of rhetoric through the direct or mediated influence of Cicero, Horace, Quintilian, and Longinus.[9] New readings of Plato supported an intense interest in the imitation of ideal models. In conjunction with the rebirth of rhetoric as a cultural art, this led in turn to the imitation of ideal literary models. Finally, the translation of Aristotle's *Poetics* into a variety of languages in the sixteenth century "provided a technical vocabulary, a statement of problems, and an array of literary data" that was adjusted to the rhetorical tradition of poetry, stemming from Horace and Longinus.[10] The result was the rhetorical humanism of the Renaissance, directed toward the creation of the new liberal art of belles lettres as the highest achievement of culture. This was conceived as a return to the ancient union of the arts of making in words and things. However, it was, in fact, a departure from classical and modern ideas that decisively reoriented culture toward the literary arts.

It is no contradiction that some Renaissance artists explored the practical arts of *architectura* and *grafice* (including the art of *pittura*) at the same time that they explored new literary arts, because the practical arts were conceived as an extension of poetic vision. The highest forms of making remained rhetoric and

poetry, since these arts were regarded as closest to the spirit of the ideal. Nor is it a contradiction that the creation of the liberal art of beaux arts soon followed the creation of belles lettres: the beautiful arts, similarly based on rhetoric, provided a new way for exploring the delightful and noble, thereby extending the subject matter and concepts of beautiful letters.[11] Thus, the first academies of art were created in the sixteenth century, "based originally on the assumption that the visual arts may be analyzed intellectually, and criticized and improved according to laws not different from those governing literature codified by Aristotle and other authors of the ancient world."[12]

The great achievement of the Renaissance was the creation of belles lettres and beaux arts, along with a rebirth of rhetorical thought. This influenced all areas of culture and all arts of making, yielding a secularized humanism which influenced the sciences, as well. Yet this achievement, particularly as carried forward in the seventeenth and eighteenth centuries, ultimately eroded the intellectual foundations of rhetoric and the practical arts of making, with nearly disastrous consequences for the conception and practice of design. Although the Renaissance artist distinguished the rational arts of rhetoric and poetry from the practical or useful arts, he also understood and appreciated their relation, and frequently cultivated the practical arts of making in innovative ways. Leonardo da Vinci's speculations on mechanical devices were simply another expression of his poetic and visual imagination. But the successors of the Renaissance artist, inheriting a reified distinction between the fine and practical arts, progressively lost understanding of, and interest in, the fertile connective link.[13]

Renaissance inventions were based on an architectonic art of rhetoric. However, what was invented by means of rhetoric—the new subject matters of culture, identified as literature, history, the fine arts, science, and philosophy—gradually attracted more interest and attention than the integrative art from which they emerged.[14] For example, Galileo was inspired by the design arts practiced in the great arsenal of Venice, but he directed his work not toward the nature of design but toward the creation of the two new sciences of mechanics. The result is easy to see: the arts of making were progressively distinguished, specialized, and

fragmented into many forms; the practical arts were developed without sound intellectual foundations which could be integrated into a humanistic conception of making; and the theoretical sciences underwent explosive growth, often relying on the industrial, mechanical, and practical arts for inspiration and devices of investigation, but without a framework for relating theoretical knowledge to its practical impact on the development of human character and society. As for rhetoric, it became one more technical, specialized branch of the literary arts, ultimately dissociated by Descartes, Newton, and others from philosophy, practical reasoning, and the new sciences.[15]

It is true that in the period from the Renaissance to the early days of the Industrial Revolution the invention of techniques for mass production in support of the practical arts allowed—and required—a separation of designing from making. However, design was also separated from the intellectual and fine arts, leaving it without an intellectual foundation of its own. Therefore, instead of becoming a unifying discipline directed toward the new productive capabilities and scientific understanding of the modern world, design was diminished in importance and fragmented into the specializations of different types of production, leaving its connection with other human enterprises and bodies of knowledge vague and uncertain. Design was rescued periodically by exceptional individuals with natural talent who could provide examples of successful design thinking, based on an intuitive grasp of broader considerations. But these individuals could not provide a systematic discipline with principles and methods appropriate to the tasks of design.

Following the Renaissance, the consequence of separating the theoretical from the practical, the ideal from the real, and the cognitive from the noncognitive was a loss of the essentially humanistic dimension of production. The forms of making which had the widest impact on the daily life of society—engineering and the other practical arts—were guided merely by a narrow profit motive or by military necessity,[16] rather than a deeper consideration of the interplay between human character and products.[17] Design was practiced by chance and intuition as a trade activity or military occupation, rather than in its full potential as an architectonic master art that guides all of the diverse forms of making which are central to human culture. In short, design became

a servile activity rather than a liberal art. It was not conceived as an art which could promote the freedom of men and women in the circumstances of the newly emerging technological culture.

Integrative Arts in the Twentieth Century

Efforts to reunite design with the arts of making began in the nineteenth century, when Ruskin, Morris, and others attempted to elevate the status of craft production as an alternative to mass production by machines. However, the most significant efforts to rejoin design and making came with the cultural and philosophic revolution at the beginning of the twentieth century. The origins of design are reasonably traced to the early decades of the twentieth century because it was in this period that individuals began to formulate new disciplines of design thinking that would combine theoretical knowledge with practical action for new productive purposes.[18]

Walter Gropius was among the first to recognize in design a new liberal art of technological culture. In the wake of the First World War, he realized that he had a responsibility to train a new generation of architects who could help to overcome the disastrous gulf which had emerged between idealism and reality. The basis of that training would be a "modern architectonic art" of design.

Thus the Bauhaus was inaugurated in 1919 with the specific object of realizing a modern architectonic art, which like human nature was meant to be all-embracing in its scope. It deliberately concentrated primarily on what has now become a work of imperative urgency—averting mankind's enslavement by the machine by saving the mass-product and the home from mechanical anarchy and by restoring them to purpose, sense and life. This means evolving goods and buildings specifically designed for industrial production. Our object was to eliminate the drawbacks of the machine without sacrificing any one of its real advantages. We aimed at realizing standards of excellence, not creating transcient novelties. Experiment once more became the center of architecture, and that demands a broad, coordinating mind, not the narrow specialist.[19]

The ground of the new art of design was not to be found in the principles of idealism, materialism, or "art for art's sake."[20] It

was to be found in human character and in the essential unity of all forms of making in the circumstances of a new cultural environment strongly influenced by engineering, technology, and commerce.[21]

> What the Bauhaus preached in practice was the common citizenship of all forms of creative work, and their logical interdependence on one another in the modern world. Our guiding principle was that design is neither an intellectual nor a material affair, but simply an integral part of the stuff of life, necessary for everyone in a civilized society. Our ambition was to rouse the creative artist from his other-worldliness and to reintegrate him into the workaday world of realities and, at the same time, to broaden and humanize the rigid, almost exclusively material mind of the businessman. Our conception of the basic unity of all design in relation to life was in diametric opposition to that of "art for art's sake" and the much more dangerous philosophy it sprang from, business as an end in itself.[22]

However, the significance of the new architectonic art of design lay precisely in encouraging the cultivation of alternative and often conflicting principles as hypotheses for making. Gropius did not claim that the new art of design provided an ultimate solution to the problems of industrialized society. What he claimed was that it revitalized design thinking by initiating a new path of experimentation and pluralistic exploration grounded in art and human character. Aside from the broad principle that an architectonic art of design connected the arts, the path or discipline presented by Gropius did not presuppose or require any particular principles of art. Rather, it was a way to explore a variety of principles in order to discover their potential consequences for making and practical life: "Modern painting, breaking through old conventions, has released countless suggestions which are still waiting to be used by the practical world. But when, in the future, artists who sense new creative values have had practical training in the industrial world, they will themselves possess the means for realizing those values immediately. They will compel industry to serve their idea and industry will seek out and utilize their comprehensive training."[23]

It is easy to confuse the idea of design that gave purpose to the Bauhaus with the separate directions in which it was developed

by the faculty in the short period of the school's institutional existence. Gropius, Moholy-Nagy, Klee, Kandinsky, and others developed individual visions that favored one or another principle of making. But to substitute particular visions and consequent results for the concept of a new discipline of design thinking misses the point of the liberal art that Gropius sought to establish. The goal was to provide a concrete connection between artistic exploration and practical action, where artists could learn how their conceptions of art might be carried forward as experiments in shaping the broad domain of the artificial in human experience, extending beyond traditional forms of artistic expression into making in all phases of life, supported by new technologies and advances in science.

Interpreted in its weakest form, this is "aesthetic" exploration in the reductive sense of the term, leading toward decoration and styling that appeals only to the senses.[24] However, interpreted in the strongest sense, it is "artistic" exploration in the sense that Dewey speaks of art, as the quality of unity and satisfaction belonging to any experience, whether the experience is primarily intellectual, practical, or aesthetic. Art should not be something outside of experience or segregated to a small area of experience. It *is* experience in its most vital and essential form.[25] Mechanization has tended to diminish the human qualities developed in all phases of life, but the new art of design sought by the Bauhaus offered a way to discover and express human qualities and values, to make them an integral part of the human-made environment.

The most important practical criticisms of the Bauhaus do not concern its effort to establish a new architectonic art of design thinking. Rather, they concern what the nature of that art should be. Evidence for this is that subsequent discussion turned toward the proper methodology of design. Unfortunately, "methodology" was interpreted in its narrow form as *specialized techniques or methods* rather than in its architectonic form as *systematic disciplines of integrative thinking,* within which diverse techniques and methods are given direction and purpose.[26] The proper question should have been, what is *forethought* in the new circumstances of twentieth-century culture? The leaders of the Bauhaus expressed a new attitude toward making that was consistent with the cultural and philosophic revolution that began in the early days of the twentieth century. Indeed, the Bauhaus was part of

that revolution precisely because of its effort to establish a new architectonic art of design grounded in character and making. However, the Bauhaus did not fully develop the new disciplines of design thinking. It left the architectonic art of design with open-ended possibilities that required further concrete development in order to be effective. It is no surprise, therefore, that the issue for debate in evaluating the contribution of the Bauhaus soon became whether it succeeded in providing the necessary intellectual tools for integrating the arts of making with knowledge gained from the natural and social sciences, and whether it succeeded in integrating design thinking with industry and the world of practical action.

The Bauhaus opened paths in these directions, but it lacked instrumentalities of forethought essential for further exploration and development—instrumentalities that were required to complete the revolution in attitude and direction of thinking that it helped to initiate. Forethought at the Bauhaus derived its strength from the creative imagination of artists. And, despite debunking by critics, the leaders of the Bauhaus went to a correct source, because all making is, in essence, an artistic, not merely an aesthetic, activity.[27] But the *thought* that must stand behind *making* in the new circumstances that have emerged in the twentieth century was only partly grasped in the vision and preparation of artists that existed at the Bauhaus. When Gropius spoke of the "comprehensive training" of the new artist, it was more an expression of optimism about future possibilities than accurate reporting about the reality of the Bauhaus program.

Considering the relation between rhetoric and making, which has been an ongoing source of innovation in Western culture, it is reasonable to suggest that what the Bauhaus lacked was a revolutionary vision of rhetoric to match its revolutionary vision of making. This would be rhetoric as a broad intellectual discipline, expanded from an art productive of words and verbal arguments to an art of conceiving and planning all of the types of products that human beings are capable of making. Without such a discipline for integrating design and making with science and practical action, the accomplishments of the Bauhaus were necessarily limited. Thus, design may have had its origin at the beginning of the twentieth century, but it required further development appropriate to the new circumstances of culture.

Moholy-Nagy took an important step in this direction when he established the New Bauhaus in Chicago in 1937. As part of the new program, he invited a philosopher from the University of Chicago, Charles W. Morris, to design a component of the curriculum suited to prepare students with a broader understanding of the relations among art, science, and technology that the school was attempting to explore in practice.[28] Morris accepted the challenge with enthusiasm and promptly recruited distinguished colleagues from the university to assist. The resulting curriculum followed the pattern of general education at the University of Chicago, with courses in the subject matter and methods of the physical and biological sciences, the social sciences, and the humanities, as well as two interdisciplinary courses: "intellectual and cultural history," and "intellectual integration."[29]

Morris taught the course in intellectual integration, using the uncorrected galley proof of his *Foundations of the Theory of Signs* as a background reading. His goal was to use "the theory of signs and the results of the unity of science movement to obtain a philosophical perspective on human activity," and thereby broaden the understanding of design students who were active in the workshops and studios of the school.[30] Unfortunately, this experiment was cut short because of financial difficulties, which forced the school to close for a short period. When it reopened, Morris and his colleagues continued to teach for a short time without compensation, but there is little documentation to suggest that the venture in intellectual integration reached its potential. Nonetheless, Moholy-Nagy viewed such explorations as an essential part of the new liberal art of design that he sought to develop and that he described in detail in *Vision in Motion*.[31] Relying on the contingent of professors from the University of Chicago to teach subject matters and methods of intellectual integration, he viewed the overall program of the New Bauhaus as a further integration in the activity of making. This was a concrete development of the original Bauhaus idea, although the significance of the innovation has passed largely unnoticed because it lasted only a short time and few results were immediately evident.

Without a Bauhäusler at once sensitive to the connection between design and making *and* prepared to explore new disciplines of forethought, further development of the Bauhaus idea

was difficult, if not impossible. This is illustrated in the fate of the Hochschule für Gestaltung (HfG) Ulm, widely regarded as the most important and influential school of design since World War II. Founded in 1953 by Max Bill and others to promote the principles of the Bauhaus, HfG Ulm was soon racked by irreconcilable differences between Bill and those among the staff who wanted to pursue new methods suited to the needs of industry. Bill, an alumnus of the Bauhaus, resigned after a short time, succeeded by his deputy, Tomás Maldonado, who encouraged the development of scientific planning more deeply informed with mathematics and analytical techniques.

The differences between Bill and his colleagues are usually described as methodological, but they were far more. The combined influence of the Frankfurt School and the Vienna Circle on Maldonado and his colleagues helps to explain the unusual and, at times, explosive contradictions that formed the atmosphere at HfG Ulm, representing a shift away from the principles of an integrative discipline of design sought by Bill and the leaders of the Bauhaus. The contrast of principles is evident in the confidence displayed by Maldonado that HfG Ulm could tell the world what forms should and should not be created to serve social goals. "The HfG we are building in Ulm intends to redefine the terms of the new culture. Unlike Moholy-Nagy in Chicago, it does not merely want to form men who would be able to create and express themselves. The school at Ulm . . . wants to indicate what the social goal of this creativity should be; in other words, which forms deserve to be created and which do not." [32] While the Bauhaus based its work on a belief in the essential freedom of individual human character in a society and culture influenced by industrialization, Maldonado viewed industry itself as the central agency shaping culture. Indeed, for Maldonado industry was culture.

> Ulm was based on one basic idea, which we all shared in spite of disagreeing on absolutely everything else: the idea that industry is culture, and that there exists the possibility (and also the necessity) of an industrial culture. . . . At that time I was particularly receptive to some of the thinking of the Frankfurt School. Although my own cultural orientation was strongly marked at that time by Neopositivism (I was eagerly reading Carnap, Neurath, Schlick, Morris, Wittgenstein, Reichenback, etc.), the presence of Adorno

in Frankfurt represented for me, as it were, a contradictory intellectual stimulation.[33]

Focus on methodology was a way of introducing a collection of scientific methods and techniques into design. It promoted the idea of a new science of design, grounded in neopositivist and empiricist philosophy, which some in the theoretical wing of HfG Ulm perhaps naively believed could be harnessed to serve a particular social, political, and intellectual agenda.

> What must be remembered is not only the limitless curiosity that we had in those years about anything that was—or seemed— new. That was a feverish, insatiable curiosity directed above all at the new disciplines that were then coming up: cybernetics, information theory, systems theory, semiotics, ergonomics. But our curiosity went further than this: it also extended, in no small measure, to established disciplines such as the philosophy of science and mathematical logic.
>
> The mainspring of all our curiosity, or reading, and our theoretical work was our determination to find a solid methodological basis for the work of design.
>
> This was a highly ambitious undertaking, admittedly: we were seeking to force through, in the field of design, a transformation equivalent to the process by which chemistry emerged from alchemy.[34]

However, the result of the work at HfG Ulm was not a new integrative science of design, but a further exploration of the relation between design and the natural and behavioral sciences begun at the Bauhaus and continued at the New Bauhaus.[35] Furthermore, without the humanistic orientation of the Bauhaus, the tendency at HfG Ulm was toward specialization, somewhat along the lines developed by Hannes Meyer in the closing days of the Bauhaus,[36] involving a belief in the ability of experts to engineer socially acceptable results through industry.[37] HfG Ulm should not be credited with initiating the "design methods movement" or the effort to find a neopositivist science of design thinking. It was a meeting ground for individuals from around the world who held such interests. It was a place where design educators could experiment with potentially useful techniques generally invented elsewhere.

However, neopositivism and empiricism are not inherently opposed to the concept of an integrative liberal art of design. This is evident in one of the most important works of design theory in the twentieth century, Herbert Simon's *The Sciences of the Artificial*. The problem addressed by Simon is the relation between the *necessary* in natural phenomena and the *contingent* features of the human-made: "The contingency of artificial phenomena has always created doubts as to whether they fall properly within the compass of science. Sometimes these doubts are directed at the teleological character of artificial systems and the consequent difficulty of disentangling prescription from description. This seems to me not to be the real difficulty. The genuine problem is to show how empirical propositions can be made at all about systems that, given different circumstances, might be quite other than they are."[38] His insight was not the reduction of design to any one of the established theoretical sciences—as appears to have been the goal at HfG Ulm. Rather, it was a recognition of the theoretical substance of design *distinct* from the substance of its supporting sciences. The result was the discovery of a new kind of science, radically distinct from the sciences of nature.

> Finally, I thought I began to see in the problem of artificiality an explanation of the difficulty that has been experienced in filling engineering and other professions with empirical and theoretical substance distinct from the substance of their supporting sciences. Engineering, medicine, business, architecture, and painting are concerned not with the necessary but with the contingent—not with how things are but with how they might be—in short, with design. The possibility of creating a science or sciences of design is exactly as great as the possibility of creating any science of the artificial. The two possibilities stand or fall together.[39]

The problem identified by Simon is surprisingly similar to the problems discussed by Aristotle in the first chapter of the *Rhetoric* and in the first chapter of the *Poetics*: how human beings reason and reach decisions about matters which may be other than they are, and how the artificial or human-made is different from, but related to, the natural.[40] Simon's proposed solution is a science of design, with features that are both *rhetorical*—an emphasis on deliberation and decision making—and *poetic*, in the sense that

all products made by human beings are subject to analysis and understanding based on the nature of the activity of making.[41] Like the leaders of the Bauhaus, Simon is not concerned with a trenchant Renaissance distinction between the fine and practical arts. He is interested in the elements of forethought operating behind all arts of making.

> The real subjects of the new intellectual free trade among the many cultures are our own thought processes, our processes of *judging, deciding, choosing,* and *creating.* We are importing and exporting from one intellectual discipline to another ideas about how a serially organized information-processing system like a human being—or a computer, or a complex of men and women and computers in organized cooperation—solves problems and achieves goals in outer environments of great complexity.
>
> The proper study of mankind has been said to be man. But I have argued that man—at least the intellective component of man—may be relatively simple, that most of the complexity of his behavior may be drawn from man's environment, from man's search for good designs. If I have made my case, then we can conclude that, in large part, the proper study of mankind is the science of design, not only as a professional component of a technical education but as a core discipline for every liberally educated person.[42]

The basis for the integration that Simon seeks for design is the new discipline of decision making, and he explores this discipline in the context of neopositivist and empiricist philosophy. However, the particular philosophic orientation of Simon's approach should not distract from appreciation of the broader direction of design thinking toward which he points. Simon is investigating the themes and arts of rhetoric in their relation to new arts of making.

Rhetoric and the New Technologies of Design Thinking

The effort to establish a new liberal art of design at the Bauhaus has given way to a search for a plurality of design arts which can provide suitable instrumentalities of forethought for a discipline which increasingly requires the incorporation of diverse kinds of knowledge. Since the search is still underway and no conventions of terminology, description, or formulation have emerged with

clarity, the precise nature of these arts remains uncertain and open to debate. Yet, central themes are evident throughout contemporary explorations of design and reflections on design practice, and the roots of those themes in rhetoric and poetics is an indication of the shape that the new integrative disciplines of design thinking may eventually take.

When Herbert Simon refers to the thought processes of creating, judging, deciding, and choosing as the real subjects of the new intellectual free trade among cultures and disciplines, he is giving new voice to the traditional arts and themes of rhetoric. However, the foundation of these processes of forethought in the disciplines of rhetoric is not yet widely recognized or understood. Rhetoric is still perceived by many people in its Renaissance orientation toward poetry, belles lettres, and beaux arts, rather than in its twentieth-century orientation toward technology as the new science of art, where theory is integrated with practice for productive purposes and where art is no longer confined to an exclusive domain of fine art but extends to all forms of making. Nonetheless, the themes of rhetoric have emerged in twentieth-century design precisely because they provide the integrative connections that are needed in an age of technology.

The pattern of rhetoric in twentieth-century design builds on distinctions which were established early in the formation of rhetorical theory and developed to meet changing circumstances. In earlier periods of Western culture, when rhetoric was oriented toward words and verbal arguments, the traditional divisions of rhetoric were *invention, judgment, disposition* (planning the sequence of argument), *delivery* (choosing the appropriate vehicle for presenting arguments to different audiences), and *expression* (choosing the appropriate stylistic embodiment of arguments). In the expanded rhetoric of Francis Bacon, who sought to overcome the separation between words and things in order to explore science and technology, the traditional divisions of rhetoric survived in the groundplan for the advancement of learning and in the four intellectual arts needed to carry out that advancement: the arts of *invention, judgment, custody,* and *tradition.* Significantly, the fifth division of rhetoric, expression, did not disappear. It was distributed by Bacon among the four intellectual arts, integrated into the larger task of intellectual exploration in each area.

In the new rhetoric of twentieth-century design and tech-

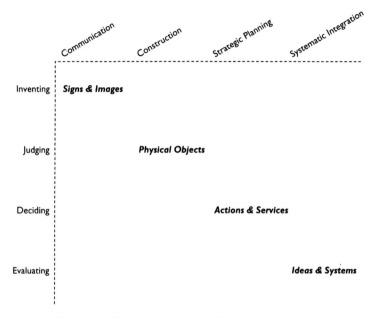

Figure 3. Matrix of abilities and disciplines in design

nology, where the effort is also to overcome the separation be-
tween words and things, the traditional divisions of rhetoric have
emerged once again to give coherence to inquiry. The investiga-
tion of design in theory and practice centers around four themes,
which may be stated briefly and ambiguously as *invention and
communication, judgment and construction, decision making and
strategic planning,* and *evaluation and systemic integration.* These
themes may be represented in the form of a matrix in order to
suggest issues and problems that stand behind the shifting debate
about design in the past seventy years (fig. 3).

In this framework, the fifth division of rhetoric, *expression and
styling,* emerges as a persistent issue in each of the disciplines.
Few designers are content to describe their work as mere styling.
Yet, most recognize that the appearance and expressive quality
of products is critically important not only in marketing but in
the substantive contribution of design to daily living. The prob-
lem is how to accommodate sensitivity to expression with the
intellectual and analytical issues belonging to communication,
construction, strategic planning, and systemic integration. The

neopositivist approach is to distinguish sharply between emotion and cognition, leaving expression as something emotive, irrational, intuitive, and noncognitive. However, in the context of a rhetorical approach, the expressive appearance or styling of a product carries a deeper argument about the nature of the product and its role in practical action and social life. Expression does not clothe design thinking; it *is* design thinking in its most immediate manifestation, providing the integrative aesthetic experience which incorporates the array of technical decisions contained in any product.

The disciplines or arts of design have their counterparts in the intellectual virtues of designers. Designers should be (1) curious and inventive beyond the bounds of specialization in addressing design problems; (2) able to judge which of their inventions are and which are not viable constructs in particular circumstances and under given conditions; (3) able to participate with others, including technical specialists from many fields, in decision-making processes which develop products from conception to production, distribution, disposal, and recycling; (4) able to evaluate the objective worth of products in terms of the needs of manufacturers, individual users, and society at large; and (5) able to embody ideas in appropriately expressive forms throughout the process of conception and planning. The disciplines of design are *enabled* by the rhetorical abilities of designers.

Design has become an art of deliberation essential for making in all phases of human activity. It applies to the making of theories which attempt to explain the natural operations of the world. It applies to making policies and institutions which may guide practical action, as in a constitution for a newly emerging state or in political, social, and economic institutions relevant to new circumstances. And, it applies to making all of the objects in the domain of production that the Renaissance arbitrarily divided into belles lettres, beaux arts, and the practical arts. Deliberation in design yields arguments: the plans, proposals, sketches, models, and prototypes which are presented by designers as the basis for understanding, practical action, or production. Design is the art of shaping arguments about the artificial or human-made world, arguments which may be carried forward in the concrete activities of production in each of these areas, with objective results ultimately judged by individuals, groups, and society.

Expanding the Discipline of Design

Three other perspectives have also exerted strong influence on the formation of design thinking in the twentieth century. However, they have shifted attention away from the discipline of design, toward different types of philosophic or cultural content. This has sometimes led to new characterizations of the method of designing that are more closely aligned with politics, science, or dialectic. Nonetheless, the discipline has expanded quite easily to accommodate such interests, demonstrating the potential of design to adapt to different rhetorical purposes and objectives.

Power to Control Nature and Influence Social Life

When the origins of design are traced to the Industrial Revolution, the principle lies in the power of individuals to control their surroundings, satisfy needs and desires, and influence social life through mechanization and technology. For example, John Heskett begins his history of industrial design with a description of the quantitative and qualitative change that has taken place in the last two hundred years.

> In the last two centuries, human power to control and shape the surroundings we inhabit has been continuously augmented, to the extent that it has become a truism to speak of a man-made world. The instrument of this transformation has been mechanized industry, and from its workshops and factories a swelling flood of artefacts and mechanisms has poured out to satisfy the needs and desires of an ever-greater proportion of the world's population. The change has not only been quantitative, but has also radically altered the qualitative nature of the life we live, or aspire to live.[43]

For writers such as Heskett, the origins of design are best traced to the Industrial Revolution, because it was during this period that the power to invent and shape useful products was distinguished from the laborious physical activities of making them. Prior to this period, design was closely associated with craft methods of production, and the crafts, in their most refined forms, were instruments to satisfy the desire of princes and kings for luxury. With the advent of new techniques for mass production, design became an instrument of merchant princes in a

new world of technological capabilities, economic competition, political and social ideas, and masses of consumers from all social classes. Design and designers came into existence within the competitive organization of production, distribution, and consumption.

From this perspective, design is an instrument of power.[44] It is the art of inventing and shaping two-, three-, and four-dimensional forms that are intended to satisfy needs, wants, and desires, thereby effecting changes in the attitudes, beliefs, and actions of others. Of course, after two hundred years of development, design is no longer the exclusive instrument of merchant princes. Yet, it is still significantly dependent on the interests of businesses and corporations, making products that are competitive in the global marketplace. The competitive environment of business provides the framework for understanding the diverse roles of professional designers today. Some work within corporate structures; some work outside, in design consultancies; and some work alone, with even greater independence, serving their own interests, working with only marginal concern for the interests of corporations, content with personal satisfaction in small-scale work or quietly seeking to bypass corporate intermediaries in order to serve the long-term interests of the general public.[45] Indeed, one aspect of the qualitative change in culture that has followed the Industrial Revolution is the widening range of individuals who may exercise the power of design.

From the perspective of design as power, a variety of traditional themes in design history and theory take on special significance. In *Objects of Desire,* Adrian Forty emphasizes the role of design in society. He argues that excessive concentration on design as an art of making things beautiful has severed design from its function in making profit and in transmitting ideas. In effect, it "has obscured the fact that design came into being at a particular stage in the history of capitalism and played a vital part in the creation of industrial wealth. Limiting it to a purely artistic activity has made it seem trivial and relegated it to the status of a mere cultural appendix."[46] For Forty, design is indeed concerned with the look of things, but the look of things is more than a matter of pure, idealized beauty: "Those who complain about the effects of television, journalism, advertising and fiction on our minds remain oblivious to the similar influence of design. Far

from being a neutral, inoffensive artistic activity, design, by its very nature, has more enduring effects than the ephemeral products of the media because it can cast ideas about who we are and how we should behave into permanent and tangible form."[47] Forty argues that design is the preparation of instructions for the production of manufactured goods. However, these instructions include more than information about formal shapes. They inevitably include an expression of ideas or myths about the world in which we live. "Every product, to be successful, must incorporate the ideas that will make it marketable, and the particular task of design is to bring about the conjunction between such ideas and the available means of production. The results of this process is that manufactured goods embody innumerable myths about the world which in time come to seem as real as the products in which they are embedded."[48]

Throughout his work, Forty seeks to establish a better understanding of the balance that exists among various influences on the design process. On the one hand, he warns against excessive emphasis on the creative power of the individual professional designer, observing that the entrepreneur's final selection among alternative design proposals is just as important a design decision as any decision made by the formally designated designer.[49] On the other hand, he warns against excessive emphasis on "extremely general dominating ideas" at the social or cultural level. This is a clear criticism of dialecticians who attempt to trace the significance of design to broad cultural ideas grounded in the spirit of the time, without adequate recognition of the diversity of specific ideas held by designers and entrepreneurs or of the variety of desires operating among individuals and groups within society at any moment in history.[50] Design is part of a social process in which there are professional designers and many others who are not formally described as designers but who make design decisions—whether in the process of product development, manufacturing, or distribution and consumption.

Material Conditions and Aesthetic Appeal

When the origins of design are traced to the creation of images and objects by primitive human beings, the principle lies in the material conditions of life. The origins of design in prehistory will never be fully understood because the surviving evidence is

fragmentary. Nonetheless, based on images and objects which have survived, the broad outlines of an account are possible, throwing light on the problems of design in the twentieth century. The earliest examples of design are tools, images drawn on cave walls, and ornamental objects with images drawn on bone or other materials. These objects reveal rudimentary technical skills in shaping materials into useful forms and, at the same time, an added psychological factor: aesthetic delight in the sensuousness of materials, patterns, and forms. The development of design throughout prehistory and recorded history is an elaboration of the technical and aesthetic considerations which have contributed to a satisfying physical and emotional life for mankind.[51]

Characteristic of this approach, human life is seen as progressively complicated by a hierarchy of needs, ascending from the physical and biological, to the emotional and psychological, to the spiritual—the most refined of the emotional needs of the human animal.[52] Design is the natural ability of human beings to shape and use materials to satisfy all of these needs.[53] However, design is partly rational and cognitive, and partly irrational, emotive, intuitive, and noncognitive. It is rational to the extent that there is conscious understanding of the laws of nature; it is irrational to the extent that the sciences have not yet succeeded in revealing the laws of complex phenomena. Indeed, there is reason to believe that design will always retain an irrational or intuitive component, because there are properties of materials and forms that possess aesthetic and spiritual appeal for which no scientific explanation seems possible. However, this is not a confirmation of the existence of a transcendental realm, since the spiritual is regarded by the materialist merely as a complex emotional state of mind.

There are three basic elements that contribute to the development of design in the contemporary world. The first element is the technique or technology of craft production, supported by a gradual accumulation of scientific understanding of the underlying principles of nature that guide construction.[54] This has led to the technology of machines, mass production, and computers. Indeed, engineering, with its reliance on natural science and mathematics, is the basic form of design for the materialist.[55] The second element is our understanding of the psychological, social, and cultural needs that condition the use of products.[56] (Practical mechanics and engineering may provide the fundamental example

of design, but industrial designers are quick to argue that they have special expertise in addressing the behavioral considerations that are associated with products.) The third element is awareness of the aesthetic appeal of forms. This sometimes leads to proposals for a "science of art" which grows out of perceptual psychology and other branches of social science.[57]

The treatment of aesthetics from this perspective may be illustrated by Herbert Read, whose book *Art and Industry* was a standard text in many design schools in the United States and Britain and served as an exceptionally influential introductory work on design for general readers.[58] Although Read is associated with the Bauhaus movement, and was a friend and strong supporter of Moholy-Nagy, his book represents a different philosophic orientation that deserves careful consideration.[59] Relying on similar themes and many of the same commonplaces of design history as told by Moholy-Nagy, he tells a subtly different story about the history of design and introduces a different thread into the history of the Bauhaus and into design thinking in the twentieth century.[60]

For Read, the problem of design in the twentieth century is precisely the consequence of developments that have followed in the linear progression of history through advances in the technology of production and efforts to add aesthetic value to products.

> For more than a hundred years an attempt has been made to impose on the products of machinery aesthetic values which are not only irrelevant, but generally costly and harmful to efficiency. Those aesthetic values were associated with the previously prevailing handicraft methods of production, but they were not essential even to these. Actually they were the superficial styles and mannerisms of the Renaissance tradition of ornament. Nevertheless, the products of machinery were at first judged by the standards of this tradition, and though there have been attempts, notably the one led by Ruskin and Morris, to return to the more fundamental aspects of handicraft—that is to say, to the forms underlying ornament—yet the problem in its essentials remains unresolved. For the real problem is not to adapt machine production to the aesthetic standards of handicraft, but to think out new aesthetic standards for new methods of production.[61]

The method proposed by Read to address this problem indicates a sharp reversal of the dialectician's concern for spirit and culture. Instead of seeking an explanation for design in the unifying ideas of a particular cultural epoch, he seeks to strip away cultural irrelevancies and reduce design to its essential elements in art and industrial production.

> [W]hat is required as a preliminary to any practical solution of the division existing between art and industry is a clear understanding, not only of the processes of modern production, but also of the nature of art. Not until we have reduced the work of art to its essentials, stripped it of all the irrelevancies imposed on it by a particular culture or civilization, can we see any solution of the problem. The first step, therefore, is to define art; the second is to estimate the capacity of the machine to produce works of art.[62]

This involves a twofold use of reasoning that leads to a "science of art" that is coordinate with the natural sciences: first, a decomposition to fundamental parts, elements, or essentials; second, a subsequent construction of understanding by the progressive addition of the complicating factors that eventually yield an approximation of the complexity that is possible in design.

> The work of art is shown to be essentially formal; it is the shaping of material into forms which have a sensuous or intellectual appeal to the average human being. To define the nature and operation of this appeal is not an easy task, but it must be faced by anyone who wishes to see a permanent solution of the problem that concerns us.
>
> The problem, that is to say, is in the first place a logical or dialectical one. It is the definition of the normal or universal elements in art.
>
> It is then complicated by the purposes which the objects we are shaping have to serve. That is to say, we are concerned, not with the works of art whose only purpose is to please the senses or intellect, but with works of art which must in addition perform a utilitarian function.[63]

The result is recognition of a type of art which is abstract or nonfigurative, with "no concern beyond making objects whose plastic

form appeals to the aesthetic sensibility." Furthermore, the nature of this appeal may be either rational or intuitional—the former obeying rules of symmetry and proportion, the latter appealing to "some obscurer unconscious faculty."[64] "We must recognize the abstract nature of the essential element in art, and as a consequence, we must recognize that design is a function of the abstract artist. The abstract artist (who may often be identical with the engineer or the technician) must be given a place in all industries in which he is not already established, and his decisions on all questions of design must be final."[65] Designers construct objects to satisfy fundamental human needs that are susceptible to some level of scientific or engineering analysis.[66] However, the constructions are inevitably complicated by arbitrary factors of taste and preference which the designer is often able to address only by emotional sensitivity and intuitive understanding. Design is based on science, but it extends its reach in addressing emotional needs through aesthetics.

Spiritual Life: Hellenism and Hebraicism in Design

There is a persistent thread of spirituality in twentieth-century art and design which has never found an adequately articulate voice in modern design theory. This is disappointing, because the widespread discontent with the fruits of science, technology, and business cannot be easily dismissed. Judged by the ideals of Western and Eastern cultures, the obsessive materialism, injustice, warfare, environmental degradation, and inhumanity of the past century of progress is a cruel denial of something fundamental in the human spirit, a betrayal of reason and conscience, of right thinking and right acting. Ironically, the two great theories of design in Western culture—one embedded in Hellenism, the other in Hebraicism—have exerted little explicit influence on the development of design thinking in the period when design is most widely practiced and discussed as a cultural art.[67] Yet, traces of these theories emerge occasionally as a reminder of a resource that remains available to illuminate the work of those designers who are not content with pragmatic design and insist that design has a more important role to play in promoting human well-being.

Distinguished designer George Nelson argues that the design process is integrated in the principle of appropriateness, and he

grounds this principle in the model provided by God and natural order.

> Going through the entire design process, which includes the important collaborations all the way down the line, with materials people, engineers, technicians in specialized areas, and marketing people, the steady movement is in the direction of a solution that is ultimately seen, not as beautiful, but as *appropriate*. The creation of beauty cannot be the aim; beauty is one of the aspects of appropriateness, and it still lies pretty much in the eye of the beholder, which makes it a by-product rather than a goal.
>
> There is very powerful support for this view in nature, which is always the best model to be followed, for God, so to speak, is still the best designer. People who work with natural organisms at any scale, such as biologists, are invariably the expression of some function or other. . . . Everything in organic nature functions in relation to survival needs; we find these things beautiful, because as creatures of nature we are programmed to respond to evidence of appropriateness as an expression of beauty. For mathematicians, and for scientists generally, words like "elegant," "appropriate," and "beautiful" are synonymous.[68]

The spiritual feature of Nelson's work is sometimes neglected by design critics and historians who interpret "function" in a narrow, mechanistic way, rather than as a connection between human beings, products, and the broader system of nature and the universe. The principle of appropriateness, regarded as a spiritual quality, serves to explain some features of Nelson's writings which otherwise appear paradoxical. For example, he offers harsh criticism of excessively narrow concepts of "functional" design; so-called "good" design, as judged by aesthetic standards such as those once promoted by Edgar Kaufmann, Jr. at the Museum of Modern Art; the pretensions of design for design's sake; and the equally pretentious idea of the designer as creator and purveyor of social meanings. Yet, he argues for a vision of design as communication and of the designer as artist. The only explanation is that he regards the designer as an artist in the Platonic sense, an enlightened practitioner seeking unity and harmony among the disparate elements of every product. Indeed, he argues that products which internally achieve harmony and balance serve the ethical life of human beings, who are actively seeking their own place in

a unity of social experience and nature—precisely at a time when culture appears to be disintegrating.[69]

The elements of Hellenism and Hebraicism which are balanced in Nelson's work—a concern for right thinking and for right acting, consciousness and conscience—are echoed whenever the origins of design are traced to the creation of the universe. The principle lies in spiritual life and the natural order. Unfortunately, scholars have exercised little ingenuity in exploring the rich, complex theory of design provided by Plato in the *Timaeus* and the *Republic*, or in rethinking the Christian tradition represented, for example, by St. Augustine.[70] Until this material is rediscovered, the spiritual discontent with design and technology will remain inchoate. We will speak of an environmental crisis, when we mean a spiritual crisis in the relation of human beings to natural order. We will be charmed by some products and infuriated by others, while remaining oblivious to their spiritual meaning. We will be mystified by the absence of an adequate cultural critique in design theory which is based on more than materialist economics and the conflict of social classes. Finally, we will be puzzled by the failure of systems theory to reach beyond its materialist origins and explore unifying cultural ideas and values as the core of all systems.

Conclusion

The four perspectives identified in this essay are based on rhetorical commonplaces in the study and practice of design. Each commonplace orients our ideas about design in a different direction, opening up a broad avenue for exploration and integration. The purpose in identifying these perspectives is to gain a more adequate representation of the pluralism of twentieth-century design thinking. The diversity of design in the contemporary world is less bewildering than it appears to the casual observer. Products embody the intentions and purposes of their makers, and there is an intelligible pattern in the ongoing development and application of design. The essential humanism of design lies in the fact that human beings determine what the subject matter, processes, and purposes of design shall be. These are not determined by nature, but by our decisions.

In the contemporary world, design is the domain of vividly

competing ideas about what it means to be human. However, the exploration of design does not break our connection with the past. The central themes and commonplaces of design—power and control, materialism and pleasure, spirituality, and character—reveal deep continuities with ancient philosophic traditions. Indeed, the pluralism of design in the twentieth century is intelligible because it rests on a pluralism of philosophic assumptions which are familiar. The exploration of design is therefore, a contribution to the philosophy of culture in our time.

Notes

1. Richard Buchanan, "Wicked Problems in Design Thinking," *Design Issues,* 8, no. 2 (Spring 1992): 5–21.

2. John Dewey, "By Nature and by Art," *Philosophy of Education (Problems of Men)* (1946; rpt. Totowa, NJ: Littlefield, Adams, 1958), pp. 286–300.

3. Philosopher Richard McKeon provides a useful interpretation of Aristotle's position on the arts. "The productive sciences are differentiated according to their products, and there are no sharply defined lines imposed by nature to separate the arts or to differentiate the kinds of artificial things. The Greeks did not differentiate the fine arts from the mechanical in the fashion that has been customary since the Renaissance, and they have therefore been criticized by humanists for confusing arts and trades, thereby degrading the artist, and by pragmatists for separating science from art, thereby reducing operations and mechanical contrivances to a servile level. The arts as conceived by Aristotle include not only such arts as painting, music, and poetry, but medicine, architecture, cobbling, and rhetoric. Since the arts imitate nature, they may be differentiated by consideration of the object, means, and manner of their imitation, and therefore, although he has no words for fine arts, Aristotle is able, in the opening chapter of the *Poetics,* to assemble the arts which we call fine by isolating their means of imitation and to differentiate tragedy from the other arts. Aristotle did, however, have a word by which to differentiate the liberal arts from the mechanical, and he sought their differentiation in the educative influence of the arts in the formation of men for freedom." Richard McKeon, ed., *Introduction to Aristotle* (New York: Modern Library, 1947), pp. xxiii–xxiv.

4. Aristotle, *Nicomachean Ethics,* 4.4.1140a1–23. Also, *Metaphysics,* 1.1.980a20–982a1.

5. Aristotle, *Poetics,* 1450b5–12. For a discussion of this issue, see Richard McKeon, "The Uses of Rhetoric in a Technological Age: Architectonic Productive Arts," in *Rhetoric: Essays in Invention and Discovery,* ed. Mark Backman (Woodbridge, CT: Ox Bow Press, 1987), p. 4. The balanced relation between rhetoric and poetics in Aristotle's philosophy gave way in the work of his successors to an emphasis on rhetoric and a rhetoricized poetics. This led to a

reading of the *Poetics* as a body of rules or laws of making to guide the literary artist, rather than a scientific analysis of made things, as Aristotle intended. Such an approach, evident in Horace and Longinus, has dominated Western literary theory in many periods, including the Renaissance.

6. Aristotle defined rhetoric as the faculty of finding the available means of persuasion with regard to any subject about which we deliberate. Along with its counterpart, dialectic, rhetoric supplied the arguments and thought which could be used by the artist to shape a particular form. Aristotle, *Rhetoric,* 1.2.

7. Vitruvius, *The Ten Books on Architecture,* trans. Morris Hicky Morgan (New York: Dover, 1960), 1.1.

8. For an extensive discussion of the classification of poetry among the sciences in the Renaissance, with useful observations on the practical arts, see Bernard Weinberg, *A History of Literary Criticism in the Italian Renaissance* (Chicago: University of Chicago Press, 1961), 1.1–37.

9. For a discussion of these three traditions in the context of the arts, see Weinberg, *A History of Literary Criticism,* 2.797–813. For a broader discussion of these traditions and representative texts by Petrarca, Valla, Ficino, et al., see Ernst Cassirer, Paul Oscar Kristeller, and John Herman Randall, Jr., eds., *The Renaissance Philosophy of Man* (Chicago: University of Chicago Press, 1948).

10. Richard McKeon, "Imitation and Poetry," in *Thought, Action, and Passion* (Chicago: University of Chicago Press, 1954), p. 175. Includes a useful discussion of the Platonic, Aristotelean, and rhetorical traditions in the Renaissance.

11. See Leon Battista Alberti, *On Painting,* trans. John R. Spencer (New Haven: Yale University Press, 1966). Also, John White, *The Birth and Rebirth of Pictorial Space* (Cambridge: Harvard University Press, 1987), pp. 121, 126. White discusses the invention of "artificial perspective" in the Renaissance and observes the emerging tendency to connect painting with mathematics, science, and theory: "It is in Alberti's *Della Pittura,* which he wrote in 1435, that a theory of perspective first attains formal being outside the individual work of art. Theoretical discussion replaces practical demonstration. The way is open, in art also, for that separation of theory and practice; that particular kind of self-consciousness which, in the wider view, showed itself most significantly in the growing realization of the historical remoteness of antiquity, and which underlies modern scientific achievement." White also notes the effort to elevate painting to the status of the liberal arts. "The innate pictorial qualities of artificial perspective were not the only sources of its popularity and prestige. Already in the *Della Pittura,* it is used as a lever with which to ease the humble craft of painting into the lordly circle of the liberal arts. With this ascent the formerly humble, but now scientific, painter was to move into the sphere of princely patrons and attendant men of letters." The transposition of themes from mathematics (Euclidean geometry) into painting should be compared with Galileo's use of mathematics to treat the new science of mechanics. Compare also the use of mathematics in the disciplines of design in the twentieth century.

12. Joshua C. Taylor, ed., *Nineteenth Century Theories of Art* (Berkeley: University of California Press, 1987), p. 11.

13. The increasing separation of art academies from the practical arts is well illustrated in the founding of the Royal Academy in London in 1768. Joshua Reynolds epitomizes the extent of the division. "An institution like this has often been recommended upon considerations merely mercantile; but an Academy, founded upon such principles, can never effect even its own narrow purposes. If it has an origin no higher, no taste can ever be formed in manufactures; but if the higher Arts of Design flourish, these inferior ends will be answered of course." Also, "The rank and value of every art is in proportion to the mental labor employed in it, or the mental pleasure produced by it. As this principle is observed or neglected, our profession becomes either a liberal art, or a mechanical trade. In the hands of one man it makes the highest pretensions, as it is addressed to the noblest faculties: in those of another it is reduced to a mere matter of ornament; and the painter has but the humble province of furnishing our apartments with elegance." Sir Joshua Reynolds, *Discourses on Art* (New York: Collier Books, 1966), pp. 19, 55.

14. The central themes of rhetoric provided the ground plan and intellectual disciplines for Francis Bacon's *The Advancement of Learning* and *The New Organon*. The goal was "the invention not of arguments but of arts; not of things in accordance with principles, but of principles themselves; not of probable reasons, but of designations and directions of works," with the effect not of overcoming an opponent in verbal argument, but "to command nature in action." What Bacon called the "operative part of the liberal arts," the mechanical arts and the crafts which have not yet grown into arts properly so called, provided experimental data for the investigation of the principles of nature. Francis Bacon, *The New Organon* (New York: Bobbs-Merrill, 1960), pp. 19, 25. For a discussion of rhetoric in Bacon, see R. S. Crane, "Shifting Definitions and Evaluations of the Humanities from the Renaissance to the Present," in *The Idea of the Humanities and Other Essays Critical and Historical* (Chicago: University of Chicago Press, 1967), 1.64–65. Also, John C. Briggs, *Francis Bacon and the Rhetoric of Nature* (Cambridge: Harvard University Press, 1989). For an important account of changes in the liberal arts from the Renaissance to the twentieth century, see Richard McKeon, "The Transformation of the Liberal Arts in the Renaissance," *Developments in the Early Renaissance*, ed. Bernard S. Levy (Albany: State University of New York Press, 1972), pp. 158–223.

15. For a discussion of the decline of rhetoric as an intellectual art and its rebirth in the twentieth century, see Chaim Perelman, "The New Rhetoric: A Theory of Practical Reasoning," in *The New Rhetoric and the Humanities* (Dordrecht, Holland: D. Reidel, 1979), pp. 1–42.

16. This is illustrated in the development of the engineering profession in the French and British traditions after the Renaissance. The military provided the primary base of employment for engineers in Europe. The *Corps du génie* was created in the French army in 1676. The need for suitable deployment of troops also led to the creation by the French government of the *Corps des ponts*

et chaussées in 1716. For a brief but useful discussion of the rise of engineering as a profession after the Renaissance, see Terry S. Reynolds, "The Engineer in Nineteenth-Century America"; and John B. Rae, "Engineers Are People," in *The Engineer in America: A Historical Anthology from Technology and Culture,* ed. Terry S. Reynolds (Chicago: University of Chicago Press, 1991). Also, Bertrand Gille, *Engineers of the Renaissance* (Cambridge: Harvard University Press, 1966). For another useful discussion of the discipline of engineering, see Carl Mitcham, "Engineering as (Productive) Activity: Philosophical Remarks," in *Critical Perspectives on Non-Academic Science and Engineering,* ed. Paul T. Durbin (Bethlehem, PA: Lehigh University Press, 1990).

17. In the twentieth century, the narrow interpretation of the principle of "profit first" in Western culture has been attacked from within and without. Criticisms of "profit first" voiced at the Bauhaus were easily dismissed as socialist ideology, but the movement of "quality first" has gained force in the business community in recent decades, suggesting that profit and quality are not opposites. For an account of the "quality control" movement that explains some of the connections between Western and Asian thinking, see Kaoru Ishikawa, *What is Total Quality Control: The Japanese Way* (Englewood Cliffs, NJ: Prentice-Hall, 1985), p. 74. Marketing expert Philip Kotler provides a suggestive analysis of the growing perception of the relation between business practices and human character. Philip Kotler, "Humanistic Marketing: Beyond the Marketing Concept," in *Philosophical and Radical Thought in Marketing,* ed. A. Fuat Firat, N. Dholakia, and R. P. Bagozzi (Lexington, MA: D. C. Heath, 1987), pp. 271–88.

18. For a discussion of this revolution and its influence on the emergence of new disciplines of design, see R. Buchanan, "Wicked Problems in Design Thinking." The rise of design in the twentieth century could be regarded as a completion of the Baconian project to command nature in action, after a three-century detour into the theoretic sciences to discover the principles of natural processes. For a discussion of the relations among art, science, and technology at the beginning of the twentieth century, see John Dewey, "By Nature and by Art."

19. Walter Gropius, "My Conception of the Bauhaus Idea," *Scope of Total Architecture* (New York: Collier Books, 1962), pp. 19–20.

20. For Aristotle, art for art's sake would be unintelligible and dangerous. It would be a vice, representing excessive preoccupation with one or another pleasure without the balance of moral and intellectual virtues found in well-formed character. Art is not an end in itself but serves human beings as a means for supplying what nature provides only by chance. In the variety of its forms, art is directed toward the range of functions which the human being must perform in order to sustain life and further the well-being of the individual and community in a complex environment. There is a sense in which art possesses autonomy and integrity as an expression of the soul of the artist and the object of imitation, but "art for art's sake" is the formula of power without responsibility. It is the basis of sophistry.

21. Criticism of the Bauhaus has become quite fashionable in recent decades. However, the criticism comes from individuals who hold precisely the principles rejected in Bauhaus writings. The most paradoxical criticism comes from idealists: some complain about an overemphasis on art (beauty detached from rational function), while others complain about an overemphasis on the practical arts (to the detriment of the spiritual aspect of fine art). In contrast, materialists criticize the Bauhaus for naively seeking to advance utopian idealism while neglecting scientific "realism" and true functionalism. Finally, individuals who believe that design should be judged by its power to influence social life criticize the Bauhaus for a failure to influence the practices of industry to a sufficient degree. Judged by principles that it did not hold, it hardly comes as a surprise that the Bauhaus fails to measure up to the wishes of its critics. The controversy surrounding the Bauhaus suggests that Gropius and his colleagues did, indeed, seek to establish a different principle for design, resisting the reduction of design to idealism, materialism, or the sophistic power represented by "art for art's sake" and its more dangerous expression, "business for business's sake."

22. Gropius, *Scope of Total Architecture,* p. 20.

23. Walter Gropius, "The Theory and Organization of the Bauhaus," *Bauhaus: 1919–1928,* ed. Herbert Bayer, Walter Gropius, and Ise Gropius (New York: Museum of Modern Art, 1938), p. 29.

24. "An esthetic conception, so to speak, has fatally displaced a creative conception of art. Creative art and history of art should no longer be confused. 'Creating new order' is the artist's task; that of the historian, to rediscover and explain orders in the past. Both are equally indispensible, but they have entirely different aims." Walter Gropius, "Blueprint of an Architect's Education," *Scope of Total Architecture,* pp. 47–48.

25. Dewey recognized the importance of those experiences that are predominantly aesthetic, but he argued that such experiences should not prevent one from recognizing the aesthetic quality of predominantly intellectual or practical experiences. John Dewey, *Art as Experience* (New York: Capricorn, 1958), pp. 38–39, 55, et passim.

26. Christopher Alexander is often regarded as a leader of the "design methods movement" of the 1960s. However, he rejected the idea in 1971, rebuking those who read his important book only for its contribution to methodology. Noting the tendency of readers to miss his central idea, he writes:

"But I feel it is important to say it also here, to make you alive to it before you read the book, since so many readers have focused on the *method which leads to* the creation of the diagrams, not on the *diagrams themselves,* and have even made a cult of following this method. Indeed, since the book was published, a whole academic field has grown up around the idea of 'design methods'—and I have been hailed as one of the leading exponents of these so-called design methods. I am very sorry that this has happened, and want to state, publicly, that I reject the whole idea of design methods as a subject of study, since I think it is absurd to separate the study of designing from the practice of design. . . . No one will

become a better designer by blindly following this method, or indeed by following any method blindly. On the other hand, if you try to understand the idea that you can create abstract patterns by studying the implications of limited systems of forces, and can create new forms by free combinations of these patterns—and realize that this will work if the patterns which you define deal with systems of forces whose internal interaction is very dense, and whose interaction with the other forces in the world is very weak—then, in the process of trying to create such diagrams or patterns for yourself, you will reach the central idea which this book is all about."

Christopher Alexander, *Notes on the Synthesis of Form* (Cambridge: Harvard University Press, 1971). It is the central idea of this book that elevates Alexander's approach from methodology toward a form of architectonic integrative discipline.

27. A frequent observation about the Bauhaus and the New Bauhaus is that their graduates tended to become artists rather than designers and that both institutions found their primary influence in the reform of education for artists rather than in concrete programs for the education of designers. How is one to evaluate this? On the one hand, the observation tends to confirm the suggestion that the Bauhaus discovered an architectonic art of *making* rather than an architectonic art of *design thinking*. On the other hand, is it without ultimate influence on design that the Bauhaus and the New Bauhaus served as institutions of basic research in the arts of making?

28. For a brief discussion of this event, see Alain Findeli, "Design Education and Industry: The Laborious Beginnings of the Institute of Design in Chicago," *Journal of Design History* 4, no. 2 (1991): 97–113.

29. Present and Former Members of the Faculty, *The Idea and Practice of General Education: An Account of the College of the University of Chicago* (Chicago: University of Chicago Press, 1950).

30. Charles W. Morris, Proposed Course Descriptions, 1937, University of Illinois at Chicago, Special Collection. (Typewritten.) See a selection by Charles Morris, "The Contribution of Science to the Designer's Task" from the prospectus of the New Bauhaus. Reprinted in Hans M. Wingler, *The Bauhaus: Weimar, Dessau, Berlin, Chicago* (Cambridge: MIT Press, 1969), p. 195. Moholy-Nagy relied on Morris and his colleagues to provide substantive content and connections between design and the arts and sciences, but he did not share the neopositivist philosophy of Morris and Rudolph Carnap. Moholy-Nagy's views were much closer to the pragmatic philosophy of John Dewey. However, Morris, Moholy-Nagy, and Dewey were able to cooperate in supporting the New Bauhaus because of a shared vision of the contribution that broader artistic education could bring to twentieth-century society and culture. See Wingler, *The Bauhaus,* pp. 195–99.

31. L. Moholy-Nagy, *Vision in Motion* (Chicago: Paul Theobald, 1947). Although usually ignored by scholars trained in the remnants of the Renaissance liberal arts of belles lettres and beaux arts, this book is an important contribution

to the development of the liberal arts in the twentieth century. Moholy-Nagy remarks that the conventional form of contemporary liberal education has tended to separate words from things, with the result that students are too often trained in verbalisms and lack experience and understanding of the things to which words refer. "'Liberal' education, which is considered a positive step to counteract a one-sided vocationalism, is at present not much different from it. Vocational education provides external skills while liberal education furnishes the skill in verbalization, both usually a mechanical accumulation." Moholy-Nagy, *Vision in Motion*, p. 21.

32. Quoted in Kenneth Frampton, "Apropos Ulm: Curriculum and Critical Theory," *Oppositions*, May 1974: 35.

33. Tomás Maldonado, "Looking Back at Ulm," *Ulm Design: The Morality of Objects*, ed. Herbert Lindinger (Cambridge: MIT Press, 1990), p. 223.

34. Ibid., p. 222.

35. "Our efforts were, as we now know, historically premature. The bits of methodological knowledge that we were trying to absorb were too 'hand-crafted'; and our instrumentation was virtually nonexistent. We did not have what we have today: the personal computer. We also lacked a full understanding of the notion of 'limited rationality,' which Herbert Simon was just beginning to develop. And so we remained prisoners of the theoretical generalities of a form of 'problem solving' that was nothing more than a Cartesian 'discourse upon method.' But in the midst of our limitless faith in method—and we were already dimly aware that it might have a negative aspect in 'methodolatry'—there lay some powerful intuitions that the evolution of information technology, especially since 1963, has to a large extent confirmed." Ibid. Regarding the Bauhaus and science, see Walter Gropius, "Is There a Science of Design," *Scope of Total Architecture*, pp. 30–40.

36. Some of the interests at HfG Ulm appear to have been foreshadowed in the reductive approach of Hannes Meyer, director of the Bauhaus in its final period. "All things on this earth are a product of the formula: (function times economy) . . . building is a biological process. Building is not an aesthetic process . . . architecture which produces effects introduced by the artist has no right to exist. Architecture which 'continues a tradition' is historicist . . . the new house is . . . a product of industry as much as such is the work of specialists: economists, statisticians, hygienicists, climatologists, experts in . . . norms, heating techniques . . . the architect? He was an artist and is becoming a specialist in organization . . . building is only organization." Hannes Meyer, quoted in Frank Whitford, *Bauhaus* (London: Thames and Hudson, 1984), p. 180. Meyer's approach is obviously the antithesis of that taken by Gropius and the other leaders of the Bauhaus, most of whom left before or shortly after Meyer's appointment as director.

37. This appears to come close to a form of the technocracy movement of the 1930s. For a brief discussion of this movement in the context of the history of technology, see Alan I. Marcus and Howard P. Segal, *Technology in America: A Brief History* (New York: Harcourt Brace Jovanovich, 1989), pp. 263–64. This

book also provides a useful account of the development of systems thinking in the nineteenth and twentieth centuries.

38. Herbert Simon, *The Sciences of the Artificial* (1969; rpt. Cambridge: MIT Press, 1981), pp. x–xi. Simon studied with philosopher Rudolph Carnap at the University of Chicago. He also taught economics in Chicago in the 1940s to architecture students of a former Bauhäusler, Mies van der Rohe.

39. Simon, *The Sciences of the Artificial,* p. xi.

40. Some of the rhetorical features of Simon's approach are discussed in a critical manner in Carolyn R. Miller, "The Rhetoric of Decision Science, or Herbert A. Simon Says," in *The Rhetorical Turn: Invention and Persuasion in the Conduct of Inquiry,* ed. Herbert W. Simon (Chicago: University of Chicago Press, 1990), pp. 162–84.

41. Traces of Aristotle's four causes are discernable in the four indicia employed by Simon to distinguish the artificial from the natural and set the boundaries for the sciences of the artificial. Simon, *The Sciences of the Artificial,* p. 8.

42. Ibid., p. 159. (Emphasis mine.)

43. John Heskett, *Industrial Design* (New York: Oxford University Press, 1980), p. 7.

44. The ancient precursor of this perspective lies in the philosophy of the Greek sophists, who present an approach to rhetoric that is strikingly different from the Platonic or Aristotelean. In Plato's *Protagoras,* the sophist presents an elegant myth of the origin and distribution of powers among human beings. These powers are held in the form of arts and technologies. Some individuals possess the techniques for creating images and objects for survival and pleasure, while others possess the political art of words, suitable for creating societies and civilization. In a later period, Machiavelli presents a vivid account of the power of princes to design their city-states through words and actions. A contemporary example of this perspective illustrates the turn from words to things: "Engineering schools continued to train generation after generation of possibly the most powerful agents of change that our planet has ever produced." George Bugiarello and Dean B. Doner, eds., *The History and Philosophy of Technology* (Urbana: University of Illinois Press, 1979), p. vii. The concept of engineering as power echoes the sophistic account of technology by Protagoras.

45. For a useful survey of views on the place of design within corporate structures, see Mark Oakley, ed., *Design Management: A Handbook of Issues and Methods* (Oxford: Basil Blackwell, 1990). For a discussion of design and the design process in the context of corporate operations and values, see John Heskett, "Product Integrity," *Design Processes Newsletter* 4 (1991). For a view of design as power outside the corporate domain, see Victor Papanek, *Design for the Real World: Human Ecology and Social Change* (New York: Pantheon, 1972).

46. Adrian Forty, *Objects of Desire: Design and Society from Wedgwood to IBM* (New York: Pantheon, 1986), p. 6.

47. Ibid.

48. Ibid., p. 9. Forty suggests an affinity between his approach and structur-

alism, but he notes the mechanical quality that often accompanies structuralist analysis. In personal conversation, he recently acknowledged that his approach perhaps shares more with rhetorical analysis than structuralism.

49. Ibid., p. 241. "It is the entrepreneur not the designer who decides which design most satisfactorily embodies the ideas necessary to the product's success, and which best fits the material conditions of production."

50. Ibid., p. 240. This is an appropriate criticism of Siegfried Giedion, who proposes a dialectical study in anonymous cultural history. "Anonymous history is directly connected with the general, guiding ideas of an epoch. But at the same time it must be traced back to the particulars from which it arises. Anonymous history is many sided, and its different departments flow into one another. Only with difficulty can they be separated. The ideal in anonymous history would be to show simultaneously the various facets as they exist side by side, together with the process of their interpenetration." This is an excellent statement of a dialectician's approach, but from Forty's perspective it fails to capture the give-and-take of individual points of view in social life, constituting a debate that advances competing ideas and myths. Siegfried Giedion, *Mechanization Takes Command: A Contribution to Anonymous History* (1948; rpt. New York: W. W. Norton, 1969), p. 4.

51. Herbert Read's account of the origin and development of ornamentation parallels his account of the origins of design and clearly points toward the materialist perspective. Psychological necessity combines with the technology of construction, complicated by the further factor of utilitarian purpose.

> Whatever physiological and psychological necessities may exist for orna-ment, its actual origin and development can be explained in simple ma-terialist terms. It is true that for the sake of simplicity we have to neglect certain anomalous types of ornament belonging to the earliest phase of human civilization—the paleolithic period. To this period belong a few objects mostly of bone, and for the most part apparently objects of per-sonal adornment, which bear incised lines, chevrons, and curves, for which no obvious explanation exists. A utilitarian explanation seems out of the question, and the suggestion that they are primitive tallies for counting does not carry much conviction; some of the forms of decoration are too complicated for such a purpose. Historically, therefore, one must begin with a psychological explanation. But when we pass to a later stage in pre-history, to the neolithic age, the evidence is much more plentiful and much less equivocal. We are able to conclude without any doubt, that whatever the purpose and appeal of the ornament, its forms arose in, and were determined by, the material and the process of manufacture. We may still assume a previous psychological necessity; but the fulfillment of this necessity was inevitable. It was inherent in the material or in the con-structive form assumed by the material.

Herbert Read, *Art and Industry: The Principles of Industrial Design* (1934; rpt. London: Faber and Faber, 1947), pp. 165–67.

52. In this sequence of primary, secondary, and tertiary needs, the latter grow out of the psychological but are sometimes described as spiritual. The materialist account of spiritual needs is easily recognized. These needs vary greatly from period to period and from place to place among human societies. They are sometimes manifested as superstitions, sometimes as religions, and sometimes in the most refined forms of art and poetry. But these needs are fundamentally psychological. On the one hand, they represent the desire to express pure, universal feelings and values that are independent of practical purpose. On the other hand, they represent the desire to excite unalloyed emotional response within ourselves and within others.

53. The ancient precursors of this perspective were the Epicureans and atomists, who equate art with pleasure.

54. In the *Principia*, Newton describes the rise of universal mechanics out of practical mechanics. The latter is based on manual arts, the former on mathematics. H. S. Thayer, ed., *Newton's Philosophy of Nature: Selections from His Writings* (New York: Hafner, 1953), pp. 9–11. Compare this account with Galileo's account of the rise of mechanics. He describes a visit to the great arsenal of Venice, where the constant activity of artisans and architects, intent on making weapons of war, "suggests to the studious mind a large field for investigation, especially that part of the work which involves mechanics." Galileo Galilei, *Dialogues Concerning Two New Sciences* (New York: Dover, 1954), p. 1.

55. For an introductory discussion of design as engineering, see M. J. French, *Invention and Evolution: Design in Nature and Engineering* (Cambridge: Cambridge University Press, 1988). For a practical discussion of engineering design, see Gorden L. Glegg, *The Selection of Design* (Cambridge: Cambridge University Press, 1972). Also, Harry Petroski, *To Engineer Is Human: The Role of Failure in Successful Design* (New York: St. Martin's Press, 1985), and Harry Petroski, *The Evolution of Useful Things* (New York: Knopf, 1993).

56. Examples include Donald Norman, *The Psychology of Everyday Things* (New York: Basic Books, 1988); and Edward T. Hall, *The Hidden Dimension* (Garden City, NY: Doubleday, 1969). The latter is not explicitly about design, but it has influenced design thinking in a variety of ways.

57. The effort to explain art and design by a reductive approach that links art with aesthetics and psychology is well represented in the twentieth century. It involves themes such as pleasure, exercise of the senses, recognition of pattern and form, and the "hushed reverberations" of associated meanings. In addition to Herbert Read, see George Santayana, *The Sense of Beauty: Being the Outline of Aesthetic Theory* (New York: Dover, 1955); and "The Rationality of Industrial Art," in *The Life of Reason: Or, The Phases of Human Progress* (New York: Charles Scribner's Sons, 1953); Rudolph Arnheim, *Art and Visual Perception: A Psychology of the Creative Eye* (Berkeley: University of California Press, 1974); and E. H. Gombrich, *The Sense of Order: A Study in the Psychology of Decorative Art* (Ithaca, NY: Cornell University Press, 1979).

58. Read's book was employed, for example, by Alexander Kostellow at

Brooklyn's Pratt Institute and served as a text for students at Chicago's Institute of Design in the early years, during the influence of Moholy-Nagy.

59. Read's philosophic position should be compared with that of David Hume, represented in works such as "Of the Standard of Taste," "Of Refinement in the Arts," and "Of the Rise and Progress of the Arts and Sciences," in *Of the Standard of Taste and Other Essays,* ed. John W. Lenz (New York: Bobbs-Merrill, 1965). While he could never be regarded as a neopositivist, Read's emphasis on a science of art, which is allied with various natural sciences in solving the problems of industrial production, appears to support the Unity of Science movement, guided by Rudolph Carnap, Charles Morris, and others.

60. See Herbert Read, "A Great Teacher," in *Moholy-Nagy: An Anthology,* ed. Richard Kostelanetz (New York: Praeger, 1970), pp. 203–6. This excellent review of Moholy-Nagy's *Vision in Motion* represents a subtle reinterpretation of Moholy-Nagy's ideas in terms of Read's own philosophy.

61. Read, *Art and Industry,* p. 9.

62. Ibid.

63. Ibid., p. 10.

64. Ibid., p. 51.

65. Ibid., p. 55.

66. For a discussion of aesthetics and ergonomics (sometimes referred to as "human engineering"), see Niels Diffrient, "Design and Technology," in *Design since 1945,* ed. Kathryn B. Hiesinger (Philadelphia: Philadelphia Museum of Art, 1983), pp. 12–16.

67. For a discussion of the two traditions of spirituality in Western culture, see Matthew Arnold, "Culture and Anarchy," in *Poetry and Criticism of Matthew Arnold,* ed. A. Dwight Culler (Boston: Houghton Mifflin, 1961), pp. 407–75. The chapter "Hellenism and Hebraicism" is particularly useful in distinguishing the spiritual relation between thinking and doing.

68. George Nelson, "The Design Process," in *Design since 1945,* p. 10.

69. George Nelson, "The Enlargement of Vision," *Problems of Design* (New York: Whitney, 1957), p. 59.

70. The Hellenistic perspective on design, products, and the spiritual life is best represented by Plato in the *Timaeus* and the *Republic* (11.369c ff.). The *Timaeus* is an account of the creation of the world and of all things within the world. The *Republic* is an account of the origin and development of the city, with extensive discussions of the nature of products and the role of products in human life. The Hebraic perspective on design, products, and spirituality is illustrated in an exquisite passage by St. Augustine, *On Christian Doctrine* (New York: Bobbs-Merrill, 1958), pp. 9–10. One of the best examples of the Hebraic tradition in nineteenth- and twentieth-century design is Shaker furniture.

SECTION

2

THE WORLD OF ACTION

"Discovering Design" Means [Re-] Discovering Users and Projects

Augusto Morello

I

There are two ways to confront the problems of relation between culture and industry, both of which are founded on Charles Peirce's category of "abduction." I'll call them the "design method" and the "marketing method." The former is based on the *interpretation of the socioeconomic system* by enterprises (and designers), while the latter is based on the *results of research on the attitudes of consumers* (and sometimes on the illusion of anticipating their wants).

My thesis is that the two ways coincide only by substituting the word (and the category of) "users" for "consumers," a point worth demonstrating because of the importance of the distinction for the future of design (and marketing).

First of all, there is a deep difference between a user and a consumer. The former is the *subject who uses* and the latter is the *subject who chooses for use.* The difference is not merely between *homo faber* and *homo oeconomicus,* since nothing excludes the interest of the user from economic questions about the product or services; and, by definition, the consumer is (teleologically)

interested in use. Both user and consumer have an explicit or implicit "project" to use with efficacy and efficiency (a ratio between results and spending, in the entire life of the products or services). But the project of the user is a microproject, defined by many specific occasions, while the project of the consumer is, relatively, a macroproject, for every possible occasion of use. Consumers are, in a certain sense, coarser or rougher than users.[1]

The two different attitudes contribute to an explanation of why "consumer" is a term that is relatively more generic or more frequently misunderstood and that is indirectly proven by the ability of producers and traders to manipulate the decisions of consumers. Nobody—especially marketers—ignores the importance of "impulse selling" in the budgets of department stores and supermarkets. Modern marketing, which started and flourished by diffusing the wholesome idea of the central position of the consumer, began a true revolution, but has not finished it.

If "design" is defined as *a complex of projectual acts intended to conceive products and services as a whole,* the only way to design properly is to have the user in mind; and the role of marketing (a new marketing) is to have in mind the true project of the consumer, which, paradoxically, is not to consume but to be put in the condition to use properly.

This statement could be considered Calvinist in a world which accepts more and more the ideology of free markets. But there is a deep contradiction here; in effect, it is quite clear that if we do not accept the paradox, design becomes a different job: to convince a user to consume a product or buy a service without respect for his or her project of use, or without a minimum of guarantees of the efficacy and efficiency of using.

Accepting such a statement, designers and marketers should be allied and not opposed, as often happens; and the projections of market research could be useful for both groups. This requires that market research methods determine *the attitudes of people as both users and consumers,* rather than the behavior of consumers alone; and fortunately, some of the best marketing policies are inspired by this intention. Unfortunately, this does not mean that policies of this kind are in the majority.

A per absurdum proof of such an evaluation of the policies of enterprises comes from the confrontation between the practices of

marketing for final products and "industrial marketing," the second being related to transactions between businesses (or, better, between enterprises). This type of marketing—though using the same decision categories as the other (product, price, distribution, communication, services)—has the user much more in mind: in a certain sense, marketing for final goods and services is accepted as being more oriented to communication, because of the utilitarian philosophy of enterprises in choosing the products and services they offer.

Obviously, the matter is not as simple as it appears in these statements. One of the popes of marketing—Wroe Alderson, the leader of the so-called functionalist school—introduced the concept of "discrepancy of assortments," a fatal condition of the inadequacy of the offer to the demand in every step of the market chain.[2] This discrepancy—which is responsible for the failure of enterprises, and an absolute waste for society—is not only a result of how products are conceived (design of phenotypes) but also of the kind of products offered and demanded (design of genotypes).

It is important to choose the kinds of products (genotypes) to produce before designing variations of performance (phenotypes), a decision important for both offer and demand. Historical periods can be distinguished by the ratio between phenotypes and genotypes offered/used/consumed: we are presently in a phase when this ratio is incomparably high. It is no wonder that so many producers and distributors are interested in design as a tool to differentiate variants of products; and this practice is certainly related to the lack of authentic product innovation.

In a period when innovation (mainly technological) is trumpeted so loudly, everyone can easily ascertain that process innovation is more prevalent than product innovation. Today, competition between enterprises is implicitly considered more important than service to users; and this attitude contributes again to the "consumer ideology." Where production costs become the main problem of enterprises, consumer prices become the principal marketing objective. As marketing success is based on incident contribution margins, the apparent differentiation of products is the only means to maintaining competitiveness.

There are many direct consequences of such a syndrome:

1. *an overcomplication of performances:* a sort of "job enrichment" of the product, involving too great an effort to differentiate a product from the competition, and without adequate information about use, and through a poor semiotics of products;

2. *the dominant idea that design is mainly a way to communicate* for the enterprises, more than an *expression* of material culture; with the tendency to include design in the area of "signals" and not the "indices"[3] of enterprises; that is, in the area of promotion and advertising, often in the same company's organizational structure (the increasing costs of media encourage this tendency);

3. *the separation of product form from structure and the reduction of design to styling:* a sort of "job impoverishment" of the product, masked by design theorists or designers disguised as theorists with a curious and not useful idea of liberation from the industrial dictatorship (in the name of a pretended freedom of designers) or merely intended to astonish buyers (consumers and distributors);

4. *an overdecoration of products* (overseparation of signs by denotations) induced both by individual (culturally, functionally, technologically and/or economically unjustified) tastes of designers and marketers, and by the confusion of form with pure ludic or hedonistic suggestions.

The main advantage of the dominating innovation by process is the reduction of costs (especially variable ones); but, as is evident in almost all occidental countries, this advantage rarely offsets the inflation rate.

Thus, both consumers and users are too often subjected to a sort of deception. "Design" becomes the coverboard of lacks or inadequacies of production, when not of a neurosis which, for false competitive reasons, is largely diffused in distributors' policies, tending to force producers to innovate for innovation's sake and not for the sake of consumers or users.

One paradox of such a practice is definable as the "waste of innovation." It is enough to visit trade fairs and stores (such as in the furniture industry) to perceive the quantity of competitive proposals offered by manufacturers (not always over the break-even point) and the poverty of a too-great assortment of stores. The result is the modest specific average quantity of any item, obtained by dividing total selling by total items. This "inflation of simultaneous proposals" can certainly be considered as a benefi-

cial peculiarity of the market philosophy, but it is also a malefic peculiarity of the overdominant importance of a badly organized distribution system, mainly in durables.

The consumer (and a fortiori, the user) is aware of this entropic phenomenon, this *reduction of proposals* (and of symbols) of the consequent permanent obsolescence of his array of goods in comparison to the increasing (and forced) acceleration of symbolic changes. And the waste of innovations not only corresponds to the waste of global resources, but also to the increase of pollution.

So the community's costs of overinnovation increase more and more, upstream and downstream. Upstream, because of financial and shorting problems; downstream because of financial and economic problems of recycling.

In this sense, this kind of marketing-oriented (as distinct from market-oriented) design is bad. Not specifically because of the marketers, but because of the real differences in the logic of design operators, market managers are less and less in conflict. The problem is not a minor one; and giving it an adequate response is equivalent to discovering (or rediscovering) design.

The renewal of design is also necessary for other reasons, mainly because of the increasing quantity of services, which are products whose immaterial structure coincides with the organization for serving. The need of design in services is more and more a reality; but which designer could, until today, design services? The professional figure of the designer has to be renewed to face the job; and this renewal will impose a deep revisitation of design's conceptions.

II

Design can be classified in two types—analytic and synthetic—depending on the methods of managing physical and intellectual resources. Different methods give different results. And it is seriously questionable whether analytic design can really be called design.

Such a distinction touches the core of the question: whether design is nothing more than the project, or specifically, whether marketers can design, not merely control the specifications, while designers can propose, and not merely respond. The present

situation of the consumer's segmented markets—in a way, "auto-segmenting," after the long phase of mass market development—leads to a contradictory condition, between the necessity of "product positioning" and the opportunity of proposing to the consumers (and to society) new criteria of judgment. Normal marketing research cannot describe products; it can only suggest general criteria for design. We meet an analogous situation in the case of Total Quality Management philosophy, not only in Japan, but mainly in the accelerated introduction of new materials and technologies.

Against the practices of managers, a neoradical school assumes the principle that design can only be art. This is the other face of the moon: from the maximum of supposed rationality of managers to the maximum of real irrationality of artists when they declare the prophetic function of art. The solution does not rest between the two tendencies; it transcends them.

The question is whether design is a process (or a method) to manage complexity (synthetic design), or to research compromises in complicated structures (analytic design). Many examples support this distinction, and the damage of "nondesign" represented by analytical methods begins from today's Japanese (and not only Japanese) mass design. On this basis, a serious analysis of many recent products leads to the conclusion that many of today's products are more nonsense-projects than gestalt-significant objects of material culture; but also that many monosignificant objects (and oversignificant ones, as many of them are) are only apparently synthetic. The optimal analytical design comes from the separation of form from structure, quality from appearance, and user from consumer.

This confusion is related to what is called, mainly in Italy, "weak thought," a quitclaim deed to manage the cultural context, and specifically, a renunciation of the project both in marketing-oriented and in art-oriented design. But this is yet a noble interpretation of the situation.

The trivial interpretation is a relinquishment of the project, of design; a sort of abandonment of illuministic (yes, illuministic) ideas themselves. These gave origin to the real improvements (and there are so many) introduced by the three past industrial revolutions.

This analysis suggests strategies for a renewed link between

culture and industry, for a new "project to design," a new "design for designing." This new strategy has to be based on the principle that we cannot, we shall not, accept any separation between material culture and culture per se: an intelligent and useful specification, introduced by anthropologists, became a tool for destroying the unity—the gestalt—of the use of intellectual resources (and financial ones too). This principle can provide a different attitude toward teaching, or a new teaching content, for society, management, and designers.

The main effort of theorists is to teach:

(1) to society itself, the principles of a useful, clear, and severe judgment about products and related matters, starting in the primary schools (a sort of civil service);

(2) to enterprises, designers, and marketers, the nature, quality, and quantity of their responsibilities and the ground of their collaboration;

(3) to themselves, the importance and the impact of intellectual integrity and probity.

III

What are the prospects for the future? No one can believe that the neoconsuming attitude can go on and on—and that for different, more or less strong, reasons, both in the middle term and in the long term, changes will occur.

For the middle term, some indicators show that consumers are increasingly aware of their user status: marketers can testify that they choose products based on clearer projects. In this respect, the new attention of companies to quality can frequently be considered a tentative effort to match the real new need for performance (although, for the moment, the prevailing philosophy of Total Quality Management seems more inclined to engender successful competition than to give real improved service), quality becoming itself an argument of communication, especially when no other real innovations are implemented in products (and services). In any case, the nature of this reason can be considered only a modification in the current practices of consumerism.

For the long term, things could be very different. It is questionable whether the present rhythm of consumption—and the present amount of waste—will be possible. If not (as I believe),

product life cycles will become longer and longer; and we will face a dramatic reduction of quantities, mainly for durable goods, with severe social and economic consequences. Since companies have to survive, prices will paradoxically increase as a result of the effort to maintain a financial/economic equilibrium; quality will be the only way to convince users to become consumers. Stability, continuity, and improvement could become the new passwords. The market itself could mutate from an arena of the product's transactions to an arena of transactions of performances, a colossal hiring system.

In that moment, design will really change, or return again, to its original global potentiality. In another paradox, material culture will be really cultured when culture tout-court will dominate a world liberated by the old neurosis of poverty, which is the ground of consumer manipulation.

This is the "project to design" that designers and managers have to investigate. And soon.

Notes

1. The condition of the consumer is quite analogous to that of the labor-lender: salary is not directly a compensation, but only a promise of it.

2. Wroe Anderson, *Dynamic Marketing Behavior: A Functionalist Theory of Marketing* (Homewood, IL: Irvin, 1965), pp. 78–83.

3. Indices and signals were introduced by Robert Hervis in *The Logic of Images in International Relations* (Princeton: Princeton University Press, 1970).

Designing Self-Diagnostic, Self-Cure, Self-Enhancing, and Self-Fashioning Devices

Tufan Orel

There is a new trend taking place in the consumer market as a consequence of the increasing use by the layman of specially designed *medical research and clinical devices,* that is, devices to be used outside the professional context of research centers and medical or paramedical institutions such as hospitals, health delivery services, or sports and fitness clubs.

The main question I want to explore on this subject is the following: what will be the impact of this trend on existing design criteria or constraints, if these devices create in the future a new sector of technology for everyday life, a sector which may become as important as today's electronic household devices, telecommunication instruments, or personal computers?

My examination of this trend and the possible ways in which the design criteria might change will take into consideration (1) knowledge of an emerging market, (2) usage locality, (3) object-user relations or user behavior, (4) power symbolism of industrial products, (5) social status and identity symbols of consumer goods, (6) product maintenance and user requirements, and (7) legislation constraints.

At the end of each section I have formulated a short hypothesis concerning the possible evolution of constraints taken for granted in today's design domain, hoping that these hypotheses will contribute to a better understanding of the challenges which design thinking and practice may confront in future decades.

Introducing the Vital Self-Technologies

Interest in research and clinical instruments on the part of industrial designers is not of recent date. In the 1970s designer Victor Papanek had already observed that "research tools are usually 'stuck-together,' 'jury-rigged' contraptions, and advanced research is suffering from an absence of rationally designed equipment." Papanek also made a point of noting that not only laboratory research tools, but also instruments for medicine, surgery, and dentistry and equipment for disabled people are "areas in which the discipline of industrial design is virtually unknown." [1]

In a similar manner, Jain Malkin, a specialist in hospital instruments and environmental designing, says in the preface of her recent book, "Most medical and dental offices in 1970 were either colorless and clinical or drab and dreary," and she draws our attention to the fact that medical instruments had a tendency to look "clean and clinical" without much concern for designs that would make them look less formidable to the patient. [2]

Although, today, research and laboratory equipment may still need more attention from designers, the designing of clinical instruments seems well on its way, not only because it has become a distinct branch of design—thanks to the effort of designers like Malkin—but also because designing in such areas has contributed to the success stories in the hit parade of the design business. [3]

Looking more closely at this new trend in design, however, we realize that much of the attention is still focused on the use of these instruments in a professional context. But when we examine more attentively the actual use of some of these same instruments, we may be struck by the more complex fact that their use is not strictly relegated to laboratories and hospitals. On the contrary we see them shifting continuously from the professional to the private sphere of consumption, adapted especially for the individual user.

This comment may be considered somewhat hasty, especially when we read, in the news, about the designers' passion to create everyday hygiene instruments (who has not heard of well-designed electronic thermometers and electronic weight-balances?). We also hear of the designers' growing interest in health-care equipment for the homes of the elderly and disabled. On this subject Malkin says, "Home health care has become a major industry, owing to the aging population and the emphasis on cost containment . . . The trend toward outpatient care will continue, with approval for many more procedures to be done on an outpatient basis."[4]

Although it may appear paradoxical, this remark constitutes an ongoing limitative aspect of design thought in the area of health technologies, because, again, these technologies are still related to hospital services—health-care delivery at home by the hospitals or private clinics—and are not considered instruments with the potential to be used as consumer goods without the assistance of professionals (nurses, or other specially trained hospital personnel).

As for the possibilities for a market in everyday hygiene and home diagnostic instruments, which indeed do belong to the individual consumption sector, designers seem to have a partial or limited view concerning the wishes and needs of the consumer for home health technologies. Today's consumer wants not only diagnostic instruments, but also instruments for health maintenance and self-cure. And what is more important, with the use of certain biological research and laboratory tools, our consumer becomes an active, creative experimenter *on* him or herself.

In other words, although my topic "designing research and clinical devices" has already been a focus of interest for many designers, my views differ from theirs in a fundamental manner. For I will try to draw attention to those devices which can be used in the private sphere of human activity, without the need for any professional or paraprofessional of the services sector. And I will also take into consideration not only everyday body-tending devices but also those instruments used for self-curing and self-transformation.

In order to sharpen this distinction I propose to name this complex of consumer products the "vital self-technologies." The vital self-technologies constitute essentially specific types of research

and medical devices which are consumer goods belonging to an emerging product sector, designed especially to be used in the private sphere, like the home, or to be carried on the body, in order that the individual consumer can maintain, cure, enhance, or transform his or her physical or psychic being. They can be grouped as follows:

1. self-diagnostic devices: for example, disease tests, stress testing, pregnancy tests, blood pressure analysis, cholesterol-level testing, electromyogram, electrocardiogram, and electronic fever thermometers;[5]
2. self-cure devices: for example, portable or home-dialysis, oxygen therapy devices, TENS, electromagnetic therapy tools, ionization instruments, portable injectors and pumps for long-term treatment, and external cardiac pacemakers for specific use;[6]
3. self-enhancing or "well-being" devices: for example, electronic aesthetic devices (face stimulators), electromyogram and muscle-enhancing devices, relaxation chairs, mechanical gymnastic instruments, and simulation ski equipment;[7]
4. self-fashioning or self-transforming devices: for example, flotation tanks, synchroenergizers, synchroscopes, alternophones and subliminal cassettes, isolation chambers, and different sorts of autotraining, biofeedback devices.[8]

Although the above-named products do not reflect a complete picture of what is on the market today, they nevertheless suffice to give us a general view of what I consider to be the vital self-technologies. The four classifications help us to realize that what was once considered by some designers (for example Papanek) as a field simply for health-care and self-diagnostic products, has today broadened enormously, so that this area is only one of the aspects of an emerging market.

What can be observed from these new or emerging products is that their use enables the individual to pursue in private not only the three principal objectives of medicine—to maintain health, to cure, and to prolong life (or retard biological aging)[9]—but also some further objectives belonging to the field of biophysiological research, such as modifying physical and psychic conditions, or adjusting them to new or hazardous environmental conditions.[10]

It could be argued that "we must not confuse the use of apparatus with the exercise of (medical) judgement,"[11] that is, the

scientific knowledge of the doctors on health and sickness. This was certainly true when the ability to tell what is "normal" and what is "pathological" was reserved for the professionals. But today the personal use of these devices seems to question, or at least make relative, some of the founding principles of the legitimate art of medicine.

For example, we realize more and more that the *means* (the technology) and the *result* (the expected normality) are not two different entities. The power to own the means also has an effect on the expected result. Thus, as I will try to show in the following paragraphs, the more access laymen have to sophisticated health technologies, the more they can develop their own personal assessments of their health and being, which may even be contradictory to professional judgments. And it is not by chance that the presence on the market of these devices is considered by many to constitute a threat to cultural and ethical values now taken for granted.[12] But if we are willing to see this emerging field of research and health devices from a broader perspective, we realize that its concerns go beyond legitimate medical principles and biological standards to create an entirely new way of life,[13] thus changing today's cultural expectations of consumer goods.

Bearing this in mind, let us try to see what will be the impact of the products used by this new health consumer on design criteria and constraints.

I. Self-Technologies Sector and Market

It is a well-established fact that the success of designers is determined not only by their capacity to design creative or innovative products, but also by their knowledge of the economic sector and the market for which they are working.

Supposing that in the near future they participate more and more in the transformation of the world of everyday objects by creating new vital self-technologies, what will then be their conception of the sector and the market to which these technologies belong?

As the classical economic sectorization (proposed originally by Colin Clark) became more and more narrow, and less useful in explaining today's complex activities of production and consumption, some economists (such as Fritz Machlup)[14] tried to show the

emergence of a totally new sector, the "knowledge sector," or "information services sector," based on knowledge and information production, distribution, and consumption. More recently, the forecast of some esteemed economists and business writers concerning the future needs of industrialized societies in new sectors of industrial products has pivoted around the major term "self-education." Some of these specialists have come to the conclusion that, although today teaching is understood as a process of a master/teacher relation, this "process is increasingly going to shift to self-teaching on the basis of new technology because we now have these self-teaching tools."[15]

Although the forecast for the future of the knowledge sector seems easily to include the idea of *cognitive* self-technologies, the same cannot be said of the future of the health sector, which has not yet fully recognized the need for *vital* self-technologies. Most of the avant-garde economic theories still seem to be waiting for the miracle of perfect health in the year 2000 to come from the development of hospital health technologies and hospital health delivery services, which will provide a high standard of health care with greatly reduced cost.[16]

On the other hand, other economists looking into the same self-oriented activities saw another and more complex change taking place in classical economic sectors. For example, André Gorz suggested that "work for the self" (*travail pour soi*) which has, until now, been taken over by the services sector, can again become a popular individual activity, thus creating a noncommodity economic sector.[17]

In fact, what Gorz was proposing from a more ideological view of production, corresponds more or less to what other authors, observing from the viewpoint of consumption and the market, have called "proconsumerism" (Alain Toffler), "self-service economy" (Jonathan Gershuny), "invisible economy" (Yan De Kerorguen), or "autonomiques" (Guy Aznar).[18] From a more popular point of view this is what is called in general "do-it-yourself" products.

Bearing in mind the existing importance of work-for-the-self and do-it-yourself products, we must ask whether the vital self-technologies designers should consider themselves as working for an already known economic sector and consumer market.[19] I suggest that if they are willing to look closely into the real meaning

of these terms they will realize that, on the contrary, a completely different market awaits them in the future.

Let us first examine the main idea behind Gorz's term "work for the self." According to him, these are the everyday activities of ordinary people concerned with self-maintenance (or self-tending),[20] such as washing oneself, dressing oneself, doing the dishes, housecleaning, and shopping.

If we take the case of washing oneself and all the other everyday body-care activities, we may come to the conclusion that, finally, what the vital self-technologies are proposing is simply the use of new technology for everyday hygiene and body-care, without using (or as a substitute for) today's services sector (beauty institutes, health clubs, thalossotherapies, etc.). This would indeed have been the case if today's consumers were involved *only* in self-maintenance or self-tending. But we know that this is not so, since they also try to cure, enhance, and transform themselves. It is for this reason that designers should not restrict their mission only to products for everyday hygiene and body-care.

Looking more deeply into the significance of such products, the expression "do-it-yourself" no doubt conveys a certain sense of productive activity or work. But what is the nature of this productive act?

All productive action is in general composed of the *material* on which the work is done and the *manner* in which this work is carried out. Now, if we try to sort out the basic elements of human production in the expression "do-it-yourself" we may realize that, although this message does not give us a clear indication of the manner in which the work should be carried out (the work methodology is left to the appreciation of the verb "do"), it does designate the nature of the material on which the work should be done: "it," that is, an object distinct from the doer.

This is a self-evident observation, but it enables us to realize that behind the message "do-it-yourself" what is proposed is an economical production (work): an activity oriented to the outer world and not an action oriented to oneself. What distinguishes the vital self-technologies from the other do-it-yourself products is that, in their case, it is possible to have the self as the *material* to develop or transform, in a personal *manner,* to be a "craftsman of oneself." In the case of production oriented to the outer world, we

become the craftsmen of carpentry, gardening, cooking, "constructing for example a house in the mountains," as was proposed by Toffler in his conception of "proconsumerism."

So the *first hypothesis on the changing design criterion* is as follows: The vital self-technologies cannot be confused with everyday hygiene and do-it-yourself products. Although the consumer may also be using these products, their self-oriented activity makes them a potential client for a broader and completely new market: the market of (vital) self-products.

II. Usage Locality

Although these vital self-technologies have been defined as for extraprofessional use, we may still have misleading conceptions concerning their locality of use because of residual limited views on this topic.

The most current or consensual view still considers these products to find their natural place in the home. This is true not only of the new hospital services literature,[21] but also of the innovation literature that relegates breakthroughs in consumer health technologies to the "smart home," the "future home," or to the "domotique" market (as they say in France).[22] And it labels these products with the prefix "home," calling them home tests, home fitness devices, home health-care devices.

Although this naming strategy (or marketing strategy) does not always correspond to the heterogenous usage locality of these objects, it nevertheless reflects a perfect market reality. Home business is good business. But is it the only business that these vital self-technologies can promise? Is it the only locality to which they are destined to belong?

With the increasing technological effort to reduce the size of chips, we know that today most of the everyday technologies (radios, telephones, fax machines, computers) can also have a portable version. Since most of the vital self-technologies are based on the electronics industry, it is obvious that these products do not need to be fixed to the home, but can be carried with us. What is more, they can also be carried *on* us. Besides the usual example of the exterior cardiac pacemaker, there exist today many devices which can be carried on us, such as synchronizers,

self-measuring devices, pulse watches, calorie tests, and portable dialysis machines.

To determine precisely the locality of use of these devices can be still more complex. Sometimes we may discover that one part of the device can be fixed at home (an electrocardiogram, for example, registering the physiological data of a person) and the other part can be worn or carried on oneself. This kind of user locality, which I call "synchronic locality," is becoming more and more possible thanks to biotelemetry (remote measurement of vital parameters).[23] Some already existing products are used to monitor one's physical and psychical parameters in hazardous environments, such as under the sea for casual swimmers, or in the mountains for weekend bicycle riders.

It is also possible to speak of other private spheres or localities in which the vital technologies of the self can be integrated, localities like cars or private planes. Therefore these devices can be fixed, yet on mobile localities. But there is no need to list all the existing and possible localities of use for these devices to be convinced that usage at home is only one alternative among others.

The second changing design criterion: Considering vital self-technologies to be strictly for use in the home may cause us to miss thinking in terms of a much broader market. Designers should be able to realize that these products can be fixed, mobile (portable), or fixed on mobile equipment as well as worn on the self. Through biotelemetry they can also be placed in synchronic localities.

III. User as Experimenter

Calling upon the necessity to go beyond purely functional requirements, Victor Margolin, historian of design thinking, underlines the fact that "there is much that designers and manufacturers to learn about the evolving relationship between products and users."[24]

A better knowledge of the product-user relation is certainly a legitimate design criterion for the future, because the designers not only must have a good knowledge of the market sector in which they are working, but also must keep that competitive market in hand by observing the user's changing requirements.

Before looking at this changing product-user relation from the point of view of industry, we may explore a general change which has occurred today in the relation between humans and everyday objects, and determine in which way this change will be oriented as a consequence of the appearance of vital self-technologies.

In one sense, the rise of consciousness of the product-user relation can be attributed to today's increasing dismantling of the "harmonic composition" of people and objects.[25] This harmonic composition, which once looked like the natural relation of the bee to the flower, the armchair to the sitter, the car to the driver, is not a result of the natural order of things, but of the process of "naturalization" of everyday objects.

Looking at this in a more analytical manner, we realize that what is responsible for such fine adjustments is, on the one hand, objects themselves that have arrived at their final phase of maturity and have hence become *closed-objects* and resist further evolution; and on the other hand, the ritualized actions through which they are used.

The kind of relation that a person has with these objects corresponds to what is correctly named the *user*. He or she uses the object by following the rules of an invisible chart of social habit or custom, or in a more institutionalized manner, by following the instructions for use, which are normally found on the tattooed skin of the products (or on the packaging), saying how they must be handled, how used, precautions to be taken, and so forth. This person/object relation could be said to be a passive one.

Until recently, consumer society with its plethora of household devices reflected much of this kind of usage. But with the arrival of high-tech products, notably computers, on the consumer scene, the objects had the tendency to become *open-objects* and the user, the active *utilizator*. The reason for this is not only that these objects are now open to continuing development, but also that the aspirations of the utilizators have change. They now wish to have in front of them an inventory of possible rational choices. Victor Margolin draws our attention to this by saying that "the designer can no longer foresee all the ways that complex products will be used and must think in terms of multiple possibilities rather than a limited number of set functions."[26]

Yet looking into the "logic of usage" of some high-tech prod-

ucts, we may observe a counterpart of the rational utilizator which can be called the "deviant" utilizator. This deviant utilizator, who has already been studied by Jacques Perriault,[27] can have a completely different relation with the consumer product.

He or she can change the project (or the purpose) for which the product was designed (for example using the Prestel, or the Minitel in France, not for consulting information but for ludic purposes), or use the product as a substitute for archaic ritual acts (for example, using CAD not for developing the total conception of a product, but only for drawing). Utilizators may even reject the product, if it does not correspond to their own perceptions of technology (for example, they may refuse to use computers which are not user-friendly). It is certain that deviant acts not only deserve more serious attention, but that they also can give us a good account of today's complexity of human behavior with relation to everyday objects.

The most outstanding and most extreme case of deritualized consumer behavior is what I will call the user as *experimenter,* which is contemporary with the emerging vital self-technologies. What differentiates this kind of user from the previous ones is that the products are no longer objects on which we act in order to have some expected, preconceived experience. On the contrary, the user may have—at least at the beginning of his or her experiments—no a priori attitude. His or her acts can therefore be inductive rather than rationally objective. As the famous philosopher of experimental action, John Dewey, put it once: "The act of inferring takes place naturally, without *intention.* It is at first something we do, not something which we *mean* to do."[28]

Some sociological field surveys concerning the usage of self-fashioning technologies[29] have revealed that as users (as experimenters) start to make more and more discoveries about themselves, they also discover—because of their experimental approach—new ways of using the device or equipment, ways for which the products were not originally designed by the manufacturer. Hence the TENS, bought for pain relief, finds erotic use,[30] flotation tanks bought for relaxation become painkillers; synchronizers bought for stress therapy become a sedative; oxygen tanks bought for respiration difficulties becomes ecstasy objects. In other words, what physicians may call the erroneous use by

nonprofessionals of biomedical devices is, in fact, nothing more than the result of discoveries of a new usage as a consequence of experimental action by consumers on themselves.

The third changing design criterion: The vital self-products must be designed not for the utilizator who seeks rationally possible ways of using a product, but for an experimental user, who may modify the purpose of use as well as the instructions for use of the product.

IV. Symbolics of Power

The symbolics of power can be considered one of the highest cultural values that today's designers consciously or unconsciously wish to channel through their creative productions.

In general, most of the literature written on this subject comes from professional sociologists and social critics. By giving this topic the generic name of "symbolics of technology," some of these social-science scholars have observed that besides their internal technical or functional characteristics, new technological goods tend to promote, above all, the images of "immortality," "ubiquity," "sentiments of participation in supreme intelligence," or "powers of divinity."[31]

Looking into this subject from the point of view of design productions, social critic of modern style and industrial aesthetics Stuart Ewen presents some very interesting observations on one of the fundamental aspects of the designers' myths of power, as they appear on ads as well as in the look of the products.

Writing on this particular subject, Ewen says, "The design of many products—particularly appliances and other electronic items—suggests that with the purchase of the products, *you will have your hands on the controls.*" Looking further on this design thematics of "control," he remarks: "Employing a visual idiom drawn loosely from what President Eisenhower termed the 'military-industrial complex,' designers enthusiastically worked to build an environment that was replete with strategically located 'command centers' . . . control panels." To draw our attention to this control panels–oriented design the author reminds us how, "at Chrysler, automotive dashboards were trimmed to suggest the cockpit controls of a jet fighter," and how some household equipment has taken the same direction.[32]

But the phenomenon of the control-panel complex may not always satisfy the client and can also negatively affect the psychology of the user of the new everyday technology. Taking computers as an example, a well-known expert in the study of high-tech products, Tom Forester, suggests that "in the future, all personal computers are likely to become even more 'user-friendly' . . . but in an effort to overcome the keyboard or terminal 'phobia' which affects millions of people, personal computer manufacturers will make greater use of the hand-held mouse, touch screens (etc.)." [33]

We may also take note that this "control panel" or "powerful terminal" symbolism is not intrinsic to household, car, and computer designing but finds most significant expression in health technologies and the biomedical instruments used in clinics and hospitals.

When biomedical technology was entirely in the hands of professionals, it was a symbol of power par excellence, not only for cultural reasons (i.e., hospitals and clinics were the predestinated temples of Asklepius), but also because of the powerful image of the medical profession in our society, an image that had to be maintained to give a rationale for their instruments, and to make the patient feel secure.

When designers finally penetrated the hospital milieu, it is true that they tried to get rid of the "Frankenstein technology" or "laboratory look" of the biomedical devices, but they did not (or could not) touch the "power demonstration" look of the doctors' objects. One has only to observe how much of today's hospital equipment, such as X-rays, electrocardiographs, echocardiographs, and so on, are still victim to the power complex of a doctor's "control panel."

This is not to doubt the designers' efforts and creativity in beautifying the hospital or the physician's private equipment. It is only to underline how designers may sometimes submit unconsciously to the desires of the professional users of biomedical devices.

Many examples can be given to show how efforts made by designers to simplify equipment and to make it look less intimidating have often been rejected by the professionals. For example, there exist today portable X-ray machines and other simplified command-panel equipment *designed for hospitals and clinics* which

work as well as the standard ones. But do the hospital doctors want to purchase them? Not always. Most of the time they give technical arguments (optimal functioning, security, etc.).[34] But it is also possible to interpret their resistance to these instruments as due to their not wanting to give the image of a "tropical medicine" practitioner, but rather preferring to maintain the image of the powerful urban doctor.

On the whole, what seems certain is that if some of the hospital equipment is to enter into the sphere of the individual consumer, this will demand more effort from designers: (1) to remain objective and not be influenced by professional demands, and (2) to always consider these devices as an intimate consumer product.[35]

The fourth changing design criterion: Although today much biomedical technology is still the victim of power symbolism, with the emerging vital self-technologies it will be necessary to give them a less rational look and make them more friendly like any intimate object, agreeable to touch, to wear, or to carry. Especially by remembering that the raison d'être of these devices is not to master and control the world (control-panel complex) or others (medical power of doctors), but to control and master the vital self, by oneself.

V. Symbols of Status and Personal Identity

Even if biomedical instruments eventually get rid of their power (or technological) symbolism as they infiltrate the private sphere as vital self-technologies, we may still ask ourselves whether they will not risk getting caught up in the social web of status values or becoming new symbols of personal identity.

One forecast, proposed by Jacques Attali, economist and personal advisor to President Mitterand and more recently director of the European Bank, considers that in future most biomedical devices will be portable, such as multifunction bracelet-watch devices which will give information on such vital parameters as skin temperature. Calling these medical devices "nomad-objects," the author predicts that they will inevitably be new "signs of distinction" for the future consumer.

Including other portable objects having educational, leisure, and communication as well as medical functions, Attali writes

that "nomad-object" is "the key word to define at best the life styles, the cultural style, and the consumption of the year 2000. Hence everyone will carry with him his whole identity; nomadism will be the supreme form of the Kingdom of Commodity." [36]

Although, for Attali, the term "identity" covers social identification or distinction (relation to others) and personal identity (relation to oneself), he often undervalues the second and puts the emphasis on these new products as status symbols.

This way of looking at the future of personal medical devices seems to me erroneous for two reasons. First, to regard objects as signs of distinction or of status value presumes that all objects necessarily participate or take place in social interaction. But we already know from recent field research [37] that even today not all consumer goods enter into the social sphere of interaction. Furthermore, there is no sound reason why people would make public their most personal objects. Today wearable radios can be hidden inside one's hat, and the techniques of hiding hearing aids are not new. On the contrary, there is a good chance that these objects will be discretely carried on the body like any other intimate or personal object.

Secondly, (and this shows Attali's limited ideas on today's complex object locality) we already know that carrying status objects may not reveal accurate information about one's economic status. To see someone carrying a credit card does not tell us how much money she has in her bank account. To clarify further the future of vital self-technologies, let us look at the prodigious development of biotelemetry and bioteleaction.

Imagine a person who, in his private self-fashioning laboratory, has accumulated very expensive technology. However, he carries on himself only a miniature electronic device which permits him to be in interaction with his material at home. Now, when he is in society, interacting with others, where are his exterior signs of status? On him or in his home? Further, if he does not socially share his self-fashioning laboratory, how can these devices shout out their status value?

This last example brings us closer to the theories of Csikzentmihalyi and Rochberg-Halton, authors of the classical work *The Meaning of Things: Domestic Symbols and the Self.* Talking about the future home and its devices, they write, "What matters about

the home of the future is not so much the number of rooms it will have or the amount of electronic marvels it will contain. The important issue concerns the psychic activity of those who live within." And, further, they make this very significant remark: "The importance of the home derives from the fact that it provides a space for action and interaction in which one can *develop, maintain and change* one's identity"(emphasis added).[38]

The authors are right in insisting that the home, with its intimate everyday objects, is not only a place for maintenance, but also an environment where one can develop and change one's personality. In one sense, this view permits them to go beyond the "conservative" and autoregulative way of looking at everyday hygiene or self-tending activity, as observed, for example, in Gorz's conception of "work for the self." But the way in which they view the self for which the everyday objects are destined still emphasizes a psychological identity. As they mention elsewhere in their work, these objects are to "shape one's personality."[39]

So, should we consider this explanation to be limited because it is influenced by psychological theories that see the role of everyday objects only in fashioning or shaping one's personality? Not really. Their theory proves the nature of objects with which we live today and the popular forecasts about the future of high-tech products, because today's conventional objects and tomorrow's electronic household marvels are indeed for this psychological purpose, which the authors define very well. But what about after tomorrow? If the objects change radically, it may be that individuals will have the opportunity to go further: the possibility of maintaining, repairing, developing, and fashioning not only their personalities or psychological characteristics, but also their biological and existential beings.

Although the vital self-technologies may not necessarily need to be status symbols because of their complex locality of use ("discrete use"), they could nevertheless be chosen as self-identity symbols, though perhaps of a different sort than is proposed today by the lifestyles and psychographics typologies.

Bearing this in mind, we can imagine. for example, a marketing interest based on some biological criteria: taking into consideration, for example, age or gender of the user. The observations on usage locality may also help to develop, for example, ongoing

marketing research on "usage situations,"[40] and maybe some new interest in color research. But this research should not be the same type as is used in the study of color in hospital and clinical instruments, to appease and calm the patient in front of medical instruments. On the contrary, it should address the personal color myths of the vital self-technologies user.

The fifth changing design criterion: Designing vital self-technologies may not need to be concerned with status symbolism or any other socio-style criteria. Designers should concentrate more on research of usage locality, color, and other concerns directly related to intimate objects. But they should bear in mind that consumers can frequently and unexpectedly change their psychological relations (and tastes) with these intimate objects proportionately to the discoveries they make about themselves by experimenting with these objects.

VI. Product Maintenance and Users Requirements

"An organism does not live *in* an environment, it lives by means of an environment." This remark by John Dewey, taken as a metaphor, can help us to illustrate how the mode of existence of industrial products began to be conceived in the consumer society of today.

In the early days of consumer society, when the products (the closed-objects, as we mentioned before) were manufactured and put on the market, it was left to their owners to use them on the basis of a set of "frozen" functions which were defined when the products left their natural environment (the factories), the place where they were born.

This mechanistic approach to industrial products has today given place to a more organic view, in the sense that the more complex the products became (like a living organism), the more the industry realized that the initial natural environment should be extended by means of a permanent institutional relation to products and to their users: to the products, because they have to be taken care of—preventive maintenance—and also repaired; and to the users, because they need training and to be listened to, concerning their desires for the possible development of the products.

Looking at the problem of product maintenance and user requirements from a more global view, the theoretical contributions of authors like Abraham Moles and Victor Margolin invite the designers of today to a fundamental discussion on a new design criterion which these authors call the "total guarantee" or the "product environment." To have a general idea of the main characteristics of this new design criteria we can refer back to Victor Margolin: "all the necessary conditions for acquiring the product, learning to use it, following its changes and improvements, providing components for it, and keeping it in a good repair are part of the product environment."[41]

Bearing in mind the importance of the product environment, we can ask ourselves how this new design criterion can be applied in the future to the case of vital self-technologies.

The main problem that the biomedical instruments industries seem to encounter today is ambiguity in the context of the usage of health technologies. This problem (which can be distinguished from long-term technical maintenance, or as it is called, preventive maintenance, PM) seems also to be at the center of the recent scientific research by biomedical engineers. And this research, which is mostly concentrated on the professional context (hospitals and clinics) and home health delivery context, is still in its beginnings concerning the usage of health technologies by the layman.

On the professional level, although PM has been practiced in hospitals for nearly twenty years,[42] it is only recently that the users' environment has been taken into consideration. On this, the view of a biomedical research team could be enlightening: "If the human user is left out of the design problem, the engineering problem is limited to designing devices whose effectiveness assumes a perfectly functioning human operator. This is a mechanistic approach that does not take into account the performance variability of those who will use equipment in the clinical environment."[43] As a remedy to this negligence another engineer proposes: "Periodic visits by the designers to the user environment followed by discussions of the perceived need [can be] effective. Where permissible, it is desirable for the designer to test the equipment in its user environment."[44]

Similar concerns can be also observed concerning home health delivery users (paramedical professions). But what is more inter-

esting for us are the observations made concerning the nonpro-
fessional users, or in our terminology, vital self-technologies users.

Field research by biomedical engineers on this subject gives the
impression that the study of the lay user's environment is the field
most neglected by manufacturers. It might be useful to mention
here the results of one of the studies concerning the use of digital
blood-pressure monitors: "About half of the market sample, says
a field research paper, was shown to require calibration (i.e.
consistent overestimation or underestimation of pressure). Only
Sharp and Norelco mention the need for recalibration in the lit-
erature accompanying their products. This is surprising in view
of the National High Blood Pressure Education Program guide-
lines on devices used for self-measurement."[45]

This neglect on the part of manufacturers and designers to
fully study the user situation in health technology makes legiti-
mate some of the concerns already put forward by the new design
concept "product environment." But how can we imagine the
product environment of the lay user of these health technologies
in the near future?

The question is twofold. What kind of technical maintenance
will be necessary? What could be the users' personal require-
ments vis-à-vis the manufacturer or the retailer?

It is an irrefutable fact that vital self-technologies will need
preventive maintenance as well as repair, like any other category
of complex products. But their users, because of their specific be-
havior in front of their devices, may have some preferences which
the institutional or service-oriented views on technical mainte-
nance have not fully taken into consideration.

For laymen to repair a complex object today is almost impos-
sible, because, to use Abraham Moles's expression, the inside and
outside of the product are separated with a "sacred seal." So lay-
men need technical repair services. But what about the preventive
maintenance: does this really need to be provided by the profes-
sional service sector?

A recent research paper on designing the test instruments for
biomedical equipment says that "these checks can be compared
with 'base-line' performance records to indicate long-term dete-
rioration of equipment performance as well as to spot specific
failures (yet) these functional tests should not involve opening
equipment covers."[46]

The state of the art of these testing tools makes them still only available for use by professionals, but tomorrow it is very possible that laymen could also have access to them. In that case, it will mean that not only will laymen be vital self-technologies users, but they will also have the capability to be "self-maintainers of the vital self-technologies." So it could be said that there is objectively no limit for the self-oriented consumer to transform every existing service into a self-technology. (It would be interesting one day to study how much of a boom-effect the progression of the vital self-technologies can have on the already existing do-it-yourself products for maintenance.)

As for user requirements, if the user's behavior is taken as experimenting, as I tried to show before, and what is more as experimenting *on* the self, then some of the clauses of the "total guarantee" can risk not being maintained by the manufacturer or the retailer.

Two of the clauses of the total guarantee proposed by Abraham Moles are focused on circumstances surrounding the use of a product: (1) it may "perturbe" personal life projects of the user, that is, the user may not have the expected experience; and (2) there can be a risk due to uncertainty in using the product, that is, the user may have an accident.[47] But will such clauses of the total guarantee still hold in future with regard to the user of vital self-technologies?

What is more risky than to give a subjective meaning to objectively measured blood pressure! What is more uncertain than to experiment on oneself! What is more risky than to try to change one's ontological being with vital self-fashioning devices! So all these experimental (or capricious, for the retailer) behaviors on the part of the consumer can be a very serious reason for the rupture of the contract between the maintenance services and the user.

The sixth changing design criterion: The designers and the manufacturers should try to develop more testing instruments that can be added to the packages of the vital self-technologies, to be used easily, especially during a process of experimenting on oneself. Also by keeping in mind that the client requirement is no longer that of a conventional user, or of a rational utilizator, but of an "abuser" (etymologically making personal use of things), the manufacturer or the retailer should try to negotiate with the client

for a financially and psychologically shared risk and not impose unilateral responsibility and assistance on the user.

VII. Legislation Constraints

Although legislation problems such as standardization, security, and quality have always been considered a part of design constraints, some designers have gone even further with this problem. Writing on this subject, Bryan Lawson draws our attention to a very important point. "Clearly from the designer's point of view," he says, "client constraints are not absolute as are legislator constraints."[48]

If legislation constraint can be considered the supreme criterion in designing industrial products, let us look at how it is applied today and will be applied in the near future to vital self-technologies. Without getting into the details of the multiple juridical aspects of this problem, I will make the following observations.

Today when health technologies are taken as over-the-counter products, that is, consumer products, it is only the category of self-diagnostic devices (and, perhaps, some of the self-enhancing devices) which becomes the subject of commercial law, and not all the other categories, such as self-curing and self-fashioning. This is, for example, clearly stated in a decree by the French government published on January 14, 1986, in *Bulletin Officiel de la Concurrance et de la Consommation* (Arreté no. 86-2/A). The other categories of health technologies are still considered to be professional material.

On the other hand, the legislation in the United States on biomedical instruments seems to be based on the principle that they will be used only by professionals. For example, the Food and Drug Administration's Bureau of Medical Device Amendments does not mention the possible use of biomedical instruments by the layman and the specific conditions which are necessary for this usage.[49] So it seems clear that, again, these lay devices do not have juridically the status of biomedical instruments.

In fact, the situation is more complex. Most of the vital self-technologies are made and sold with disregard for these decrees and amendments by giving them less medicalized names such as relaxation, anti-stress, fitness, or well-being products. And most

of the time, they are tolerated by official institutions. But what happens is that when professionals make a complaint concerning the abusive selling of these devices, the technical quality and functioning of the devices are not taken into consideration by law, but on the contrary, the devices are criticized for not satisfying the scientific principles of healing and experimenting. This is an absurd judgment, because these devices are of the same nature, as far as the technology is concerned, as those that researchers and physicians use in their laboratories and clinics.

Most of the court cases brought against the commerce of vital self-technologies on the basis of the Food and Drug Administration, or other authorities, are based on the opinions of professionals, and not on the users' points of view and their capacity to use these devices.

The absurdity of this scientifically backed, *liberal market* view of the consumer was very well put by the former commissioner of the FDA, Arthur Hull Hayes. In an interview given after his departure from the FDA, he said: "The FDA can't have standards that are impossible . . . because the scientific community cannot measure up to standards that they have not yet achieved."[50] This shows, in a certain sense, how much the research laboratory people and the laymen using vital self-technologies have in common. They are both experimenters, in the sense that they have the right not only to try, but also to fail. But when laymen fail, the judge is the law, and when the scientists fail, they are judged by the scientific community. Two different laws for the same human experience?

In France, the law seems to confuse the medical charlatanism of Molière's day with the selling of scientific self-diagnostic and self-cure devices today. In the earlier days of the popular myth of the "doctor of oneself,"[51] medical charlatanism was judged on the basis that the means or technology proposed did not have scientific status. Today, laymen and professionals use the same technology, although in different contexts; yet the law still considers this technology, when sold to the layman, to be similar to "elixir gadgets," and most of the recent court cases against retailers[52] show that they are treated as vulgar criminals to be judged on the basis of criminal law.

The seventh changing design criterion: Designers who get involved with vital self-technologies will find themselves confront-

ing great ambiguity concerning legislation. In one sense, this vagueness permits them to face more relative legislation constraints, and gives them more freedom for their design imagination. But on the other hand, they will more and more have to confront ethical problems of perhaps a larger nature than the problems, for example ecological, facing today's designers.

Will designing the vital self-techologies be the next threshold in design ethics? An exhaustive examination of this question remains to be carried out on a future occasion.

Notes

1. Victor Papanek, *Design for the Real World* (New York: Bantam Books, 1973), pp. 78, 199.

2. Jain Malkin, *Medical and Dental Space Planning for the 1990s* (New York: Van Nostrand Reinhold, 1990), preface, p. xi.

3. See Design-profile: "A/S L Goof, Danish Manufacturer of Dental and Surgical Instruments," in *The Design-Based Enterprise*, (N.p.: Design Council/European/EEC Design Editions, n.d.).

4. See Malkin, *Medical and Dental Space Planning*, p. xvii.

5. Let us give here some vital facts concerning self-diagnostic devices. In an article published in 1986 by an international scientific revue, *Biofutur*, T. J. M. Clark stated that the annual turnover of home tests sold in the world in 1985 had risen to 6.1 billion French francs (approximately $1 billion), and in 1990 this total will be 10 billion francs. On the other hand, the development of MABS technologies, i.e., the special field of biotechnology on which most of the diagnostic kits are based, has, in fact, an even greater growth in Europe. The international market research organization Frost and Sullivan puts total Western European sales of health-care products, incorporating MABS, at $318 million in 1988. It predicts a fivefold expansion to $1.58 billion in 1993. See Clive Cookson, "Big Prizes in Small Packages," in *Financial Times*, Oct. 19, 1989, 11.

In France, a survey made in 1988 shows that because of the growth of home tests, medical laboratories are expecting a decrease of 15–25% of their turnover and 60–70% of their profit (Béatrice Bantman, "Les exclues de la nomenclature," in *Le Monde*, Oct. 18, 1989, 23). And a French review on economics reports that 1.2 million units of pregnancy tests were sold in France in 1987 (turnover: 50 million francs), as well as 4.8 million units of diabetes tests, sterility tests, and ovulation predictor tests (turnover: 70 million francs). See G. du Poux-Verneuil, "Home tests et doctor tests," *Le Nouvel Economist*, no. 633 (March 4, 1988).

As for the latest innovations, in 1989 a famous American company, Kis, announced a new product: a mini-laboratory analysis kit (different kinds of tests all integrated in the same box) which is destined for the moment for professional use, but which can also be used, with slight modifications, by the layman (see Emmanuel Amara, "Kis sort du purgatoir," in *Le Figaro-Economie*, Oct. 9, 1989,

20). And in Japan a year ago the Inax company was ready to market a new generation of diagnostic tests to be integrated into bathroom equipment; Loic Chauveau, "Toto san et Doctor WC," in *Liberation* (May 30, 1989).

6. Concerning the importance of the self-cure devices: a few years ago a travel agency organized a special trip to the tropics for three hundred tourists. What was special about this trip was that each of these tourists was wearing four kilos of portable and miniaturized renal dialysis equipment. Thus, while the service offered by the agency was leisure, the health-care service was provided by self-cure equipment. Jean Michel Bader, "L'homme aux pieces rapportées," *Science et Vie* (Feb. 1988): 63.

Without necessarily waiting for the coming of a "bionic" kidney, portable or home dialysis seems already to have become a major debating point among doctors. A French specialist on dialysis, Professor Galletti, discussing hospital versus home dialysis says that "as far as I know there are up until today no objective economical field-studies done" to prove that hospital dialysis will be cost-reducing ("L'heure des choix economiques," *Sciences et Avenir*, special issue no. 28, "Les organes artificiels," p. 18). Another French doctor says, "The annual cost of one patient treated in a center is twice that of the same patient treated out of a center (home dialysis, self dialysis and limited care dialysis." See J. L. Funck-Brentano, "Towards Dialysis 'à la carte,'" *Artificial Organs* 2, no. 6 (1987): 447–51. This is not a vain debate, especially when we realize that in 1986 there were approximately 80,000 individuals in the United States, and over 200,000 worldwide, with chronic kidney failure being kept alive with a variety of dialytic therapies; Prakash R. Keshaviah, "A Technological Assessment of the Current and Future Status of Hemodialysis," *Medical Instrumentation* 20, no. 2 (1986): 65–72.

The TENS market seems also to have become very important. In 1988 in France and Switzerland 150,000 units of a famous trademark of transcoutanous nerve simulator, "Quartzo," were sold, of which only 5,000 units were bought by physicians (informal information given by the director-manager of the chain Boutique du Dos, on a television health program).

7. Since their appearance in the 1970s as body-building and fitness devices, the self-enhancing technologies seem to be changing their orientation. The father of body-building instruments and fitness clubs, Arthur Jones, already sees interest in self-cure instruments. In a televised interview in 1989, Jones showed his latest invention, a sophisticated electromechanical armchair for dorsal pains, and said, "This breakthrough will sell more than did any other body instrument that I have ever invented. I'm certain that I will sell it to every American family" (tape transcription from a television program in France). Also recently, body-building and fitness equipment is more and more shifting from health clubs into homes. On this trend see the article of Barry Schiffman, "The Fitness Boom Ends Up at Home," *New York Times*, Nov. 4, 1990.

8. The self-fashioning devices are certainly the best indicators of the future of vital self-technologies. During the past decade the most important need for vital self-technologies has been for body care and body fitness, but according to

some experts, this body-oriented cult is, in fact, only one aspect of a larger interest in self-improvement, especially in the United States. Michael Hutchison, the author of a bestseller on self-transformation devices, *Megabrain,* says, "The time is right for mind-machines; in the next years they will become increasingly popular. One reason for this is that our national obsession with physical fitness continues to grow. And the logical next step after physical fitness is mental fitness. The mind machines can be seen as the brain-training counterpart to . . . the ergonometers and rowing devices and cross-country ski contraptions. It's not hard to imagine serious brain athletes getting their gray matter in shape by pumping peptides and neurotransmitters while yelling 'Feel the burn!'" Michael Hutchison, *Megabrain: New Tools and Techniques for Brain Growth and Mind Expansion* (New York: Balantine Books, 1987), p. 317. For a sociological field study concerning the flotation tanks, see Tufan Orel, "Les technologies d'autofaçonnage: l'exemple des caissons à isolation sensorielle," *Cahiers Internationaux de Sociologie* 85 (1988): 295–312.

9. "As early as 1770, John Gregory declared the trifold purpose of medicine to be (1) the preservation of health, (2) the cure of disease, and (3) the prolongation of life." Stuart F. Spicker, "Terra Firma Infirma Species: From Medical Philosophical Anthropology to Philosophy of Medicine," *Journal of Medicine and Philosophy* 1, no. 2 (1976): 104–35.

10. For an exhaustive field study on this see Michael Hutchison, *Megabrain.*

11. Lester S. King, *Medical Thinking: A Historical Preface,* (Princeton: Princeton University Press, 1982), p. 308. This "judgement" can be considered of two sorts, as in the terms of Stephen Toulmin, "The distinction between theoretical knowledge (or science) and praxis (technology or craft knowledge) is reproduced in the medical field as a distinction between biomedical science and general clinical medicine"; in "On the Nature of the Physician's Understanding," *Journal of Medicine and Philosophy,* 1, no. 1 (1976): 32–50.

12. Referring to a concept that I tried to put forward a few years ago, the "techniques of self-fashioning," a well-known physician and researcher in biophysics and also a member of the French Medical Ethics Committee, Henri Atlan, sees a real danger for mankind and its ethics in the abuse of these recent technologies. On this see the introduction to his book, *A tort et à raison: Intercritique de la science et du mythe* (Paris: Seuil, 1986), p. 23.

13. Philosopher Gilbert Hottois, speaking on the possible impact of technology on human biological mutation, says that an individual is "adapted to his world in which he lives, but if we wish to disseminate man in space, we should reconstruct the human form." He remarks, however, that we should not be dogmatic about this, since "the mutations could be of different sorts: genetic, cybernetic or related to conquest of Space." Interview with Gilbert Hottois, in *Le spatiopithèque* (Paris: Editions Le Miel-Radio France, 1987), p. 148. But why could not these mutations take place also in other forms, for example, simply by people experimenting on themselves, not necessarily with organically integrated "bionic prostheses," but with vital self-technologies?

14. For a good examination concerning the different meanings given to

terms such as "knowledge sector" and "information services" see Fritz Machlup, *Knowledge and Knowledge Production* (Princeton: Princeton University Press, 1980), pp. xv–xxix.

15. See the interview with Peter Drucker in *Time,* Jan. 22, 1990, 42.

16. Yet there is one economist, Jacques Attali, who does not seem to share these hospital-oriented views and brings a totally new perspective concerning the possible evolution of health technologies (see below).

17. André Gorz, *Metamorphoses du travail, quête du sens: critique de la raison economique* (Paris: Galilée, 1988), p. 191.

18. See Alain Toffler, *Previews and Premises* (New York: William Morrow and Co., 1983); Jonathan Gershuny, *After Industrial Society? The Emerging Self-Service Economy* (Atlantic Highlands, NJ: Humanities Press, 1978); Yan De Kerorguen, "Les messages de l'économie invisible," in *Modernes et après: Les immatériaux* (Paris: Autrement, 1985); Guy Aznar, "La sociéte des trois revenus," *Lettre Science-Culture du GRIT,* no. 24.

19. This question is not so idle as it may seem, since very often there can be an involuntary confusion between the two. For example, in a recent book a specialist of technology and engineering design, Yves Deforge (*L'oeuvre et le produit* [Paris: Champ Vallon, 1990], p. 134), referring to our concept of "auto-façonnage" (self-fashioning), considers it to be an activity of do-it-yourself or building a kit. I, however, insist on the fact that these two are totally different types of human activities.

20. Gorz, *Metamorphoses du travail,* p. 191. For a different notion of self-tending see the important remarks of Mihaly Csikszentmihalyi and Eugene Rochberg-Halton, in *The Meaning of Things: Domestic Symbols and the Self* (Cambridge: Cambridge University Press, 1981), p. 173ff. (See also Section V of the present article.)

21. On this topic see Robert F. Rushmer, "Home care: A Biomedical Engineering Challenge," in *Biomedical Engineering* (April 1976): 121–23; and the special issue of *Medical Instrumentation* 5, no. 22 (Oct. 1988), on "Health Care at Home."

22. Another popular perception of home health devices is that of being connected to one's doctor's computer. On this see Pierre Brun and Edmond-Antoine Deschamps, *La domotique* (Paris: PUF, 1988; "Que sais-je" no. 2427), pp. 77–78.

23. On this subject see C. Frampton, H. C. Riddle, and J. R. Roberts, "An ECG Telemetry System for Physiological Studies on Swimmers," *Biomedical Engineering* (March 1976): 87–94; and John Hanley, "Telemetry in Health Care," *Biomedical Engineering* (Aug. 1976): 269–72.

24. Victor Margolin, "Expanding the Boundaries of Design: The Product Environment and the New User," *Design Issues* 4, nos. 1 and 2, special issue (1988): 59–64.

25. On the "harmonic composition" of the product and user, see Tufan Orel, "The Technologies of Self-Fashioning: Beyond Universality and Variance of the Industrial Product," *Design Issues* 4, nos. 1 and 2, special issue (1988): 38–51.

26. Margolin, "Expanding the Boundaries," p. 60.

27. See Jacques Perriault, *La logique de l'usage* (Paris: Flammarion, 1988); see especially chap. 9, pp. 202–27.

28. John Dewey, *Essays in Experimental Logic* (New York: Dover Publications, 1953), p. 420. On the similarity of scientific and everyday experimentation, see Tufan Orel, "Le principe de serendipity ou l'imaginarie appliqué dans la conduite experimentale," *Cahiers de l'Imaginaire* 4 (1989): 69–77.

29. See Tufan Orel, "Les technologies d'autofçonnage: l'exemple des caissons à isolation sensorielle," quoted article.

30. See the article of Alice Kahn on erotic use of E-STIM TENS, "Shocking Regimen: Zapped in the Name of Fitness," *Chicago Tribune,* March 12, 1989.

31. See Christian Miquel and Guy Menard, *Les ruses de la technique: Le symbolisme des techniques à travers l'histoire* (Paris: Meridiens/Klincksieck, 1988), pp. 291–331.

32. Stuart Ewen, *All Consuming Images: The Politics of Style in Contemporary Culture* (New York: Basic Books, 1988), pp. 215–16.

33. Tom Forester, *High-Tech Society: The Story of the Information Technology Revolution* (Cambridge: MIT Press, 1987), p. 145.

34. On this subject see, John Madeley, "Low-Cost X-Rays Come into View," *The Financial Times,* Nov. 22, 1989.

35. A biomedical engineer gives a good account of what should be a user-friendly TENS in the following manner: there is a "need for a well-designed stimulator that would give the patient confidence. Clearly a rather poor quality plastic box with a few wires coming out and a battery hanging on the leads would not boost anyone's confidence." J. M. Stamp, "A Review of Transcutaneous Electrical Nerve Stimulation (TENS)," *Journal of Medical Engineering & Technology* 6, no. 3 (1982): 99–103.

36. Jacques Attali, *Lignes d'horizon* (Paris: Fayard, 1990), p. 161.

37. See Grant McCracken, *Culture and Consumption* (Bloomington: Indiana University Press, 1988); and Csikszentmihalyi and Rochberg-Halton, *The Meaning of Things.*

38. Csikszentmihalyi and Rochberg-Halton, *The Meaning of Things,* p. 144.

39. Ibid., p. 138.

40. The marketing concept "usage situation," which involves the change of the "setting" and "time" of the purchased goods, can be extended to what I called changing "usage locality." There is certainly a need to do deeper studies in this marketing concept and its application to vital self-technologies. On usage situation see J. F. Engel, R. D. Blackwell, and P. W. Miniard, *Consumer Behavior,* 6th ed. (Chicago: Dryden Press, 1990), pp. 215–22.

41. Margolin, "Expanding the Boundaries," p. 62.

42. See Seymour Ben-Zvi, "An Urgent Plea for Realistic Preventive Maintenance Guidelines," *Medical Instrumentation* 16, no. 2 (1982): 115–16.

43. Lee E. Ostrander, "Attention to the Medical Equipment User in Biomedical Engineering," *Medical Instrumentation* 20, no. 1 (1986): 3–5.

44. Paul L. Woodring, "Applying Technology to Operator Requirements in Medical Equipment Design," *Medical Instrumentation* 20, no. 1 (1986): 6–7.

45. David W. Harrison and Patti L. Kelly, "Home Health-Care: Accuracy, Calibration, Exhaust, and Failure Rate Comparisons of Digital Blood Pressure Monitors," *Medical Instrumentation* 21, no. 6 (1987): 323–28.

46. Charles McCullough and Laurence S. Baker, "Designing Special Test Instruments for Preventive Maintenance," *Journal of Clinical Engineering* 4, no. 1 (Jan.–March 1979): 25–28.

47. See Abraham Moles, "The Comprehensive Guarantee: A New Consumer Value," *Design Issues* 2, no. 1 (Spring 1985): 53–64. Quotations are translated from the original French version.

48. Bryan Lawson, *How Designers Think,* 2nd ed. (London: Butterworth Architecture, 1990), p. 69.

49. See Robert S. Kennedy, "The 1976 Medical Device Amendments: A Status Report," *Medical Instrumentation* 14, no. 3 (1980): 153–56.

50. Quoted in Larry R. Pilot, "Device Development and FDA Scientific Review," *Medical Instrumentation* 17, no. 5 (1983): 341–42. Although this remark was made for pharmacological research, it can easily be applied to biomedical devices.

51. On the popular myth of "Doctor of oneself" see E. Aziza-Shuster's *Le médecin de soi-même* (Paris: PUF, 1972). Talking about this theme I hope also that the reader will not consider my views as simply a continuation of the oldest myth of humankind, *Vis medicatrix naturae,* of which the latest version is found in Ivan Illich's well-known book *Medical Nemesis: The Expropriation of Health* (New York: Pantheon, c. 1976). I am not trying to say that the body is wise and can cure itself. On the contrary I am talking about the possibilities the layman has today for transforming his biological and psychological functioning by using a "technology."

52. Concerning some court cases brought against the commerce of vital self-technologies, see the articles of Maurice Peyrot, April 29 and May 26, 1990, issues of *Le Monde;* Cathérine Bezard, "10 000 F: La panoplie du parfait margoulin," *L'événement de jeudi,* Oct. 16, 1989. Catherine Feldman, "Charlatan, Pub à Gogos," *Courrier Cadres,* no. 806 (Sept. 8, 1989): 29–32.

Discovering Design Ability

Nigel Cross

Introduction

Perhaps the most significant development in the discipline of design studies has been the emergence and growth of respect for the inherent strengths of design ability. The infant discipline seemed, thirty years ago, to have been founded on a disrespect for natural design ability and with a strong desire to scientize design. The desire was to recast design in an image of science, and to replace conventional design activities with completely new ones.

These original aims may well have been an understandable reaction to a previous view of design as an ineffable art, and the deification of hero-figure designers. There are still those, outside the discipline of design studies, who regard design as ineffable, and there are still those, within but on the fringes of the discipline, whose lack of understanding of design ability still leads them into attempts to reformulate design activities in inappropriate ways. However, at the core of the discipline there is, I believe, a more mature and enlightened view of design ability.

This mature view has grown from a better understanding of the nature of design ability, from analysis of its strengths and weaknesses, and from a desire to defend and nurture that ability.

In a previous paper[1] I called for a research program in design studies based around the "touchstone theory"[2] of the legitimacy of designerly ways of knowing, thinking, and doing. In this paper I wish to outline some of the "defensive theories" that have grown around this touchstone.

Dictionary definitions of design (as a verb) usually refer to the importance of "constructive forethought," or, as Gregory puts it, "Design generally implies the action of intentional intelligence."[3] I shall try to develop a more explicit view of this constructive, intentional intelligence.

1. Design Ability Has Distinctive Features

When designers are asked to discuss their abilities and to explain how they work, a few common themes emerge. One theme is the importance of creativity and intuition. For example, engineering designer Jack Howe has said: "I believe in intuition. I think that's the difference between a designer and an engineer. . . . I make a distinction between engineers and engineering designers. . . . An engineering designer is just as creative as any other sort of designer."[4] Some rather similar comments have been made by industrial designer Richard Stevens: "A lot of engineering design is intuitive, based on subjective thinking. But an engineer is unhappy doing this. An engineer wants to test; test and measure. He's been brought up this way and he's unhappy if he can't prove something. Whereas an industrial designer, with his Art School training, is entirely happy making judgements which are intuitive."[5]

Another theme that emerges from designers' own comments is based on the recognition that problems and solutions in design are closely interwoven—that "the solution" is not always a straightforward answer to "the problem." For example, commenting on one of his more creative designs, furniture designer Geoffrey Harcourt said, "As a matter of fact, the solution that I cam up with wasn't a solution to the problem at all. I never saw it as that. . . . But when the chair was actually put together [it] in a way quite well solved the problem, but from a completely different angle, a completely different point of view."[6]

A third common theme is the need to use sketches, drawings, and models of all kinds as a way of exploring problem and

solution together, and of making some progress when faced with the complexity of design. For example, Jack Howe has said that, when uncertain how to proceed: "I draw something. Even if it's 'potty' I draw it. The act of drawing seems to clarify my thoughts."[7] Given the complex nature of design activity, therefore, it hardly seems surprising that structural engineering designer Ted Happold should suggest that "I really have, perhaps, one real talent; that is that I don't mind at all living in the area of total uncertainty."[8] If that seems a little too modest, there are certainly other designers who seem to make more arrogant claims, such as architect Denys Lasdun: "Our job is to give the client, on time and on cost, not what he wants, but what he never dreamed he wanted; and when he gets it he recognises it as something he wanted all the time."[9] Despite the apparent arrogance, there is the truth in this statement that clients often do want designers to transcend the obvious and the mundane, and to produce proposals which are exciting and stimulating as well as merely practical.

From this brief review so far, we can summarize the major aspects of what designers do. Designers

• produce novel, unexpected solutions
• tolerate uncertainty, working with incomplete information
• apply imagination and constructive forethought to practical problems
• use drawings and other modeling media as means of problem solving

2. Design Ability Can Be Articulated

For thirty years now, there has been a slowly growing body of understanding about the ways designers work, based on a wide variety of studies of designing.[10] Some of these studies rely on the reports of designers themselves, such as those we have just seen, but there is also a broad spectrum of studies, running through observations of designers at work, to experimental studies based on protocol analysis, knowledge elicitation for expert systems, and theorizing about the nature of design ability.

Such studies often confirm the comments of designers themselves, but try also to add another layer of explanation of the nature of designing. For example, one feature of design activity that

is frequently confirmed by such studies is the importance of the use of conjectured solutions by the designer. In his pioneering case studies of engineering design, Marples suggested that "the nature of the problem can only be found by examining it through proposed solutions, and it seems likely that its examination through one, and only one, proposal gives a very biased view. It seems probable that at least two radically different solutions need to be attempted in order to get, through comparisons of sub-problems, a clear picture of the 'real nature' of the problem."[11] This view emphasizes the role of the conjectured solution as a way of gaining understanding of the design problem, and the need, therefore, to generate a variety of solutions precisely as a means of problem analysis. It has been confirmed by Darke's interviews with architects, where she observed how they imposed a limited set of objectives or a specific solution concept as a "primary generator" for an initial solution: "The greatest variety reduction or narrowing down of the range of solutions occurs early on in the design process, with a conjecture or conceptualization of a possible solution. Further understanding of the problem is gained by testing this conjectured solution."[12] The freedom—and necessity—of the designer to redefine the problem through the means of solution-conjecture was also observed in protocol studies of architects by Akin, who commented: "One of the unique aspects of design behaviour is the constant generation of new task goals and redefinition of task constraints."[13]

It has been suggested that this feature of design behavior arises from the nature of design problems: they are not the sort of problems or puzzles that provide all the necessary and sufficient information for their solution. Some of the relevant information can be found only by generating and testing solutions; some information, or "missing ingredient," has to be provided by the designer himself, as suggested by Levin from his observations of urban designers: "The designer knows (consciously or unconsciously) that some ingredient must be added to the information that he already has in order to arrive at a unique solution. This knowledge is in itself not enough in design problems, of course. He has to look for the extra ingredient, and he uses his powers of conjecture and original thought to do so."[14] Levin suggested that this extra ingredient is often an "ordering principle," and hence we find the formal properties that are so often evident in

designers' work, from towns designed as simple stars to teacups designed as regular cylinders.

Designers, however, do not always find it easy to generate a range of alternative solutions in order to better understand the problem. Their ordering principles or primary generators can, of course, be found to be inappropriate, but they often try to hang on to them because of the difficulties of going back and starting afresh. From his case studies of architectural design, Rowe observed: "A dominant influence is exerted by initial design ideas on subsequent problem-solving directions. . . . Even when severe problems are encountered, a considerable effort is made to make the initial idea work, rather than to stand back and adopt a fresh point of departure."[15] This tenacity is understandable but undesirable, given the necessity of using alternative solutions as a means of understanding the real nature of the problem. However, Waldron and Waldron, from their engineering design case study, came to a more optimistic view about the self-correcting nature of the design process: "The premises that were used in initial concept generation often proved, on subsequent investigation, to be wholly or partly fallacious. Nevertheless, they provided a necessary starting point. The process can be viewed as inherently self-correcting, since later work tends to clarify and correct earlier work."[16]

It becomes clear from these studies of designing that architects, engineers, and other designers adopt a problem-solving strategy based on generating and testing potential solutions. In an experiment based on a specific problem-solving task, Lawson compared the strategies of architects with those of scientists, and found a noticeable difference: "The scientists were [attempting to] discover the structure of the problem; the architects were proceeding by generating a sequence of high-scoring solutions until one proved acceptable. . . . [The scientists] operated what might be called a problem-focussing strategy. . . . In a supplementary experiment, Lawson found that these different strategies developed during the architects' and scientists' education; while the difference was clear between fifth-year, postgraduate students, it was not clear between first-year students. The architects had therefore learned their solution-focusing strategy, during their design education, as an appropriate response to the problems they were set. This is presumably because design problems are

inherently ill-defined, and trying to define or comprehensively to understand the problem (the scientists' approach) is quite likely to be fruitless in terms of generating an appropriate solution within a limited timescale.

The difference between a scientific approach and a design approach has also been emphasized in theoretical studies, such as Simon's, who pointed out that "The natural sciences are concerned with how things are. . . . Design, on the other hand, is concerned with how things ought to be."[18] And March has categorized the differences between design, science, and logic: "Logic has interests in abstract forms. Science investigates extant forms. Design initiates novel forms. A scientific hypothesis is not the same thing as a design hypothesis. A logical proposition is not to be mistaken for a design proposal. A speculative design cannot be determined logically, because the mode of reasoning involved is essentially abductive."[19] This "abductive" reasoning is a concept from the philosopher Peirce, who distinguished it from the other more well-known modes of inductive and deductive reasoning. Peirce suggested that "deduction proves that something must be; induction shows that something actually is operative; abduction merely suggests that something may be."[20] It is therefore the logic of conjecture. March prefers to use the term "productive" reasoning. Others have used terms such as "appositional" reasoning in contradistinction to propositional reasoning.[21]

Although March, Simon, and others have attempted to construct various forms of "design science," they have been careful to distinguish this from popular conceptions of deductive scientific activity. Cross and Naughton have also pointed to the potential error of basing models of design activity on naive views of the epistemology of science,[22] and Glynn has suggested that scientists actually might have something to learn from the epistemology of design.[23]

Design ability is founded on the resolution of ill-defined problems by adopting a solution-focusing strategy and productive or appositional styles of thinking. However, the design approach is not necessarily limited to ill-defined problems. Thomas and Carroll conducted a number of experiments and protocol studies of designing and concluded that a fundamental aspect is the nature of the approach taken to problems, rather than the nature of the problems themselves: "Design is a type of problem solving in

which the problem solver views the problem or acts as though there is some ill-definedness in the goals, initial conditions or allowable transformations."[24] There is also, of course, the reliance in design upon the media of sketching, drawing, and modeling as aids to the generation of solutions and to the very processes of thinking about the problem and its solution. The process involves what Schon has called "a reflective conversation with the situation." From his observations of the way design tutors work, Schon commented that, through sketches, the designer "shapes the situation, in accordance with his initial appreciation of it; the situation 'talks back,' and he responds to the back-talk."[25]

Design ability therefore relies fundamentally on nonverbal media of thought and communication. This deep-seated aspect of design ability perhaps accounts for designers' traditional reluctance, or inability, to verbalize their skill. Some commentators have even suggested that there may even be distinct limits to the amount of verbalizing that anyone can productively engage in about design ability. Daley has suggested that "the way designers work may be inexplicable, not for some romantic or mystical reason, but simply because these processes lie outside the bounds of verbal discourse: they are literally indescribable in linguistic terms."[26] This view throws into doubt my claim that design ability can indeed be articulated. I hope I have provided enough evidence to refute the nonverbalizers, and to show that empirical design studies have led to some coherent articulation of features of design ability.

This review of studies of designing enables us to summarize the core features of design ability as comprising the abilities to
• resolve ill-defined problems
• adopt solution-focusing strategies
• employ abductive/productive/appositional thinking
• use nonverbal, graphic/spatial modeling media

3. Design Ability Is Possessed by Everyone

Although professional designers might naturally be expected to have highly developed design abilities, it is also clear that nondesigners also possess at least some aspects, or lower levels of design ability. Everyone makes decisions about arrangements and

combinations of clothes, furniture, and so forth—although in industrial societies it is rare for this to extend beyond making selections from available goods that have already been designed by someone else. In other societies, however, especially nonindustrial ones, there is often no clear distinction between professional and amateur design abilities—the role of the professional designer may not exist. In craft-based societies, for example, craftspeople make objects that are not only highly practical but often also very beautiful. They would therefore seem to possess high levels of design ability, although in such cases, the ability is collective rather than individual: the beautiful-functional objects have evolved by gradual development over a very long time, and the forms of the objects are rigidly adhered to from one generation to the next. Even in industrial societies, with a developed class of professional designers, there are often examples of vernacular design persisting, usually following implicit rules of how things should be done, similar to craftwork. Occasionally there are examples of "naive" design breaking out in industrial societies, with many of the positive attributes that naive art has. A classic example is the "Watts Towers"—an environmental fantasy created by Simon Rodia in his Los Angeles backyard between the nineteen-twenties and fifties.

Recently, in architecture especially, there have been moves to incorporate nonprofessionals into the design process, through design participation[27] or community architecture.[28] Although the experiments have not always been successful—in either process or product—there is at least a recognition that the professionals could, and should, collaborate with the nonprofessionals. Knowledge about design is certainly not exclusive to the professionals. A strong indication of how widespread design ability is comes from the introduction of design as a subject in schools. It is clear from the often very competent design work of schoolchildren of all ages that design ability is inherent in everyone.

4. Design Ability Can Be Damaged or Lost

Although some aspects of design ability can be seen to be widespread in the general population, it has also become clear that the cognitive functions upon which design ability depends can be

damaged or lost. This has been learned from experiments and observations in the field of neuropsychology, particularly the work which has become known as "split-brain" studies.[29]

These studies have shown that the two hemispheres of the brain have preferences and specializations for different types of perceptions and knowledge. Normally, the large bundle of nerves (the corpus callosum) which connects the two hemispheres ensures rapid and comprehensive communication between them, so that it is impossible to study the workings of either hemisphere in isolation from its mate. However, in order to cure epilepsy, some people have had their corpus callosums surgically severed, and became subjects for some remarkable experiments to investigate the isolated functions of the two hemispheres.[30]

Studies of other people who had suffered damage to one or other hemisphere had already revealed some knowledge of the different specializations. In the main, these studies had shown the fundamental importance of the left hemisphere, which controlled speech functions and the verbal reasoning normally associated with logical thought. The right hemisphere appeared to have no such important functions. Indeed, the right became known as the "minor" hemisphere, and the left as the "major" hemisphere. Nevertheless, there is an equal sharing of control of the body; the left hemisphere controls the right side, and vice versa, for some perverse reason known only to the Grand Designer in the Sky.

This left-right crossover means that sensory reception on the left side of the body is communicated to the brain's right hemisphere, and vice versa. This even applies, in a more complex way, to visual reception; it is not simply that the left eye communicates with the right hemisphere, and vice versa, but that, for both eyes, reception from the left visual field is communicated to the right hemisphere, and vice versa. Ingenious experiments were therefore devised in which visual stimuli could be sent exclusively to either the left or right hemisphere of the split-brain subjects. These experiments showed that the separated hemispheres could receive, and therefore "know," separate items of information. The problem was how to get the hemispheres to communicate what they knew back to the experimenter. The left hemisphere, of course, can communicate verbally, but the right hemisphere is mute. Some experimenters resolved this problem by visually

communicating a word or image to the right hemisphere, and asking it to identify a matching object by touch with the left hand.

From experiments such as these, neuropsychologists developed a much better understanding of the functions and abilities of the right hemisphere.[31] Although mute, it is by no means stupid, and it perceives and knows things that the left hemisphere does not. In general, this is the kind of knowledge that we categorize as intuitive. The right hemisphere excels in emotional and aesthetic perception, in the recognition of faces and objects, and in visual-spatial and constructional tasks. This scientific, rational evidence therefore supports our own personal, intuitive understanding of ourselves, and also supports the (often poorly articulated) view of artists and many designers that verbalization (i.e., allowing the left hemisphere to dominate) obstructs intuitive creation.

Anita Cross has drawn attention to the relevance of split-brain studies to improving our understanding of design ability.[32] One set of experiments which seems to be particularly relevant to design ability tested split-brain subjects on their recognition and intuitive comprehension of shapes and objects belonging to different geometrical classes.[33] No formal knowledge of geometry was required, but the shapes were presented in sets corresponding to euclidean, affine, projective, and topological geometries. Each subject was presented visually with five shapes in each set, and then asked to select from three further shapes, by touch only, one which belonged to the same set. On comparing the performance of left and right hands, the left hand (i.e., right hemisphere) was clearly superior. However, the superiority also varied consistently over the four geometrical categories, from euclidean, through affine and projective, to topological, suggesting that the left hemisphere becomes progressively less able to identify the more complex, subtle, and unconstrained geometries.

Several examples of the problematic behavior and perception of people with right-brain damage have been reported by Sacks, including "the man who mistook his wife for a hat" and who could not recognize a glove.[34] When Sacks held up a glove and asked "What is this?" the patient described it as "a continuous surface, ... infolded on itself. It appears to have five outpouchings, if that is the word ... A container of some sort." There is a weird logic to this reasoning, but no intuitive perception of the object

and its obvious function. It is now known, therefore, that damage to the right hemisphere can impair brain functions that relate strongly to intuitive, artistic, and design abilities. This has been confirmed by studies of, for instance, drawing ability. One classic case is that of an artist who suffered right-brain damage.[35] Although he could make an adequate sketch of an object such as a telephone when he had it in front of him, he could not draw the same object from memory and resorted instead to reasoning about what such an object might be like. Studies of split-brain subjects have also shown, in general, that they can draw better with their left hands (even though they are not naturally left-handed people) than with their right.[36] Recognition of this right-brain ability has been put to constructive use in art education by Betty Edwards, who trains students to "draw on the right side of the brain."[37]

There is also, of course, a long history of studies in psychology of cognitive styles, which are usually polarized into dichotomies such as

convergent/divergent
focused/flexible
linear/lateral
serialist/holist
propositional/appositional

Such natural dichotomies may reflect the underlying dual structure of the human brain and its apparent dual modes of information processing. Cross and Nathenson have drawn attention to the importance of understanding cognitive styles for design education and design methodology.[38] This work has also been taken up by Powell and his colleagues in the design of information systems for designers.[39]

5. Design Ability Is a Form of Intelligence

What I have attempted to show is that design ability is a multifaceted cognitive skill, possessed in some degree by everyone. I believe that there is enough evidence to make a reasonable claim that there are particular, "designerly" ways of knowing, thinking, and acting.[40] In fact, it seems possible to make a reasonable claim that design ability is a form of natural intelligence, of

the kind that psychologist Howard Gardner has identified.[41] Gardner's view is that there is not just one form of intelligence, but several, relatively autonomous human intellectual competences. He distinguishes six forms of intelligence: linguistic, logical-mathematical, spatial, musical, bodily-kinaesthetic, and personal.

Aspects of design ability seem to be spread through these six forms in a way that does not always seem entirely satisfactory. For example, spatial abilities in problem-solving (including thinking "in the mind's eye") are classified under spatial intelligence, whereas many other aspects of practical problem-solving ability (including examples from engineering) are classified under bodily-kinaesthetic intelligence. In this classification, the inventor appears alongside the dancer and the actor, which does not seem appropriate. It seems reasonable, therefore, to try to separate out design ability as a form of intelligence in its own right.

Gardner proposes a set of criteria against which claims for a distinct form of intelligence can be judged. These criteria are as follows, with my attempts to match design intelligence against them.

Potential isolation by brain damage. Gardner seeks to base forms of intelligence in discrete brain-centers, which means that particular faculties can be destroyed (or spared) in isolation by brain damage. The evidence here for design intelligence draws upon the work with split-brain and brain-damaged patients, which shows that abilities such as geometric reasoning, three-dimensional problem solving, and visual-spatial thinking are indeed located in specific brain-centers.

The existence of idiots savants, prodigies, and other exceptional individuals. Here, Gardner is looking for evidence of unique abilities which sometimes stand out in individuals against a background of retarded or immature general development. In design, there are indeed examples of otherwise ordinary individuals who demonstrate high levels of ability in forming their own environments—the "naive" designers.

An identifiable core operation or set of operations. By this, Gardner means some basic mental information-processing operations which deal with specific kinds of input. In design, this might be the operation of transforming the input of the problem brief into

the output of conjectured solutions, or the ability to generate alternative solutions. Gardner suggests that "simulation on a computer is one promising way of establishing that a core operation exists." Work on the application of artificial intelligence to design is therefore helping to clarify the concept of natural design intelligence.

A distinctive developmental history, and a definable set of expert, end-state performances. This means recognizable levels of development or expertise in the individual. Clearly, there are recognizable differences between novices and experts in design, and stages of development among design students. But a clarification of the developmental stages of design ability is something that we still await, and is sorely needed in design education.

An evolutionary history. Gardner argues that the forms of intelligence must have arisen through evolutionary antecedents, including capacities that are shared with other organisms besides human beings. In design, we do have examples of animals and insects that construct shelters and environments, and use and devise tools. We also have the long tradition of vernacular and craft design as a precursor to modern, innovative design ability.

Susceptibility to encoding in a symbol system. This criterion looks for a coherent, culturally shared system of symbols which capture and communicate information relevant to the form of intelligence. Clearly, in design we have the use of sketches, drawings, and other models which constitute a coherent, symbolic media system for thinking and communicating.

Support from experimental psychological tasks. Finally, Gardner looks for evidence of abilities that transfer across different contexts, of specific forms of memory, attention, or perception. We have only a few psychological studies of design behavior or thinking, but aspects such as solution-focused thinking have been identified. More work in this area needs to be done.

If asked to judge the case for design intelligence on this set of criteria, we might have to conclude that the case is not proven. While there is good evidence to meet most of the criteria, for some there is a lack of substantial or reliable evidence. However, I think that viewing designing as a form of intelligence is productive; it focuses attention on design as a cognitive activity, it helps to identify and clarify features of the nature of design ability, and it offers

a framework for developing further the case for designerly ways of knowing, thinking, and acting.

Conclusion

In this paper, I set out to develop an explicit understanding of the nature of design ability. I have outlined some defensive theories that might be built around the touchstone theory of the legitimacy of designerly ways of knowing, thinking, and doing. In particular, I have tried to show that design ability can appropriately be regarded as a distinct form of intelligence.

My broader aim, to which I hope this paper will contribute, is the establishment and development of a view of design as a discipline in its own right. This is a view shared by some of my colleagues in the invisible college of design studies, but is by no means a universally held view. For many people, design is and should remain an interdisciplinary field of studies. But that would mean that we design scholars would forever be dependent on other disciplines as our paradigms and sources. That surely cannot be a satisfactory state of affairs for us, and as Buchanan[42] and others have argued, we must work at and in our own discipline of design studies.

Notes

1. N. Cross, "Designerly Ways of Knowing," *Design Studies* 3, no. 4 (1982): 221–27.

2. I. Lakatos, "Falsification and the Methodology of Scientific Research Programmes," in *Criticism and the Growth of Knowledge,* ed. I. Lakatos and A. Musgrave (Cambridge: Cambridge University Press, 1970).

3. R. L. Gregory, ed., *The Oxford Companion to the Mind* (Oxford: Oxford University Press, 1987).

4. Quoted in R. Davies, "A. Psychological Enquiry into the Origination and Implementation of Ideas" (M.S. thesis, UMIST, Manchester, 1985).

5. Ibid.

6. ·Ibid.

7. Ibid.

8. Ibid.

9. D. Lasdun, "An Architect's Approach to Architecture," *RIBA Journal* 72, no. 4 (1965).

10. N. Cross, ed., *Developments in Design Methodology* (Chichester: Wiley, 1984).

11. D. Marples, *The Decisions of Engineering Design* (London: Institute of Engineering Designers, 1960).

12. J. Darke, "The Primary Generator and the Design Process," *Design Studies* 1, no. 1 (1979): 36–44.

13. O. Akin, "An Exploration of the Design Process," *Design Methods and Theories* 13, nos. 3/4 (1979): 115–19.

14. P. H. Levin, "Decision Making in Urban Design," *Building Research Station Note EN 51/66,* BRS, Watford (1966).

15. P. Rowe, *Design Thinking* (Cambridge: MIT Press, 1987).

16. M. B. Waldron and K. J. Waldron, "A Time Sequence Study of a Complex Mechanical System Design," *Design Studies* 9, no. 2 (1988): 95–106.

17. B. R. Lawson, "Cognitive Strategies in Architectural Design," *Ergonomics* 22, no. 1 (1979): 59–68.

18. H. A. Simon, *The Sciences of the Artificial* (Cambridge: MIT Press, 1969).

19. L. J. March, "The Logic of Design," in *The Architecture of Form,* ed. L. J. March (Cambridge: Cambridge University Press, 1976).

20. Quoted by March from C. Hartsborne and P. Weiss, eds., *Collected Papers of C. S. Peirce* (Cambridge: Harvard University Press, 1931–35).

21. J. E. Bogen, "The Other Side of the Brain II: An Appositional Mind," *Bulletin of the Los Angeles Neurological Societies* 34, no. 3 (1969): 135–62.

22. N. Cross, J. Naughton, and D. Walker, "Design Method and Scientific Method," in *Design: Science: Method,* ed. J. Powell and R. Jacques (Guildford: Westbury House, 1981).

23. S. Glynn, "Science and Perception as Design," *Design Studies* 6, no. 3 (1985): 122–26.

24. J. C. Thomas and J. M. Carroll, "The Psychological Study of Design," *Design Studies* 1, no. 1 (1979): 5–11.

25. D. Schon, *The Reflective Practitioner* (London: Temple-Smith, 1983).

26. J. Daley, "Design Creativity and the Understanding of Objects," *Design Studies* 3, no. 3 (1982): 133–37.

27. N. Cross, ed., *Design Participation* (London: Academy Editions, 1972).

28. N. Wates and C. Knevitt, *Community Architecture* (London: Penguin, 1987).

29. M. S. Gazzaniga, *The Bisected Brain* (New York: Appleton Century Crofts, 1970).

30. R. W. Sperry, M. S. Gazzaniga, and J. E. Bogen, "Interhemispheric Relations: The Neocortical Commissures; Syndromes of Hemispheric Disconnection" in *Handbook of Clinical Neurology,* vol. 4, ed. P. J. Vinken and G. W. Bruyn (Amsterdam: North-Holland, 1969).

31. T. R. Blakeslee, *The Right Brain* (London: Macmillan, 1980).

32. A. Cross, "Towards an Understanding of the Intrinsic Values of Design Education," *Design Studies* 5, no. 1 (1984): 31–39.

33. L. Franco and R. W. Sperry, "Hemisphere Lateralisation for Cognitive Processing of Geometry," *Neuropsychologia* 15 (1977): 107–14.

34. O. Sacks, *The Man Who Mistook His Wife for a Hat* (London: Duckworth, 1985).

35. W. Wapner, T. Judd, and H. Gardener, "Visual Agnosia in an Artist," *Cortex* 14 (1978): 343–64.

36. J. E. Bogen, "The Other Side of the Brain I: Dysgraphia and Dyscopia Following Cerebral Commissurotomy," *Bulletin of the Los Angeles Neurological Societies* 34, no. 2 (1969): 73–105.

37. B. Edwards, *Drawing on the Right Side of the Brain* (Los Angeles: Tarcher, 1979).

38. N. Cross and M. Nathenson, "Design Methods and Learning Methods," in *Design: Science: Method,* ed. J. Powell and R. Jacques (Guildford: Westbury House, 1981).

39. P. Newland, J. A. Powell, and C. Creed, "Understanding Architectural Designers' Selective Information Handling," *Design Studies* 8, no. 1 (1987): 2–16.

40. Cross, "Designerly Ways of Knowing," pp. 221–27.

41. H. Gardner, *Frames of Mind: The Theory of Multiple Intelligence* (London: Heinemann, 1983).

42. R. Buchanan, "Myth and Maturity: Towards a New Order in the Decade of Design," *Design Issues* 6, no. 2 (1990): 70–80.

The Product Milieu and Social Action

Victor Margolin

> Thus in this mortal life, wandering from God, if we wish
> to return to our native country where we can be blessed
> we should use this world and not enjoy it, so that the "in-
> visible things" of God "being understood by the things
> that are made" may be seen, that is, so that by means of
> corporal and temporal things we may comprehend the
> eternal and spiritual.[1]

Saint Augustine, *On Christian Doctrine*

Introduction

Within the tradition of social action theory, the relation between products and action remains invisible. Social theorists such as George Herbert Mead, Max Weber, Talcott Parsons, Alfred Schutz, Thomas Luckmann, and Alain Touraine have given much attention to the motives, objectives, and consequences of action, but they have ignored the ways that products enable or inhibit it.[2] They have also failed to recognize the significance of the design activity that brings products into being. According to these theorists, it would seem that humans live in a world without products and act in a vacuum. A notable exception to this postulation is the late French sociologist Abraham Moles, who developed a calculus of actions that is highly dependent on the relations people establish with objects. These relations, which determine the ways people acquire, maintain, and use products, play an important part in Moles's larger theory of action.[3]

Even though we cannot imagine a world without products, social action theory, Moles notwithstanding, lacks a conception of

products that can explain their relation to human activity. What is needed is an understanding of the product that connects it to action in such a way that it does not simplistically mediate between motives and acts but functions instead as a dynamic factor in the development of both.

By "products" I mean the human-made material and immaterial objects, activities, and services, and complex systems or environments that constitute the domain of the artificial.[4] And I intend "design" to denote the conception and planning of these products. As I apply the term "products" in this essay, I refer not only to the outcomes of professional design practice but also to the vast results of design activity that everyone engages in.[6]

I have chosen the term "product milieu" to represent the aggregate of objects, activities, services, and environments that fills the lifeworld.[7] Although it is the site of both material and immaterial products, this milieu is nonetheless always physically or psychically tangible and must be accounted for in the interpretation of action. Even an immaterial product such as a zoning code or a customer-service strategy in a bank has a distinct form that defines parameters of activity. I have designated activities, services, and environments as products in order to maintain the unity of the product milieu as a single field of activity and to make greater connections among its diverse components.

The product milieu is not a neutral layer that mediates between prior motivation and subsequent action. It is an interactive presence in the lifeworld. We are always in the midst of it and we experience it as something lively, flexible, and even aggressive. While it offers possibilities for action, it also inhibits action both through the more permanent components of the built environment and through immaterial things such as legal codes and service delivery systems.[8] Such products are not inflexible, however, and often invoke oppositional action to alter or remove them.[9]

Conceiving design broadly enough to include buildings and corporate identity programs, spoons and towns, computer software and health care delivery systems, adds a new and needed dimension to our reflection on it as a social practice.[10] Thinking of all these products as *designed* makes us more aware that they are conceived, discussed, and planned, before they are made. As the results of human decisions, they can always be questioned. Just as children come to the realization that the printed words on

a page are there by choice rather than necessity, so can we come to realize that we design and make the product milieu ourselves. By recognizing this, we can engage its components with more awareness, either by supporting them or attempting to alter or eliminate them. The debates over whether or not to preserve specific buildings as historic landmarks and over the laws that prevent or allow abortions are good examples. Preservation groups realize that they can oppose developers just as pro-choice advocates understand that they must fight to defend the legal encoding of this position against pro-life opponents.

What Is Design and Who Is a Designer?

A liberal definition of "design" calls into question the rules we now use to demarcate terrains of subject matter. It also creates opportunities for new relations between isolated practices. Lawyers study the law, architects learn about building, and graphic designers master typography and layout. While these activities tend to be constituted on distinct terrains of knowledge, they nonetheless intersect frequently in the lifeworld and might therefore be defined differently at the stage of professional preparation. The result would be a different quality of practice that could open up new possibilities of collaboration among professionals through a greater understanding of what others do.

Besides challenging the way professionals define their own spheres of knowledge, a broad definition of "design" also confronts the boundaries of professionalism itself. In order to explore the product milieu in all its fullness, we need to recognize the way that everyone, not only professionals, contributes to it. Therefore an understanding of what distinguishes professional from nonprofessional activity becomes crucial.[11]

Professionalism is based on knowledge and skills. In professions such as mechanical engineering or medicine it is difficult if not impossible to develop sufficient expertise without some type of institutional formation. In the case of medical training, for example, this formation provides training experiences that are impossible to come by otherwise. Based on the perceived importance of institutional experiences, licensing requirements are established that prevent nonlicensed practitioners from officially engaging in these activities.[12]

Even when knowledge and skills are readily accessible to non-professionals, as in graphic design, professionals may still reserve some criterion such as aesthetic judgment or taste to distinguish them from nonprofessionals. But even here, aesthetic judgment is becoming more accessible through computer software that incorporates it within its programs. It is increasingly easier to manage a desktop publishing enterprise and turn out publications that are at least marked by their competence if not by some modicum of invention.

To counter the challenge to professional boundaries that such access implies, more rigorous criteria for establishing professional identity are then established. Lev Manovich has described how the smoothness of an image has become a criterion of professionalism among computer animators, who themselves have access to the expensive equipment that makes such smoothness possible.[13]

Conditions of professional exclusion do not, however, prevent people from designing and building their own homes, drawing up their own legal documents, publishing their own books, healing themselves, or otherwise becoming proficient and self-sufficient in fields normally dominated by professionals.[14]

Nigel Cross notes a shift within design studies in the conceptualization of design ability. He compares earlier attempts to develop design as a normative science of planning to the current interest in discovering characteristics of design ability that are inherent in everyone.[15] He points out that the distinction between professional and amateur designers is more of an issue in industrialized countries than in craft-based societies, particularly traditional ones, where almost everyone makes things. In industrialized countries, Cross says, "Everyone makes decisions about arrangements and combinations of clothes, furniture, and so forth—although in industrial societies it is rare for this to extend beyond making selections from available goods that have already been designed by someone else."[16] Despite the fact that more people actually make products of their own than Cross's statement would suggest, even the selection of available goods usually requires the conception and planning of an outcome—the ensemble—which functions as a product. A style of dress will evoke particular responses from others just as an arrangement of furniture and decorative objects will.

To identify another example of combinatory design, let us con-

sider the domestic space, which is the most prevalent site of design activity. People arrange their living spaces, plan meals, organize social rituals, build domestic objects, and so forth. While a certain amount of this activity follows existing plans, recipes, photographic models, kits, and guidebooks, there is usually some measure of invention in the organization of domestic life. Like play, the domestic space offers most individuals the greatest degree of freedom to make choices about product invention and adoption.

The body is another important site for invention, as Dick Hebdige notes in his important study, *Subcultures,* and in a later essay on punk hair styles.[17] But here we must distinguish between original designs and imitations, although the point in inventing a new style is often not to be unique but to be recognized as part of a group, albeit with one's own accent.

Today the ever-widening access to new technologies is giving people the chance to do more than simply combine existing products into ensembles or adorn their bodies. It is breaking down the distinction between industrialized and craft-based societies by enabling people to do for themselves what professionals once did for them. For example, millions of people in the United States, men included, own sewing machines and make everything from costumes and children's clothes to curtains and slipcovers for couches. This spreading interest in sewing has also spawned a booming industry in fabric stores.

At the same time, flexible manufacturing systems, which facilitate small-batch production, are increasing the opportunities for user participation in the choice of product components. We can see this in the most advanced sector of the automobile industry, for example.

To argue, however, that design ability and opportunities for practice are more widespread than the spheres of professional activity is not to ignore qualitative differences in expertise among those who design. We can easily rely on well-established social conventions to distinguish between degrees of skill mastery in the areas of problem formulation, product invention, tool manipulation, model execution, and adaptability for production. But we should also note that high levels of competency, measured by the same conventions, are evident in many products made by nonprofessionals.

Thus it is not innate capability, exclusive access to knowledge,

or the capacity to master skills that determines the social distinctions between professional and nonprofessional designers, but other qualities such as motivation, experience, access to design tools and production facilities, along with criteria determined by professional associations, cultural institutions, and the media. We must therefore disregard the model of the designer as a demiurge who creates products that are then adopted by a public with a lesser consciousness of what it needs than professional designers have.

Human beings engage with design in four ways, all of which are active rather than passive:

1. they design products *for* others;
2. they design products for themselves;
3. they use products designed *by* others; and
4. they use products they design for themselves.

We cannot disregard the inventiveness of professionals, but we must also pay attention to the innovative activities of nonprofessionals as designers of products for themselves and others. At the same time we need to recognize as design activity the role that large numbers of nonprofessionals play in public debates about design policy. These debates address such topics as whether or not to fund weapons systems, what devices automobile manufacturers need to install for maximum safety, and what forms of packaging produce the least landfill refuse. They focus as well on many other topics that range from issues of national and international import to local community concerns. Citizen activism in these debates is a part of the design process. It is an attempt to support or oppose the development of a product based on a variety of factors: social value, environmental impact, and cost of production, to name a few. In recent years, consumer movements have made a growing impact on what products companies make and how they make them. A precedent for citizen activism in product development was Ralph Nader's 1965 book *Unsafe at Any Speed,* which strongly critiqued the safety deficiencies in American automobiles and thus encouraged a protest movement that has led to the installation of new features such as seatbelts and air bags. Such activities are increasingly part of the conception and planning of new products as a result of the growth of consumer movements.

Besides considering the roles that nonprofessionals play in the

design process itself, we must also acknowledge the creativity involved in using products, whether they are designed by oneself or others. The identification of the user as a collaborator with the designer has become especially relevant with the advent of smart products that are not in themselves complete but rather invite the creative participation of users to achieve results.

The Creation and Classification of Products

Having acknowledged the broad participation of many different people in the design of products, we need to portray the extent of the product milieu. I want to argue for the integration of three spheres of design within this milieu: civic and state projects, the market, and independent design. My intention in being so inclusive is to identify design as a unified presence in multiple spheres of activity that are usually regarded as separate from one another.

Civic and State Projects

We can begin at the macroscale by considering large civic projects such as dams, bridges, highways, parks, electricity generation and distribution facilities, public buildings, and the entire realm of weapons technology. We need also to include here the design of service delivery systems such as medical assistance, welfare, and recycling activities. For the most part these projects are administered by public officials who conceive them and plan their execution. Depending on the political sensitivity of the project, the public may have more or less access to the planning process. In the case of some civic projects, particularly those that have an environmental impact, there are open hearings and opportunities for citizens to register opinions. But other projects, such as weapons systems that are deemed to be more politically sensitive, exclude public participation, and people must get involved indirectly through public forums, usually with insufficient information to debate the issues in a thorough way.

Depending on the degree of centralized government control in an economy, the macroscale may encompass almost all of the built environment as well as a near monopoly of social service delivery systems. This has been the case in the formerly socialist countries which are now beginning to change as they move toward more

open economies. In countries where the open market has a longer history of dominance in economic affairs, a significant percentage of civic projects at the macroscale are market driven, as we see with the development of office buildings, private housing, museums, and other cultural centers in the developed world. While there is generally a public demand for accountability in a market-driven civic project, public participation in such projects is more difficult to negotiate unless zoning, environmental, or related issues are involved.

The politics of participation that surrounds processes and services, structures and systems such as laws, social policies, and service delivery, is similar to that relating to the built environment but frequently offers a greater opportunity for public involvement because, on the one hand, the issues of design are often less technical and more accessible to nonprofessionals and, on the other, the different political processes that engender such products are more accessible to public activists. The fight for passage of the Equal Rights Amendment is a good example. Citizens across the United States were involved in the attempt to pass the amendment, which was, however, ultimately defeated.

The Market

Apart from the realm of civic projects, we have the vast array of products that enter the product milieu through the market, which is a mechanism for regulating the introduction and distribution of products through a system of economic exchange. Depending on the degree of centralized planning in an economy, new products may be based more or less on systematic surveys of likely economic success. But the public cannot be compelled to buy products, as the experience of formerly socialist economies has shown. Much of the failure in such economies was due to the fact that inferior products languished on the shelves because they held no appeal for consumers.

Philip Kotler has distinguished four different seller orientations toward customers in the market.[18] At one end of the spectrum are sellers who view customers as *prey* to be influenced and manipulated. Kotler calls this approach "the mark of the quacks, fly-by-night operators, and rip-off artists." The role of design in products offered by such sellers is negligible, since their primary

concern is to engage in the exchange process with the lowest possible level of quality.

The second orientation is that of a *stranger,* where the seller wants to make a sale but is indifferent to the customers' real concerns. Here design contributes to a differentiation of products from their competition but is not a significant factor in generating products that are deeply satisfying.

A third seller attitude regards the customer as a *neighbor* who is courted and offered special services but whose lifeworld is still not well known or thoroughly attended to. The function of design corresponding to this attitude is modest product improvement and innovation but without the drive for excellence that can anticipate and fulfill customer expectations.

The fourth view, which Kotler finds rare in practice, is to see the customer as a *friend.* Sellers who hold this view engage their customers as they might their own family. They want to provide quality merchandise and service and to know that the customer is satisfied. This view comes out of an engagement with customers that converts the sales process into a means of establishing a closer relationship. In design terms, this means successfully encoding an ideal relationship into the product design itself so that the user feels at one with the product and even possibly inspired by it.[19]

The view of the customer as a friend comes closest to Kotler's definition of "humanistic marketing," which recognizes the customer as someone actively attentive to product differences and benefits, concerned with getting sufficient product information and good service, interested in the organization as well as the product, responsive to new products and services, and cognizant of long-term interests in the selection of products.[20] Companies that hold this marketing philosophy also offer the greatest opportunities for designers to work on products that will be most satisfying to users. To develop such products, however, requires a thorough knowledge of who the user is and how he or she functions in the lifeworld. Such knowledge comes through a heightened relationship between the designer, the company, and the user. This relationship is considerably enhanced by possibilities for users to provide feedback on current products and suggestions for improvements and new products. Through such a process of communication, users make their needs and interests known to

companies and designers and to some degree become participants in the conceptual stage of the design process.

Heightened user feedback has been particularly effective in the software field, where some software developers have established electronic bulletin boards for users to discuss current products. Such intensive feedback works well with software in particular because it is a product rich in information and low in mass; hence it can be frequently changed and reintroduced in improved forms.[21] User feedback is of little value when discussing a large-scale civic project, such as a bridge, that is embodied in material form. However, Kotler's four seller orientations can nonetheless be applied to civic projects, even if it is difficult or impossible to change such projects once they have been built.

Independent Design

Kotler makes clear the complexities of matching products to user concerns, particularly since only a limited segment of those who make products pay close attention to these concerns. Kotler's four seller orientations mark differences in the development of market-driven products but do not account for the products that users design for themselves. If we are to get a full view of the relations between social actors and products, we need to acknowledge the extent and importance of this sector of the product milieu.

Despite Kotler's use of needs satisfaction as a norm for distinguishing among seller orientations, manufactured goods and services do not occupy the full range of products that people make use of. This, of course, is recognized by manufacturers, who sometimes divide the public into markets based on the public's inclination to adopt new products. Critics of market-driven economies often speak of the manufacturers' impetus to commodify more and more aspects of experience into material and immaterial products. While we must acknowledge this impetus, it does not mean that manufacturers are always successful. It is unusual to find people who are totally dependent on marketed products, just as it is rare to find people in almost any society who are entirely self-sufficient.

There are numerous reasons why social actors will do things for themselves rather than rely on the marketplace:

1. *Cost:* Manufactured products cost money. The customer pays for the labor, the materials, and the producer's profit. Doing things for oneself can save money, whether this entails building one's own furniture or cooking rather than eating out or buying frozen meals.

2. *Satisfaction:* A social actor may get more satisfaction out of doing something for herself or himself. In the late nineteenth century William Morris wrote about the pleasures of making things and based his whole social philosophy on this premise. He criticized the "cheap and nasty" factory-made goods of his time and urged a return to individual craftsmanship as a way of improving products.[22] Today many people design their own homes, customize their cars, or program their own software because they believe that what they produce themselves will be more satisfying than what they can buy.

3. *Empowerment:* People can feel more in control of their lives and confident of their own capabilities by doing things for themselves. Such confidence enables them to assert their own sense of individuality more fully.

4. *Self-reliance:* A political stance that is based on the will to reduce one's dependence on civil society for the purpose of avoiding participation in an alien value system or living according to a different one. This can take the form of specific activities or an almost complete lifestyle. It was the intention of nineteenth-century utopian communities such as the Shakers to design products according to their own values. Today the Amish in the United States try to limit their dependence on the marketplace as well as their compliance with federal and state laws and social policies with which they disagree. They still use horses and buggies as a means of transportation, for example.

5. *Self-actualization:* Designing and making things is a form of self-fulfillment that is highly valued by some people. Just as someone may become a professional designer because it is a satisfying activity and an avenue for self-development, so can social actors design for themselves according to the same premises. One aspect of this is self-representation, the motivation to see oneself in dress and display, social spaces, decorative arts, and other forms. A classic example of self-representation is the Watts Towers in Los Angeles, which were designed by Simon Rodia over a

period of many years. Today they stand as a testament to Rodia's imaginative vision and his will and ability to complete such a large project on his own.[23]

6. *To satisfy a social need:* People design projects to accomplish social goals. In the United States, for example, a vast amount of social welfare work is done independently of professional agencies. Thousands of social projects are designed and conducted by nonprofessionals.

The product milieu thus incorporates three spheres which are distinctive but also overlap. It is the rare social actor who is entirely independent of any of these spheres, although the proportion of engagement with each of them will vary from culture to culture as well as from person to person within a given culture.

The Design of Action and the Design of Products

The relation between the product milieu and action is twofold. Products become part of this milieu through acts of designing and making. At the same time designing and making also depend on products. As users, designers are like other social actors who continually scan the product milieu for things that suggest possibilities for action. In this process of mutual influence of action on products and products on action, it is difficult to claim the predominance of one or the other. The two are intertwined.

The phenomenologists Alfred Schutz and Thomas Luckmann state that action is a component of everyone's daily life.

> The life-world is the quintessence of a reality that is lived, experienced, and endured. It is, however, also a reality that is mastered by action and the reality in which—and on which—our action fails. Especially for the everyday life-world, it holds good that we engage in it by acting and change it by our actions. Everyday life is that province of reality in which we encounter directly, as the condition of our life, natural and social givens as pregiven realities with which we have to cope. We must act in the everyday life-world if we wish to keep ourselves alive.[24]

The origin of action for Schutz and Luckmann is the Ego, which focuses its attention on selected experiences that become "thematic kernels within the syntheses of consciousness";[25] Out of

consciousness intentions become manifest and are codified in what Schutz and Luckmann call "projects." [26] "In the project the goal of the act is envisioned in advance (*Vorstellung*); the individual steps of the act relate to this goal." [27] Projects, they say, need not be provoked directly by concrete situations. They can also arise from past experiences independently of a given set of circumstances. In this sense projects can be either adaptive or innovative. They are not superficial activities but belong "to the total context of the origin of the self, of a personal identity, in the lifeworld." [28]

The self exists in the lifeworld with other selves; hence action does not arise exclusively from the self nor is it directed only toward the self. As Schutz argued in a work that preceded his collaboration with Luckmann, "Once the existence of the Thou is assumed, we have already entered the realm of intersubjectivity. The world is now experienced by the individual as shared by his fellow creatures, in short, as a *social* world." [29] The activity of other selves forms the context of one's own activity, and the self must thus be both observer (of the activity of other selves) and actor, with its own projects and actions.

Schutz states that our knowledge of the social world varies with our experience. Therefore it does not affect our actions in a uniform way. He differentiates between the "world of directly experienced social reality" (*Umwelt*), and the "world of contemporaries" (*Mitwelt*).[30] In the *Umwelt,* we exist with others and are in reach of their direct experience, while in the *Mitwelt* this experience of others becomes more remote and anonymous. To the degree that we live in the *Umwelt,* our action corresponds more closely to others' experience. And conversely, in the *Mitwelt,* it can only approximate or guess at this experience.

In his distinction between the *Umwelt* and the *Mitwelt,* Schutz provides a basis for examining different qualities of designing. We can discuss these qualities in relation to Kotler's four seller orientations. The seller who regards the customer as prey locates him or her at the impersonal margins of the *Mitwelt.* Designers, manufacturers, and sellers of shoddy merchandise that is produced without any care for the user are least attentive to the intersubjective nature of action, while those who regard customers as friends mark them as people to be drawn into their *Umwelt.* This latter process is what Kotler means by "humanistic

marketing," which is based on a high degree of intersubjective awareness.

While Kotler's typologies of seller orientations suggest the diversity of design qualities that relate to them, we also need to consider what Schutz's and Luckmann's theories of action mean for an understanding of design in a more fundamental sense. Most important is their recognition of the project as a plan that is "brought to fulfillment by *action.*"[31] Without stretching the term "design" too far, we can argue that the project as plan is also a *design of action,* a broad concept that denotes the relation between projects and acts. Projection, the process of formulating projects, is designing activity, although in the usage proposed here it is not necessarily directed to the act of making a product.[32] Taking a walk may involve designing an itinerary and planning some activities along the way, but there will be no product at the end. The same might be said for a game of tennis.

The design of products, then, is a particular kind of action, whose results make up the product milieu. In some design processes, we can distinguish stages of projection—developing an initial concept, planning, modeling, making prototypes, and so forth. Variants of this process will also apply to the design of immaterial products such as organizational structures or service delivery systems. In such cases we can delineate the roles of different kinds of designers, such as social planners, product designers, engineers, and marketing experts.

In some instances, the stages of projection cannot be identified as separate entities, nor can the division between designing and making. An improvised splint for an injured person is one example. Found materials are brought together to create a splint. The final product—the splint—is designed, but in an ad hoc manner rather than a systematic way that involves distinct stages of conception.

Throwing a clay pot also exemplifies the fusion of designing and making. The self-conscious planning involves selecting the clay and deciding to turn it on the potter's wheel. But as the clay turns and the potter shapes it, only with difficulty, if at all, can we separate the conception of the shape from its embodiment in the clay. The distinctions between conception, planning, and making will vary from one project to another. The design of

products therefore cannot be characterized by a singular process or methodology.

To the degree that actions depend on products, the design of action is thus shaped by what is available in the product milieu. When we refer to the design of products we are also referring indirectly to the possible acts that products enable. These actions may or may not be foreseen by the product designer. As an example of unforeseen action, we can think of the way Chinese students used fax machines to send information to the West during the demonstrations on Tienanmen Square in 1990. The fax machine in this instance became a people's telegraph, enabling the students to transmit information cheaply in order to gain support for their resistance.

The Influence of Products on Action

When Schutz discusses intersubjectivity, he does not give sufficient attention to the rhetorical aim of action. He emphasizes intersubjective understanding, suggesting that we address our actions to others as we come to know who they are. But a rhetorical interpretation suggests that actions are also attempts to persuade others to act differently than they might otherwise. As Richard Buchanan states, "By presenting an audience of potential users with a new product—whether as simple as a plow or a new form of hybrid seed corn, or as complex as an electric light bulb or a computer—designers have directly influenced the actions of individuals and communities, changed attitudes and values, and shaped society in surprisingly fundamental ways." [33]

The story of the Rollerblade is a good example of how a new product fulfills a rhetorical function. The Rollerblade is a skate whose wheels are arranged in a single line like the blade of an ice skate. It was developed in the Netherlands for racing on land and then adapted for summer hockey training in the United States. Initially the manufacturer sold in-line rollers that could be attached to ice hockey skates in the off season. The company then aimed the skate at the general fitness market. In 1987, it gave away hundreds of pairs of Rollerblades to beachside skate rental shops in Los Angeles, which led to the burgeoning of a Rollerblade subculture across the United States. The enthusiastic adop-

tion of these skates spawned a new line of ancillary equipment such as knee and elbow pads, and special helmets.

The Rollerblade success is not a typical story of product development. As Theodore Levitt has noted, "In spite of the extraordinary outpouring of totally and partially new products and new ways of doing things that we are witnessing today, by far the greatest flow of newness is not innovation at all. Rather it is *imitation*. A simple look around us will, I think, quickly show that imitation is not only more abundant than innovation, but actually a much more prevalent road to business growth and profit." [34] Levitt coined the term "innovative imitation," to designate a successful strategy of capitalizing on risks taken by other companies. He suggested that companies adopt a policy of "reverse R&D" to create their own versions of innovative products which are introduced into the market by others. Within Levitt's concept, companies might imitate newer products like the digital clipboard computer as well as more traditional ones like the coffeemaker. But they would normally have to offer some innovation to establish a market niche. This could be a slight improvement in function or form, or, as in the case of computer clones, a lower price.

Most products support traditional patterns of activity rather than create new ones. For every pair of Rollerblades, there are hundreds, if not thousands, of products, that conform to existing conventions of action. Seen in a broader sense than business competitiveness, product imitation supports these conventions through maintaining existing typologies of objects or services.

To better understand the interactivity between products and actions in the lifeworld we need a characterization that recognizes the full complex of objects, activities, systems, services, and environments that individuals engage with in three spheres of the product milieu. I call this complex the *product web*. At the center of each web is an individual or group that animates a set of relations with products. Some of the products in a web, such as a lipstick, are used by a single individual, while others, such as a public building, are shared by thousands of people. Some products, such as certain kinds of office equipment or networking software, are used only by groups. [35]

Market research tends to define users in relation to manufactured consumable products. The system known as VALS (Values

and Lifestyles), for example, identifies a spectrum of consumers that ranges from "belongers," who are considered conservative and conformist, to "experientials" who are regarded as innovators. While this research is useful for manufacturers who are concerned with identifying markets for specific products, it is misleading as a broad profile of user activity in the lifeworld.

Firstly, market research does not sufficiently account for the fullness of the product web. It defines use specifically in terms of primary market exchange rather than the broader milieu that includes civic projects as well as independent design. Even within the exchange framework, such research rarely accounts for the secondary and tertiary markets for used goods, for barter and underground economies, or for the things people make themselves with materials they buy. The definition of action within the market research framework is therefore limited by what is bought rather than by the totality of what is used.[36]

Whereas market studies such as the VALS system construct typologies of social actors which are located along a scale of product adoption that ranges from aggressive to passive, in actual fact the way in which product webs are constituted is much more complex. First, we must note the absence of a user profile that seeks correlations between the three spheres of the product milieu. Nor would such a profile be easy to ascertain. Given the extreme differences between the design processes in the three spheres, it is difficult to imagine how an engagement with them might be envisioned within a single personality type.

Barring the likelihood of a unified set of principles that might characterize different types of user action across the three spheres, we are left to reflect on the complexity of product use. While market surveys are often good at predicting consumer behavior within specific market niches, we are only dealing with one segment of a user profile in such cases and may well find through the kinds of interview techniques used by interpretive social scientists that people are inconsistent in their relations to different types of products. A community activist who is extremely involved in supporting a civic plan for a new health-care facility might be extremely passive in relation to new technology such as cellular phones, computers, or fax machines. Although this passivity can sometimes be attributed to the cost of such products, it may also be evidence of the different values that operate in the decision to

support a civic plan and one to adopt a new technological object. People have different tolerances and capacities for innovation and may trade off an activist practice in one sphere for a more passive engagement with products in another.

In a collective sense, product webs form patterns of culture that are both stable and innovative. The design of homes, for example, falls within a set of conventions that may vary only slightly for most people. According to these conventions, interior spaces are divided into kitchens, living rooms, bedrooms, etc. Experimental houses that differ from this division are rather rare within the total aggregate of dwellings. They become showcase homes, extensively publicized in architecture and design magazines, but not widely adopted by the public.

Conversely, we can cite among more innovative cultural patterns the continuous transformation of high-technology communication products—cellular telephones, computers, beepers, and fax machines—that are constantly being replaced by newer, more powerful ones.

Users interact with the product milieu, supporting those products such as the VCR and the personal computer that are valuable to them and ignoring those that are not. They engage in a process of indirect negotiation with producers by deciding whether or not a product is worth sustaining. When people either ignore a product or consciously refuse to use it, that product's influence wanes, and we even refer to a product's "death" when it is no longer deemed useful for human projects. Not only may small products like items of clothing disappear from the product milieu for lack of use, but large ones like buildings may be torn down or rehabbed for a new function.

The term "negotiation" denotes a relation between products and users that is flexible rather than fixed. When Karl Marx spoke about "commodity fetishism" in *Capital,* he presupposed a power that objects had over people.[37] We can call this a determinist relation. It is the base on which most Marxist and neo-Marxist critiques of consumer capitalism are founded. In such critiques, the market with its concomitant apparatuses of analysis and sales is at odds with the real needs of users who are persuaded to buy products they neither need nor value in a true sense. We can contrast this determinism with its opposite, user autonomy, exemplified by the user who is in full control of his or her projects and fashions a

product web independently of the stimuli and persuasive activities of others within the product milieu. Reductive representations of a consumer capitalism that dictates behavior through an aggressive manipulation of the market or a free market that postulates the consumer's autonomy are both inadequate to explain the product-action relation. I prefer to characterize this relation as one of negotiation rather than domination. This means that the locus of power is not inherently identified with either products or users. In given circumstances it may reside with one or the other but it may easily shift from one to the other or be divided between them. Therefore, we need interpretive strategies that do not prefigure an a priori power relation between the two. What makes more sense than either of these is the recognition that users relate to the product milieu interactively, trying to make a space for their projects and actions amidst an array of products and product proposals which they either support or resist in varying degrees.

Products are only successful if they can be incorporated into the product webs of enough users to develop sufficient networks of support. Involvement with a product may be as simple as purchasing it, which provides capital to the company that makes it. Greater engagement comes from utilizing whatever ancillary services are necessary to maintain it, or providing user feedback to the manufacturer. Besides the role of individual users in such networks, we should also acknowledge the involvement of advertising agencies, journalists, retailers, and others. It is the users, however, who provide the ultimate support through their informal constitution as a viable market.

New products do not simply appear in the lifeworld, but are heralded and accompanied by extensive promotional campaigns that both argue for their superiority to competitive products and suggest new uses. Ads that proclaim the value of having copying machines at home, for example, are attempts to change behavior and introduce an activity that was formerly reserved for the office into the domestic setting.[38]

In recent years the VCR, the personal computer, the fax machine, the video cassette recorder, the Walkman, and the copying machine, have all become important objects in the lives of many people. But the purchasers of these products do not necessarily follow the suggested uses of the manufacturers. Often they invent new actions and the objects become consonant with human

projects in ways that were not foreseen by their designers or manufacturers. A good example is the video of a group of Los Angeles policemen beating Rodney King, an unarmed black motorist who had been pulled from his car. The video was shot from a nearby balcony by a man who just happened to have his video cassette-recorder with him. The tape was shown on national television, instigated a countrywide debate on police brutality, and played a central role in the conviction of two of the officers.[39]

Conclusion

In this essay, I have attempted to present the product milieu as a unified field comprising spheres of activity that are not usually considered together. By joining the spheres of civic and state projects, the market, and independent design, I am proposing an experience of products that is continuous across the entire social space in which humans act. It includes objects designed with the most advanced technology as well as simple things that people make themselves.

The relation I establish between design, projects, and action may appear to some to be too liberal a use of the term "design." But I seek to recognize design as a fundamental constituent of all human action.[40] Hence, my interest in questioning the socially constructed distinctions between professional and nonprofessional designers and in delineating the social space for professionally designed products as only part of the larger space in which humans act.

My use of action theory as the basis for interpreting social behavior, along with my conception of product webs and product support networks, is intended to contest the often reductive postulations of a consumer culture in which people are manipulated by advertisers to buy things they don't need or should not have.[41] I have attempted to restore more power to the social actor, without asserting that the product milieu lacks influence on the way she or he lives.

Although the concreteness or presentness or products does constitute a discourse about action, it is only one among many. Discourses about how we might live take many social forms, from mythic projections to public debates. While actual products often

stimulate or arouse action, humans envisioned themselves flying well before the invention of the airplane and imaginative writers like Jules Verne and H. G. Wells were postulating the exploration of space and the ocean floor long before the technology existed to carry out these activities. Likewise discussions and debates about human values often precede the development of products that enable these values to be turned into action. The current debates about the relation between nature and the expansive domain of the artificial, for example, are affecting the realm of design and production in a way that will only increase in years to come.

In conclusion, my description of the product milieu is intended to expand our awareness of how we participate as designers and users in the lifeworld. Design, once narrowly defined as a marginal activity concerned with the aesthetic appeal of a limited range of consumer goods, can now be seen to be at the core of all our conceptions and plans for our personal and collective social lives. To recognize this concept and develop our understanding of it, we need such an all-encompassing terrain as the product milieu, where we can explore the multiple dimensions of design activity and the way it operates as a powerful instrument of social construction.

Notes

1. Saint Augustine, *On Christian Doctrine* (Indianapolis: Bobbs-Merrill, 1958), p. 9.

2. For an account of action theory in sociology see Jonathan H. Turner, "The Concept of 'Action' in Social Analysis," in *Social Action,* ed. Gottfried Seebass and Raimo Tuomela, Theory and Decision Library, vol. 5 (Doordrecht: Reidel, 1985) pp. 61–87. See also George Herbert Mead, *The Philosophy of the Act* (Chicago: University of Chicago Press, 1938); Max Weber, *Economy and Society,* trans. Günther Roth (New York: Bedminster Press, 1968); Talcott Parsons, *The Social System* (New York: Free Press, 1951); Alfred Schutz, *The Phenomenology of the Social World,* Northwestern University Studies in Phenomenology and Existential Philosophy (Evanston, IL: Northwestern University Press, 1967); Alfred Schutz and Thomas Luckmann, *The Structures of the Life-World,* 2 vols., Northwestern University Studies in Phenomenology and Existential Philosophy (Evanston, IL; Northwestern University Press, 1973); and Alaine Touraine, *Return of the Actor: Social Theory in Postindustrial Society,* trans. Myrna Godzich (Minneapolis: University of Minnesota Press, 1988).

3. See Abraham Moles and Elisabeth Rohmer, *Théorie des Actes: Vers une*

Ecologie des Actions (Paris-Tournai: Casterman, 1977). Moles relates his micro-psychological calculus of actions to the problem of product maintenance in "The Comprehence Guarantee: A New Consumer Value," in *Design Discourse: History, Theory, Criticism,* ed. Victor Margolin (Chicago: University of Chicago Press, 1989), pp. 77–88.

4. This is a condensed version of the definition Richard Buchanan and I adopted for the program statement of the Discovering Design conference where most of the papers in this volume were presented.

5. In a 1986 essay, prominent American designer George Nelson equated social improvement with a widening of design activity. He made reference to "a world where things used to happen and are now beginning to be designed." George Nelson, "Who Designs?" *STA Design Journal* (1986): 54.

6. There is a growing literature on all aspects of nonprofessional and participatory design. See, for example, Charles Jencks and Nathan Silver, *Adhocism: The Case for Improvisation* (New York: Doubleday, 1972); *Construire et Participation* (Paris: Centre Georges Pompidou/CCI, 1984); Helen Martin, "Do-It-Yourself und das Britische Interieur," in *Herzblut: Populäre Gestaltung aus der Schweiz,* ed. Martin Heller and Walter Keller (Zürich: Museum für Gestaltung, 1987), pp. 102–9; and David Johnson, "The History and Development of Do-It-Yourself," in *Leisure in the Twentieth Century* (London: Design Council, 1977), pp. 68–71. See also the series of articles related to the exhibition *Designing Yourself?* that was held at London's Design Museum (June 5–Sept. 15, 1991). These appear in the museum's journal *Issue* 7 (Summer 1991): 14–36.

7. The concept of a "milieu" was suggested by Marco Diani. Elsewhere I have used the term "product environment" to designate "everything that surrounds the product and becomes part of its identity and value." In this sense I intended the term to refer to those conditions that support the product's usability, such as replacement parts, repair services, and instruction manuals. See Victor Margolin, "Expanding the Boundaries of Design: The Product Environment and the New User," *Design Issues* 4, nos. 1–2 (1988): 59–64.

8. Langdon Winner, a political scientist, has written extensively about the political role of artifacts in daily life. See his essay "Do Artifacts Have Politics?" in the anthology of his writings, *The Whale and the Reactor: A Search for Limits in an Age of High Technology* (Chicago: University of Chicago Press, 1986), pp. 19–39, and his essay in this volume.

9. Among some groups of the early twentieth-century European avant-garde, notably the Italian Futurists, there was a fascination with an architectural milieu that was constantly changing. See, for example, the manifesto on Futurist architecture where F. T. Marinetti, adding to Antonio Sant'Elia's original document, makes the prophecy that "houses will last less long than we. Each generation will have to build its own city." Antonio Sant'Elia/Filippo Tommasso Marinetti, "Futurist Architecture," in *Programs and Manifestoes on 20th-Century Architecture,* ed. Ulrich Conrads (Cambridge: MIT Press, 1970), pp. 34–38. The idea of an even more transient environment was introduced in the 1960s by the British group Archigram, particularly with their Instant City project.

10. A number of thinkers in the postwar years have broadened the conception of design in order to address it outside the framework of professional activity. See László Moholy-Nagy, *Vision in Motion* (Chicago: Paul Theobald, 1947); Herbert Simon, *The Sciences of the Artificial,* 2nd ed., rev. and enl. (Cambridge: MIT Press, 1981); Ivan Illich, *Tools for Conviviality* (New York: Harper and Row, 1973); and John Chris Jones, *Design Methods,* 2nd ed. (New York: Van Nostrand Reinhold, 1992).

11. I use "nonprofessional" instead of "amateur" to designate a category of practice that is different from, rather than less than, what professionals do.

12. A helpful discussion of issues related to professionalization can be found in the first chapter of Donald Schon, *The Reflective Practitioner* (New York: Basic Books, 1983).

13. Lev Manovich, "'Real' Wars: Esthetics and Professionalism in Computer Animation," *Design Issues* 8, no. 1 (Fall 1991): 18–25.

14. Ivan Illich has made some particularly cogent arguments against the tyranny of professionals in such books as *Deschooling Society* (New York: Harper and Row, 1971); *Tools for Conviviality;* and *Medical Nemesis: The Expropriation of Health Care* (New York: Pantheon, 1976).

15. See Nigel Cross, "Discovering Design Ability," in this volume.

16. Ibid., p. 111–12.

17. Dick Hebdige, *Subculture: The Meaning of Style* (London: Methuen, 1979); and "Hiding in the Light: Youth Surveillance and Display," in Hebdige, *Hiding in the Light: On Images and Things* (London: Routledge, 1988), pp. 17–36. There is also an extensive feminist literature on the body as a site of power.

18. Philip Kotler, "Humanistic Marketing: Beyond the Market Concept," in *Philosophical and Radical Thought in Marketing,* ed. A. Fuat Firat, Nikhilesh Dholakia, and Richard P. Bagozzi (Lexington, MA: Lexington Books, 1987), pp. 272–88.

19. Since Kotler wrote his essay, this approach has gained wide credence among marketing theorists. See "King Customer," *Business Week* (March 12, 1990): 88–91, 94. It has also been central to the "quality movement" instigated by management gurus such as W. Edwards Deming and Joseph M. Juran. The movement is discussed in "Quality," *Business Week* (Nov. 30, 1992): 66–72, 74–75; and in Lloyd Dobyns and Clare Crawford-Mason, *Quality or Else: The Revolution in World Business* (Boston: Houghton Mifflin, 1991).

20. Kotler, "Humanistic Marketing," p. 276.

21. Paul Hawken discusses the relation of information to mass in products in *The Next Economy* (New York: Holt, Rinehart and Winston, 1983). Hawken distinguishes the mass economy from a new informative economy that is replacing it with products that are more differentiated, efficient, and better adapted to user projects.

22. See *Political Writings of William Morris,* ed. and with an introduction by A. L. Morton (New York: International Publishers, 1973).

23. The California custom-car subculture offers another example of how people represent themselves in products of their own design or redesign. For

a lively account of this subculture, see Tom Wolfe, "The Kandy-Kolored Tangerine-Flake Streamline Baby" in his book by the same name (New York: Pocket Books, 1966), pp. 62–92.

24. Alfred Schutz and Thomas Luckmann, *The Structure of the Life-World,* vol. 2, trans. Richard M. Zaner and David J. Parent, Northwestern University Studies in Phenomenology and Existential Philosophy (Evanston, IL: Northwestern University Press, 1989), p. 1.

25. Ibid., p. 2.

26. I find the term "project" useful in circumventing the fruitless attempts to distinguish between needs and desires. Ostensibly needs are basic requirements, and desires are either superfluous or undesirable. But who makes this judgment? A project is simply a focus for action which can be given various meanings by different value systems.

27. Ibid., pp. 18–19.

28. Ibid., p. 19.

29. Alfred Schutz, *The Phenomenology of the Social World,* trans. George Walsh and Frederick Lehnert, Northwestern University Studies in Phenomenology and Existential Philosophy (Evanston, IL: Northwestern University Press, 1967), p. 139.

30. Ibid., p. 150.

31. Ibid., p. 75.

32. The Italians use the concept of projection in a more restricted way. Their term *progettazione* refers specifically to the industrial product. *Progettazione* is also embedded in a culture of *progettistas,* or designers who together form a "culture of the project." For an elaboration of the latter term, see Maurizio Vitta, "The Meaning of Design," in *Design Discourse,* ed. Margolin, pp. 31–36. A book that made an extremely important contribution in the early 1970s to the literature on *progettazione* in Italy was Tomás Maldonado's *La Speranza Progettuale: Ambiente e Società* (Torino: Einaudi, 1971), translated into English as *Design, Nature, and Revolution* (New York: Harper and Row, 1972). Because Anglo-American culture lacks the Italian understanding of design as a project, Maldonado's book went almost unnoticed in its English translation.

33. Richard Buchanan, "Declaration by Design: Rhetoric, Argument, and Demonstration in Design Practice," in *Design Discourse: History, Theory, Criticism,* ed. Victor Margolin (Chicago: University of Chicago Press, 1989), p. 93.

34. Theodore Levitt, "Innovative Imitation," in *The Marketing Imagination,* new and exp. ed. (New York: Free Press, 1986), pp. 200–201.

35. Companies that sell products through catalogs often try to create product webs for specific kinds of customers. One of the more interesting of these attempts is *The Sharper Image Catalog,* which combines products that relax the body, sports equipment, novelty fashions, products to enhance sexual pleasure, and high-end small appliances. At the center of this web is a mythical male with plenty of discretionary income and time and extraordinary taste in products and companions.

36. This is beginning to change, however, particular within the burgeoning

field of consumer research, which brings a more interpretive rather than directive approach to questions of consumer behavior. For an excellent summary of contemporary tendencies within this field, see John Sherry Jr., "Postmodern Alternatives: The Interpretive Turn in Consumer Research," in *Handbook of Consumer Behavior,* ed. Thomas S. Robertson and Harold H. Kassarjian (Englewood Cliffs, NJ: Prentice-Hall, 1991), pp. 548–91. A useful case study is Sherry's article "A Sociocultural Analysis of a Midwestern American Flea Market," *Journal of Consumer Research* 17 (June 1990): 13–30.

37. Karl Marx, "The Fetishism of Commodities and the Secret Thereof," in *Symbolic Anthropology,* ed. Janet L. Dolgin, David S. Kemnitzer, and David M. Schneider (New York: Columbia University Press, 1977), pp. 245–53.

38. Canon, through its spokesperson Jack Klugman, has been particularly active through its print advertising in promoting a small copier for home use. Among the projects the company proposes are copying recipes, making greeting cards, doing school projects, and reproducing children's drawings.

39. "Victim of Videotaped Police Beating Released without Charges," *Chicago Tribune,* March 7, 1991.

40. I have avoided the binary distinction between rational and irrational action because I believe with many psychologists that so-called irrational action is designated as such only because of a prior norm of what is rational rather than because it is unplanned or has no strategic value.

41. This rhetoric has a long history which extends back to Karl Marx's notion of "commodity fetishism" and continues through Veblen's formulation of "conspicuous consumption" as a symbolic act, Vance Packard's characterization of advertising agencies as "hidden persuaders," and Victor Papanek's characterization of advertising design as "the phoniest field in existence today." According to Papanek, in his preface to *Design for the Real World* (New York: Bantam Books, 1972), "Industrial design, by concocting the tawdry idiocies hawked by advertisers, comes a close second."

Political Ergonomics

Langdon Winner

Politics and design: what is their shared territory? At first glance the two spheres of practice seem to have little in common. Politics, after all, concerns human affairs in flux, the colorful motion of public life—rising and falling contenders for influence, volatile coalitions, unpredictable contingencies, and bitter partisan struggles. To be engaged in politics involves speaking and doing, trying to persuade or coerce others within a continuing drama that includes intense negotiations, deals, and power plays, few of which have any neat, enduring contours. Design, in contrast, usually centers upon the production of lasting patterns in artificial things, the attempt to give shape to things expected to be fixed, stable, well-planned, even inert. Far removed from the bustle and verbal din of political machinations, design focuses upon objects that are useful and/or beautiful in the satisfaction of human purposes. While the activity of design sometimes involves "political" battles within organizations and between professionals and clients, its focus seems entirely different from what we normally consider politics—election campaigns, lobbying,

governing nations, the conduct of international relations, and the like.

But judgments of this kind are no longer helpful; the conventional boundaries that once separated design from politics have begun to dissolve. In advanced industrial society, relationships of power and authority are frequently expressed in material settings that are deliberately designed and built. Within ongoing processes of technological innovation, basic patterns of private and public life are continually reorganized, renegotiated, and reconstituted. Many of the qualities in key relationships and common practices of civic culture arise directly from the making and use of instrumental devices and systems. Hence, the structure of a new transit system reestablishes the boundaries that connect or separate different socioeconomic communities; the shape of new instruments in the workplace redistributes power, competence, and the possibilities for decision-making; the built forms of a new communications system open possibilities for expression by some in a community while excluding others.

In this light, what are often taken to be mere tools and instruments are better seen as *political artifacts* that strongly condition the shared experience of power, authority, order, and freedom in modern society. By the same token, an interplay of demonstrably political forces is often decisive in determining what forms of instrumentality—and, therefore, of instrumentally based political conditioning—a society will contain. To comprehend modern politics fully, therefore, one must understand the selective forces that influence the shape of useful material things as well as the role that these patterns play in shaping human affairs. Here politics and design meet face to interface.

This topic is not one upon which modern thought has been deeply discerning. Several intellectual idols have long posed barriers to new thinking: the myth of progress, unquestioning faith in growth, uncritical tool/use notions, the idea of technical "neutrality," recurring lures of technological utopianism, and the dominant idea that technological development is basically an economic race in which competing firms and whole nations charge ahead or fall behind. Such concerns still occupy a central place in discussions about what technological choices mean and what people ought to do as a consequence. For the most part public

deliberations about these matters focus only upon first-order technical advantages and expected contributions to economic growth. As long as the gross domestic product is increasing, all is well (or so most politicians believe).

An interesting challenge for those able to shake the hold of these modernist conventions is to articulate a positive, critical, and perhaps even practical position about the possibilities that patterns within specific technologies present to social and political life. How that inquiry might advance a step is my theme here.

For clarification on this question one looks in vain to the two major traditions of modern political thought, liberalism, and Marxism. By and large both schools of thought are committed to a view of the human relation to material things that identifies the key question as the production and distribution of wealth. Seen from that vantage point, technology—the collection of instruments, techniques, and systems available to society at a given time—is regarded as a vast cornucopia. Liberalism and Marxism are at one in celebrating industrialism's horn of plenty and assume that advancing technology and economic growth are ultimately beneficial to humankind.

Marxism once seemed to offer a promising variant of the modernist, economistic faith, looking forward to a revolution in the ownership and control of the means of production as the source of a new beginning to remedy the ills of capitalist society. But the hopes this message inspired were to a great extent undermined by the theory's commitment to the institutional and material patterns characteristic of capitalism. While Marxist socialism promised the abolition of class power, redistribution of wealth, and restructuring of society, it typically assumed either (1) that the same tools and instruments developed within capitalist industrialism would be compatible with the ends of a socialist state and/or (2) that the creation of a social system founded upon emancipated social principles would inevitably bring a reform of the systems of material life. As a consequence, further reflection about the politics of technology or practical research on the topic was usually thought to be unnecessary. Occasional creative experiments in the design of workplaces and living arrangements, for example, in the Soviet Union of the 1920s, stand in direct contrast to the policies of mainstream Marxist states. In practice, such regimes have been notorious for mimicking the material forms of

capitalism and for going even further to generate enormous, grotesque models of industrial production and political display.

In the last analysis, neither the liberal nor Marxist traditions have been much interested in probing the relation between the choice of specific patterns within technology and the qualities of a good society. Both persuasions have welcomed new technical systems as basically neutral while celebrating their contributions to economic growth, efficiency, and the limitless development of "forces of production." While there have been occasional exceptions in both traditions—optimistic souls and social movements willing to speculate about sociotechnical structures more graceful than those developed during the industrial age—these exceptions merely highlight the dominant point of view. Nothing in theories billing themselves "postmodern" has done much to address the prevailing lack of imagination on this score. Postmodernism shares the modernist willingness to leave the boundary between politics and design well enough alone, producing critiques without a vision of practical alternatives.

The Category of Work: A Project of Design

The strong but largely unacknowledged relation between design and politics emerges from the fact that particular devices or systems which contain important social consequences do not first appear as single, unambiguous, finished entities. In many cases there exists at the outset of a particular variety of technological development a spectrum of possibilities for the creation of devices with a variety of features. There are many patterns that an artifact or system can assume, each pattern likely to generate somewhat different sorts of social and environmental consequences than alternative ones. From that spectrum, social actors eventually select the form of the device that eventually becomes an object in common use. One way in which such choices are expressed is in the design of both material objects and the institutions that accompany them.

But it is not enough to conclude, as sociologists and historians recently have done, that "technology is socially constructed." For unless one presents an argument about how different alternative constructions matter to people's experience in political society, analyses of social construction say little more than that human

actors and social processes produce various patterns of techno-logical change, something everybody knew anyway. Reports of Martian constructions of technology remain largely unconfirmed.

A more fruitful way to think about design and politics, in my view, begins from the recognition that things shaped, built, and put to use can be seen as "works." I use that term in the sense suggested in Hannah Arendt's *The Human Condition* in which "work" is identified as a fundamental category within the *vita activa,* distinguished from "labor" and "action." What charac-terizes work in this view is *the making of things that will en-dure*—works of art, poetry, architecture, monuments, industrial machinery, among others. The works of our hands provide a last-ing, artificial framework for the biological processes of labor in which human life is endlessly produced and reproduced. At the same time the works fashioned by architects, engineers, poets, and political founders provide stage settings upon which the ongoing dramas of political action are mounted. As Arendt explains, "In order to be what the world is always meant to be, a home for men during their life on earth, the human artifice must be a fit place for action and speech, for activities not only useless for the neces-sities of life but of an entirely different nature from the manifold activities of fabrication by which the world itself and all things in it are produced."[1] To have built the furnishings of such a world properly means that human words and deeds arise within stable, artificial structures of support, ones well suited to the practices of public life. In this light, special care must be taken in the fashion-ing of all things built to last.

Arendt did not pursue the implications of her argument about work through a discussion about the range of possible relations between work and politics. In her view the conceptual territory that urgently needed to be reclaimed in modern political thought was that of "action." The rise of modern political society had ig-nored or suppressed roles and institutions where citizens could experience freedom by taking action in public life. While she rec-ognized that the works of technology were profoundly troubling from the standpoint of her political philosophy—creating labor-ers undermined by automation and citizens bedazzled by con-sumption and media spectacle—Arendt did not propose any-thing like the reconstruction of technological society or a vocation

that would undertake the task of providing an agreeable world as a backdrop for modern citizenship.

As one takes up inquiries about work and its relation to the quality of public life, the moment of design is never far from view. For a crucial stage in the introduction of any work is the point at which alternative features and configurations of a device or system exist as abstract possibilities subject to imaginative manipulation. Within the realm of things made to endure, the activity of design chooses from among these possibilities, eventually offering an idea, plan, diagram, or blueprint proposed for implementation. For anyone concerned with conditions that shape political society, a crucial question becomes: Do our enduring, useful artifacts enhance or frustrate the possibilities of free, meaningful activity within human communities?

Speculation about design and alternatives in design can be especially fruitful because it pushes attention to the making or construction of technical artifacts back to the drawing board, back to a point before choices have hardened in cement or in other finished material or organizational structures. To seek genuine choice in technology—a matter about which there often seems to be no option but to respond to firm economic imperatives—involves an effort to explore alternative prospects for the making of useful devices and to understand what importance those options would have in practice. If we are to appreciate qualitative differences between the works found in a technological society and the forms of civic life they sustain, such differences must first be seized within the space of design possibilities.

There is as yet no well-developed discipline or well-focused tradition of thought and practice that tries to do this, to specify which patterns of material, instrumental systems are well suited to different kinds of political conditions, especially ones worth sustaining. Which avenues of inquiry could help open this topic?

One can imagine many ways to proceed, many research projects that might be undertaken. A fruitful approach, for example, would be to move deductively, identifying and defending desirable goals of political association and matching them to patterns in the devices and systems that correspond to those ends. While this path is obviously a promising one, it risks becoming fixated on issues at the front end of the design project, arguing endlessly,

as philosophers are inclined to do, about the grounds for adopting one set of first principles as opposed to another and never moving on to any thoroughgoing speculation of how the ideas might be implemented. Thus, one focuses upon a theme (justice, order, authority, freedom, or some other), explores its properties in depth, and eventually argues a position on the matter. But at the end of the day philosophers tend to pay little attention to how their grand position statements can be translated into practical programs. This is especially true of speculations aimed at the realm of technical/instrumental things. Faced with a world of rapidly emerging technologies, the reflections of political philosophers and political scientists have tended to stall out, and they have taken shelter behind the nostrums of the economists when nothing else comes to mind. An astonishing weakness in modern political theory is that, in the midst of multiple technological "revolutions," it includes scant critical attention to the qualities of structure within the realm of things made to last. The relation between cherished political principles and their realization in design and construction seldom receives focused exploration, as if desired outcomes will somehow emerge automatically, as the beneficent contribution of divinely inspired "progress."

If we are to proceed on firmer ground, another pathway must be found. Recognizing that the politics of design is not a highly developed contemporary art, it is also worth noting that there are many historical contexts and traditions in which design has been a project invested with considerable care and intelligence. While much of this experience is not directly useful to today's problems, there are many concepts, episodes, and material patterns from the past that one can draw upon as one ponders present choices. Noticing what historical examples and traditions of practice have to suggest and where they fall short, one can begin to develop an understanding of design that could be usefully applied to contemporary technological choices and their political dimensions. To that end I have chosen to examine briefly both the actual works and styles of discourse found in three traditions of design: (1) statecraft, (2) architecture and urban planning, and (3) engineering. What ideas are central to the conception of design in each of these traditions? How do they view the relation between form and content in the structures they study? How do they treat issues about the contribution of design to the quality of social and

political life? Each of these traditions of practice contains important features that the others lack. Taken together they provide a suggestion as to what a positive, critical, and perhaps even practical philosophy of technological design might be.

Statecraft

From its beginnings in ancient Greece to the present day, political thought has involved the attempt to describe, explain, and justify structures of public life. In that context political philosophers and statesmen have often been interested in issues of design, usually the design of institutions. Thus Plato and Aristotle asked: What is the structure of the best state? Political science began with that question. At its culmination, Plato's *Republic*—paradigm of paradigms in Western political thought—offers a design for an ideal political society, a design that derives from and expresses Plato's idea of justice, which he insists is a reflection of a higher knowledge, the knowledge of the forms. Plato's dialogue *The Laws* goes even further, spelling out institutional shapes and practices in some detail. But it is not merely the idealists and visionaries in Western thought who have recognized the importance of political design. Indeed, one of the identifying marks of political philosophy is that it deals with what are ultimately practical matters, including recommendations about the organization of society. If a theory succeeds fully, it may well include something like blueprints for its own implementation.

As we have already seen, however, many political philosophers tend to dwell upon the earliest stages of the process of political design—developing general arguments for adopting certain underlying principles in public matters—rather than upon specific, detailed plans for realizing the principles in institutional form. In Thomas Hobbes's *Leviathan,* for example, the primary effort is to give strong reasons for justifying submission to absolute authority; however, Hobbes says very little about what form the specific institutional prescriptions for such political authority would take. Similarly, in our time John Rawls's *A Theory of Justice* develops a critique of utilitarianism and a theoretical defense of social contract as the basis of government. But while Rawls wants us to understand that his concept of justice as fairness ought to influence how we might design whole constitutions or specific governmental programs, he devotes comparatively little attention to spe-

cific institutional design features expected to generate conditions specified by his theory. Philosophers tend to assume that once we have our fundamental principles clarified and well grounded, it will be a fairly trivial matter to decide what institutional forms should embody those principles. Even socialist thinkers (Marx leading the way) who were eager for a thorough reconstruction of society tended to refuse speculation about the design features of the organizations of postrevolutionary society, arguing that such work is best reserved for the revolutionaries themselves. Unfortunately, that attitude has contributed to a view within socialism that to be thoughtful about design is an exotic luxury rather than a task crucial to achieving a revolution's ultimate goals.[2]

Western political thought, however, also contains moments in which design is a central concern. Some writers and practitioners have recognized that there is a certain wisdom and craftsmanship about the matter that might be cultivated. That understanding of statecraft looms large in the works of the ancient Greek lawgivers—Solon, Lycurgus, Cleisthenes, and others—whose notable contribution was to create laws establishing the basic framework of the state. Similar concerns are expressed in Polybius's writings on the mixed constitution, a pattern of power-sharing that Polybius observed in the historical evolution of the Roman republic and recommends as a universal device for maintaining political order. Such concerns for the relation between general ends and the design of institutional features are renewed in modern thought in the works of Baron de Montesquieu, Jean-Jacques Rousseau, the American Founders, and a number of anarchists, utopian socialists, and feminist reformers: Charles Fourier, Robert Owen, William Morris, Pyotr Kropotkin, and Ellen Swallow Richards, to name some of the more prominent.[3] What these figures share is a sense that the quality of social and political life is crucially affected by the form of the institutional patterns a society adopts. While most utopian speculation has focused upon the rules, roles, and relations of political and social order, there have been occasional attempts to spell out which specific economic practices and varieties of technical equipment—housing arrangements, factory design, and the like—are congruent with the workings of a good society. That many of the specific recommendations of utopian design seem unworkable today should not

prevent us from acknowledging that the basic thrust of these projects confronted an important challenge.

In a more practical, robust manner the framers of the U.S. Constitution took up the intricate work of expressing a number of well-explored first principles—liberty, equality, limited power, republican government—within a coherent set of institutional design features that would embody those principles in a practical, enduring way. Collecting what they found best from previous theories and historical cases, they refashioned them as parts and pieces of the audacious political erector set finally unveiled at the Constitutional Convention in Philadelphia in 1787. Interestingly enough they used some terms and metaphors also found in eighteenth-century natural science and engineering—the notion of checks and balances, for example—to help clarify the design features of their grand invention, the U.S. Constitution, a device whose operation generation after generation would produce certain predictable qualities in the nation's public and private affairs.[4] As a nineteenth-century commentator observed, Americans came to regard the Constitution as "a machine that would go of itself," a device that would produce predictable patterns of political behavior generation after generation.[5]

From this standpoint the crucial question is not only what justifications in principle can we give to support the adoption of certain kinds of laws, practices, and institutions, but also on what basis can we suppose that the laws, practices, and institutions we propose will have the desired effect? This involves theoretical understanding of the relation between patterns in things made to last and the anticipated experience of those who will use or otherwise encounter those patterns. The idea of separation of powers, for example, involves a theory about the influence of these institutional structures upon the exercise of power. In this light, projects in statecraft all contain a moment in which they must treat the relation between form and substance in politics. At that point the question becomes: How clearly is that relation specified and what institutional pattern does a thinker or politician recommend?

In a period in which many aspects of political life are expressed in and around technological systems, the traditional concern of statecraft—creating "good order"—must be refocused to include

structures and processes beyond those of government as such. At least as important now are the artificial patterns, including technology-centered patterns, that affect civic culture—the broad range of social relations, personal habits, popular beliefs, and styles of communication that give any political system its distinctive character. Of course, not all of what comprises civic culture is directly connected to the design and making of technological devices. There is more to it than that. But if the traditional concerns of "politics as making" are to respond to the challenge at hand, technological design must become a focus of political reflection. If Alexis de Tocqueville were visiting the United States in the late twentieth century, his book on its customs might well be entitled "Technology in America."

Architecture and Urban Planning

In the tradition of Western architecture and urban planning similar questions arise, this time in the context of the making of material forms. How do the shapes of buildings, cities, and furnishings influence patterns of human interaction? How can one translate ideals about community and good order into the design of material structures?

Concerns of this kind are found at least as early as the ancient Greeks. Thus, Hippodamus of Miletus, legislator, urban planner, and flamboyant aesthete, offered city-states a design for good order that entailed a geometrical urban gridwork in which different social classes were to be located, arguing that such an arrangement would provide a positive imprint upon the life of any city that adopted it. In the *Politics* Aristotle notes that "Hippodamus was the first to discourse about the Best State," and describes how the innovative town planner tried to realize ideas of the good society in physical embodiment as well as constitutional rules, a project that Aristotle cites with interest in his general overview of Greek political institutions.[6]

Certainly the work of medieval cathedral builders, Abbot Suger of St. Denis, for example, shows a very strong sense of the meaning of material patterns for human experience. The physical shape of the cathedral was to reflect the religious and philosophical ideals of Christianity. The practical problem was how to render those ideals in built form. Once the structure was in place, those who experienced the building would receive a spiritual

imprint to help them live as better members of the Christian community. This sense of things is reflected in the Latin root of the words "edifice" and "edification," *aedificare,* which means both to build and to instruct. A work of architecture builds something within the souls of men and women.[7]

In its very nature the vocation of architects and urban planners involves a commitment to environmental determinism, at least to some degree. For the past two centuries there have been heated debates among practitioners and theorists about the extent to which it is legitimate or even possible to use architecture to impose social or political ideas. Among those most sanguine in this regard were Frank Lloyd Wright and Le Corbusier, both of whom offered comprehensive proposals for a good society to be expressed in the material configuration of buildings and whole cities.[8] As Peter Hall has noted, urban plans of this kind spring from the grand ideals of the nineteenth-century utopian thinkers and express the utopian desire to make urban dwellings a heaven on earth.[9]

Unlike political theorists, architects seldom engage in lengthy speculation about underlying principles of justice, freedom, or social order. But architectural thought is strong where political theory has often been weak, exploring in detail the reasons why a particular design could be expected to have desirable consequences. As contemporary architect Christopher Alexander describes the issue, "It is certainly not enough merely to say glibly that every pattern of events resides in space. That is obvious, and not very interesting. What we want to know is just how the structure of the space supports the patterns of events it does, in such a way that if we change the structure of the space, we shall be able to predict what kinds of changes in the patterns of events this change will bring."[10]

Nineteenth-century architects and architectural critics frequently took the view that what was socially and politically significant about buildings were the symbolic qualities embedded in their forms. For example, John Ruskin's idiosyncratic masterwork *The Stones of Venice* defends the Gothic style as an expression of aesthetic and moral strength while heaping scorn on Renaissance architecture as corrupt. The book brashly proclaims that when we are in the presence of true Gothic architecture or participate in its building, our souls are ennobled; when we

encounter structures informed by less noble ideals, our souls suffer. Ruskin's arguments for these conclusions are fairly murky. There are intimations of what theory of architecture and public life would explain, a theory that connects recurring individual aesthetic perceptions to the qualities of moral and political life in society as a whole.[11]

Twentieth-century architectural thought is, in comparison, typically much more behavioristic. The architect tries to influence social experience by arranging collections of material features that constrain or enable activity in particular ways. Those who use the buildings find their lives determined in part by the pushes and pulls the built environment creates. Christopher Alexander's own work offers a fascinating perspective on this topic. His book *A Pattern Language* spells out some 250 or so patterns of spatial relation that embody the good life as revealed by his work of grand theory, *The Timeless Way of Building*.[12] His writings explore explicitly and in detail what architects have been concerned with for centuries: how the shape of the spaces we encounter affects the qualities of individual and social experience. Similar explorations are taken up by urban planner Kevin Lynch, who offers a vision of the "good city" as one that helps individuals and groups freely develop their potential. On that basis Lynch identifies several "performance dimensions" of the "good city form." His suggested dimensions—vitality, sense, fit, access, control, efficiency, and justice—are applied to choices about the spatial organization of cities.[13] But they could, with some modification, be applied just as well to the political artifacts of statecraft and engineering.

Whether in the mode of Ruskinian symbolism or the environmentalist/behaviorist orientation of twentieth-century architecture, the theory of architecture and society usually hinges on a notion of resonance between material form and civic culture. Something in the movement of the human body or the body politic finds resonance with the fixed structures of buildings. While this something has always been difficult to pin down, it seems increasingly difficult to form any consensus about the relation between the built forms of architecture and life to political society as a whole. A characteristic of the postmodernism and deconstruction of our time is a pronounced skepticism about the ability

to assign meanings to architectural patterns. Reacting to the optimism of modernist reform programs of earlier decades, postmodernism recoils at what it takes to be the failure of the international style and restores decoration to buildings in an aesthetic of sheer whimsy. Postmodernists who invoke stylistic signatures of the past within functional patterns of homes and offices have at the same time rejected the modernist conviction that these patterns will have any predictable, positive effect. What one can do is to elicit a chuckle and nod of appreciation from the cognoscenti who have memorized Jacques Derrida's maxim that there "is nothing beyond the text." That buildings in this style are typically funded by large business firms and stand as monuments to them points to a growing cynicism about the cultural role of design. In a more positive vein, today's mood of irony and distance challenges us to ask more critically what is known about the relation between what architects hope to accomplish and what people actually experience when confronted with particular architectural forms.

Engineering

A third tradition of work that can illuminate the study of politics and design is that of engineering. Its approach resembles architecture in that it deals directly with the world of artificial material structures; in fact, an early Roman treatise on architecture, Vitruvius's *The Ten Books on Architecture* of the first century B.C., identifies engineering as merely a branch of architecture. In the modern era, of course, the primary concern of engineering has been not so much the making of spaces and places, but rather the creation and application of useful tools, techniques, and systems. For such purposes engineering has developed its own distinctive ways of handling issues of form and substance, focusing upon such principles as functionality, efficiency, cost-effectiveness, and elegance of instrumental performance. Following such principles today, a great deal of engineering design is explicitly oriented toward problem-solving. Engineers work on design problems employing more or less explicit design criteria which in turn reflect certain underlying goals of technical improvement and economic gain. The designers of a new automobile part, for example, might seek to improve the performance of the part while at the

same time striving to reduce production costs; designers of computer chips try to compress the largest computing power into the smallest possible space at the lowest competitive price.[14]

As it has arisen so far in industrial society, the vocation of engineering has devoted relatively little effort to examining or justifying the social theories or social role its vocation implies. Its efforts lie at the opposite end of the spectrum of thinking from that occupied by philosophers and political theorists, focusing upon immediate practical tasks rather than abstract speculation. Indeed, one can say engineering is strongest where philosophy is notoriously weak: finding solutions robust enough to withstand a great many practical contingencies.

Although this trait is by no means necessarily entailed by the nature of their vocation, engineers have seldom engaged in thoroughgoing self-reflection about the social or political meaning of design work they do. In general they have simply accepted as sole context for their work the goals handed them by the business firms, government agencies, and the military branches that employ them. Social histories of engineering point to the fact that it has never succeeded in becoming a truly independent profession in the way that, for example, law and medicine clearly have.[15] For the most part engineers expect that the primary authority to establish design criteria and design specifications rests in the hands of property owners and corporate managers. Indeed, a typical career path for a capable engineer is to move up the ranks to another quasi-profession—management.

Nevertheless, within the boundaries that define its work, engineering design sometimes does express an ethic or ideal. As a number of historical studies have shown recently, engineering design has often sought to contribute to democracy in some sense by creating the kinds of systems, processes, and products that make both the necessities and conveniences of life available to a mass populace at a reasonable price. In the field of industrial design, for example, Walter Dorwin Teague's designs for the Kodak camera and Henry Dreyfuss's work for Bell Telephone are examples of this belief in action.[16] Numerous examples of a similar faith can be found in the engineering of water systems, transportation systems, electrical power systems, and the like where the democratic idea is expressed as the goal of farsighted planning to provide for

the long-term material needs of a growing populace. This is a design ideal compatible with the institutions of a market-oriented, consumer-oriented society. It is also an ideal in harmony with the view that technology is a kind of cornucopia.

Usually missing from the perspective of engineering is any sense that there might be a special wisdom and skill required to match the form of technology to nonmaterial social and political ends, for instance, those of freedom, justice, and democratic participation. Attempts to provide a positive political philosophy for engineering have failed utterly. In the early twentieth century Thorstein Veblen argued that the engineers' devotion to efficiency set them at odds with the captains of industry and made them a potentially revolutionary class. Similar notions inspired the organization Technocracy, Inc., led by crackpot visionary Howard Scott in the United States during the 1930s. But this initiative attracted only a tiny following. The call for engineers to mobilize and define an independent public role is certainly a legitimate one. But the notion of efficiency is not a suitable rallying point because it lacks any genuine substance; one must always specify the basic ends that serve as the reference point for any efficiency measure. The exploration of fundamental ends, however, is just about the last thing practicing engineers are asked to do. If one could begin to discuss alternative numerators and denominators for measuring efficiency, the topic would certainly be much more lively. But it would involve entering a realm of discourse where engineers often feel uncomfortable, a realm in which there is never any guarantee of a right answer or best solution.

Political Ergonomics

This brief survey has noted some fragments of culturally available understanding that might be woven together within a project to decipher the political significance of technological design. Among the fields I have discussed, there are both interesting similarities and differences in their approaches to the making of things that will endure. In summary, statecraft and its corresponding political theories have a great deal to say about the first principles that underlie the choice of institutional patterns. In some cases a

political vision will include the elaboration of specific design criteria and even some ingenious mechanisms of implementation. But to this point few political thinkers or politicians have recognized the need to apply such wisdom to patterns in modern technology. At a time in which technological change is everywhere recognized as a potent element in changing the conditions of social and political life, this lack threatens to render irrelevant much of what passes for political thought in our time.

In comparison, architecture and urban planning have a rich heritage for exploring the relation between the shape of material things and the experience of social life. They are committed to the view that design is crucial to the quality of human interaction and even claim to provide detailed knowledge on that score. But the focus of these traditions is usually limited to the features of towns, cities, and buildings. It has little to say about technology as such, other than to draw upon new materials and techniques for building.

The vocation of engineering, of course, does treat changing technology directly. Indeed, the works and pronouncements of some practitioners show an increasing awareness of the ethical dimensions of technological choices. But for a variety of reasons engineering shows little of the subtlety about the political dimensions of design found in either architecture or classical statecraft. Although it is the vocation closest to the actual shaping of new technologies, it is as distant as any of them from comprehending the meaning of that shaping power.

The important unfinished task, therefore, is that of learning to decipher the design features—both general and specific, large and small—of technological devices for their social and political significance. Equipped with that ability it would be possible, in principle, to anticipate and guide the contribution that a particular device or system makes to the quality of political society. In much the same way that political thinkers of the past have praised the qualities of bicameral legislatures, separation of powers, checks and balances, judicial review, and the like, a politically astute observer in an age of pending technological revolutions ought to be able to specify which sociotechnical forms are desirable or undesirable and why.

The field of study I am recommending might be called political ergonomics. The term "ergonomics" is used by engineers and

industrial designers as a name for the process in which the shape of a useful instrument is tailored to the human form.[17] At issue is the physical fit between bodies and tools. Hence, the instruments in the cabins of airplanes are ergonomically arranged to give pilots optimal access to their controls. Office chairs are ergonomically designed to match the contours of the body. The hardware and software of later-generation personal computers have been ergonomically fashioned to provide ease of use. The linguistic root of the concept is, appropriately for our purposes, the Greek *ergon,* which means "work." As practiced by most engineers and industrial designers, such work is narrowly focused upon ways in which instruments do or do not offer ease of individual performance; however, the social, moral, and political dimensions of the human relation to material implements are seldom taken into account.

The study of political ergonomics, in this sense, is a logical outcome of the critical study of technology and politics that has been brewing in much of twentieth-century thought. Many criticisms about the relation of technology and social life are actually a commentary about an unhappy fit between the two. If different forms or designs of technology are suited to qualitatively different forms of social and political existence, then the science of politics must include an ergonomics able to specify a suitable fit between the body politic and its instruments. Which kinds of hardware and software are distinctly compatible with conditions of freedom and social justice? How can we design instrumental systems conducive to the practices of a good society? And how can we prevent the introduction of technologies at odds with the kinds of personal habits, social relationships, and institutional patterns needed to sustain the civic culture of democracy?

At present there exists no focused practical art or organized field of inquiry that addresses such questions. I have suggested that by comparing the activities of design in three traditions, one may find some bearings to orient new work. But that proposal must be more specific. What is it that allows us to compare these domains of work and their projects of design? What sorts of correspondence can be found among the design traditions I've mentioned?

In one way or another each of the three traditions deals with recurring issues of structure. Statecraft, architecture, urban plan-

ning, and engineering share the desire to create structures meant to endure for long periods of time. The structures at issue can be interpreted and compared for the ways they establish coherent patterns of enablement and constraint within a given medium or set of related media; all three traditions seek to create structures that strongly encourage certain outcomes while preventing others. To recognize patterns of enablement and constraint within qualitatively different media offers a way to compare the practical works and intellectual themes of the three approaches to design.

Thus, the structures of interest to statecraft are composed of rules, roles, and relations within social and political life. Political theorists interested in statecraft attempt to explain why certain laws and organizational arrangements are better than others. In a true sense the structural objects in focus here are intangible. The ultimate force that underlies political authority, for example, is the widely shared belief in legitimacy of certain institutions, offices, and practices. Ultimately, what many political theorists hope to accomplish is to install a particular design within a society's collective political consciousness. A law, constitution, or government, habitually observed, enables certain activities and interactions to emerge while discouraging others.

Architecture and urban planning, by comparison, deal with structures that are at some level entirely tangible. The significance of a building or city plan is ultimately the pattern of material forms they present to their inhabitants. Rooms, doors, hallways, ceilings, and windows present users with physical forms that enable some varieties of social interaction to occur while constraining others. It is also true that there are added on to buildings social rules that specify who gets to use which space and under what conditions. At times architecture deals with establishing such rules. Its primary emphasis, however, is less the creation of rules than the expression of enabling and constraining features within physical mass.

In the same light engineering contains aspects of both architecture and statecraft with some additional features as well. Part of its work deals with the design of instruments and systems that will become objects of use. The structure of an instrument contains physical opportunities for use as well as physical constraints upon use. In that sense an implement resembles a building and an architect's sensitivity might well be applicable. But in a great

many cases the physical apparatuses of technical instruments and systems are also accompanied by rules for proper use and the specification of social conditions necessary to make them function. Computers introduced into an office or factory, for example, are often accompanied by rules that someone prescribes as appropriate to their effective use. Such rules are typically presented to affected workers as instrumentally necessary. It is possible to interpret these intangible structures of instrumental rules and techniques in much the same way a political philosopher looks at laws and constitutions, noticing how a rule-guided installation enables some activities while constraining others and how these possibilities for activity are distributed within a population.

Thus, one way to open the world of material, instrumental structures for social and political scrutiny is to recognize that one must combine the ways of seeing found in the traditions of statecraft and architecture, bringing them into dialogue with the problem-solving abilities of engineering. For example, looking at alternative designs of an evolving technology one might notice that different structures involve the creation of (1) different social contracts, (2) different physical environments, and (3) different sets of technical problems. To understand the technology fully at the stage of design requires that one be able to envision its combined political, spatial, and technical dimensions.

If one looks to the growing literature about technology and society, there are many examples of the politics of technological design that can be cited, in retrospect at least. Historians of technology and of industrial design have done much to explain how the shapes of things in common use often reflect more or less self-conscious attempts at social control. Thus, Adrian Forty has shown how social definitions of class, status, gender, age, domesticity, and workplace hierarchy are neatly packed into the furnishings of everyday life. The rolltop desk, for example, was replaced by the "modern efficiency desk" because early twentieth-century office managers wanted the work of their subordinates constantly open for inspection, something that the nooks and crannies of the old-fashioned rolltop made difficult.[18]

Turning from history toward contemporary experience, one finds scattered but interesting attempts to apply positive, critically examined political criteria in the design of technological devices and systems. The most commonly noted examples are

those of workplace technologies designed in ways that enhance, rather than curtail, the autonomy and decision-making authority of workers. The Volvo plants at Kalmar and Uddevalla in Sweden which sought to replace the assembly line and its apparatus by machinery suited for small work teams, provide a now classic example of the attempt to match technology to the political culture of Scandinavian social democracy. Similar concerns appear in recent Scandinavian and American research on computer systems development in which "participation in design" and the "cooperative approach" are proposed as alternatives to the narrow-minded rationality and rigid centralization of orthodox computerized workplace systems.[19]

Another frequently cited illustration of the positive social shaping of technological systems is the story of the attempt at the Lucas Aerospace Company in Great Britain during the mid-1970s to involve workers in making socially useful devices as a part of plan to convert from military production to production for domestic markets. That work continued in the 1980s as former Lucas Aerospace union leader Mike Cooley and his colleagues in the Greater London Enterprise Board's Technology Networks sought to institutionalize facilities in which ordinary citizens of London could develop new technologies and small businesses informed by democratic, socially responsible goals.[20] Yet another project in political ergonomics is reflected in ongoing attempts to engineer technologies that conserve energy or produce energy from renewable resources, efforts sometimes inspired by the reasonable conviction that a "soft energy path" is more closely compatible with freedom and democracy than the "hard energy path."[21]

Of course, the reform and reshaping of material things is never an end in itself. It must always be seen in the context of broader political debates, goals, projects, and struggles. Thus, in the 1970s and 1980s in the United States a movement of disabled persons set about to alter the social, political, and material conditions under which they suffered. Among its many concerns the movement focused upon language commonly used to talk about disabled persons; terms like "handicapped" and "crippled," for example, were criticized and new categories proposed as more helpful ways to describe who they actually were. The movement also focused

upon a wide range of social and legal policies that tended to discriminate against the disabled, sometimes ostensibly in their own interest. Eventually the movement also engaged in a good amount of what I am here calling "political ergonomics," calling attention to a whole range of obnoxious features in buildings, vehicles, public works, technical instruments, and the like that proved a bad fit for their physical capabilities. Thus, there was a demand that lawmakers, architects, engineers, and industrial designers join in reforming those aspects of the built environment that curtailed the prospects of disabled people to move about and take part in a full range of contemporary activities. Passage of the Americans with Disabilities Act of 1990 required, among other things that many public facilities be restructured to accommodate all citizens, including those whose movements were previously limited by standard architectural and engineering structures. Opposition to the law and the measures it requires focused on the costs of rehabilitating these facilities; opponents claimed that "a special interest group" was being favored at an exorbitant price. But, in fact, the principle affirmed nothing more than the quest for equal citizenship, realized in ways that finally includes all citizens. The covert "special interest" rested in the group of citizens who previously insisted that they were "normal" and, perhaps unthinkingly, supported both misshapen social policies and misshapen facilities.[23]

Conclusion

If one considers a broad range of historical periods and political regimes, it is evident that political ergonomics is not something new. The rich and powerful in society have always had a good instinctive sense of the advantages to be found in controlling the built forms of material civilization. What is new is the possibility that these matters will become a widely contested terrain of debates and choices, rather than one of quietly imposed conventions.

It remains to be seen whether or not technologies shaped by a democratic, egalitarian political ergonomics would also be competitive in the world economic system. Indeed, the program for thinking and action I have briefly outlined here is at odds with the dominant obsessions of our time: efficiency, productivity,

competitiveness, and the desire to be in the lead of the technology race. As a practical matter, it seems likely that the destiny of twenty-first-century societies lies in the hands of those bound and determined to build heavy-handed, instrumentally rational, and politically divisive systems. Mirroring the pungent trends of nineteenth- and twentieth-century economic and technological "development," the best financed pattern-making still tends to favor gigantism, centralization, authoritarianism, regimentation, inequality, and the whittling away of freedom. Nevertheless, to recognize that unhappy drift of technical constructions is no excuse for relaxing one's efforts. For it should be clear that there is nothing about the human activities of design and engineering that makes them inherently unfriendly to the ends involved in creating a good society. As the population of the planet soars past the six-billion mark at the end of our century, the work of building desirable frameworks for civic culture will be no less important than the crucial challenge of preserving the Earth's biosphere from destruction. All societies will have to ponder seriously the meaning of the term "environment," taking into account what artificial environs as well as natural ones offer their citizens.

As I am suggesting here, political ergonomics should be seen as a complement to other varieties of political inquiry and action. Better known approaches, especially the study of power typical in the analyses of political economy, remain crucial for understanding how existing institutions, instruments, and practices come into being, how they operate, and how they can be effectively challenged. Indeed, the kinds of projects I am proposing would remain a mere dream if there were no social, political, or economic power able to attempt them. Under present conditions it seems unlikely that a humane, democratically motivated, broadly effective political ergonomics will emerge. But it is also true that in modern society one of the most grievous manifestations of society's rudderless condition is a widespread atrophy in the ability *to imagine* what an alternative society and its technologies would look like. Even those eager reformers and revolutionaries who have succeeded in achieving real power in the twentieth century have shown a woeful inability to apply the powers of human creativity in shaping a more positive connection between human

purposes and the structure of technical means. To realize a better connection between politics and the design of things is the challenge that awaits us.

Notes

1. Hannah Arendt, *The Human Condition* (Chicago: University of Chicago Press, 1958), pp. 173–74.

2. For a comment on the lasting residue of this policy, see my "Ill-Equipped for Democracy," *Technology Review* 95, no. 4 (May–June 1992): 74.

3. For a good discussion of the ideas and design projects of utopians and visionary social reformers see Frank E. Manuel and Fritzie P. Manuel, *Utopian Thought in the Western World* (Cambridge: Harvard University Press, 1979); and Dolores Hayden, *The Grand Domestic Revolution: A History of Feminist Designs for American Homes, Neighborhoods, and Cities* (Cambridge: MIT Press, 1981).

4. For a discussion of the resonance between metaphors of engineering and political thought in eighteenth-century Europe and America, see Otto Mayr, *Authority, Liberty, and Automatic Machinery in Early Modern Europe* (Baltimore: Johns Hopkins University Press, 1986).

5. For discussions of this belief see Michael Kammen, *A Machine That Would Go of Itself: The Constitution in American Culture* (New York: Alfred A. Knopf, 1986); and Sanford Levinson, *A Constitutional Faith* (Princeton, NJ: Princeton University Press, 1990).

6. Aristotle, *The Politics*, trans. T. A. Sinclair (Harmondsworth, England: Penguin Books, 1962), pp. 77–78.

7. See Otto von Simson's discussion of edification in *The Gothic Cathedral* (Princeton, NJ: Princeton University Press, 1956), pp. 128–33.

8. See Robert Fishman's discussions of Wright's and Le Corbusier's political ideas in *Urban Utopias in the Twentieth Century: Ebenezer Howard, Frank Lloyd Wright, and Le Corbusier* (New York: Basic Books, 1977).

9. Peter Hall, *Cities of Tomorrow: An Intellectual History of Urban Planning and Design in the Twentieth Century* (Oxford: Basil Blackwell, 1988).

10. Christopher Alexander, *A Timeless Way of Building* (New York: Oxford University Press, 1979), p. 83.

11. John Ruskin, *The Stones of Venice*, 3 vols. (New York: John Wiley and Son, 1865). Ruskin argues that it is a "duty of monuments or tombs, to record facts and express feelings; or of churches, temples, public edifices, treated as books of history, to tell such history clearly and forcibly" (1:39).

12. Christopher Alexander, et al., *A Pattern Language: Towns, Buildings, Construction* (New York: Oxford University Press, 1977).

13. Kevin Lynch, *Good City Form* (Cambridge: MIT Press, 1981).

14. A fairly typical approach to engineering design can be found in William H. Middendorf, *Engineering Design* (Boston: Allyn and Bacon, 1969). A

more recent overview is offered in Atila Ertas and Jesse C. Jones, *The Engineering Design Process* (New York: Wiley, 1993).

15. See Edwin T. Layton, *The Revolt of the Engineers: Social Responsibility and the American Engineering Profession* (Cleveland: Case Western Reserve University Press, 1971).

16. Jeffrey L. Meikle, *Twentieth Century Limited: Industrial Design in America, 1925–1939* (Philadelphia: Temple University Press, 1979). See also Terry Smith, *Making the Modern: Industry, Art, and Design in America* (Chicago: University of Chicago Press, 1993).

17. See for example, Peggy Tillman and Barry Tillman, *Human Factors Essentials: An Ergonomics Guide for Designers, Engineers, Scientists, and Managers* (New York: McGraw-Hill, 1991); and David J. Osborne, ed., *Person-Centered Ergonomics: A Brantonian View of Human Factors* (London: Taylor and Francis, 1993).

18. Adrian Forty, *Objects of Desire* (London: Thames and Hudson, 1986), pp. 124–31.

19. See Gro Bjerkens, Pelle Ehn, and Morten Kyng, *Computers and Democracy: A Scandinavian Challenge* (Aldershot, U.K.: Avebury Press, 1987); Joan Greenbaum and Morten Kyng, *Design at Work: Cooperative Design of Computer Systems* (Hillsdale, NJ: Lawrence Erlbaum Associates, 1991); and Ake Sandberg et al., *Technological Change and Co-Determination in Sweden* (Philadelphia: Temple University Press, 1992).

20. For a discussion of the Lucas Aerospace efforts see Mike Cooley, *Architect or Bee?* (Boston: South End Press, 1982).

21. See Hunter L. Lovins, Amory B. Lovins, and Seth Zuckerman, *Energy Unbound: A Fable for America's Future* (San Francisco: Sierra Club Books, 1986).

22. Public Law 101-336, "Americans with Disabilities Act of 1990," 101st U.S. Congress 104 Stat. 327, *United States Code Service,* no. 8 (August 1990): 1663–1714.

SECTION **3**

VALUES AND
RESPONSIBILITIES

Ethics into Design

Carl Mitcham

Ethics constitutes an attempt to articulate and reflect on guidelines for human activity and conduct. Logic is the attempt to articulate and reflect on guidelines for human thought. Both ethics and logic further develop theories about the most general principles and foundations of their respective guidelines. But what is it that articulates and reflects on guidelines for that intermediary between thought and action called design?[1]

As an English word, "design" is a modern derivate of the Latin *designare,* to mark or point out, delineate, contrive, by way of the French *désigner,* to indicate or designate, and can be defined as planning for action or miniature action.[2] It is remarkable, however, that neither Greek nor Latin contains any word that exactly corresponds to the modern word "design." The closest Greek comes to a word for "design" in the modern sense is perhaps *hupographein,* to write out. Much more common are simply *ennoein* (*en,* in + *noein,* to think) and *dianoein* (*dia,* through + *noein,* to think).

For the Greeks, human conduct can be ordered toward the production of material artifacts or nonmaterial goods, through

activities with ends outside themselves (*poieses,* makings), or it can be taken up with activities that are ends in themselves (*praxes,* doings). The pursuit of what is fitting in the domain of makings is discovered through *techne,* in the domain of doings, through *phronesis.* In one sense *phronesis* is only one among many virtues; in another it is the foundation of all virtue and thus coextensive with ethics.

Beyond the Greeks, planned making or doing—as distinct from simply intending to act, consideration of the ideals reflected or intended by different makings and doings, or the development of skills (*technai*) through practice—involves the systematic anticipatory analysis of human action. With regard to making, especially, such systematic anticipatory analysis entails miniature or modeled trial-and-error or experimental activity. In the modern context, this planning for making or miniature making, which was once severely restricted by both traditional frameworks and methodological limitations, has become the well-developed and dynamic activity of designing or design. The latter term can refer as well to the formal characteristics of the articulated plan or the static composition of the product brought forth by the scaled-up process that emerges from what has also been called "active contemplation."[3]

The modern attempt to reflect on designing or design has engendered primarily studies of the social or aesthetic quality of designed products and analyses of the logic or methodology of design processes. The thesis here is that both aesthetic criticism and the logic of design must be complemented by the introduction of ethics into design studies, in order to contribute to the development of a genuinely comprehensive philosophy of design.

On the Existence of Design

But if it is so important, why does ethics not already exist in design? The simple answer is that ethics was not needed within design until quite recently because until quite recently the activity known as designing did not play a prominent role in human affairs.

The most fundamental question regarding design—an ontological question, as it were—is this: Why is there design at all and not just nondesign? Certainly it is historically obvious that design

has not always been and therefore need not necessarily be. In nature, for instance, the design process does not occur. According to modern science, nature brings forth either by blind determination or by random change. Hence there arise debates about whether human beings as designers are part of nature, and whether the science of nature is able to be unified with the human sciences and humanities, not to mention theology. (The idea that God created the world "by design" is a unique conflation of Greek rationalism and Judeo-Christian-Islamic revelation.) Even on an Aristotelean account, to be "by *phusis,* nature" and "by *nomos,* convention" (if not design) constitute two distinct ways of being.

To be "by design" in any possible (weak) premodern sense typically denotes no more than affinity with that unique human reality, *nomos,* convention or custom, and *nous,* mind. Convention reified or in physical form is labeled artifice, that which has form not from within itself, like a rock or a tree, but from another, like a statue or a bed (see *Physics* 2, 1). Prior to the development of design as miniature making one could speak only of mental intention or static composition, thought or final material product, not any special or unique physical activity. The activity was simply making.

Vernacular human activity, especially vernacular making, insofar as it is restricted to traditional crafts, proceeds by intention but not necessarily by or through any systematic anticipatory analysis and modeling. Plato's shuttle maker looks to the form or idea of a shuttle and thereby does not have to design it (*Cratylus* 389a). Indeed, many central societal conventions and artifacts (e.g., traditional village customs and architectures) are, although human-made, not even the direct result of human intention.[4] (In the vernacular world, the "designing" actor is also one who proceeds with schemes, deviously, improperly.) What is most characteristic of nonmodern making activities are trial-and-error full-scale fabrication or construction, intuition and apprenticeship, techniques developed out of and guided by unarticulated and nondiscursive traditions and procedures. Reflection in relation to such making focuses more commonly on the symbolic character of results than on processes and methods of, say, efficiency in operation or production. To speak of design in crafts is to refer to something which is not yet, which occurs largely in unconscious or provisional forms—that is to say, design without

design. Yves Deforge in one attempt to write about such "design before design" calls these phenomena "avatars of design."[5]

Design as a protoactivity is manifest originally in the arts in the form of sketches for paintings. The unfinished chambers of Egyptian tombs reveal that drawings sometimes preceded finished murals. But for Vasari and his contemporaries, *disegno* or drawing and preparatory sketches are the necessary foundation of painting. The need for arguments in defense of this position reveals its special historical character. And there are at least two observations that can be ventured about such anticipatory activity in the artistic realm. First, it exhibits a continuity with that to which it leads. The tomb drawings are even the same size as the final mural that will follow; the Renaissance sketches develop skills that are repeated on canvas or wall. Second, conspicuous by its absence is any quantitative or input-output analysis. At the time of the Renaissance, however, design also appears in a distinctly modern form as the geometric construction of perspective, as a correlate of modern scientific naturalism, and as the precursor to engineering drawing.[6]

The distinctive feature of modern science as an activity rather than as a body of knowledge is experimental modeling. Through experimentation modern science constructs models of different natural processes, and by means of arguments based on a principle of proportionality uses them to reason from known cause-effect relations to unknown causes of known effects. Galileo was the pioneer of such modeling in physics (falling bodies), which has since been extended to chemistry (atomic models), biology (models of DNA), and even human psychology (computer modeling of cognitive processes).[7]

Modern scientific experimentation constructs models of what (it thinks) already exists, to expand knowing. The activity of design constructs models of what (it thinks) might be, to extend making. For science, models take in or receive and simplify complex phenomena, thereby disclosing order. For modern technology, or scientifically refined makings and usings in all their diversity, models project complex possibilities in realistic form, thus determining or enabling the control of power. When this projective modeling exhibits a conceptual break with the final result toward which it is pointed, a break to be bridged by analogy, it takes on its distinctly modern character.

Design models in engineering can, for instance, be "true" models, although more commonly they are merely "adequate" or even "distorted" and "dissimilar." As one engineer has put it, "A distorted model is [one] in which some design condition is violated sufficiently to require correction of the prediction equation. Under certain conditions, particularly where flow of fluids is involved, it is impracticable, if not impossible, to satisfy all of the design conditions [under a common scale]."[8] Likewise, "dissimilar models are models which bear no apparent resemblance to the prototype but which, through suitable analogies, give accurate predictions of the behavior of the prototype."[9] Another engineer distinguishes between models that are "totally direct," "totally indirect," "combination," "visual," and "competitive," with each being suited to test different aspects of a new idea.[10] All such models can be manifest in drawings, block diagrams, network schematics, mathematics, physical materials, and related systems of representation.[11]

Receptive, scientific modeling *embodies* knowledge; with regard to knowledge, embodiment necessarily entails simplifying *concepts*. Projective, technological modeling *disembodies* action; with regard to action, disembodiment that leaves *things* out, idealizes them. The former materializes, the later dematerializes. The paradoxical aim of projective, dematerialized or idealized modeling is not so much explanation as practical leverage, effectiveness. The present and its desires are cast with great force and power into the future.

Because of the complexity of variables, theory alone cannot be used to deduce, for instance, the shape of an airfoil, or to determine the optimum spatial arrangements of elements within a given structure. Engineers have to "figure out" such things by simulation, often employing a variety of models. So they construct a miniature, model airfoil and test it in a wind tunnel (now in a computer program); by means of such activities they are testing not some illustrated theory, but a represented artifact.[12] For structures, engineers create scaled-down floor plans or two-dimensional facades in order to play with alternative arrangements of shapes by means of sketched geometries or manipulated cutouts. In each case the model or mock-up constitutes a temporary reduction to be eventually scaled up in the production not of knowledge but of objects. Design uses created microscale cause-

effect relations rendered in models to engineer known or create-able macroscale causes into the production of desirable or desired macroscale effects.[13]

On the Social Dimensions of Modern Design

As has been noted, for example by José Ortega y Gasset in his *Meditación de la técnica* (from lectures first delivered in 1933), traditional technics includes both the "invention of a plan of action"—which is not the same as a planning process—and the "execution of this plan."[14] Traditionally, both the formal-final and efficient causes remained within the mind and hand of the artisan. It is the modern separation of mental and manual, and the coordinate creation of inventor-engineer and worker, that grounds the original character of modern design. The two new categories of designing and working are not just thinking and making separated. Thinking and making are too inextricably conjoined in traditional craft for such a simple disjunction,[15] which is discerned only by critical abstraction. In the separation of intending and making are created instead an embodied, active form of intending (design) and a nonreflective but methodologi-cal form of making (labor).

This separation of formerly unified aspects of human experi-ence is further coordinate with the becoming autonomous of a whole range of elements in human culture. Religion and politics are to be independent, likewise with art and religion and politics and science and education; all, along with economics as a kind of paradigm, become what Karl Polanyi terms "disembedded" from social life as a whole.[16] This separating and becoming indepen-dent of previously interwoven dimensions of a way of life consti-tutes, for Jürgen Habermas, the essence of the modern project.[17]

The emergence of disembedded and autonomous design con-stitutes as well a movement from vernacular to professional de-sign, and has thus been variously defined by the two professions which claim it, engineers and artist-architects. The former com-monly emphasize the quantitative, analytic, but iterative charac-ter of a multiphase process that includes preparatory and evalu-ative moments. The latter presents design as embodied, poetic thinking. Louis Bucciarelli, in "an ethnographic perspective," has described engineering design as a social process,[18] whereas

Richard Buchanan has argued for design as a kind of rhetoric. But what kind of social process? What form of rhetoric? What is to distinguish engineering and artistic design from the social process and rhetoric of politics? Whether engineering or architecture, accidentally reflecting social process or rhetoric, the defining activity is miniature making. For Bucciarelli this is found in a social process centering around distinct "object worlds"; for Buchanan it is a rhetoric of artifacts.

On the Ethics of Designing

Possibility and contingency are the fundamental ground of ethics. On the one hand, in the absence of any recognition of the possibility of some course of action, no ethical reflection is called for. On the other, if the course of action is strictly necessary, reflection can give rise only to theoretical explanation, not ethical judgment. One does not ask ethical questions of what cannot be or of what cannot be otherwise.

The historical discovery of design as systematic anticipatory analysis and modeling as a unique form of human action roughly contemporaneous with the rise of modern science and technology uncovers a new way of being in the world. The most fundamental ethical question concerning design is this: To what extent is this new way of being in the world desirable or good?

It is now common to recognize that, as Langdon Winner has said, technologies are "forms of life," [19] or as Buchanan has put it, "design involves the vivid expression of competing ideas about social life." [20] But not only do different designs embody (implicitly or explicitly) distinct sociopolitical assumptions and visions of life, designing itself constitutes a new way of leading, or a leading into, different technological lifeworlds. Part of the unified newness of this way of leading into the techno-lifeworld, the activity or process of designing, can be indicated by noticing some difficulties or inadequacies of standard approaches to ethics in relation to it.

Consider, for example, what can be termed an ethics of correspondence, which judges action by the extent to which it is in harmony with or corresponds to what is already given by some pre-existing order. Common forms of such an ethics of correspondence are found in appeals to tradition or to natural law. The attempt to judge the design act as lawful or unlawful in accord with

the degree to which it harmonizes with and represents or opposes a tradition is contradicted by the core effort within design not to be guided by tradition, but to figure things out anew, to create new artifacts, to break with tradition. Modern design is traditional precisely to the extent that it opposes tradition.

Perhaps, then, one should adopt a deontological approach and consider the intentions of the designer or the principles of the design act in terms of consistency and universalizability. Indeed, as something less than full-bodied action, designing might well be compared to having an intention. Although many of its particular maxims may be open to serious challenge, it is difficult to see how the design process as a whole should not be inherently universalizable. Criticisms of modern technological design often focus on the inherent consistency, the rightness and wrongness, of various design maxims. But without the design process as a whole, how could one possibly address the problems inherent in the designed techno-lifeworld?

Nevertheless, as practice in miniature, design is something more than an intention. In however diminished a form, it is still physical activity. It is thus a busyness which, as such, does not encourage inner self-examination. Moreover, as physical activity, design is something that always has immediate physical consequences—even if they are, as it were, quite small, even minute. Its inner principle is the linking together of physical materials and energies in functional units to meet predetermined specifications, something to be worked out through models and testing. Design is inherently tipped toward action, is immanent activity, a protopragmatism.

Consider, then, an ethics of consequentialism, which would refer the moral character of action to the goodness or badness of its results. But the designing of an airfoil or a structure has no socially significant consequences. How could one calculate costs and utilities except in the most indirect terms? Probably most such designing leads nowhere, since the majority of designs never serve as a basis for full-scale construction. Design is more like a self-contained game. Its full-scale consequences, whatever they may be, occur only at secondary or tertiary removes—once the design serves as a basis for construction. A consequentialist judgment of designing readily strikes any designer as an abstract, far-fetched

focusing on remote contingencies into which an indefinite number of variables may intervene.

There are two further points that can be made about the difficulties of consequentialism. As Hannah Arendt has noted with regard to human action,[21] and as Hans Jonas has argued with regard to modern technology,[22] the remote consequences of activities are inherently difficult to predict. John Stuart Mill, anticipating such an argument, replies that the remote and unpredictable character of consequences can be mitigated by experience.[23] In more recent language, the difficulties of "act utilitarianism" can be met with "rule utilitarianism" grounded on common experience.[24] Human beings can learn that telling lies eventually has bad consequences most of the time. The problem with any appeal to experience in the case of modern design acts, however, is that insofar as designs are unique, their consequences are also continuously new. Principled change undermines the mitigating power of historical experience. (Could this account for the modern resistance to any reduction in the pace of technological change, and that continuously renewed optimism about design transformations that makes it so difficult to learn from failed experience and expectations?)

Yet the apparently diverse material products grounded in the new way of life defined by the principled pursuit of technological change through design do exhibit certain common features. Albert Borgmann has linked these together insightfully in what he terms the "device paradigm." Devices are to be contrasted with things. A thing, such as the fire-bearing hearth, entails bodily and social engagement. A device, such as a central heating unit, "procures mere warmth and disburdens us of all other elements." "Technological devices . . . have the function of procuring or making available a commodity such as warmth, transportation, or food . . . without burdening us in any way [by making them] commercially present, instantaneously, ubiquitously, safely, and easily."[25] The products of modern design are typically commodities that fit the device paradigm. Indeed, modern designing might even be described as "devising," the process of making present devices.

But devising and devices escape the reach of any full-bodied consequentialist criticism because of the apparently amorphous

neutrality or ambiguity of commodities, of deontological restriction because of the apparently inherent morality of its intention merely to make available without presupposition, and of the ethics of correspondence because of their principled rejection of corresponding to anything. Devices are neutral commodities. How, in themselves, could they be considered lawful or unlawful, right or wrong, good or bad, since they are designed to be nothing but pure receptivity to any law, right, or good? The thermostat, the light switch, the plastic bowl are simply available for use.

But if neither traditional correspondence nor deontologism nor consequentialism has any immediate purchase on designing, how is one to address the problems manifest in the new techno-lifeworld?

Two Versions of an Ethics in Design

Prescinding from any fundamental questioning of designing as a way of being in the world, it is still necessary to inquire about the presence of ethics in design. The modern systematic modeling of making—that is, design—has taken two distinct forms. One of these is technical, the other aesthetic. The former focuses on inner operational or functional relations within mechanical, chemical, electrical, and other artifacts and processes. The latter takes external appearance or composition as its concern. One evaluates its products in terms of the ideal of efficiency, striving with some minimal possible input of material and energy for a maximum output. The other seeks a formal concentration and depth of meaning.

To use less, engineers design increasingly complex but specialized objects devoid of decoration, although precisely because of their inner complexity the inner workings must be covered by some kind of decoration. To mean more, to become "charged and supercharged with meaning" (Ezra Pound), artists and architects render increasingly rich, ambiguous artifacts, textured and decorated in detail.

Each design tradition also develops its own professional ethos, which constitutes an implicit ethics of design. In engineering there has been a stress upon subordination, if not obedience and sameness.[26] In the arts the commitment is to independence and difference. Each brings to the fore complementary aspects of the

modern design experience: on the one hand, its authority and power: on the other, its revolution and independence. Extremes on both sides are reined in with appeals to responsibility.

The selective ethical responses to the problems summoned forth by the processes unleashed through modern design activity—from social disruption, dangerous machines, and anaesthetic consumer products to crowded and polluted urban environments—further reflect these two traditions. One stresses the need for more efficiency and argues for pushing forward toward increasingly extensive and systematic expansions of design, from time-and-motion studies to operations research and human factors engineering. The other calls attention to anomie, alienation, and cultural deterioration, and calls for either a turn toward the arts and crafts or the creative design of postmodern bricolage. The problems of "bad design" are viewed as caused either by insufficient design or by too much and the wrong kind.[27]

One tradition thus promotes methodological and empirical studies of engineering design processes; the other develops broad interpretative studies of the aesthetic and cultural dimensions of artifacts.[28] Aesthetic sensitivity meets the engineering mentality in industrial design and functionalism.[29] Engineering reaches out toward aesthetic criticisms with proposals for more socially conscious or holistic design programs.[30]

Both traditions depend on what may nevertheless be described as incomplete philosophical reflections. They uncritically seek either to export design methods across a whole spectrum of human activities or to import extraneous ideas into design. The proposal here is for the cultivated emergence of ethics within design as an effort to deepen the two traditions by moving from partial reflections and possible reforms to deeper understandings of the challenge of techno-lifeworld design and more comprehensive assessments of its problems.

Notes Toward an Inner Ethics of Design

According to Aristotle, the study of ethics depends on the practice of ethics (*Nichomachean Ethics* 1, 4; 1095b4–6). One cannot articulate and reflect on what one does not already have. Ethics cannot come from on high, as it were, to articulate guidelines for action. The attempt to cultivate ethics within design thus begins

with the attempt to articulate guidelines for that miniature action called designing such as they already exist. Only from here is it possible to move toward considerations of their adequacy, beginning perhaps with a recognition of special problems.

The fundamental ethical problem of design is created precisely by its principled separation from the inner and the outer worlds. It is not pure intention and part of an inner life, something that can be examined by means of self-reflection. Nor is it simply an overt action that readily calls for consequentialist evaluation. It is more like a game or play.

Indeed, in the premodern world, models functioned primarily as toys. Mayan toy carts and Alexandrian steam engines were never recast into the quotidian world as construction tools or industrial machines. With models one creates a provisionally self-contained or miniature world rather than thoughts that can be integrated into an inner life or actions that are part of everyday human affairs.

Models and their making thus easily take on a kind of independence, to constitute a phenomenon that demands evaluation on its own terms, whether technical or aesthetic. The inherent attractiveness of modern design activities lies not just in their potential utilitarian results but just as much in their technical beauties and beautiful techniques. Johan Huizinga, vulgarizing Friedrich Nietzsche and anticipating Jacques Derrida—the prophet and priest of postmodern culture—speaks for the modern attempt to find new values in the midst of the destruction of the old when he describes play as segregated from all "the great categorical antitheses": "Play lies outside the antithesis of wisdom and folly, and equally outside those of truth and falsehood, good and evil. . . . [I]t has no moral function. The valuations of vice and virtue do not apply here." [31]

The game, precisely because of what it is *qua* game, that is, a break from or setting aside of the world, asks not to be subject to the rules or judgments of the world. Children with dolls or with guns can behave in all sorts of ways that would not be acceptable were their toys people or weapons. A game of cards has its own rules, which are all that must be obeyed in order to be a "moral" card player. Clay modeling needs only to keep the clay wet enough to manipulate but not so wet as to run; otherwise it is wholly without rules.

Precisely because of its independence from and potential op-
position to traditional morality, ethical reflection from Plato to
the Puritans has argued for circumscribing and delimiting the
world of play. Play at work, for instance, limits production and
causes accidents. Playful sex readily degenerates into the promis-
cuous and pornographic.

Yet play need not be wholly rejected; it can also be delimited
and preserved—perhaps in ways that maintain, even enhance, its
very playfulness. Cut wholly free from any reference to the world,
play can actually cease to be interesting. Pure play with words or
numbers, as in *Finnegans Wake* or the higher reaches of mathe-
matics, attracts fewer and fewer players and less and less of an
audience. Under such situations it is appropriate to call for a re-
vival of the relationship between play and life.

And insofar as play can be taken as a metaphor for design, this
inner obligation that would preserve the activity from its own in-
ternal disintegration might be formulated as the following fun-
damental principle: "Remember the materials." "Return to real
things." Do not let miniature making become so miniature that it
ceases to reflect and engage the real world.

By way of attempting to elaborate on this suggestion, consider
the following speculative observations:

1. The great temptation of any game is for it to become too
self-contained, an activity of purely aesthetic pleasure or technical
achievement. Insofar as all play becomes not a temporary separa-
tion from quotidian realities, but a pull away from life, it becomes
subject to social criticism. The artist concerned only with form,
the engineer concerned only with technical solutions—the pur-
suit of art for art's sake, engineering for the sake of engineer—
can be challenged by more inclusive issues and social orders.

2. The human practice of designing simply as designing can
be said to deepen the tendency inherent in all play by exhibit-
ing a marked inclination to distance the designer from self-
examination or social responsibility. Studies of the psychology
and behavior of computer hackers dramatically confirm this
point,[32] but it is one that is hinted at as well by the ethos of each
design tradition. The engineering tradition of obedience and the
avant-garde tradition of independence in the arts are but two ex-
pressions of disjunctions, from self and community.

3. Designing, unlike more limited forms of play, constitutes a

general pulling away from or bracketing of the world that can have immediate practical impact. The paradoxical strengths of the mathematization and modeling of modern design are that more effectively than ever before they separate from the world of experience *and* provide new levers for the technological manipulation of that world. Modern designing opens itself to being pulled back into the world beyond anything that designers themselves might imagine, desire, or plan. Hence, again, there exists a fundamental obligation to remember the materials, return to real things, and not let miniature making become so miniature that it ceases to reflect and engage the real world.

4. Perhaps nowhere is the challenge of remembering reality more important than in computer-aided design. Although tremendously powerful and attractive, computer-aided design is equally dangerous, precisely because even more than designing with pencil and paper against a background of practical experience with real-world artifacts, design with computers works in a rarefied medium with a facility that tends to deny the need for worldly experience. As Eugene Ferguson has argued, "To accomplish a design of any considerable complexity—a passenger elevator or a railroad locomotive or a large heat exchanger in an acid plant—requires a continuous stream of calculations, judgments, and compromises that should only be made by engineers experienced in the kind of system being designed. The 'big' decisions obviously should be based on intimate, firsthand, internalized knowledge of elevators, locomotives, or heat exchangers."[33]

5. But just as obviously, in a society in which elevators, locomotives, and heat exchangers are increasingly run by computers, and children rather than playing with trains play with train video games, it is difficult to cultivate an intimate, firsthand, internalized knowledge of anything real. Virtual experience is no substitute for real experience. The problems of design are not isolated in design. They are part of, even at one with, the larger culture as a whole. To return to real things is a challenge throughout the ways of life characteristic of postmodern society.

6. The real experience of struggling to return to real things taking ethics beyond fundamental principles into specific cases will be the basis for development of a *phronesis* of the techno-lifeworld.

The problems with design are not just technical or aesthetic, but also ethical. Indeed, introducing ethics into design revels the deepest aspects of our difficulties. But the difficulties we face cannot begin to be addressed without clear-sightedness. To attempt to recognize them is itself to struggle for the right and the good.[34]

Notes

1. For a different but related notion of the intermediary character of design, see C. Wright Mills, "Man in the Middle: The Designer," in *Power, Politics, and People: The Collected Essays of C. Wright Mills,* ed. Irving Louis Horowitz (New York: Oxford University Press, 1963), pp. 374–86.

2. Aspects of this definition are first developed in Carl Mitcham, "Types of Technology," *Research in Philosophy and Technology* 1 (1978): 245–48. It is further elaborated in slightly different ways in "Engineering as Productive Activity: Philosophical Remarks," *Critical Perspectives on Non-Academic Science and Engineering,* ed. Paul T. Durbin (Bethlehem, PA: Lehigh University Press, 1991), pp. 96ff., and *Thinking through Technology: The Path between Engineering and Philosophy* (Chicago: University of Chicago Press, 1994), pp. 220ff.

3. Richard Buchanan, "Declaration by Design: Rhetoric, Argument, and Demonstration in Design Practice," in *Design Discourse: History, Theory, Criticism,* ed. Victor Margolin (Chicago: University of Chicago Press, 1989), pp. 98, 103.

4. See F. A. Hayek, "The Results of Human Action But Not of Human Design," in his *Studies in Philosophy, Politics, and Economics* (Chicago: University of Chicago Press, 1967), pp. 96–105. Hayek uses "design" in the weak sense as equivalent with intention.

5. Yves Deforge, "Avatars of Design: Design before Design," *Design Issues* 6, no. 2 (Spring 1990): 43–50.

6. On the last point, see Peter Jeffrey Booker, *A History of Engineering Drawing* (London: Chatto and Windus, 1963).

7. Key studies of the role of model construction in modern science can be found in Mary B. Hesse, *Models and Analogies in Science* (Notre Dame: University of Notre Dame Press, 1966); Rom Harre, *The Principles of Scientific Thinking* (Chicago: University of Chicago Press, 1970); and William A. Wallace, "The Intelligibility of Nature: A Neo-Aristotelian View," *Review of Metaphysics* 38, no. 1, whole no. 149 (Sept. 1984): 33–56.

8. Glenn Murphy, *Similitude in Engineering* (New York: Ronald, 1950), p. 61.

9. *Ibid.,* pp. 61–62.

10. Gordon L. Glegg, *The Development of Design* (Cambridge: Cambridge University Press, 1981), pp. 44–45.

11. See William H. Middendort, *Design of Devices and Systems* (New York: Dekker, 1986), pp. 156ff. (Note, in passing, that the positive connotations of "schematic representation" build on while transforming the traditional negative implications of a "scheme.")

12. For more on this point, see Walter G. Vincenti, *What Engineers Know and How They Know It: Analytical Studies from Aeronautical History* (Baltimore: Johns Hopkins University Press, 1990).

13. For an extended discussion of the dimensional problems engendered by such modeling, see Stephen J. Kline, *Similitude and Approximation Theory* (New York: McGraw-Hill, 1965).

14. José Ortega y Gasset, *Meditación de la técnica* (originally published 1939), in *Obras Completas,* vol. 5 (Madrid: Alianza and Revista de Occidente, 1983), p. 365.

15. See Andrew Harrison, *Making and Thinking: A Study of Intelligent Activities* (Indianapolis: Hackett, 1978).

16. See Karl Polanyi, "Aristotle Discovers the Economy," in Karl Polanyi, Conrad M. Arensberg, and Harry W. Pearson, *Trade and Market in the Early Empires: Economics in History and Theory* (Glencoe, IL: Free Press, 1957), pp. 64–94.

17. See, e.g., Jürgen Habermas, "Modernity—An Incomplete Project," in *The Anti-Aesthetic: Essays on Postmodern Culture,* ed. Hal Foster (Port Townsend, WA: Bay Press, 1983), pp. 3–15.

18. Louis L. Bucciarelli, "An Ethnographic Perspective on Engineering Design," *Design Studies* 9, no. 3 (July 1988): 159–68.

19. Langdon Winner, "Technologies as Forms of Life," in *The Whale and the Reactor: A Search for Limits in an Age of High Technology* (Chicago: University of Chicago Press, 1986), pp. 3–18.

20. Richard Buchanan, "Declaration by Design," p. 94.

21. See Hannah Arendt, *The Human Condition* (Chicago: University of Chicago Press, 1958), especially chapters 32–34.

22. See Hans Jonas, *The Imperative of Responsibility: In Search of an Ethics for the Technological Age,* trans. H. Jonas and David Herr (Chicago: University of Chicago Press, 1984), particularly chapter 1, "The Altered Nature of Human Action." For further analysis extending the ideas of both Arendt and Jonas, see Barry Cooper, *Action into Nature: An Essay on the Meaning of Technology* (Notre Dame: University of Notre Dame Press, 1991).

23. John Stuart Mill, *Utilitarianism* (1861), chapter 1, near the end.

24. See William K. Frankena, *Ethics,* 2nd ed (Englewood Cliffs, NJ: Prentice-Hall, 1973), pp. 35ff.

25. Albert Borgmann, *Technology and the Character of Contemporary Life: A Philosophical Inquiry* (Chicago: University of Chicago Press, 1984), pp. 42, 77.

26. For more on this tradition, see Carl Mitcham, "Schools for Whistle Blowers: Educating Ethical Engineers," *Commonweal* 114, no. 7 (April 10, 1987): 201–5.

27. For a good brief survey of the literature of these two traditions, see Victor

Margolin, "Postwar Design Literature: A Preliminary Mapping," in *Design Discourse,* ed. Margolin, pp. 265–87.

28. See, e.g., in the first instance, M. J. de Vries, N. Cross, and D. P. Grant, eds., *Design Methodology and Relationships with Science* (Boston: Kluwer, 1993); and in the second, John Thackara, ed., *Design after Modernism: Beyond the Object* (New York: Thames and Hudson, 1988).

29. See, e.g., Herbert Lindinger, ed., *Ulm Design: The Morality of Objects,* trans. David Britt (Cambridge, Mass.: MIT Press, 1991).

30. See, e.g., Victor Papanek, *Design for Human Scale* (New York: Van Nostrand, 1983), and *Design for the Real World: Human Ecology and Social Change,* 2nd ed. (New York: Van Nostrand Reinhold, 1984).

31. Johan Huizinga, *Homo Ludens: A Study of the Play-Element in Culture* (Boston: Beacon, 1955), p. 6.

32. See, e.g., Sherry Turkle, *The Second Self: Computers and the Human Spirit* (New York: Simon and Schuster, 1984), especially chapter 4.

33. Eugene S. Ferguson, *Engineering and the Mind's Eye* (Cambridge, MA: MIT Press, 1992), p. 37.

34. This paper owes improvement, though still no doubt not enough, to critical comments from Tim Casey (University of Scranton).

Sacred Design I

A RE-CREATIONAL THEORY

Tony Fry

Our (the) ecological crisis exists as internal and external to our physiology. There is nowhere for us to be other than here, wherever we are. We are the crisis; it is our creation. Crisis is extended by us, how we are, the way we live, in fact by everything we do. Our actions, dreams, desires, and demands drive it.

It also can be said that the ecological crisis arrives by design: in actuality the crisis is the compound of our failures as designers. Equally, many solutions to this critical situation can but arrive by design. Design can now be more clearly seen to ride the line between creation and destruction. In such a characterization, design has to be seen as a figure of contestation, and in viewing it in this way what is at stake is on what side of the line it is made to fall.

The significance of design in crisis, as a feature of the function of mind, as a practice, as object, as agency, is that it needs a great deal of scrutiny. This significance has been grossly underestimated within design, and across all other disciplines. This is because design's acknowledged and celebrated forms have been attached to explicit economic functions and cultural appearances

that lack any ability to engage in critical reflection, especially of design's impact on the social and the environmental fabric of our world. This is to say that the foundational and structuring characteristics of design have been overlooked, or underestimated, not least by the power and the visibility of the manner of its projection as function, performance, style, and taste. What has gone unnoticed is that every design decision and form has an ongoing directional outcome—the designed always goes on designing. In other words, design, materialized design in the present, maps the future, usually by an noninterrogated reoccurrence. The assumption here is that the future is deterministically constituted in forms that travel from the past.

For example (and without seeking to wield a moralism that would restrict human spatial movement), as many commentators have pointed out, it is not the mechanical function, machine performance, or styling of the motor car that needs to go on being redesigned, but the very basis of the systems of private and public transport, as well as the logistics that generate that need to travel. Moreover, pollution, as well as the social and urban problems that the motor car has generated, evidence design's limited, and often myopic, view of the environmental impact of its own creations. Now, in this context, consider how many designers and design resources are employed designing those modes of transport, or transport technologies, that go on generating environment problems, versus the number of those working on their solutions.

What so often is presented as the objective of design is the realization of made forms, aesthetics, systems, or financial return. This view is in error; it is a registration of means as end, and is the reason why directional effect goes by the board. The sought end of design, no matter what its modality, to be argued below, can be stated as: the creation of material change that can increase the prospect of the continuity of the interconnected systems of life, including the maintenance of the social ecology upon which we depend and which we name as community.

> Do we stand in the very twilight of the most monstrous transformation our planet has ever undergone, the twilight of that epoch in which earth itself hangs suspended? Do we confront the evening of a night which heralds another dawn? Are we to strike off on a journey to this historic region of earth's evening?

Martin Heidegger, in contemplating the past and the fate of the world, viewed the understanding of the history of early Greek thinking and the overcoming of Western thought as an inseparable exercise.[1] The questions above, written in 1950, are drawn from many that he posed in this consideration. Their resonance intensifies in this eco-critical epoch, for our shadow continues to lengthen and the thread from which life hangs ever thins.

There is but one answer to each of Heidegger's questions. What follows from this affirmation, then, is that we have imminently the act of creation, as a re-creation, before us.

A new way of thinking about design is vital in understanding and undertaking the urgent, long-term, and truly massive task before us. New design, in this avocation, is set within the potential of a new direction, a new ethics, and a new becoming at the end of, and beyond, the unrealized telos of the nature of humanity—humanism.[2] The act of re-creation is itself not a new project to us. Our first denaturalization was delivered by the Enlightenment.[3] Put at its simplest, the aim of this five-hundred-year undertaking was the invention of the knowing individual elevated above nature, which was then deemed to be the object of human dominion. Thus, in the circumstances we find ourselves, to advocate re-creation is actually to reinvent the already nonnatural being of things.

Design against Darkness

Concurring with Barbara Herrnstein Smith, I argue that the only viable theory of value is a contingent one.[4] The fundamental contingent value of design to be adopted here is predicated upon the ability of it to help secure the survival of that biodiversity of life in which we are implicated and upon which we depend.

Without rehearsing all the arguments, I will simply reassert that the compounding of problems like climate change, the reduction of the planet's biomass, desertification, salination, waste, pollution, population growth, and social dysfunction all place life (especially human life) under threat. This is because the breakdown of biophysical systems leads to a social and psychological breakdown. It follows that the essential theory of a design that we need to realize must also enfold a theory of the re-creation of the

means to produce the biological and social conditions of our survival. In this conceptual setting, design can appear as the domain of a practical philosophy, one with a sacred mission. In such a frame the ways of "thinking design" cannot be easily placed in the current topography of the metaphysical tradition. This tradition, of course, has as its core a productivist and anthropocentric drive to dominate, to command and exploit that named and designated as "nature." This history has delivered an artificial environment of organic being in conflict with a displaced biophysical system. Nature denaturalized and transformed into an antagonistic artificial environment is a product of the mediations of humanity. It is a product of design. Living, as we do, in artificiality, has ended forever the dream, the fiction of a return to nature, that is, to that moment before our actions transformed our environment and our thinking reified all and everything by the imposition of the invented category (nature). The changes we have made of ourselves and our world are too great. Not only are we now unable to liberate ourselves from the artificial, but the nonartificial, including our biology, depends upon it; it has become "nature."

If we are to terminate the destruction of that upon which we depend, our only chance is to modify the industrial, the artificial that sustains life. At worst, in terms of environmental impact, the artificial has to be made benign, while, at best, it has to be made proactive in the conservation of life. The task of re-creation, therefore, centers on the task of creating the manufactured means of life support.

The Sacred

The sacred I seek to expose, as nonscientific theory of design, is profoundly profane. It is of the earth and elements; it makes no appeal to spirit beyond us. Rather, it posits faith in the celebration and action of a common love of life which brought us to social being and ever drives us toward survival. It is faith we have to find or create in the world of objects.

To evoke the sacred as configured, and to explicate the rhetorical logic of what will be presented as a nonproductivist general economy (also to name it as the locus of a practical philosophy) Georges Bataille and the spirit of the College of Sociology

can be evoked: "It has been stated most emphatically that the sociology we intended to expound here was not the generally accepted sociology, nor was it a religious sociology, but rather, very precisely, sacred sociology. Actually, the realm of the sacred goes beyond the realm of religion, but cannot be identified with the totality, the whole of the social realm."[5] The sacred is given a place at the center of that which is "necessary to the collective human emotion" and, as such, it is deemed to be at the nucleus.[6] "What unites men?" asked Goethe. The College replied: "They are united by what makes them men because they are not men before they are united" (clearly woman has to be equally affirmed within the same statement).[7]

The ability of advanced societies to survive is inseparable from the survival of the sacred, this because without the sacred neither animality nor waste is maintained within a total system of ecological sustainability, a total economy which, in part, was named by Bataille as general economy. The validation of, and belief in, the total system, by its configuration as God, idol, spirit, reason, good, nature, or community, is thus essential for life (rather than just a life) to be posited with value. Understanding, reason, is subordinate to this valuing, for knowing does not have the ability either to discover life as meaningful or to fuse an individual being to all being. We, whoever we are, have so often adopted modes of being that lack any reference to regimes of meaning that can bond community. Modernity, as thought and action, has atomized us as individuated subjects by the ways we live, work, and think. It has subverted the positing of life with inverted/artificial meaning. Without life as given value, ethics, morality, and belief all lose their ability to cement a collective body, which is normative of social action, in place.

The sacred, as a (or perhaps the) bridge between the language of difference of nature and culture unites that which is, de facto, the same. It transformed mere existence into being within a domain of meaning.[8] The loss of meaning or structure, which is claimed as a primary feature of postmodern culture, is thus an indicator of the loss of the sacred. No matter how powerful the dynamic of the productivist drive of metaphysics, as it is now manifested within, and as, advanced technologies, the future cannot be secured without a foundation of function (total economy)

in which being is the only projectable truth and value. To give value to this foundation is not, however, to give a foundation to truth grounded by metaphysics, for what is in total, the "all and everything," cannot be brought to presence. Rather it is the giving of a value to a foundation of sacred value outside, before, or beyond productivism, that can cohere the social with all its difference. Rather than displace the error of foundationalism with the resonating difference of an indeterminate play, what is 'needed' is a provisional truth of the value of life—a truth paradigm that, while not able to be confirmed as absolutely true, is able to be taken for granted without being elevated as an object of faith. One does not have to have faith in survival to value it.

Paradoxically, the more this sacred is needed the more impossible it is for it organically to come out of the culture. It cannot arrive through a natural anthropological process. The sacred has to be brought into being by artificial device. Here we return to design. Design cannot be the agency for survival so long as it is locked into the productivist drive of domination that lacks any ability to create an operative community. This lack indicates an inability of design to address the essential interaction of the social, since it is elemental in articulating the mechanisms of undoing social formation—design deliverers, users, operators, viewers, customers, images. It follows that design cannot secure the future without the rupture of its functional subordination to instrumental reason—that is to say, it has to be ruptured from the "normal condition" in which it operates as idea, processes, and object.

For the ecological to become the essential ground of the sacred materialized, what is made has to be taken as an object of belief, a totem, an idol, which functions beyond its utility and meaning as it is articulated by reason. What prevents this statement simply being reducible to pantheism is the negation of the transcendental by the artificial.

Community

Community is not available to simply be summoned. To appeal to community is to call up an essential problematic to work upon. In the words of Jean Luc Nancy, "The gravest and most painful testimony of the modern world, the one that possibly involves all

other testimonies to which this epoch must answer (by virtue of some unknown decree or necessity, for we bear witness also to the exhaustion of thinking through History), is testimony of the dissolution, the dislocation, or the conflagration of community."[8] The popular imperative to confront thinking about community (expressed in many kinds of utterances and acts) comes, I suggest, out of assumptions of absence and recognitions of fear and loss.[9] This is equally taken to be a fear of the disappearance of present and of future generations. If the history of community were to be attempted to be written, it would have to be said that the idea so often destroyed the prospect of actuality. The idea of a commonality of modernized being was used to deliver the theory that legitimized the destruction of premodern formations of common action toward survival that became idealized as community.[10]

James Boon understands communities not as structurally posited qualities, with a given identity, but social formations that formulate a sense of themselves as coherent and distinctive through their confrontation with others.[11] While thinking in a similar direction, Nancy puts a more powerful view by exploring the catalytic force of resistance.[12] If this is correct, we might ask who are the others we need to confront?

There can be no appeal to the naturalism of community. Community arrives before us as an idea that becomes inscribed in a given knowing of common sense. There is, however, no single commonly held idea to be found at the base of the term. Competing and connected ways of "thinking community" arrive. The attachment to the mythology of community, the binding together of people in adversity, sacrifice for the ideal, the attempt to negate nothing are all offered as registrations of thinking the foundation of community.[13]

One designates community as that which exists and requires to be structurally understood, in its difference, as part of social formation and its functionality. This space is the space in which a great deal of positivistic anthropology and sociology constitutes its object of enquiry, both in terms of a structural operationality of community and as empirically claimed symbolic divisions within and between one community and its others. Emile Durkheim can be taken here as a generative figure in the founding of this kind of functionalist thinking.[14] Herbert Spencer adopted Durkheim's functionalist accounts and gave them added impetus by bolting

them to Darwinian evolutionary theory.[15] The power of the no-
tion of communities being placed in an evolutionary disposition
toward each other in a schema of natural selection is still evident
in a good deal of everyday thought in a country like Australia.[16]
Thinking, and setting out to document, community as a func-
tioning organism became one of the dominant paradigms of so-
ciological theory, and one that established an influential insti-
tutional presence.[17] Another way community was posited was as
that which could be explored only by making experiential ethno-
graphic accounts objects of study. Community has equally been
viewed as an ethical structure that exists to curb the excesses
of the individual. This was certainly Freud's view, a view that
folded back into evolutionism: "A community constitutes the de-
cisive step of a civilisation."[18] Yet another way of thinking the
formation of community, as a life-world, is put on offer in media
theory constructions of it. Such an approach to the arrival of lan-
guage, in particular modes, is cast as determinate of the form of
imagination in which the *sens* of community is formed. With this
view, the advent of the book, for example, is asserted as effecting
a shift from a linguistic community to a community by lan-
guage.[19] Equally philosophy asserts community in various ways
as the historical necessity of the coming to being of a being de-
pending upon the being of others. Michael Zimmerman puts it
this way: "I am not a human being in general but a particular be-
ing in a particular historical community."[20] The trouble here is
that most people live in conditions of displacement in which com-
munity has become historically divested of its communality. In
contrast, Emmanuel Levinas's recognition of dependence upon
an other is predicated upon the actuality of the act of communi-
cation, rather than the ideal of community. Moreover, Levinas is
not working with a binary of self/community but rather the in-
divisibility of self/other.

Now to leap to a more contemporary understanding and con-
cern with community—as it has failed to arrive in the forms of
its idealizations and as it has been negated by the birth of the sub-
ject.[21] "Community is what takes place always through others
and for others . . . It is not 'a space of *egos* . . . but *I*'s who are al-
ways others . . . It is a community of others . . . A community is
the presentation to its members of their mortal truth . . . It is
a presentation of the finitude and the irredeemable excess that

make up finite being."[22] Thinking community has been power-
fully registered as absent from the metaphysics of the subject,
a metaphysics of the "absolute-for-itself."[23] Community is in
danger; what threatens is the community without community,
community without being with others—that is, the "inoperative
community."[24] Community then is not reduced to organic func-
tionality; rather it is the dialogue in action of what is made in
common by myth. "Community and myth are defined by each
other."[25] Myth can be taken here as the explanation, the para-
digm, the meaning, that enables the one and an other to com-
mun(icat)e and cooperate. Equally, "Myth is above all full, origi-
nal speech, at times revealing, at times founding the intimate
being of a community."[26]

The most powerful community formative myth has of course
been that spoken of as the sacred—which in the contemporary
epoch has so often been claimed to bind people together in belief,
thereby positing immanence with the worshipers rather than the
worshiped. As Nancy puts it, "Community is the sacred, if you
will: but the sacred stripped of the sacred."[27] The space of com-
munity is the place we are given, and give, the gift of being
"here."[28]

An inoperative community is a community of noncommuni-
cation. That is a noncommunal community without myth, for
there can be "no community outside of myth."[29]

The other that brings the being of a being into being is no
longer just a human being. The very distinction between the ani-
mate and the inanimate is becoming meaningless. Myth, that
taken to be recognition, the face of an other as known, all arrive
by both the animate other being from which one comes to know
oneself and the inanimate, which for us of the now is the techno-
logical other, the televisual, the "other lifeless being" from which
one also comes to know self and others.

Community, like being, can never just be. Both depend on a
process of diversity and change; both then are in flux and thus
can never be absolute or totalized. "Community remains an open
community in so far as it is based on the recognition of difference,
of difference of the Other to be the same."[30] While always be-
coming amid the world of beings and things, we are now more
dramatically delivered here by the hand and head of the human

and inhuman, the animate and inanimate. As technology passes from being near to hand to fully integrate with mind and body, we now increasingly live outside the space, scope, and orbit of human commonality.

Reconnections to Design

If we are going to start to advance a practical philosophy of re-creation as both a pragmatic and sacred mission of taking the ecological into care, then we have to invert the drive to dominate biodiversity and its cybernetic interaction with the inanimate (this would normally be called the domination of nature).

The organic, as the material base which we need to care for, has to become the regulatory norm of design. This is not to say that the artificial has to be a mirror of nature, but rather that it has to be configured and judged by contingent values of natural account. Re-creation theory, as the design theory of necessity, has to put together the relation of total economy, the sacred, and time-life. The latter (a theory of dedicated product recycling where the manufactured constantly returns as itself or as elemental to other products) acts as the check on Bataille's unchecked advocation of consumption within his notion of general economy. The problem is not so much how much we consume, as the volume of energy depleted. Consumption that produces waste that restores life is clearly no problem; in fact it is essential. It is consumption from which there is no return which must be displaced. The measure of consumption then should be based on a scale of entropic consequence rather than on raw volume. Good consumption then becomes simply that which extends the totality of life, and bad consumption, that which reduces it.

Bataille's concept of general economy is predicated upon a nonresistent metabolism with (1) the sun as the source and essence of our wealth, (2) the circulation of energy on Earth, and (3) the disposal and take-up of waste produced by this exercise. The health of this metabolism thus demands: the light and warmth of the sun; the earth as the medium that stores and enables the passage of energy named as life, food, fuel, movement; and the folding of death into life, for "Neither growth nor re-production . . . would be possible if plants and animals did not

normally dispose of excess."[31] In this cycle of multiple destruction and generation there is always a return on excess. Recycling, then, is not the invention of ecological politics but is inherent in the biomachine of natural process. Within a total economy, an eco-system, recycling can be conceived of as an economic norm. Thus survival is not a matter of the elimination of death, but the return of a form of life with an ability to reabsorb waste as re-stored energy.

All that the most advanced thinking on time-life (also called "life-cycle" or "cradle-to-grave") "ecodesign" appears currently to do is to transcribe the principle of the metabolism of general/total economy to the design process. However, it is more than this. Design has to be the materialization of the sacred, as the processes, forms, appearances, and relations that bring care (the means of survival) to difference (in particular, our cultural differ-ences named in any way) as a valued being-in-the-world. Design here is the coming to be, and the extension, of the form of being of the artificial. In this way its agency is bonded to the idoliza-tion of the artifice of survival. It is therefore the creation of that which cares as material effect. Design thereafter becomes the bringing into being and the taking into care of that which already cares and a destruction of that which destroys caring.

Thinking design, in the way that has been outlined above, re-quires a fundamental break with it, at least as it is usually con-figured—as the agency or object of applied reason which desig-nates an ordering. The concern expressed in this argument aims at affecting a conception of design on another encounter—that is an ontology of design, understood here as the being of design as it designs (which includes what the designer designs). Design is never finished, its excess never contained. Whatever it is, it sel-dom fully determines subject, object, or being, rather it, itself, always goes on designing the material conditions of possibility of being, which can be pragmatically posited as the existence of hu-man being and that which is being with this being.

The Object/Thing

To put an ontological theory of design in place is, by implication, a metaphysics which contests the adequacy of current modes of design theory and more general understandings of design. This

contestation, de facto, glides into a deconstruction of those theories of knowledge of the author function of design which represent it as a determination of processes, material forms, spaces, relations, and appearances. To make the move to an ontological theory is to undercut the foundation of the logos upon which the designing and design is claimed to rest. Moreover, this move not only carries a transformation of the means by which design is understood but also entails a fundamental change of what are taken to be the objects of study that are named that "thing," *design*.

"Thing," in stasis or animated (thinging) wraps a form (*morphe*) in a look (*eidos*). In being surrounded by things we are enmeshed in the web of their performative presence. We think of things relationally as how they appear and act. While we inscribe things they mark us. We/things act to reveal and conceal themselves.[32]

Hereafter, the ground of studying design shifts. Being of design (the study of the material deposit of any design practice or practices themselves) is displaced by being by design (the study of the productivist inscription of the artificial life-world as it brings being to being).[33]

An ontological theory of design, while important as a way to explore what comes into being through material conditions of existence, is even more significant as an approach to constitute a general re-creation in the face of what retrospectively appears to be a crisis. The genesis of this crisis has a locatable creation and detectable trace. This is viewable across the productivist trajectory, as begun in classical Greece, and is seen as leading to, and existing within, the chronopolitical entropic present—that is, our plural time as it is running out at the "end of history."[34] Which is, in turn, the evaporation of time at the end of the breakup of the faith in, and viability of, the narratives of evolution, be they called development, modernity, or progress. This present of varied historical life-worlds (and not just time and space) displays its relative, concurrent, and discontinuous relations of past, present, and future. What is new for us of this here and now is not this coexistence but the absence of a teleology that can support a social investment in, and the projection of, the future as the figure that orders the direction of movement of all that is measured in time and seen in space.

Although design—at least as we know it—did not get named

until the rise of industrial culture, the productivist drive has always employed design as central to force a prefiguration that was crucial in the domination of the natural world and its making as artificial. The re-creation of what design has delivered requires an inversion of its directional drive through the conservation of being, the survival of being, but now in the form of a contingent value which directs designing under the provisional laws of "total economy." This relation has to become the reference for an ontological rethinking of design as a practical philosophy that not only needs to understand design differently, to re-create the artificial of artificial re-creation, but also must drive further into the nature of designing and the designer.

As a prefiguration of what could be, postindustrial society has to be given paradigmatic status as the concrete sacred society at the end of the history of productivism. This means a society configured as the type-form, without a uni-form, of a total economy that brings value into being. Time-life design, in such a frame, is life-centered design that is not predicated upon the anthropocentric or formalized utopian model that was such a mark of modernist visions.

The kind of ideas put into circulation so far have profound implications upon not only how we view design, as it is and as it could be, but also upon who is concerned with it. Design values, the value of design, design discourse, but more than anything else, being by design, has to be shown to be too important to be primarily the concern of the design profession, design history, and the design industry. Design has to be brought into the public sphere and the closure of the critical distance between design and survival made an evident and general social concern.

The bringing to recognition of design conceptualized, either in creation or encounter, by an ontological mode of understanding depends upon the production of visibilities of forms that can attract and capture the materialized imagination of the public. This capturing of imagination needs to be based on a new aesthetics of sacred design by which the desiring power of fetishized commodities offers and delivers a cared-for becoming. Rather than by overcoming the limits of the world-at-hand by faith in the transformatory power of an enlightening rhetoric (to change action), design and desire are mobilized to unite, in very tangible ways, in

order to bridge the felt, or unfelt, need for survival with the cre-
ation of an imminent sacred that could bond making and the
made with a common sociality of mutual interests. Rather than
set out to gain this recognition in the name of design ("design"
itself is of course deeply encoded in the deep structure of the
language of productivism), another rhetoric of word and deed is
needed.

The Touch of Craft and Care

Craft is not, as most accounts would have it, just the mark of a
human being upon the being of its product of labor. It is more
than this; it is also the outcome of a relation of a tacit understand-
ing between a maker and the made in which skill, which may or
may not be visible through the evidence of an artefact, has to be
an essential presence if an object is to be brought into existence
and revealed for both subject and object. Revealing here is display
rather than disclosure; it is actuality rather than truth (which is
that "enframed" as the essence of the made which is beyond that
which technology produces or can explain).[35] As the outcome
bringing the object into being, it is a nascent caring which goes
ahead of creation, this for both the being of the object and its re-
lation to the being of being. The argument to be presented here is
quite contrary to the mostly myopic and conservative attempts,
past and present, to confine craft and its aesthetics to hand-
work and low-volume production: "There are for example a
whole range of products, including electric kettles, irons, toasters,
sandwich-makers, ovens, micro-wave ovens, dish-washers, wash-
ing machines, freezers, videos and television sets, where the craft
aesthetic has no place . . . There is no role for the craftsperson in
the design of such products."[36] Characterizations like this are
restrictive visions of both craft and the craft aesthetic. Machine
skills, as they are exercised in the process of production and as
they are expressed by the quality of manufacture can, and should,
be included in the recognition of craft. They are not necessarily
the antithesis of the handmade.

Touch, the knowledge of the hand, the dialogue of eye and
hand, can be at work in the use, or direction, of a machine. The
bench, and then machine-shop-based "fitter tradition"—which

delivered so many of the most beautifully engineered objects of industrial culture, with its concern for the harmony of material, precision of assembly, the feel and weight of what is made, the finish, and the sound and performance in use of the product—not only was embedded in the craft tradition but also extended it. Much of the craft basis of the industrial workshop has been over-looked through art, reduced to image, acting as a screen. The recovery of such a tradition of knowing, a tradition of *technë*, is not a romantic indulgence but a sound practical move within the logic of total economy—we no longer need volume disposable products.[37] In fact, if we use total accounting methods, which can be built from the notion of total economy, it can be shown that we cannot afford their true cost (the cost of material and energy consumption, greenhouse gas expenditure, immediate environmental impact, and repair).[38]

Care is that which divides life from death. Heidegger defines it as "being-ahead-of-oneself," that is, going before oneself in the world with concern to guide the detail of one's existence in order to exist.[39] At its most basic it is that perpetual interpretation of conditions elemental to our being here and human. Care guides and directs the detail of our passage through the everydayness of our lives in the actuality of our circumstances. More than this it takes self into the world (as being thrown "here") with an intense interest in its fate. Care is conservation, and preservation—conversely, to be care-less is a negation that puts one out of touch with that which acts to guide oneself. It thus opens the self to the danger of being life-less. A lifetime is a measure of care, it is the state in which the individual and compound (the earth) body life dwells if it is to be secured. In the first and last instance homo "is made out of humus (earth)"—we are made by and make our place of being. Without care life ends.[40] "The stronger my care becomes, the more open I am to self and others."[41] Care is the love of one's own life and the lives of others.[42] Subjectivity in this setting is the illusion that homo is humus—that is, to live with only care for one's own being. Subjectivist-derived subjectivity, then, is a collapse of all distance between self and world and is thus an abandonment of being in the world by making oneself the world.

Craft is a material practice of caring in making that folds into the maker and the made. It is therefore a conduit between being homo and the being of humus. The potential of craft as care, as

seen as expression and as time-life design, is as a paradigmatic
practical philosophy of re-creation.

A Philosophy of Practice: In Practice

There is no way to find or to recognize new ways of thinking
without old thought. Even so, we can ask, where does a new para-
digm and a fundamental change of direction come from?

Consider Spinoza—a philosopher craftsman, a radical whose
ideas disturbed the Judeo-Christian cultures of his own cultural
formation in seventeenth-century Holland to such an extent that
an assassin attempted to take his life. His trade was that of the lens
maker. A theory of optics was central to his action in thought and
his thought in action—Spinoza's preoccupation was with a tri-
adic relation of values, ethics, and vision as they centered around
the joy of the body (the loci of vision around which his philosophy
was constructed). A living body that sees, discovers, perceives,
imagines, and images. For Spinoza, according to Gilles Deleuze,
ethics was elaborated as "a topography of immanent modes of ex-
istence, replaces Morality, which always refers existence to tran-
scendent values. Morality is the judgement of God, the *system of
Judgement*. But Ethics overthrows the system of judgement. The
opposition of values (Good-Evil) is supplanted by the qualitative
difference of modes of existence (good-bad)." [43] Thus, the impetus
to the deconstruction of the foundation of value (the value of any
category upon which an appeal to truth is made) is itself within
the metaphysical tradition. As such, it prefigures the undercut-
ting of recent critiques of logocentrism delivered by the anti-
metaphysical project as it bled from Nietzschean nihilism to de-
constructive strategies via Heidegger. Equally, contingent value,
with Spinoza, is inseparable from his materialist-biased practical
philosophy, especially as expounded in his ethics. Such thinking,
which returns us to Protagoras (for whom the judgment of value
was not grounded in truth but upon an assessment of quality—
the pragmatic truth), travels via Spinoza to the root of those phi-
losophies of action advocated by Henri Bergson and Pragmatists
like John Dewey, William James, Charles Sanders Peirce, and
F. C. S. Schiller.

It is possible, of course, to discover the traces of a philosophy of
practice as evidenced in Aristotle's notions of *phronesis* and *praxis,*

which have been made inseparable from the economic evolution-
ism of the telos of the Hegelian-Marxist tradition. Such notions
are clearly at the very root of productivism, but, as Hans-Georges
Gadamer makes clear and Richard Bernstein reiterates, they are
not the basis of instrumental reason as it "degrades practical rea-
son to technical control." Conversely, Heidegger, also from the
Greek tradition, presents another modality of making a place in
the world—*poiesis.*[45]

Practical philosophies combine contemplation with action, the
action of coping with the world. This philosophy spins in one di-
rection toward reason as directive of action, in the other toward
action coming out of a knowing being. Spinoza displays both of
these directions in tension, he can teach us in a variety of ways.

The geometry of Spinoza cannot be characterized solely by the
reasoned perfection of the form of his argument, as expressed not
only by his claim to truth through theorem and demonstration,
but also by the reason of his life as it was evidenced by care as a
lived ethics. In coping with his life he traveled before his action
and toward us. His action was the craft of hand and thought. For
him, nature was the one body of all bodies, and all action was
therefore within the system of nature, the substance of the total
economy. His antianthropocentrism is not predicated upon hu-
manity outside nature, for as Deleuze makes very clear, Spinoza
speaks to us in our predicament of being; we are with(in) him, his
nature, our nature. It follows that it does not take a great effort to
push the form of coping displaced by Spinoza into care.

Action, as care, is thus posed here by Spinoza and Heidegger
as a mode of production that does not simply fold back into pro-
ductivism. Care is able to be claimed as the custodianship of one's
own life as elemental to life itself, and as the love of others it joins
with the generality of sacred design. It is predicated not upon
command but attachment.

Craft-Care at Hand: A Theory of Design
within a "Total Economy"

Martin Heidegger declared that "the substance of man is exis-
tence." The quality of that existence is, as he made clear, directly
related to the quality of care for reality. As the place of existence,

reality is not fixed but an effect of care.[46] Care for self and future, as a working practice toward a quality of the being of objects, and being with objects, clearly is inseparable from the quality of survival of all being. The creation of the imminence of the survival of being, to enable a quality of being, can be regarded as the pragmatic that specifies what is named as the primary contingent value.

Care has to be designed into being, and craft is the means by which this can be done. Craft in this context is: a form of knowing the materiality, care in making, and the quality of the made. To view craft from this perspective requires that we challenge, and perhaps displace, the ways in which it is classified. What we need to do is undercut the conventions in which the ways of craft activity and craft objects are constructed and characterized. Specifically, this means the placement of craft on the economic margins and within a wholly aestheticized space as an expressive object and practice. At the same time, craft has to be placed in the path of the otherness of nonhuman-centered manufacturer as an expression of the human being as carer and cared for.

What is advocated adds up to a deconstruction, but not to the destruction, of craft. The aim is the subversion of the basis of that division that separates the visibility of craft from its actual possible presence. The current actuality of craft is its invisibility, its unrealized condition of being in which it is seen to be there but with its agency unseen and inactive. This is the inertia of its aesthetic presence wherein its status as a commodity negates its invitation to instruction as knowing, being with, and making to a standard.

What should be delegitimized in the exercise of craft's deconstruction is the standing of craft as an obstacle to its realization—this is to see it as the myth of an aesthetic community of artists and craftworkers, and as a privileged aesthetic of art and craft, within the cultural sphere and marketplace, disengaged from destructive productivist forces. Critical activity here aims not to destroy craft but to realize it.

The key to gaining a more adequate view of craft, and its realization as an expression of the agency and value of care, is to make visible its potential connection to, and place within, contemporary cultures of manufacture. From the mid–nineteenth century onward, the machine was proclaimed the enemy of craft,

especially by the Arts and Crafts movement.[47] Craft was designated as nonalienated handwork, bonded to art by romantic notions of a past (in which no division between art and work existed), which could be recovered.

William Morris proclaimed, if at times in a contradictory manner, that the industrial machine was the enemy of craft. At the moment of its utterance the statement was incorrect, but now we can see it to be both true and false. That is, it is not true of the skill-centered machine of the fitter/skilled machinist tradition of the nineteenth and twentieth centuries; and it is true of the machines that destroy: these are machines of human-decentered, lifeless, information-driven, dead labor machines as integrated into simulated cybernetic systems of production (for instance, numerically controlled machine tools and robotics that operate in integrated systems that even when they have a live labor component, reduce it to the dead, depopulated processes of an objectified condition).

Such "new technologies," of and beyond neo-Fordism and Japanese production pragmatics, threaten the culture of the industrial workplace and machine-based craft traditions, which while largely invisible, are extremely important to our future as a key form of care. Statements like these need to be explored in terms of what exactly is lost with the termination of a viable basis of the tradition of the being of craft.[48]

Craft is an expression of the hand; it literally means "the strength and skill in our hands."[49] Craft-making, including the making of knowledge, the employment of precision machining, and the use of advanced production system has, or can have, a great deal in common with technically based handcrafts. Both, as forms of practical behavior, are ways of acting knowingly in which care is elevated to method. If we view craft as method it is possible to see that a good deal of technical change, rather than destroying the conditions for the exercise of craft, has shifted the location where it can be used. The question then becomes how craft practice can be encouraged and shown to exist. As a generalization, for example, one could claim the design of computer software requires a craft sensibility if its application in any way seeks to be generative of new skills.

The hand, as a tool or with a tool "handy" (be it hammer or keyboard), is no mere instrument or mute extension of mind. Its

abilities go beyond what it is instructed to do. The hand is the locus of the knowing of craft:

> The hand is a peculiar thing. In the common view, the hand is part of our bodily organism. But the hand's essence can never be determined, or explained, by its being an organ that can grasp . . . The hand does not only grasp and catch, or push and pull. The hand reaches and extends, receives and welcomes—and not just things: the hand extends itself and receives its own welcome in the hands of others. The hand holds. The hand carries. The hand designs and signs, presumably because man is a sign . . . Every motion of the hand in every one of its works carries itself through the element of thinking, every bearing of the hand bears itself in that element. All work of the hand is rooted in thinking. Therefore, thinking itself is man's simplest, and for that reason hardest, handiwork, if it would be accomplished at its proper time.[50]

The hand, erroneously pitted against the head, mediates the immaterial and the material. In the knowing of the hand, what is known is lodged in the practical performative act that knows what it will create, as it is expressed by exercised skill, ahead of itself. Its knowing thus does not correspond with those judgmental knowledges that are understood as reflection or description upon that which already exists. The knowing of the hand, which may or may not translate to action, is prefigurative knowledge, in that it guides. This is not to say that it is not also reactive, through responding to the directive/corrective knowing of touch, sight, smell, hearing—the machine, for instance, becomes a sensory arena in which the worker has to constantly monitor, interpret, and act on the object in making. For example, the color and smell of sparks of a universal grinder in action, its sound, and the felt finish of the ground surface all deliver information that skill reads and directly translates in machine adjustment.

To lose, or reduce, preindustrial, or postindustrial craft practices and craft sensibilities means the loss of a very important, if often nascent, manner of knowing, materially interacting with, and in the end, making the artificial, but naturalized, environment to hand. The workplace, and cultures of the workplace, clearly had, and partly still have, a very significant informal function in the creation and transmission of many forms of noninstrumental knowledges. These knowledges can be extended

into and developed by human-centered systems, which are high-technology based, but are contrary to robotic cybernetic modes which extrapolate skill from workers to build it into the technological systems.[51] Moreover, while craft is, it is clearly not just a particular type of care, work, knowledge, or product. For it is also, or can be, an act of human making in community, which is increasingly important to retain in the face of technologies that de-democratize the power to shape the artificial environment through one's labor, one's own hands.

Craft recenters the human maker whom advanced technology decenters and displaces even when it reskills with systems-serving knowledges. In doing this, working life is retained as a life-world in which the care of the world is lived as a practice of making, with care for materials, tools, processes, products, and the life of the made object in the life of its user. There is nothing in this statement which assumes that craft exists only if it is lodged in traditional skills. The qualification of craft practice is predicated neither upon established hand-working, machine-based skills nor upon new methods which employ advanced technology, but rather on the articulated relation between hand and mind in making, which secures a direct human presence, as the loci of power and knowledge, in the made.

As Aristotle pointed out in *De Anima,* survival cannot be prolonged without touch.[52] In this context, it is that, along with the eye, which articulates being "in the world" and bringing the world into a being. The ecological function of the hand thus realized in this active relation of exchange within the sensory field is a relation of gathering, giving, feeling, knowing, and guiding.

The hand acts before (and after) the anthropocentric impetus. It is cast, with language, as that which distinguishes humans from other animals.

> Man himself acts [handelt] through the hand [Hand]; for the hand is, together with the word, the essential distinction of man . . . Through the hand occur both prayer and murder, greeting and thanks, oath and signal, and also the "work" of the hand, the "hand work," and the tool. The handshake seals the covenant. The hand brings about the "work" of destruction. The hand exists as hand only where there is disclosure and concealment. No

animal has the hand . . . The hand sprang forth only out of the word and together with the word. Man does not have hands, but the hand holds the essence of man, because the word as the essential realm of the hand is ground in the essence of man.[53]

The word, as writing, as handwriting, was for Heidegger authorship of man's being in language. The inscriptive power of the word, opened out as inscription, as marking, is that which enables making, and therefore craft, and thereby gave humans permanence. The mechanization, and now electronic creation, of writing here can be viewed as a transformation of the ground of human being, and a further erosion of the difference between humans and technology. A process which started, as Jacques Derrida observes, at the very moment that technics arrived (that is, when the hand first turned to grasp an object "at hand" as a tool).[54]

It is by the hand, with care as craft, that the sacred can be made—the sacred here becomes not only that which delivers the beliefs which unite but also the material which cares. The object of idolatry, the crafted object that could be, has more than its totemic function of bringing into existence a community of care, for its actual material effect would be to sustain life. Spirit, in this context, is understood not to rise above the earth, but rather is bound to serve its continued existence.

Toward a Basis of Neo-Craft Design Practices

A critical basis of re-creational technology clearly has to go beyond the conservation and extension of skill of the hand that cares. It has to extend to what is made as caring and refuse to continue the aesthetic celebration of traditions of beautifully crafted objects of death—weapons.

The avocation put forward here adds up to advancing craft in the cultures of commodification. Commodity fetishism is thus being redirected rather than morally contested—the worship of the relation of things could be said to be too deeply embedded in modern being. However, if things are created to extend community and protect life, then such worship is not misplaced.

Craft, as care, has a major part to play in the designed establishment of the conditions of an artificial nature for the survival of the denaturalized. The denaturalized, of course, as has already

been registered, includes us and all of that upon which we depend. Now a listing:

•Craft value can deliver a new ethical claim. It is possible, via the reconfigured view of care/craft as put forward here, to articulate the idea of new design ethics. Such an ethics is not claimed to stand on a foundation of truth but can be viewed as contingent. Making with care, as central to human-centered systems, thereafter can be designated as an indicator of a contingent ethical value toward survival. craft then becomes a materialized ethical reference lodged in the agency of its (enframing) material.

•Craft value, as contemplated here, is a means to sustain a recreational manufacturing environment (which also could be named as a life-centered system), one not devoid of advanced technology but one that subordinates it to the development of sustained being. This centeredness, as a contingent ethical basis of value, is not dependent upon the anthropocentric, logocentric, and ethnocentric configuration of the European humanist tradition. It is, in fact, antihumanist, for it is not based on a centeredness of individuated humans over nature and Western knowledge and values over all others. Rather, it is the centrality of present and future life, as the metabolic nature of total economy, over inert cybernetic systems.

•Craft knowledge, as a key element of an applied ecology, centers on the conservation of skill that maintains re-creational knowledge for present and future uses. Knowledge, it will be remembered, has not just been assigned to that held by the mind, for it has also been posited with the hand and as the traffic between these sensors of being.

The fundamental point being made is that craft knowledge should not be viewed in a developmental lineage in which it is placed behind new or high technologies, for it is essential in keeping and making the world human and in artificially sustaining an ecosystem. Craft knowledge is, therefore, behind, in front of, and in competition with noncraft technologies. It is not, in terms of importance, marginal. Craft knowledge is in fact of central importance to the future.

We now have in play a time-life configuration of design. This directly links to design, through craft, as care, which in turn feeds a bonding between contingently qualified ethical values. All of

these reconsiderations of design are directed at establishing its place as a philosophy of practice. A practice that brings in "bringing into being" as an integrated condition of both assured survival and the community that strives for that condition—the sacred community. All that is presented here travels toward the value of a recognition of total economy as a whole and in specific nodal forms—idolized products.

Craft then can be the design and practice, the caretaker, of the made, and the making, upon which the coming to be and the reproduction of the organic life of the total economy depends. It is a counter to the dysfunctionality of the endpoint of productivism. None of this, of course, is by the rule, naming or directive of elites with a vision, but by the material re-creation of creation, that is, by the re-creation of an artificial nature as the biotechnological carer of the naturalized.

In the kind of setting of ideas outlined here, how can we actually think about manufactured products? What would be good product design? And what values can be brought to or seen through products?

Products would clearly be a major agency and marker in a desired re-creational change. The essential re-creation of artificial nature, the made world, is unlikely to arrive by education, rising awareness, or attitudinal shifts. Enlightenment and humanism have delivered the problems and failures of productivism and failed to resolve them. Implicit in what has been argued is that faith in the power of enlightened social subjects to act rationally has to be replaced by material means of sustainability (as the conditional environment of object and use choice). It is vital to create neocraft products as the main elemental features of the re-formation of economic-metabolic practices (the organic cycle of production/consumption) which have to be the heart of bringing into being the burgeoning of community. The manufactured has to be designated one of the main fronts in the struggle for survival.

The kind of products that are needed should conform to certain technological and ecological performance. For example, if possible they should draw on a low amount of nonrenewable energy in their production, use, and disposal. They should also have either a long product life or be easy to recycle (again at a low energy cost). The amount of greenhouse gas and other toxic sub-

stances produced and emitted in production or use should be as small as possible. Products need to be designed and made so they can be repaired. They should minimize the creation of waste.

Technical factors, however, have to subordinate themselves to an aesthetics of change that powers humanity toward a culture of survival. Within this aesthetic, design needs to create objects of desire which deliver the material fabric from which the wish and will for change is united with values and agency. This does not preclude the object giving pleasure to its maker and giving a pleasure of appearance and use across its entire life.

The very basis of what is meant by good design and design quality has to be placed within the invented (artificial) logic of the total economy. In this way the quality of the characteristics of the product, culture, life, and the environment cannot be disaggregated from the quality of care of design and making. In this, quality itself becomes a rematerialized ethical value. Such a value would, in part, be underpinned by the exchange value of, for instance, long-life, time-life products.

Re-created products can be viewed as elemental not only to the rematerialization of artificial nature as a condition of possibly of becoming (survival), and to the material establishment of the ethical as a contingent value, but also to the transformation of utility beyond functional use and thus of use value itself. thus, every re-created product would act as a figure of care. In this way products, as a sign of life, a sign of myth, invite placement in a community of readership which expresses both the desire for, and a method to secure, survival. The product would hereafter be an object and idol of care: something to be cared for, something that could deliver care. Sacred design then is capable of generating a community of care, a community of survival, a mood toward the love of life which seeks to establish nonhumanist ethical value through the power of the commodity, commodity culture, and the marketplace. It is a re-creation from the inside of that from which there is no outside or morality, a re-creation about which we have no choice if we wish for future generations to have a choice of life.

Here a faith in technological solutions ends. What follows is a recognition that the way in which we make things, and the way in which those things act, has a profound effect upon how we ourselves are made, and what we become. In this frame, work on or with the ecological systems will always be equally a reaching out,

a touching, and changing the social ecology, the ecology of community that demands the myth of the value of life as given from the elsewhere—the sacred.

Notes

1. Martin Heidegger, *Early Greek Thinking: The Dawn of Philosophy* (San Francisco: Harper and Row, 1984), p. 17.

2. "That which gives bounds, that which completes, in this sense is called in Greek telos, which is all too often translated as 'aim' or 'purpose,' and so misinterpreted. Telos is responsible for what is matter and for what aspects are together co-responsible for the sacrificial vessel." Martin Heidegger, *The Question Concerning Technology and Other Essays,* trans. William Lovitt (New York: Harper and Row, 1977), p. 8.

3. Alastair MacIntyre, *After Virtue: A Study in Moral Theory* (Notre Dame: University of Notre Dame, 1981).

4. Barbara Herrnstein Smith, *Contingencies of Value* (Cambridge: Harvard University Press, 1988).

5. Georges Bataille, "Attractions and Repulsion 1," in *The College of Sociology 1937–39,* ed. Dennis Hollier, trans. Betsy Wing (Minneapolis: Minnesota University Press, 1988), p. 104.

6. Ibid., p. 106.

7. Ibid., p. xvi.

8. These are the opening lines of chapter 1 of Jean Luc Nancy, *The Inoperative Community,* trans. Peter Conner et al. (Minneapolis: University of Minnesota Press, 1992), p. 1.

9. Ibid., pp. 9–10.

10. Nancy argues that community has never been what we have imagined it to be. Ibid., p. 11.

11. James Boon, *Other Scribes, Other Tribes* (Cambridge: Cambridge University Press, 1982).

12. Nancy, *Inoperative Community,* pp. 14–15.

13. This is done with complexity and insight by Nancy.

14. Durkheim developed his functionalist theory of society using ethnographic accounts of "primitive" peoples as the means to identify the foundational elements of the divisions, forms, and operations of the social organism. In particular he used material on the Aboriginal peoples of Australia. It thus could be said that in significant part the interpretation of Aboriginal culture authored sociology. His first great work, *The Division of Labour in Society,* first published in 1893 (New York: Free Press, 1933), was theoretically restructured by Australian material. See Boon, *Other Scribes,* especially pp. 54–68.

15. Spencer acted as the link between Durkheim and the rise of structural functionalism founded by Malinowski and Radcliffe-Brown and given a modern impetus by Talcott Parsons. See Stanislav Andreski, ed., *Herbert Spencer* (London: Nelson, 1971).

16. It is interesting to note that, as is evident in the current "Mabo debate," Aboriginal forms of community organization are polemically cited as evidence of a lack of social development that deligitimizes claims to social justice (the ethnocentrically inspired proposition being that a lack of discernible socio-organizational structures meant that there was no body politic with which to strike a social contract). In contrast it could be argued that much of the roman-ticized appeal of Aboriginal cultures is that, notwithstanding a great deal of genocidal and ethnocidal damage, their sociocultural forms, art, and artifacts communicate the strength of the imagined communal bond of the cultures. In this respect Aboriginal cultures become constituted as the fictive cultures of the desired. It becomes offered up as the evidence of community to the community without community, and thereby gets projected (remythologized) to those who recognize absence, as a figure of desired sociality.

17. The Chicago School of Sociology, founded in 1892 at the University of Chicago, was the first graduate school of sociology in the world. Its early work was in large part based on the work of Robert Part, and Ernest Burges spawned urban ethnography as a major method of extending sociological analysis of the city of Chicago.

18. Sigmund Freud, *Civilization and Its Discontents,* trans. and ed. James Strachey (New York: Norton, 1961), p. 42.

19. See for example Marshall McLuhan, *The Gutenberg Galaxy: The Making of Typographic Man* (Toronto: University of Toronto Press, 1962); Benedict Anderson, *Imagined Communities* (London: Verso, 1983); Lucien Febvre and Henri-Jean Martin, *The Coming of the Book* (London: New Left Books, 1976).

20. Michael E. Zimmerman, *The Eclipse of the Self* (Athens: Ohio University Press, 1981), p. 126.

21. Nancy, *The Inoperative Community,* p. 15.

22. Ibid.

23. Ibid., p. 4.

24. Ibid.

25. Ibid., p. 42.

26. Ibid., p. 47.

27. Ibid., p. 35. To evoke the sacred, again as configured by Georges Bataille and the spirit of the College of Sociology, is to call up that which is placed at the center of the formation of the social. The college emphatically proposed that the sociology they intended to expound was not the generally accepted sociology, nor was it a religious sociology, but rather, very precisely, a sacred sociology—a so-cial logic of community. Bataille, and the college, asserted that the realm of the sacred went beyond the realm of religion, but could not be identified with the totality, the whole of the social realm. The sacred was given a place at the center of that which is "necessary to the collective human emotion" and, as such, it is deemed to be at the nucleus. See Dennis Hollier, ed., *The College of Sociology 1937–39,* pp. 104–7.

28. On the notion of the gift, see ibid., pp. 35–36.

29. Ibid., p. 50.

30. Simon Critchley, *The Ethics of Deconstruction* (Oxford: Blackwell, 1992), p. 219.

31. Georges Bataille, *The Accursed Share*, vol. 1, trans. Robert Hurley (New York: Urzone, 1988).

32. "Whatever becomes a thing occurs out of the ringing of the World's mirror play." Martin Heidegger, "The Thing," in *Poetry, Language, Thought,* trans. Albert Hofstadter (New York: Harper and Row, 1975), p. 182.

33. The term "being" is used here, and throughout this paper, to designate ontic/ontological conditions of passive and active existence. See Martin Heidegger, *Being and Time,* trans. John Macquarrie and Edward Robinson (London: Basil Blackwell, 1962).

34. On the chronopolitical see Masao Miyoshi's analysis of Japan as a society outside the ethnocentric category of the modern as a single and universal chronology: "Against the Native Grain," in Masao Miyoshi and H. D. Harootunian, *Postmodernism and Japan* (Durham: Duke University Press, 1989), pp. 143–68.

35. Enframing is one of the most complex and important ideas exposited in Heidegger's "The Question Concerning Technology" in *The Question Concerning Technology.*

36. Peter Dormer, "The Ideal World of Vermeer's Little Lacemaker," in *Design after Modernism,* ed. John Thackara (London: Thames and Hudson, 1988), pp. 143–44.

37. *Technë*—"knowing in the widest sense . . . is the name not only for the activities and skills of the craftsman, but for the arts of mind and fine arts." Heidegger, *The Question Concerning Technology,* p. 13.

38. True or total cost accounting is now being developed by, for example, the World Bank as a mainstream economic indicator. The ambition is for this form of accounting eventually to displace GNP.

39. Heidegger, *Being and Time,* p. 241.

40. Ibid., p. 242.

41. On care and love see Michael E. Zimmerman, *Eclipse of the Self,* p. 65.

42. Ibid., pp. 128–29.

43. Gilles Deleuze, *Spinoza: Practical Philosophy* (San Francisco: City Lights, 1988), p. 23.

44. Gadamer as quoted by Richard J. Bernstein, *Beyond Objectivism and Relativism* (Oxford: Basil Blackwell, 1983), p. 39.

45. See Martin Heidegger, "Poetically Man Dwells," in *Poetry, Language, Thought,* trans. Albert Hofstadter (New York: Harper and Row, 1971), pp. 213–29.

46. Heidegger, *Being and Time,* pp. 254–56.

47. See, for example, "The Lesser Arts," in *Political Writings of William Morris,* ed. A. L. Morton (London: Lawrence and Wishart, 1973), pp. 31–56.

48. See Tony Fry, "Green Hands against Dead Knowledge," in *Remakings: Ecology, Design, Philosophy* (Sydney: Envirobook, 1994).

49. Martin Heidegger, *What is Called Thinking?* trans. J. Glen Gray (New York: Harper and Row, 1968), p. 16. In this text Heidegger not only points out

the action of the hand as it reaches and extends, receives and welcomes, but also that the joining of hands is the linking of one with an other. If not the means to constitute community, this linking does at least (in the context of craft) deliver cooperative labor. Help and care converge in the "giving of a hand."

50. Ibid.

51. Mike Cooley, "From Brunelleschi to CAD-CAM," in *Design after Modernism*, pp. 197–207.

52. Aristotle, *De Anima*, trans. Hugh Lawson-Tancred (London: Penguin Books, 1986), p. 219.

53. Martin Heidegger, *Parmenides*, trans. André Schuwer and Richard Rojcewicz (Bloomington: Indiana University Press, 1992), p. 80.

54. Jacques Derrida, "*Geschlecht* II: Heidegger's Hand," trans. John P. Leavey Jr., in *Desconstruction and Philosophy: The Texts of Derrida*, ed., John Sallis (Chicago: University of Chicago Press, 1987), pp. 161–96.

More generally, in terms of contemporary ecological dangers, it can be noted that Heideggerian thought, besides its influence on Deep Ecology philosophy, is now regarded as a significant analytical tool for understanding the tradition of thought which has delivered and continues this "crisis." For example: Michael Zimmerman, "Implications of Heidegger's Thought for Deep Ecology," *Modern Schoolman* 64 (Nov. 1986): 19–43; and Bruce V. Foltz, "On Heidegger and the Interpretation of Environmental Crisis," *Environmental Ethics* 6 (Winter 1984): 323–38. The concept of care, as an issue of ecofeminism and deep ecology, is beyond the scope of this paper. For an introduction to this debate I refer the reader to Jim Cheney, "Ecofeminism and Deep Ecology," *Environmental Ethics* 9 (Summer 1987): 115–45. See also Arne Naess, *Ecology, Community, and Lifestyle*, trans. David Rothenberg (Cambridge: Cambridge University Press, 1990), and Warwick Fox, *Towards a Transpersonal Ecology* (Boston: Shambala, 1990).

Prometheus of the Everyday

The Ecology of the
Artificial and the Designer's
Responsibility

Ezio Manzini

One Promethean ability of human beings, to act in a purposeful manner upon the environment, is articulated on various planes: from the most advanced research topics (artificial intelligence, genetic engineering, new materials) to grand programs to intervene in environmental structures (alimentary systems, energy systems, telematic systems, transport systems) to the diffuse production of material and immaterial artifacts from which we build the daily environment.

These first two planes have been the subject of profound critical analysis for quite some time,[1] but the level of reflection upon the third plane is much poorer. What are the anthropological implications of the widespread penetration of technological science on the products of our daily lives? When this question is asked,[2] too few useful hints exist to predict a system of values—and

This paper was first presented at the "Prométhée éclairé" conference organized at the University of Montreal in May 1991, and appeared in *Design Issues* 9, no. 1 (Fall 1992): 5–20.

therefore an ethics—that can be adapted to whatever is proposed for purposeful action on this level. In other words, the debate on ethics, which is defined in reference to large choices, is hard to articulate in relation to the smaller and more minute choices made in the manufacture of daily objects. We continue to lack, then, an ethics of design adequate to the new problematic framework and to new sensibilities.

I am certainly in no position to offer exhaustive responses to these arguments. In the following remarks, I limit myself therefore to proposing a general scenario concerning the problems that have arisen and to articulating it, as far as possible, in reference to the designer's activity. My thesis is that the environmental problematic can generate a new sensuous horizon for design and can be the source of a vast series of cultural transformations and contemporary societal practices. More specifically, starting from inevitable discussions about industrial society's values, which the emergence of the environmental problematic imposes, it will be possible not only to arrive at a system of consumer production more favorable to the environment but also to propose new values and deeper conceptions of quality.

Making the World Habitable

Considered as an operator acting in relation to the daily environment, the designer's ultimate responsibility can only be to contribute to the production of a habitable world, a world in which human beings not merely survive but also express and expand their cultural and spiritual possibilities. The term *habitable,* referring to the environment, indicates a complex existential condition that cannot be reduced to its functional component. It is a condition arising from the intersection of a multiplicity of questions rooted in the anthropological and social nature of the human race. Some questions can be grouped according to different temporal situations: They can present great stability across time; they can vary gradually over long periods of history; or they can evolve rapidly in connection with abrupt social, cultural, and environmental changes.

It is just this complexity of the term *to inhabit* in its inter-

mingling of permanence and change that causes design culture*
to have difficulties in defining its goals; if the final objective is
clear, the means of realizing it in a given historical situation are
not. This is particularly true in the present phase, in which the
rapidity of change in the environment has exploded the previous
cultural stratifications associated with the meaning of the term *to
inhabit*. Does *inhabiting* mean living in an environment in which,
in the past few decades, the impact of technological innovation
has acted so extensively and intensively as to force a crisis with all
the cultural instruments that we have consulted traditionally and
in many of the operative instruments with which we intervene?
To avoid vagueness in these questions it is useful to summarize
briefly some of the characteristic aspects of the contemporary
environment and how it presents itself to social and subjective
experience.

The Postindustrial Metropolis

The world that we intend to make habitable is the postindustrial
metropolis: the "global village" extended across the planet, whose
characteristics are conspicuously marked by the diffuse and pro-
found impact of new technologies. To say that this is the world in
which we must intervene does not mean accepting it as it is. It
means understanding how it appears, how it is made up, and the
problems that threaten it; regardless of what we want to achieve,
this is the material with which we must work.

A first observation can examine its very physicality, the meta-
morphoses of the matter from which it is made, the times and
the modes of its transformations.[3] In the contemporary world,
matter—which is always considered the solid, stable, inert coun-
terpart of ideas—seems to have become pliable and capable of
being molded into any possible form. The integration of science
and technique, penetrating the daily environment with its own
results, has eliminated many of the traditional technical barriers,

*The Italian *cultura del Progetto*, literally "culture of the project," refers to all those
involved in the act of planning or projecting—not only designers, but everyone engaged
in bringing an idea to fruition. The term is unique to Italy and denotes a more cooperative
activity than one in which the designer acts as a lone individual. —*Ed.*

thus enormously enlarging the field of possibilities; forms and functions that were inconceivable as recently as yesterday are possible today.

On the other hand, commercial competition has pushed forward the most rapid employment of these possibilities, leading to the multiplication of images and services offered and to the accelerated introduction of the "new." At the same time, the lack of a design culture capable of confronting these new technological possibilities has resulted in the dissemination of worthless products. So the potential of the old technology is distributed in the banal forms of gadgets, disposable products, and ephemeral objects lacking any cultural significance. A feeling of generalized transcience, an impoverishment of sensory experience, of superficiality and the loss of relations with objects derives from this; we tend to perceive a disposable world: a world of objects without depth that leaves no trace in our memories,[4] but does leaving a growing mountain of refuse.

As we have already seen, in the very moment in which technological innovation affects the loss of many limits to our possibilities, society has begun to realize that other limits we had not previously recognized exist. The "discovery" of environmental limitations and their implications is certainly another aspect that characterizes the current historical phase and requires a profound reconsideration of the meaning that we have thus far given to the verbs *design* and *produce*.

The Discovery of Limits

The physical limits of the environment attest that conceiving of a single design activity is no longer possible without relating it to the wider network of relations that the product will have with the environment in its complete life cycle (production, use, disposal). Recognizing these relations, in turn, allows for an extraordinary growth in the complexity of the system with which the designer and producer must interact.[5]

But the discovery of environmental limits does not refer merely to the physical limits of the biosphere. We are in the process of discovering another type of limit: the limit of our capacity to deal with the increasing mass of information. In short, we find

that our semiotic environment (that is, our semiosphere) is limited. Immersing ourselves in an uncontrolled number of signs is impossible because doing so results in a new kind of pollution: semiotic pollution, caused by the confusion, loss, and distortion of meaning and by the generalized production of semiotic refuse.[6] So we find that the result of the "liberalization of forms and of services" permitted by technology can also be the production of a big "noise," which is precisely the opposite of what that increase in information meant to add.[7]

Recognizing environmental limits then necessitates connecting products to their environment not only in terms of their physical relations with the biosphere, which has already been stated, but also in terms of their relations to the semiosphere. It means that it is necessary not just to produce new images but to construct stable and lasting identities that can be placed in a recognizable manner in the cultural space in which we are immersed. The problem is that going in this direction requires the development of a new product culture, a culture that radically questions how the existing culture fits into our environment and how it relates to the fruitful subject.

Given the present-day system of production that is strongly geared to the ever accelerating production of worthless goods, the ideas expressed above could seem beyond the range of possibility. But perhaps not: Something is moving, whether in the direction of a demand or an offer. (A demand for a new quality, of which *green consumerism* is just one aspect—though the most obvious and significant—is beginning to be felt.) Some businesses are beginning to understand that the environmental question is now an ineluctable fact of the system in which they operate, and that this realization is a necessary step if they are to continue to exist and be successful in a physical environment saturated with products and a semiotic environment saturated with signs.

This countertendency within the system of production and consumption is, in my opinion, the determining aspect of the definition of a terrain on which the designer can act, seeking coherence between ethical and cultural options and design practices: Without this broader sociocultural phenomenon, the designer could only think of suitable things, not realize them. On the other hand, operating in relation to this countertendency and not to

other demands is not to be altogether discounted: It deals with a choice, an option among many possibilities. Responding to all demands then is not required but, in all its consequences, is an ethical choice. However, to move in this direction in a significant manner, to contribute to giving more ample voice to the weak signs that society is transmitting, requires a cultural transformation more fundamental than that which has occurred so far. The spontaneous adjustments that have taken place up to now do not suffice; the question of rethinking the relation between the human race and the environment must be asked in a radical manner, beginning with the deepest aspects that characterize it.

The Culture of "Doing"

A profound redefinition of the relation between human beings and their environment can take as a point of departure an up-to-date consideration of the meaning of the term *to do:* today it means to design and to produce. Why and for whom are things designed and produced? This question, though seemingly simple, leads directly to more radical questions, practically, the ultimate meaning of life. It is not my intention to confront that question except on a philosophical plane.

For the moment, then, we will disregard the commonsense view, which says that human beings design and produce because it is in their nature to do so. We will also disregard a view that derives from this affirmation: everything made by human beings, all design and productive work from one generation to another, the transformations generated, and the progressive artificiality of the environment that derives from these activities are all natural consequences of this particular trait of the species *homo sapiens.* With this ahistorical background, moment by moment, situation by situation, designing and producing has meant various things; it appears as a complex of historically and socially determined activities. Thus human beings, among other peculiarities, have a tendency to construct a system of internal meanings in which to place their own existence and thus also their own doing. For American Indians, but also for the great number of cultures that humanity has generated with infinite variations throughout the course of history, "to do" means to produce and reproduce their cultural—and thus artificial—world, seeking to be in tune with

the natural environment. They situate themselves in a framework that, on a temporal scale of individual experience, seems locked into immobile cycles.

On the other hand, for the past two or three centuries, Europeans have tended to think of "acting to change things," "acting to dominate nature," "acting to seek a different type of welfare," and "acting for a better tomorrow." All these conceptions have been developed over a short period of time (a few centuries) and only by a relatively limited number of people in Europe. That these ideas have become the basis for an upsetting and devastating practice which, in spite of a thousand contradictions, has been imposed upon the whole planet, in no way changes the contingent nature of their historical character. Beginning with this confrontation between different cultures of doing does not reopen the debate about which is the preferable cultural model; it only makes modern Western thought upon "doing" relative; the culture of design, production, and consumption that the West has generated is a historical phenomenon. As such, its destiny is open: it can continue, die, or change.

As it has been formulated, the modern Western culture of doing cannot continue for a practical reason: Its goal of dominating nature must confront the grave obstacle that nature can be manipulated locally but cannot be dominated globally. Western doing cannot continue for an ethical reason, as well: the tradition and basically elementary elaboration of the goal to "act for a better tomorrow" no longer yields satisfactory answers. The ethical force of modern industry is really an idea about the democracy of consumption. The equation "a better tomorrow equals the diffusion of products" links together the notion of progress and quantitative parameters that are imagined to be infinitely expandable. This victorious idea moved and acted as a catalyst for a whole society. However, this idea has lost its force today.

Today we must look with a critical eye upon the way things are really going. We must evaluate both the pros and cons of product diffusion; we must perceive the social inequalities that can be verified and must state the environmental costs that we are paying. Concerning these points, we can express differing judgments. We can draw up negative balance sheets or underline the advantages that are commonly acquired.

But in both cases, the traditional justification of doing cannot

be proposed in the same terms as before. The idea that increasing production automatically disseminates well-being is no longer valid. Linking progress to parameters of quantitative growth could seem acceptable in a world that still seemed simple (assuming elementary needs that could be met by standard products). But now the themes of quantity are being undermined by those of quality. This is not because there are no further problems concerning quantity which are urgent, whether in the sense of increasing it in some contexts or diminishing it in others. Rather we realize that if there is progress, it can be judged only by qualitative measures. The qualitative dimension cannot be measured by simple frames of reference: In fact, quality means complexity.

On the other hand, neither can the Western culture of doing die. The transformations on the planetary level are such that, for good or ill, they now constitute an irreplaceable element in the functioning of the technological macrosystem on which rests the existence of the whole human race. If, as we must hope, the planet finds its equilibrium, it will have to be an ecotechnological equilibrium. As far as cultural transformations, hybridism, and crossbreeding can take place, something from the starting point of modern technology, of the Western idea of doing, must be inscribed in the DNA of the technological system that will support eight billion people in the near future. To find the means of escaping this impasse, trying to look more deeply into the characteristics of Western doing will be useful. One way to do so is to begin with the concept of "finalized consciousness," as proposed by Gregory Bateson.

Purposive Consciousness

"On the one hand," writes Bateson, "we have the systemic nature of the individual human being, the systemic nature of the culture in which he lives, and the systemic nature of the biological, ecological system around him; and, on the other hand, the curious twist in the systemic nature of the individual man whereby consciousness is, almost of necessity, blinded to the systemic nature of the man himself. Purposive consciousness pulls out from the total mind sequences that do not have the loop structure which is characteristic of the whole systematic structure."[8]

The problem we are facing then is rooted in the human specificity of acting in a purposive way. It is just this purposive action that meanwhile leads to obtaining results and to avoiding what would be wise behavior in systemic terms: "It [consciousness] is organized in terms of purpose. It is a shortcut device to enable you to get quickly at what you want; not to act with maximum wisdom in order to live, but to follow the shortest logical or causal path to get what you next want, which may be dinner, it may be a Beethoven sonata, or it may be sex. Above all, it may be money or power."[9]

At a time when human beings are questioning themselves about their goals, these thoughts and preoccupations of Bateson could be a radically antagonistic point of departure in respect to everything that has been said and thought up to now. What Bateson brings into the discussion is really not just the functionalist paradigm of modern design (precisely defined as optimally constructing design and manufacture as a function of its achievement), but also the more general matrix, the purposive consciousness, a factor characterizing the totality of humanity. "But you may say, 'Yes, but we have lived this way for a million years . . . why worry about that? But what worries me is the addition of modern technology to the old system. Today the purposes of consciousness are implemented by more and more effective machinery. . . . Conscious purpose is now empowered to upset the balance of the body, of society, and of the biological world about us."[10]

The discussion of how purposive consciousness—the way it is expressed and is specific to humans—can now relate to the available technological apparatus does not exempt us from an in-depth consideration of the functionalist form that Western culture has assumed in the modern period. This is the form of consciousness that is dominant today, if only because it has been shaped by the technological system that we must use to investigate it. If it is true that the development of technology is coeval with that of purposive consciousness, the extraordinary growth of its power, the acceleration of its rhythms of innovation, is also coeval with the entrance by purposive consciousness into the path of thought, functionalist procedure, and present-day technology that is, for good and ill, the offspring of this thought and this practice.

If, as Bateson writes, "cybernetic nature of self and the world tends to be imperceptible to consciousness, insofar as the contents of the 'screen' of consciousness are determined by considerations of purpose,"[11] the pragmatic content of modern design may be seen as a further distancing of the systemic character of human beings and of their environment, as a further contracting of the screen of consciousness. This very radical simplification of models for comprehending existence is what first science and then technology have reached in their results. The extraordinary "invention" of modern thought consists of simplifying reality to simple and even easily attained goals. The technological performance of modern thought is completely internal at the stage in which the purposive consciousness learns to work with simplified models.

But this way of thinking and operating, which has shown its efficacy over a long period of time, is now beginning to look simplistic and myopic. The continuous fracture of circular and cybernetic structures and their substitution by linear sequences cannot continue forever. The links that have been neglected are reappearing as problems. The grand project of the simplification of reality is showing its limitations. The systemic complexity that was thrown out the window is entering now through the front door. To confront it, to find a type of behavior that can bring up to date our Western idea of doing, we must first develop new models with which to comprehend reality. We need models that will let us understand reality without losing what we have discovered about its irreducible complexity.

The working hypothesis that I propose is to apply to the artificial environment the interpretive models that ecology has developed for the natural environment. In my opinion, the best ground on which to develop this concept is once again found in Gregory Bateson's thought.

The Ecology of the Artificial

"The social scene," writes Bateson, "is nowadays characterized by the existence of a large number of self-maximizing entities which in law have something like the status of persons' trusts, companies, political parties, unions, commercial and financial agencies, nations, and the like."[12]

For Bateson, then, the artificial environment may be read with an ecological model, viewing it as the place of competition among the self-maximizing entities and as the sedimentation of the artifacts produced as the outcome of the activities of these entities. We can understand by the expression "ecology of the artificial" the dynamic equilibrium that is determined among these entities from moment to moment. Coherent with this definition is the view that the search for new environmental qualities can be regarded as the search for a new equilibrium, for a "new ecology of the artificial environment."

To speak of "the ecology of the artificial" then refers to a mode of reading contemporary artificiality as a stream of material and immaterial artifacts, which we call "the system of artifacts," that relates and competes with each other within a limited environment.[13]

The possibility of applying the ecological metaphor to these entities and to the relations among them is established by the fact that, as we have said, they appear as self-maximizing entities, which means that they are endowed, like living creatures, with an impulse toward expanded reproductions of themselves (or better, of the informational programs that characterize them). Obviously, we need to be aware of the differences as well as the similarities between the elements in this comparison, differences that can be attributed to the nonpurposive character of natural evolution as opposed to the purposive character of cultural change and the organization of artificial societies.

With that premise, we must define the adoption of this model and of this terminology in a way that fits reality better than other models already proposed. The first, and perhaps most important contribution, is the consideration of how to make the artificial environment into a complex phenomenon, in which the roles of subjects are recognized and carry weight, without allowing an idea of subjectivity to dominate the entire system. This combination of planning, subjective purposiveness, and systemic relations (determined, to be sure, by more than subjective laws) is the way to look at the production of the artificial environment, which is emerging from the paralyzing grasp of the idea that the artificial human product is a unitary project. This unitary project gives rise to a delirium for power by the designer-demiurge, who

designs and produces a total environment, from a spoon to a whole city. It also supports the view of the artificial that creates itself autonomously, according to laws that have nothing to do with our conscious choice (the weak designer, who goes by the rules of the system in which he or she happens to operate, regardless of what they are, or vice versa, and withdraws into marginal areas of minority criticism and rules). Each artifact, each image, each idea contains something of the rationality, values, and sensibility of the designer, but each is part of a broader and more complex dynamic system—a system in which equilibria and disequilibria, and thus their final quality, depend on conflicts and power relations generated between subsystems and constituent parts, which are vying to guarantee their own existence within set limits.

The second cultural contribution that this ecological model makes concerns the idea of the equilibria and disequilibria of the system, beginning with the impulse of the elements composing it toward an enlarged version of itself.[14] This adversarial vision of equilibrium and the interpretation of the displacement of the preceding equilibrium might be compared to the slippage of a variable in an exponential curve made possible by the slack handling of one of the control variables. It permits, in my opinion, an interesting reading of many phenomena that characterize the production of the artificial environment.

Finally, an awareness of limits is the third important aspect that characterizes an ecological reading of the artificial. We must now pass from a culture that considers itself to be a part of a dynamics of unlimited development to a culture capable of thinking for itself of possible changes caused by limitations. We have already considered some physical limitations (of resources, energy, space) even though we do not yet have in place cultural instruments and operational practices adequate for this new awareness. The concept of limitations, however, emerges in other areas of production and material and immaterial consumption: We have stated that one of the aspects of characterizing our current phase is just this very appearance of limits in our semiotic environment.[15] Given the complex nature of artifacts as physical entities, functional operatives, and communication media, the ecological reading of the system in which they are united cannot neglect an

analysis of the way to integrate these diverse aspects in the environmental problematic.

An Ecological Reading of the Artificial Environment

The ecological reading of the artificial environment is the arena for a close competition between products (which really means producers) in the presence of limitations: limitations endogenous to systems of production and consumption (limitations of physical saturation with respect to quantity, time limitations with respect to their usefulness, economic limitations with respect to their acquisition, cognitive limitations with respect to their intelligibility) and exogenous limitations that arise from the interaction between a system of artifacts and the natural substrate on which it is based.

This type of reading is still in the early stages of development. Nonetheless, we can already observe how, in the presence of the limitations endogenous to the system of artifacts and under pressure of environmental changes due to technological innovations, the strategies for the survival of present "artificial species" make up a series of synthesized changes along certain fundamental lines. We will consider, for instance, three important evolutionary tendencies that are currently at work: (1) the increasing speed of the processes of production and consumption that result in built-in obsolescence and the throw-away nature of many products; (2) the increased sophistication of services that lead to the appearance of "mutable products," which entail diverse and complex services; and (3) the multiplication of linguistic codes in the definition of form that leads to a formal specification of products in relation to precise and limited user groups. The totality of these evolutionary tendencies may be seen as the result of the competition among artifacts in an environment—the industrialized world—in which is manifested, on the one hand, the saturation of more immediate needs, such as the appearance of a physical limitation, and, on the other, the increase in wealth and thus in the availability of objects to purchase.

In evolving along this path, however, the system of artifacts collides with limitations that we have defined as exogenous. On one hand, there are the traditional ecological limitations based on

scarcity of resources and the increasing quantity of environmental wastes (physical pollution). These limitations lead to, or could lead to, a curb especially on the first evolutionary tendency defined above: The acceleration of the processes of production and consumption runs up against limitations set by the lack of resources and the need to eliminate waste products. On the other hand, there are biological and cultural limitations of the subject whose biological nature is poorly adapted to the progressive dematerialization of the objects that it confronts (sensorial pollution) and whose cognitive processes and cultural structures cannot manage the accelerated flood of messages that it is called upon to decipher (semiotic pollution).

The appearance of these limitations induces curbs upon the second and third evolutionary tendencies and will do so to a greater extent in the future; the object can increase its functions but not beyond the point of intelligibility; the object can change form but not beyond limits set by the semiotic codes that make it recognizable.

The Ecology of the Artificial Environment and Subjectivity

Within the conceptual framework just proposed, we may ask why the current artificial environment is so uncontrollable along evolutionary lines. "In biological fact," answers Bateson, "these entities are precisely *not* persons and are not even aggregates of whole persons. They are aggregates of *parts* of persons. When Mr. Smith enters the board room of his company, he is expected to limit his thinking narrowly to the specific purposes of the company or to those of that part of the company which he represents."[16] In other words, the logic of self-maximizing entities is not human because the subjects in which it operates are dehumanized; "Ideally, Mr. Smith is expected to act as a pure, uncorrected consciousness—a dehumanized creature. Mercifully it is not entirely possible, and some company decisions are influenced by considerations which spring from wider and wiser parts of the mind."[17] In this possibility of amplifying the role of "wider and wiser parts of the mind" is found the hope for modifying the behavior of self-maximizing entities, of pursuing new qualities, of definitively producing a "new ecology of the artificial environment."

But what possibility is there that this will happen? The possibilities, in my opinion, are exclusively connected with systemic changes that "the discovery of limitations" necessarily makes the order of the day. Encountering the limitations of the external environment, on the one hand, and those of the "internal environment," on the other, Western thought, as we have said, is forced to discover complexity, to discover something that was always there, to be sure, but that the finalizing consciousness, caught by the hybris of its technological success, did not want to see, the circularity of systems. This is the point in time in which we are now. It is a matter of seeing the paths that lie ahead of us. But first we will make two observations that are perhaps obvious but necessary.

The first is that the purposive character of human consciousness is a specific fact (in the literal sense, a fact about our species) and thus is essentially and basically impossible to eliminate. The thinking ego can also imagine the systemic character of the world. It cannot think and act without self-referentiality, without breaking the connections with the environment and thinking of itself as a separate entity, without in some way finalizing its own ideas and intentions.

The second observation is that history is irreversible, and this is also true for the history of technology. For this reason, even if we do not precisely know how the technological system may evolve, we cannot ignore the historical point at which it has arrived. The technological system of the future can be something other than what it already is. In other words, nostalgia for the past can give rise to different futures but it cannot bring back all the conditions of the past. These two observations, while leaving an infinite range of possibilities, limit the spectrum of theoretical options. At the extremes of possibility are the continuous-technocratic solution,[18] on the one hand, and the development of a culture of limits and complexity, on the other.[19] The first solution consists of not making any important changes. It assumes that new environmental problems can be resolved within the given functionalistic cultural framework by introducing new purposes and goals within the cultural and technological framework that proceeds without any decisive solutions. This, in my opinion, is a pseudo-solution because the same considerations are involved and the same experiences produce as many new prob-

lems as they solve and thus increase the web of problems that sooner or later come to light.

The second solution is also basically a pseudo-solution insofar as human consciousness cannot escape teleology and the rupture of systemic bonds between the individual mind and the environment. Nonetheless, searching to understand the complexity and to act within one's limits can be see as an asymptotic tendency toward a goal that can never be attained but always seems close at hand. Adopting this cultural position requires a profound change in the basis on which design culture is founded and, more generally, in the ethical references of doing.

An Ethics of Doing

The concept of "doing" in the West—given the vast simplifications of which we have spoken regarding a schematic framework—is sustained by two fundamental convictions: that objectives can be clear and can be generalized (progress as historical destiny and the unambiguity of humanity), and that technology can be the material instrument to obtain it. All efforts in this system of certitudes converge toward an unambiguous logical scheme (the realized industrial society) with results that are optimal (being products of objective rationality) and definitive (as advances along the road of progress).

Such was the designer's ethical conduct, in trying to operate coherently within this system of convictions. Today the totality of social and cultural transformations that we have synthesized in the expression "discovery of complexity" has caused a crisis for this system and is giving rise to new frames of reference that are, in many respects, symmetrical to previous values. The central point, in a sense the axis of the new construction, is a new concept of ethics. This ethics does not predicate universal and unquestionable values but refers to a system of values exhibiting the consciousness of relativity, in the context of a general attitude built on the principles of responsibility and solidarity.[20] Responsibility and solidarity are directed toward not only present generations but toward future ones:[21] the responsibility of leaving them an inhabitable world endowed with a range of alternative possibilities analogous to what we have today.

Certainly this implies pursuing the variety and multiplicity of

alternatives and logical considerations from which the artificial environment is constructed.[22] It requires, given the difficulty of being sure of the validity of one's own objectives (and particularly their future validity), the search for choices that present a strong element of reversibility.[23] It furthermore requires more than the search for the optimal, error-free result, the search for "error friendly"[24] solutions that are able to coexist with the human tendency to make mistakes. Finally, it requires bringing the meaning of the opposition "innovation-conservation" back into the discussion: "We must tie the new idea of revolution to the idea of conservation, which we must also purify and diversify. We must conserve nature, conserve cultures that we want to survive, and conserve the human patrimony of the past because it holds the seeds of the future. At the same time, we must revolutionize this method in order to conserve it. We must conserve the idea of revolution by revolutionizing the idea of conservation."[25]

The problem at hand is in presenting these general signs in such a way that they can constitute a guide for action, not only for big strategic choices but also for small daily choices, choices by which people (particularly designers) habitually act. In terms of degrees of diffuse intervention in the environment, the general features of the new ethical context in which human doing may be arranged, can be synthesized in the following way: One passes from a "culture of doing as production" to one of "doing as re-production." It concerns moving toward a production culture in which human activity has as its primary objective the regeneration of conditions that permit, and will continue to permit, the continuation of existence, a culture that assumes as its principle ethical foundation leaving an inhabitable planet, rich in possibilities, to all the generations after ours. This will be translated into quotidian practice in the way in which the processes of production and consumption occur on a wide scale.

Doing as Reproducing

The culture of "doing as producing" is developed through the use of linear processes: Production and consumption are linked together in a long chain with natural resources on the one end and waste products at the opposite. Thus, it is a product culture that is founded on a simple system in which relatively few variables

operate, the variables influencing the economy of production and those connected to product function in relation to the end user. The culture of "doing as reproduction," on the other hand, presupposes a system that is intrinsically more complex because the line of material transformations tends to close in upon itself, forming a circle: What we start off with always gives us what we end up with and should, in turn, foretell what will be done (insofar as it becomes a "resource" for a successive cycle). This requires the recognition of a greater number of variables (the feedback arising from various phases of the product's life cycle) and demands greater attention, care, and participation on the part of all concerned, not just the designers and producers, but the consumers as well. It also demands a new aesthetics that attributes worth to materials and products that in some way are able to embody vestiges of their earlier existences.

Our present culture is certainly a long way from all this. There are some positive indications,[26] but we lack a broader vision in which these weak signals can be collected and strengthened, a vision that tries to conceive of basic motivations and possible outlets for a new culture and for the new social practices that it necessitates. What is lacking, moreover, is this very capacity to visualize the socioenvironmental schemes that the culture of reproduction could generate. Thinking of the way in which today we speak of the environmental thematic, one perceives that present-day language is still linked to expressions such as "environmental emergency" and "resource crises." These expressions are descriptive of the stupefaction of discovering unforeseen barriers and the uneasiness created by the prospect of renouncing some hypothetical future Land of Cockaigne where the culture of doing as producing had been foretold. Today we know that this Land of Cockaigne is an illusion—no technological discovery, not even the most optimistic hypotheses of new limitless availability, will ever produce a world without limitations.

But the idea of a limited world does not necessarily mean a world of privations. Privation does not refer to absolute values, to not reaching a qualitative "objective" standard. Rather, it refers to the lack of something in relation to a conventional model that is historically and culturally defined. A society that lives within its limits, then, needs a culture that proposes models of quality that are compatible with given limitations, a culture in which the

theme of quantity is integrated with that of quality, and the criterion of beauty includes respect for the environment. It is in such a frame that the practices of reproducing and regenerating can be assumed as the highest and most mature expression of human endeavor. Making this "visible," producing new scenarios for quality, can be a specific task for designers. In my opinion, it is really their most specific task.

Visions of Possible Worlds

The designer's ecological attitude, the attempt to translate personal values into design activities, can take place on diverse levels: from the selection of material that is nonpoisonous and recyclable, to the proposal of new products endowed with the best environmental qualities, to the proposal of new schemes for quality. If it is true that there is a lot to do at each of these levels, it seems to me, however, that especially in relation to the proposal of new schemes the designer's task may be as fundamental as it is somewhat impractical.

At this level of activity, the designer is not so much a professional capable of solving given problems, as a cultural figure in the process of creatively linking the possible with the hoped-for in visible form. To take a specific example, the designer provides scenarios that visualize some aspects of how the world could be and, at the same time, presents it with characteristics that can be supported by complex ecological equilibria, which are acceptable socially and attractive culturally.

This is the great challenge that design culture must be able to meet: If science and technology march under the banner of "everything is possible," design culture must know how to point out a path for these potential possibilities, a path that can be completely opposed to that which technological-scientific development has followed up to now, a path whose scenarios prefigure results.

The question is complex and slippery; the danger is in falling into the demiurgic delirium (so typical of modern thought) of redesigning the world. Thus, to better explain my proposal and to synthesize some passages that I have espoused above, I will make the following points, beginning with the presuppositions on which they are based:

1. The strategic solution to the environmental problematic is the intervention from above in the production and consumption system and in redesigning the system based on new values.

2. The more "from above" this intervention is, the more it calls into question sociocultural aspects, the more it associates them with ideas and anticipated structures of the social imagination.

3. The ecological reorientation of the social imagination and the successive reorganization of the processes of production and consumption can occur either through the force of fear or by the attraction of new possibilities. In the latter case, which is obviously the more desirable, change is produced by attraction that can act upon new proposals of quality and is thus based on the image of new lifestyles that are socially and culturally appreciable.

4. A weakness of ecological culture and of contemporary design culture is the difficulty in developing images (or fragments of images) that can set forth the poles of attraction cited in the preceding point. Certainly, possible motive forces for a transformation aimed at systems of production and consumption can be established, based on a new criteria of quality.

5. The social imaginary, such as it is, cannot be the object of design; it emerges from dynamic complexes of sociocultural innovation in which a plurality of actors play a part. In this framework, however, designers have an important role insofar as they are—or can be—culturally equipped to gather, interpret, and propose, in a clearer and more stimulating form "into the circle" ideas that are produced in society and to readmit them.

6. The processes in the formation of the social imaginary are intrinsically involved with the historical phases in which they occur. The current age may be characterized as that in which industry has reached its maturity, modern thought has lived through its crisis, and a new culture has come into being, a culture capable of considering the complexity of the system and of facing limitations. No possible hypothesis of a new environmental scheme can ignore this framework and the ways in which ideas and visions of the world are generated and propagated internally.

7. New environmental schemes cannot be proposed in terms of unitary representations, as likenesses of closed worlds. Instead, one must find guiding ideas that constitute exemplars of quality and that are potential generators of an extensive totality of solutions that are diverse but coherently organized in certain respects.

It is desirable that design culture advance a plurality of possibilities, diverse socioenvironmental schemes. For my part, I want to finish by presenting one that seems particularly suggestive to me: to think of objects not as instruments for our use, but as entities that are effectively linked and that need care—to think of objects as plants in our garden.

A Garden of Objects

Today we live in a world of objects designed for rapid consumption, objects requiring a minimum of effort and attention to use them, but also objects requiring a minimum of effort and attention to use them, but also objects that leave no lasting impression on our memories—a throw-away world that requires no effort but, at the same time, produces no real quality.

Now imagine a garden with flowers and fruit trees. Think of the attention, time, and energy required, and think of the results: flowers and fruit. For those who have grown them, value cannot be measured in banally economic terms. Of course, a garden should produce flowers and fruit, but the person tending it does so for a more general reason—love of the plants. Now try to imagine an analogous relation between objects. Think of objects that are beautiful and useful as trees in your own garden, objects that endure and have lives of their own, objects that perform services and require care.

If the more general role of design is to produce images of an inhabitable world, one way is to propose criteria of quality that have as reference points the garden and the care that it requires. I am thinking of criteria for quality that lead to a system of objects that have the variety, complexity, life, and blend of beauty and utility of a garden but, at the same time, are a product of the real world, a world extensively and intensively artificial.

It is not simple; following this indication implies overturning the way design traditionally is more highly regarded than production. It implies an inversion of the relation between subjects and objects. It implies a purposive consciousness that profoundly redefines the sense of its goals. It implies a new ecological sensibility—caring for objects can be a way of caring for that larger object that is our planet.

Notes

1. The problems of the relation between technology and ethics are already the subject of a lengthy debate, beginning with Heidegger's reflections and continuing in the recent controversies on bioethics. The articles and bibliographies in *Prométhée éclairé* (a special number of *Informel* 3, no. 2 (Summer 1990) offer a vast and interesting survey of this argument.

2. The articulation of the relation between technology and ethics at the design level of industrial products and, particularly, of consumer goods, is touched on by some design theoreticians. I would particularly mention two authors, Victor Papanek and Tomás Maldonado. See Tomás Maldonado, *La speranza progettuale* (Turin: Einaudi, 1970); Maldonado, *Il futuro della modernità* (Milan: Feltrinelli, 1987); Maldonado, *Cultura, democrazia, ambiente* (Milan: Feltrinelli, 1990); and Victor Papanek, *Design for Human Scale* (New York: Van Nostrand Reinhold (1983). Other texts on this theme include Mary Douglas and Baron Isherwood, *The World of Goods* (New York: Basic Books, 1979); Donald A. Norman, *The Psychology of Everyday Things* (New York: Basic Books, 1988); Gilbert Simondon, *Du monde d'existence des objets techniques* (Paris: Editions Montaigne, 1958). See also my book, *Artefatti: Verso una nuova ecologia dell'ambiente artificiale* (Milan: Edizioni Domus Academy, 1990).

3. This phenomenon of change is treated by numerous scholars who concentrate on different aspects. Among the first authors who described it was Alvin Toffler. See Toffler, *Future Shock* (London: Pan Books, 1970); and *The Third Wave* (London: Pan Books, 1981). Another author of particular interest is Paul Virilio. See his *Vitesse et politique* (Paris: Editions Galilée, 1977); *L'espace critique* (Paris: Christian Bourgois Editor, 1984); and *La machine de vision* (Paris: Edition Galilée, 1988); see also Ezio Manzini, *La materia dell'invenzione* (Milan: Arcadia, 1986); Manzini, *Artefatti*.

4. The theme of "superficialization" and "dematerialization" in the experience of objects has been treated from different points of view. See Virilio, *Vitesse et politique; L'espace critique;* and *La machine;* Jean Baudrillard, *L'autre par lui-même* (Paris: Galilée, 1987); Fredric Jameson, "Postmodernism or the Cultural Logic of Late Capitalism," *New Left Review,* no. 146 (July–Aug. 1984): 59–92; "Machines Virtuelles," *Traverses* 44–45 (1988); *Les chemins du virtuel* (special number of *Cahiers du CCI,* 1989). More general philosophical aspects of this theme were central to the exhibition "Les Immateriaux," which was held at the Centre Georges Pompidou in Paris in 1985. See also: F. Carmagnola, *La visibilità* (Milan: Guerini, 1989).

5. For example, in regard to the problem of the reduction of waste products, one must introduce some considerations of recyclability into the very first design phases and follow not only the strategies of "design for assembly," but also those of "design for disassembly."

6. Ugo Volli recently proposed the concept of "semiotic ecology," a semiotic space that is relatively enclosed, in which messages, texts, and codes cooperate and compete at the same time. "We're condemned to live in the midst of our

own messages, texts, codes, our semiotic waste, and we aren't free to reestablish them, to give them the meaning that they have lost without paying a price for this in further increasing entropy." Ugo Volli, *Contro la moda* (Milan: Feltrinelli, 1988), p. 149.

7. In other words, the multiplication and continuous transformation of forms, colors, and textures of objects can lead to the impossibility of reading any real difference and any real meaning in them. So it can follow that all these colorations and extravagances form a complex image that is confused, gray, and flat. This difficulty in decoding the language of things is a fundamental aspect of what we may define as "semiotic pollution." This is precisely what is happening today: The multiplication and change in products are going forward at a rate that far exceeds the subjective capacity to develop codes that permit reading their possible significance. The problem is not simply in the object itself (and the meaning that the designer tried to give it) but in the knowledge that the object relates to other objects, with the semiotic environment in its totality.

8. Gregory Bateson, *Steps to an Ecology of Mind* (New York: Ballantine Books, 1972).

9. Ibid., pp. 433–34.

10. Ibid., p. 434.

11. Ibid., p. 444.

12. Ibid., p. 446. Other authors have considered the theme of the artificial using ecological models. See P. Degli Espinosa, "Può la società umana produrre l'equivalente di una barriera di Weissmann?" in *Oikos* no. 1 (1990): 193f; Manzini, *La materia dell'invenzione,* pp. 76f. Close to this attitude are product analyses in terms of "populations." One may speak of their demography and sociology. See Abraham Moles, *"Objet et communication,"* *Communications* no. 13 (1968): 10f; Maldonado, *La speranza progettuale,* pp. 68f.

13. Some clear definitions of the formulation just introduced are in order. Whenever we consider reality in systemtic form, the problem arises of the definition of limits, of the frontiers of the system itself and of those that constitute its "evolutionary unity." (This is certainly true of the elementary entities whose survival is being considered.) In our case, the frontiers of the system considered are set by the environment, which has been transformed by the technicocultural activities of human beings; among these are physical artifacts (objects) but also immaterial artifacts such as services, language, and ideas. Let us consider artifacts in terms of "evolutionary unity." In speaking of artifacts and their competition for survival, we see that this really means referring in a synthetic form to their sociocultural entities and to their competition for survival. The artifacts that we can consider from time to time are really a kind of materialization of cultural contexts, organizing forms, technological systems, economic systems, and of the will of designers, groups of designers, contractors, and the manufacturing sector.

14. "Any species that does not potentially produce more young than the number of the population of the parental generation is out. . . . But, if every species has potential gain, it is then quite a trick to achieve equilibrium. All sorts

242 *Ezio Manzini*

of interactive balances and dependencies come into play. The Malthusian curve is exponential. It is not inappropriate to call this the population *explosion*. On the other hand, in a balanced ecological system whose underpinnings are of this nature, it is very clear that any monkeying with the system is likely to disrupt the equilibrium. Then the exponential curves will start to appear. Some plants will become weeds, some creatures will be exterminated; and the system as a balanced system is likely to fall to pieces. In society, the same is true. I think you have to assume that all important physiological or social change is in some degree a slipping of the system at some point along an exponential curve. The slippage may not go far or it may go to disaster." Bateson, *Steps to an Ecology of Mind,* pp. 430–31.

15. As we have seen, this means not only dynamics in the immaterial semiosphere of printed or broadcast communications but also in that part of the semiosphere in which communication is supported by physical artifacts, the relation of collaboration or competition that is established between objects insofar as they are themselves media for communication.

16. Bateson, *Steps to an Ecology of Mind,* p. 446.

17. Ibid.

18. This position is the most widespread within contemporary technico-economic propaganda and corresponds to the position technocratic structures tend to espouse when it is no longer possible to ignore the reality and gravity of environmental problems.

19. The "discovery of complexity" has constituted one of the central themes of the philosophical and scientific debate of the past few years. Since it is impossible to cite all the literature on this theme, I'll mention in particular a book that has been a starting point for discussion in Italy: Germano Bocchi and Marco Cerruti, eds., *La sfida della complessità* (Milan: Feltrinelli, 1985). The following are also particularly interesting: Marco Cerruti and E. Laszlo, eds., *Physis: abitare la terra* (Milan: Feltrinelli, 1988); and Cerruti, *Il vincolo e la possibilità* (Milan: Feltrinelli, 1986).

20. The theme of ethical responsibility has been dealt with by several authors. See, for instance, Salvatore Veca, *Una filosofia pubblica* (Milan: Feltrinelli, 1986); Veca, "La nozione di progresso in etica" in Cerruti and Laszlo, *Physis;* Giorgio Ruffolo, *Potenza e potere: La fluttuazione gigante dell'Occidente* (Bari: Laterza, 1988).

21. The theme of responsibility for future generations has become fundamental because the potential of our present technological system is such that today's choices may determine tomorrow's global environmental system in the sense that their results can have irreversible consequences for the planet.

22. Bocchi, Cerruti, and Morin describe a "design ecology" in this way: "It is not necessary that a global project be dependent on a central concern; in many cases, the net of various local projects, whose heterogeneity of nature and of scale is not eliminated, but, on the contrary, employed to full advantage, becomes the fundamental reason for the proper functioning of a global system which means taking the phenomenological complexity of human existence seriously." Bocchi,

Cerruti, Edgar Morin, *Turabare il futuro* (Milan: Moretti and Vitali, 1990), p. 81.
The theme of the articulation of the logical principles on which the artificial
environment is built is discussed in many essays by Andrea Branzi. See especially
Branzi, *Pomeriggi alla media industria* (Milan: Idea Books, 1988).

23. At a time in which the relativity of values and the subjectivity of points
of view are coming to the fore, a positive criterion for the orientation of design
choices that will impinge on the future (see note 21) is one that will allow suc-
cessive generations to change their ideas and to select other solutions.

24. In this light, the design criterion is not so much one that claims to set
right possibilities arising from error but one that, admitting the impossibility of
setting them right, proposes resilient solutions that can adapt themselves to in-
evitable errors. On this topic see Ernst and Carl von Weizsacker, "Come vivere
con gli errori? Il valore evolutivo degli errori," in Cerruti and Laszlo, *Physis*.

25. Bocchi, Cerruti, Morin, *Turabare il futuro,* p. 267.

26. A total picture of the sociocultural innovation of the 1980s and 1990s is
found in Francesco Morace, *Contròtendenze* (Milan: Edizioni Domus Academy,
1990).

Appendix
DISCOVERING DESIGN
A Conference Report

Victor Margolin and Richard Buchanan

Chicago has become an important center of design thinking in
recent years because of the cooperative activities of a number of
scholars, researchers, and practicing designers. Through ongoing
discussions and small conferences, these individuals have become
part of an informal "Chicago group" comprised of experts in
fields such as history, industrial and graphic design, philosophy,
rhetoric, sociology, marketing, and psychology. The central inter-
est of the group is to encourage reflection on the theory and prac-
tice of design from a wide variety of perspectives. This is based on
a shared belief that out of a plurality of voices will come new ideas
for the study and practice of design. Where other groups have
formed around one or another narrow definition of design and
attempted to develop it in exclusion of alternative possibilities,

This report was written shortly after the conference in order to disseminate its results
to colleagues in the United States and abroad. It was published initially as "Discovering
Design," in *Design Studies* 12, no. 3 (July 1991): 189–91; and then in *Revue Sciences et tech-
niques de la conception* 1, no. 2 (1992). The report gives the flavor of the conference and
locates the event within the discussions of an informal Chicago group which is less active
now than it was in in 1990. —*Eds.*

the Chicago group has deliberately chosen to focus on concrete problems and attempted to promote conversations made more productive precisely because of the inclusion of alternative viewpoints on those problems.

On November 5–6, 1990, the University of Illinois at Chicago hosted a small international conference entitled "Discovering Design." The goal of the conference, organized by Richard Buchanan and Victor Margolin, was to broaden contemporary dialogue about design among practicing design professionals and individuals from a wide variety of academic disciplines. The twenty-five invited participants included experts in history, sociology, rhetoric, critical theory, cultural studies, social psychology, philosophy of technology, and political theory, as well as practitioners in fields such as industrial design, software development, and marketing. Adding to the variety of the group, participants came from seven countries: the United States, Canada, Australia, France, England, Norway, and Italy. Under ordinary circumstances, it is unlikely that such a diverse group would ever meet together. But the emergence of design thinking in recent years, with important interdisciplinary significance, has led to the discovery of many unexpected connections and mutual interests.

The conference was organized around four central themes that those concerned with the study and practice of design will likely explore in the coming years. Papers developing these themes were presented in five working sessions, and each session included an extensive discussion period.

The first session focused on design and innovation in the content of products, the ways in which products can serve as devices for the inventive exploration of experience, and the extent to which well-designed products enable users to become part of ongoing, living design in everyday life.

The second session featured design and the relation of products to changing material, social, and cultural conditions. Here the emphasis was on the contingencies of objective situations in which products are made and used.

The third and fourth sessions foregrounded design and action. The concern was with how products can be made consonant with the qualities of human action and how they can be integrated into the lives of users. The fifth session featured design

and values. Presenters explored the relation between design and individual, cultural, and social values.

The organizers selected fourteen papers for presentation from the many initial proposals submitted. These papers represented distinctly different perspectives on the nature of design and on the broad themes identified by the conference organizers. Individuals not presenting papers participated as moderators or discussants in the lively conversation periods of each session.

In the first session, Richard Buchanan, a specialist in the history and philosophy of rhetoric, helped to set one of the conference's directions by discussing the sense in which design thinking is emerging in the twentieth century as a new liberal art of industrial culture, serving to connect theory and practice in many new ways for productive purposes. He discussed the transformation of design thinking from the early days of the New Bauhaus in Chicago, when Laszlo Moholy-Nagy invited philosopher Charles Morris from the University of Chicago to establish a liberal arts program as part of the New Bauhaus design curriculum, to Herbert Simon's definition of design as the science of the artificial, a view which influenced the reformed curriculum of the new Carnegie Mellon University. He noted how design thinking, emerging around the four disciplines of communication, construction, decision making, and systemization, is transforming design from a narrow trade skill and a professional specialization into a new art of conceiving and planning the artificial.

On the theme of innovation, Daniel Cheifetz, the president of a software development firm, spoke about his aim to create software that could become transparent to the user by integrating so well with the user's own psychic and intellectual functioning that it would no longer be noticed. Tufan Orel, a French sociologist who has studied a class of new products that are used for self-diagnostics, self-transformation, and related purposes, outlined some of the ways that such products are related to larger processes of social change.

Speakers in this session had not only applied the theme of innovation to new products for use. Buchanan had considered design itself as a product whose conception required the same mode of innovative thought. This attempt to rethink design proper was also to appear in presentations by others and it became one of the strands that ran through the conference. Cheifetz, in fact, had

made reference in his presentation to flexible software that turned the user into a designer.

The references that Orel and Cheifetz made to products that invited more engagement from users was echoed in the next session by philosopher Albert Borgmann, who spoke about "deep design," by which he meant design that could enable users to recover a new depth of interaction. Inherent in Borgmann's presentation was the proposition that well-designed products, which included cities as well as more personal objects, could be instruments to help users achieve human happiness.

From the designer's perspective, Gianfranco Zaccai also addressed the topic of user satisfaction, raising the question of why industrial objects do not provide the same gratification as craft objects. He exposed some of the problems in the product development process and argued that designers need to reclaim the generalist role from marketing experts.

Langdon Winner, a political theorist, broadened the categories of experience that include design. He posited that political theory, architecture, and engineering all contain extremely different approaches to the practice of design, and then proposed that a new field of research, political ergonomics, be established to study the appropriate fit between technology and social organization.

This move to broaden the definition of design beyond what professional designers do surfaced a number of times during the conference. What seemed to be at stake was the expectation that design as a concept could have much wider applications in humanistic thought than has been previously recognized. For Winner, as a theorist, and Zaccai, as a practitioner, "design" was a term that cut across different practices and could thus be used to draw unifying elements from them.

Both speakers in the next session, on design and action, addressed the questions of how products come into being through action as well as how they enable users to act. John Heskett, a design historian and theorist, spoke about the conditions of creating products in industry, stating that a harmonious blend of talents was necessary in order to produce products of quality. Recognizing the power struggles that often take place in industry between professionals with competing points of view, Heskett identified design as the horizontal linkage to all aspects of product planning.

The second speaker, Victor Margolin, also a design historian and theorist, explored the broad question of how design relates to action in society as a whole. He designated two relations of design to action: design itself as a form of action, and design as a means to enable the actions of users. Using the phenomenological theory of Alfred Schutz, he identified design as an intersubjective practice which never occurs outside the context of its relation to the action of others.

By the end of the first day, a number of common themes had surfaced in the different presentations, and the conferees were beginning to engage the speakers and each other more actively. On the second day, this engagement intensified and the normal restraints of disciplinary difference no longer prevailed. The morning session continued the theme of design and action. Clive Dilnot, a cultural theorist, was concerned with the limitations of thought that obstruct the revelation of an object's full meaning. According to Dilnot, the act of making things is always marginalized by thinking, which is regarded as a superior way of knowing. For Dilnot, the object is not dumb; it has subjective identity that gives it a much more powerful role in social life.

Nigel Cross, a professor of design studies, focused on the question of design ability, what it is and how it is cultivated. Cross claimed that such ability is a form of intelligence, has distinctive features, is possessed by everyone, can be described, and can also be damaged or lost. Here he brought another dimension to the theme, raised by others, that designing is a much wider activity than what professionals do.

Augusto Morello, a marketing consultant and design educator from Milan, returned the locus of inquiry to industry. For Morello, the market is an arena of performance where users find meaningful products. He defined products and their use as an essential part of culture, which was a theme proposed by other speakers in different ways. Morello outlined a sophisticated semiotic method for analyzing a product or service according to its semantic, syntactic, pragmatic, and symbolic identity. Such a method, as Morello demonstrated by using a knife as an example, can enable manufacturers to think much more consciously about a product or service and its use.

While issues of ethics were implicit in all the presentations at

the conference, it was only in the last session, on design and ethics, that the topic was explicitly addressed. Carl Mitcham, a philosopher of technology, addressed the difficulties of trying to link ethics and design. In fact, he argued for a separation of the two, claiming that design is its own action and that truth and morality are imposed on it from without.

Mitcham's argument was directly relevant to the case study of green design in Scandinavia, presented by Fredrik Wildhagen, a design historian and theorist from Oslo. Wildhagen explored the question of why Scandinavian designers had not more actively taken up the green challenge, raising the question, put forth in Mitcham's presentation, of how to put an ethical value on this situation.

In the final presentation of the conference, Tony Fry, a cultural theorist from Sydney, argued for a "sacred design" that was essential to human survival. Fry's postulation of a new design paradigm, contradictory to Mitcham's intent to separate design from ethics, provoked a heated debate about the relation of ethics to action while at the same time uniting the conferees around two topics—ethics and design. Fry's presentation came at a point in the conference when the participants had already tacitly agreed that design was a common subject even though no one had tried to mark it out with a single definition.

It was, in fact, the refreshing lack of definitions and constricting propositions that characterized the open process by which the conferees coalesced into a community of inquiry. Through a process of pluralistic investigation, all had identified a common topic and, as the intense response to the final paper indicated, had begun to invest in characterizing it. At stake in this process was the opportunity to bring one's own knowledge to bear on a set of problems that were located outside any single discipline. The organizers had specifically chosen broad themes in order to provide space for different kinds of contributions. The conference demonstrated that an engaging set of problems can overcome the disciplinary constraints that often prevent a pluridisciplinary conversation.

Discovering Design also made clear that *design* is a much broader topic than is usually recognized. If, as some conferees argued, there is much at stake in the way we design and constitute

designing as a social activity, then we need a better knowledge of what design is, as well as how we might do it. Theory and practice need not be constructed as separate activities, and professional designers need not operate in a distinct sphere from nonprofessionals. As a number of speakers proposed, reflection on practice can be deepened as a way of making better products.

There was no consensus on what the conference accomplished other than that it served as a process of inquiry which all the conferees found satisfying. However, a number of themes appeared repeatedly, though in different guises. Most significant was the theme that design is a widely practiced activity which is not confined to professionals. Buchanan sought the intellectual underpinnings for this in his characterization of design as a liberal art, and Winner did something related by suggesting the need for a political ergonomics. Cross stated that everyone has design ability, and Margolin argued that design is a form of action that corresponds to the human propensity to plan. Mitcham sought to extract design from a specific sociocultural context and examine it as an activity in its own right.

As a corollary to the proposition that design is a widespread activity, the theme of the conscious user surfaced in presentations by Cheifetz and Orel, discussing the user's relation to new products; in Borgmann's quest for design that engages the user at a deep, fulfilling level; and in Morello's description of the user's behavior in the marketplace. Related to this was the theme that products are not dumb objects but instead have the capacity to engage users and suggest action. Several speakers referred to the propositional quality of products. Dilnot wanted to abolish the distinction between subject and object, while Fry envisioned products as bringing about a set of new ethics.

And last, a theme addressed by Heskett and Zaccai, as well as Morello, was that design, clearly articulated, was the activity that could unify the complex process of industrial production. Related to this theme was Wildhagen's case study of why Scandinavian designers had not taken a greater leadership role in creating a new "green" quality in industrial products.

As an outcome of Discovering Design, the organizers have prepared the collection of the conference papers for publication. As well, there will be other meetings with varying groups of

people. The conference made it evident that a new process of inquiry has begun. This inquiry has room for participants from diverse disciplines and practices. Its results can form the basis of a new field—design studies—where problems of design can be discussed in an open and unfettered way.

About the Contributors

ALBERT BORGMANN is professor of philosophy at the University of Montana.

RICHARD BUCHANAN is professor of design and head of the Department of Design at Carnegie Mellon University, and editor of the journal *Design Issues*.

NIGEL CROSS teaches in the design discipline of the faculty of technology at the Open University in Great Britain and is general editor of the journal *Design Studies*.

TONY FRY is senior lecturer at the University of Sydney, Australia, and director of the EcoDesign Foundation.

EZIO MANZINI is professor of environmental design at the Politecnico di Milano and vice president of the Domus Academy.

VICTOR MARGOLIN is associate professor of design history at the University of Illinois at Chicago and editor of the journal *Design Issues*.

CARL MITCHAM is associate professor and director of the Science, Technology, and Society Program at Pennsylvania State University.

AUGUSTO MORELLO is a marketing consultant in Milan, Italy.

TUFAN OREL is a consultant to the research association EuropIA, located in Paris.

LANGDON WINNER is professor of political science at Rensselaer Polytechnic Institute.

GIANFRANCO ZACCAI is an industrial designer and head of the firm Design Continuum, Inc., located in Boston.

4050